DESIGN BASICS

DAVIDA. LAUER / STEPHEN PENTAK

Professor Emeritus, The Ohio State University

EIGHTH EDITION

Design Basics, Eighth EditionDavid A. Lauer, Stephen Pentak

Publisher: Clark Baxter

Senior Development Editor: Sharon Adams

Poore

Assistant Editor: Ashley Bargende Editorial Assistant: Elizabeth Newell

Media Editor: Kimberly Apfelbaum

Executive Marketing Manager: Diane

Wenckebach

Marketing Coordinator: Loreen Pelletier

 $Senior\ Marketing\ Communications\ Manager:$

Heather Baxley

Senior Content Project Manager: Lianne Ames

Senior Art Director: Cate Barr

Print Buyer: Julio Esperas

Rights Acquisition Specialist: Mandy Groszko

Production Service: Lachina Publishing Services

Text Designer: Anne Carter Cover Designer: Anne Carter

Cover Image: Howard Hodgkin, detail from *You Again*, 2001. © Howard Hodgkin, courtesy

Alan Cristea Gallery, London.

Compositor: Lachina Publishing Services

© 2012, 2008, 2005 Wadsworth, Cengage Learning

ALL RIGHTS RESERVED. No part of this work covered by the copyright herein may be reproduced, transmitted, stored, or used in any form or by any means graphic, electronic, or mechanical, including but not limited to photocopying, recording, scanning, digitizing, taping, Web distribution, information networks, or information storage and retrieval systems, except as permitted under Section 107 or 108 of the 1976 United States Copyright Act, without the prior written permission of the publisher.

For product information and technology assistance, contact us at Cengage Learning Customer & Sales Support, 1-800-354-9706

For permission to use material from this text or product, submit all requests online at www.cengage.com/permissions
Further permissions questions can be emailed to permissionrequest@cengage.com

Library of Congress Control Number: 2010932861

ISBN-13: 978-0-495-91577-5

ISBN-10: 0-495-91577-7

Wadsworth

20 Channel Center Street Boston, MA 02210 USA

Cengage Learning is a leading provider of customized learning solutions with office locations around the globe, including Singapore, the United Kingdom, Australia, Mexico, Brazil and Japan. Locate your local office at international.cengage.com/region.

Cengage Learning products are represented in Canada by Nelson Education, Ltd.

For your course and learning solutions, visit www.cengage.com.

Purchase any of our products at your local college store or at our preferred online store **www.cengagebrain.com**.

ABOUT THE COVER ART

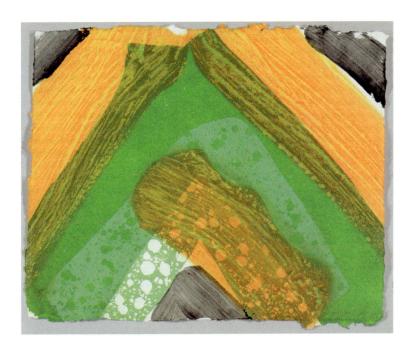

HOWARD HODGKIN

You Again. 2001. Hand-painted, etching, aquatint, caborundum; image size: 11" \times 1' 2"; paper size: 11" \times 1' 2". Edition of 50.

Howard Hodgkin was born in London in 1932 and attended Camberwell School of Art and the Bath Academy of Art, Corsham. In 1984 he represented Britain at the Venice Biennale and in the following year won the Turner Prize. He has exhibited internationally for over four decades, and his work is included in major public and private collections all over the world.*

The hand-painted print *You Again* shows Hodgkin's characteristic concern for explicit marks or brush strokes and an attention to the border or boundary of the composition. The image on the cover of this book is a detail, and the decision to crop the image was a compromise. The rough border would look trapped against the hard edge of the cover, so better to crop it and let the shapes appear to move in an unbounded energy. These bold strokes appear to continue beyond the edge of the book. The cover design includes the title and author of course, and this provides an anchor to the composition.

Here on this page you can see the artist's work, in its full and original format.

CONTENTS

Part 1 **DESIGN PRINCIPLES**

CHAPTER

DESIGN PROCESS 2

INTRODUCTION

Design Defined 4

PROCEDURES

Steps in the Process 6

THINKING

Getting Started 8
Form and Content 10
Form and Function 12

LOOKING

Sources: Nature 14 Sources: Artifacts 16

Sources: History and Culture 18

DOING

Thinking with Materials 20 Doing and Redoing 22

CRITIQUE

Constructive Criticism 24

CHAPTER

2

UNITY 26

INTRODUCTION

Harmony 28 Visual Unity 30

GESTALT

Visual Perception 32

WAYS TO ACHIEVE UNITY

Proximity 34
Repetition 36
Continuation 38
Continuity and the Grid 40

UNITY WITH VARIETY

The Grid 42
Varied Repetition 44
Emphasis on Unity 46
Emphasis on Variety 48
Chaos and Control 50

UNITY AT WORK

Figurative and Abstract 52

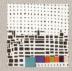

EMPHASIS AND FOCAL POINT 54

INTRODUCTION

Attracting Attention 56

WAYS TO ACHIEVE EMPHASIS

Emphasis by Contrast 58 Emphasis by Isolation 60 Emphasis by Placement 62

DEGREE OF EMPHASIS

One Element 64

ABSENCE OF FOCAL POINT

Emphasizing the Whole over the Parts 66

CHAPTER

SCALE AND PROPORTION

INTRODUCTION

Scale and Proportion 70

SCALE OF ART

Human Scale Reference 72

SCALE WITHIN ART

Internal References 74 Internal Proportions 76 Contrast of Scale 78

MANIPULATING SCALE AND PROPORTION

Surrealism and Fantasy 80

PROPORTION

Geometry and Notions of the Ideal 82 Root Rectangles 84

CHAPTER

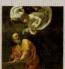

BALANCE 86

INTRODUCTION 88

IMBALANCE

Horizontal and Vertical Placement 90

SYMMETRICAL BALANCE

Bilateral Symmetry 92 Examples from Various Art Forms 94

ASYMMETRICAL BALANCE

Introduction 96 Balance by Value and Color 98

Balance by Texture and Pattern 100 Balance by Position and Eye Direction 102 Analysis Summary 104

RADIAL BALANCE

Examples in Nature and Art 106

CRYSTALLOGRAPHIC BALANCE

Allover Pattern 108

CHAPTER

RHYTHM 110

INTRODUCTION

Engaging the Senses 112 Visual Rhythm 114

RHYTHM AND MOTION

Shapes and Repetition 116

ALTERNATING RHYTHM

Patterns and Sequence 118

PROGRESSIVE RHYTHM

Converging Patterns 120

POLYRHYTHMIC STRUCTURES

A Study in Contrast 122

Part 2 **DESIGN ELEMENTS**

CHAPTER

LINE 126

INTRODUCTION

A Point Set in Motion 128

LINE AND SHAPE

Defining Shape and Form 130

TYPES OF LINE

Actual, Implied, and Psychic Lines 132

LINE DIRECTION

Horizontal, Vertical, and Diagonal Lines 134

CONTOUR AND GESTURE

Precision or Spontaneity 136

LINE QUALITY

Creating Variety and Emphasis 138

LINE AS VALUE

Using Lines to Create Dark and Light 140

LINE IN PAINTING

Outline of Forms 142 Explicit Line 144

LOST-AND-FOUND CONTOUR

Suggestions of Form 146

INHERENT LINE

Structure of the Rectangle 148

CHAPTER

8

SHAPE 150

INTRODUCTION

Shaping Perception 152

PREDOMINANCE OF SHAPE 154

VOLUME/MASS

Working in Two and Three Dimensions 156

NATURALISM AND DISTORTION

Exaggerated Shapes 158

NATURALISM AND IDEALISM

Nature and Aspiring to Perfection 160

ABSTRACTION

Essence of Shape 162

NONOBJECTIVE SHAPES

Pure Forms 164

CURVILINEAR SHAPES 166

RECTILINEAR SHAPES AND COMBINATIONS 168

POSITIVE/NEGATIVE SHAPES

Introduction 170 Isolation or Integration 172 Emphasis on Integration 174 Ambiguity 176

CHAPTER

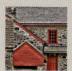

PATTERN AND TEXTURE 178

PATTERN

Creating Visual Interest 180 Order and Variety 182

TEXTURE AND PATTERN

Similarities and Differences 184

TEXTURE

Creating Visual Interest 186

TACTILE TEXTURE

Actual and Implied 188 Collage 190

VISUAL TEXTURE

Verisimilitude and Trompe L'oeil 192

CHAPTER 1

ILLUSION OF SPACE 194

INTRODUCTION

Translating Space to Two Dimensions 196

DEVICES TO SHOW DEPTH

Size 198
Overlapping 200
Vertical Location 202
Aerial Perspective 204
Plan, Elevation, Perspective 206

Linear Perspective 208

One-Point Perspective 210

Two-Point Perspective 212

Multipoint Perspective 214

AMPLIFIED PERSPECTIVE

A Different Point of View 216

MULTIPLE PERSPECTIVE

A Pictorial Device 218

ISOMETRIC PROJECTION

A Spatial Illusion 220

OPEN FORM/CLOSED FORM

The Concept of Enclosure 222

TRANSPARENCY

Equivocal Space 224

CONCLUSION

Complexity and Subtlety 226

CHAPTER 1

ILLUSION OF MOTION 228

INTRODUCTION

Stillness and Arrested Action 230

ANTICIPATED MOTION

Seeing and Feeling
Impending Action 232

WAYS TO SUGGEST MOTION

Figure Repeated, Figure Cropped 234
Blurred Outlines and Fast Shapes 236
Multiple Image 238

OPTICAL MOVEMENT

Afterimage and Eye Movement 240

12

VALUE 242

INTRODUCTION

Light and Dark 244

VALUE PATTERN

Variations in Light and Dark 246

VALUE AS EMPHASIS

Creating a Focal Point 248

VALUE AND SPACE

Using Value to Suggest Space 250

TECHNIQUES

An Overview 252

chapter 13

COLOR 254

INTRODUCTION

Color Theory 256

COLOR CHARACTERISTICS

Color Perception 258

PROPERTIES OF COLOR

Hue and the Three Dimensions of Color Perception 260 Value 262 Intensity/Complementary Colors 264

PALETTES

Mixing Light and Mixing Pigments 266

VISUAL COLOR MIXING

Techniques That Suggest Light 268

COOL/WARM COLORS

Identifying Color with the Senses 270

COLOR AS EMPHASIS

Color Dominance 272

COLOR AND BALANCE

Achieving Balance within
Asymmetrical Composition 274

COLOR AND SPACE

Color's Spatial Properties 276

COLOR SCHEMES

Monochromatic/Analogous 278 Complementary/Triadic 280

GLOSSARY 290 BIBLIOGRAPHY 294 PHOTOGRAPHIC SOURCES 296 INDEX 298

COLOR DISCORD AND VIBRATING COLORS

Unexpected Combinations 282

COLOR USES

Local, Optical, Arbitrary 284

EMOTIONAL COLOR

Color Evokes a Response 286

COLOR SYMBOLISM

Conceptual Qualities of Color 288

PREFACE

PENTIMENTI

The new edition of *Design Basics* continues a process of refinement and revision that has characterized the text over eight editions. One can rightly ask, "What changes have occurred that would change the elements and principles of design?" Well, in fact, nothing to speak of, but the forms and media in which we discover them have certainly evolved at a rapid rate.

So, as would be expected, new media and new art and new images from the vernacular are brought into each new edition. These stand alongside examples from all eras and diverse cultures, as they have in past editions. Something else happens with revision, however. Links between different parts of the text connect, and when they do, ideas resonate from one section to another. This is most obvious as we track two paintings that recur in each chapter. How different Picasso's *Harlequin* is from Gerome's *Duel after the Masquerade*. How much they have to say to each other about composition and all aspects of design beyond the fact that they share a "figure" in harlequin pattern.

Revision is inherent to the design process. Even in a masterpiece we can learn from the rejected steps as we can see in the photo record Matisse kept of his painting *The Pink Nude* (see Chapter 1). Artists don't always record their revisions, but often evidence can be found of changes. The tracks and changes we can observe in a painting are called *pentimenti*, which translated from Italian means quite literally "the artist repents." This is sometimes the hardest lesson for young designers or artists to embrace: to avoid preciousness about a first idea and to push it to a better conclusion through revisions. The writing and revision of this text requires the same consideration and reconsideration.

As previously mentioned, there are many new images in this revision. There are also many new discussions. Following are a few highlights.

Chapters 2 and 3 include new examples of graphic design. Chapter 4 includes new work by contemporary artists including Pavel Pepperstein, who was prominent at the 2009 Venice Biennale. Chapter 5 now includes a discussion of symmetry as we perceive it in the human face. Chapter 6 includes two examples of Jazz Posters from the many done by Niklaus Troxler. Chapter 7 now includes examples of line from the prosaic topographical map to Picasso drawing in the air with a light. Chapter 8 now offers more insight across different art and design disciplines. A similar love of shape is found in fashion and painting. Chapter 9 now includes Anni Albers' transformations of found materials and their textures into decorative purposes.

In Chapter 10 the depiction of space through perspective drawing can now be seen in an unfinished Leonardo painting as well as Frank Lloyd Wright drawings. Chapter 11 expands the discussion of depicted motion including a "decisive moment" captured by Cartier Bresson and the digital image of a dancer by Elliot Barnathan. Chapter 12 explores the limits of our perception with an example of Roman Opalka's paintings as they approach a "white on white" conclusion. Chapter 13 contains new insights into the development of painters' palettes across the centuries.

The revision of this text was assisted by the insights of reviewers who are engaged in teaching and research and by the art team at Wadsworth/Cengage Learning who continue to guide me through the publishing process.

RESOURCES

Many new resources are available for instructors and students with this edition.

For Students

The **Premium Website** explores the elements and foundations of art and design through interactive modules that enhance the understanding of concepts presented in the text. The site also offers video demonstrations of studio art techniques, image flashcards, chapter quizzes, research assignments, and design projects. Icons appear throughout the text to specific modules.

The **Premium Website with Interactive eBook** provides all the premium assets just mentioned as well as an eBook, with direct links to the interactive modules.

For Instructors

Online Digital Image Library and PowerPoint Slides

bring digital images into the classroom. High-resolution images (diagrams and almost all of the fine art images from the text) are easily accessible via our one-stop, password protected website. The zoom feature allows you to magnify selected portions of an image for more detailed display in class. PowerPoint lectures are downloadable for each chapter of the text, which makes it easy to assemble, edit, and present customized lectures for your course using Microsoft® PowerPoint®. The Digital Image Library may also be requested on a USB thumb drive.

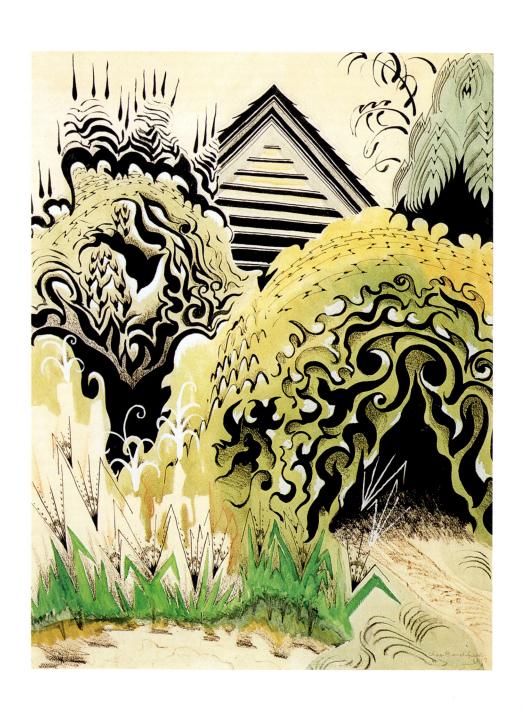

DESIGN PRINCIPLES

CHAPTER EMPHASIS AND FOCAL POINT 54

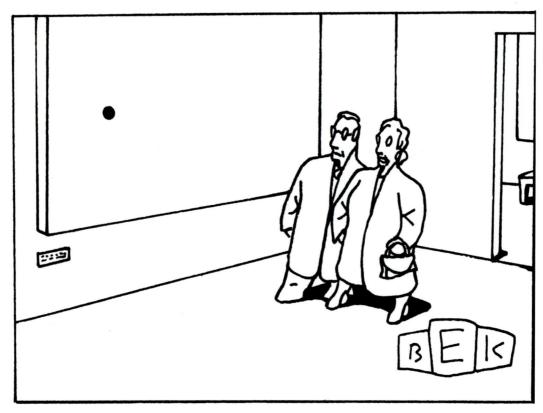

"Where does he get all his ideas?"

DESIGN PROCESS

INTRODUCTION

Design Defined 4

PROCEDURES

Steps in the Process 6

THINKING

Getting Started 8

THINKING

Form and Content 10

THINKING

Form and Function 12

LOOKING

Sources: Nature 14

LOOKING

Sources: Artifacts 16

LOOKING

Sources: History and Culture 18

DOING

Thinking with Materials 20

DOING

Doing and Redoing 22

CRITIQUE

Constructive Criticism 24

DESIGN DEFINED

What do you think of when you hear the word *design*? Do you associate design with fashion, graphics, furniture, or automotive style? Design has a more universal meaning than the commercial applications that might first come to mind. A dictionary definition uses the synonym *plan*: To **design** indeed means to plan, to organize. Design is inherent in the full range of art disciplines from painting and drawing to sculpture, photography, and timebased media such as film, video, computer graphics, and animation. It is integral to crafts such as ceramics, textiles, and glass. Architecture, landscape architecture, and urban planning all apply visual design principles. The list could go on. Virtually the entire realm of two- and three-dimensional human production involves design, whether consciously applied, well executed, or ill considered.

Visual Organization

Design is essentially the opposite of chance. In ordinary conversation, when we say "it happened by design," we mean something was planned—it did not occur just by accident. People in all occupations plan, but the artist or designer plans the arrangement of elements to form a visual pattern. Depending on the field, these elements will vary—from painted symbols to written words to scenic flats to bowls to furniture to windows and doors. But the result is always a visual organization. Art, like other careers and occupations, is concerned with seeking answers to problems. Art, however, seeks visual solutions in what is often called the design process.

The poster shown in **A** is an excellent example of a visual solution. How the letters are arranged is an essential part of communicating the idea. Two other posters offer a comparison

John Kuchera. It's Time to Get Organized. 1986. Poster. Art Director and Designer, Hutchins/Y&R.

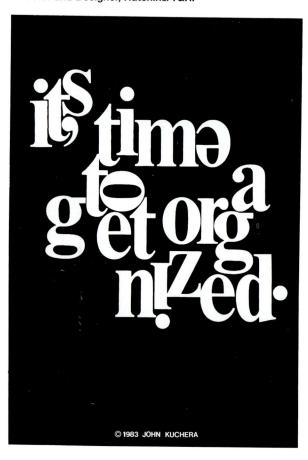

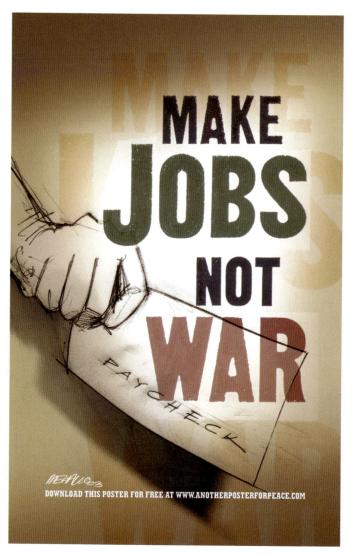

Steve Mehalo. *Make Jobs Not War.* Poster design. Copyright: free art for public use.

and contrast of how text can be organized to create a visual message from what could be a merely verbal message. Make Jobs Not War (B) is composed to communicate a simple and unambiguous statement. "War" is given a special focus through the color red, but the message is primarily verbal, not visual. In C red is again used for emphasis, but in this case the design of the text is more critical to the creation of a visual statement. The red that brings forward the word "war" from the text "what is it good for?" appears to have been crudely brushed on with drips and rough edges accentuating a violent urgency. This stands in contrast to the graceful formality of the text in black. This contrast conveys the message via a visual solution. If we recall the message in C, it will be because we will recall how the elements are organized.

Creative Problem Solving

The arts are called creative fields because there are no predetermined correct answers to the problems. Infinite variations in individual interpretations and applications are possible. Problems in art vary in specifics and complexity. Independent painters or sculptors usually create their own "problems" or avenues they wish to explore. The artist can choose as wide or narrow a scope as he or she wishes. The architect or graphic and industrial designer is usually given a problem, often with very specific options and clearly defined limitations. Students in art classes are often in this "problem-solving" category-they execute a series of assignments devised by the instructor that require rather specific solutions. However, all art or visual problems are similar in that a creative solution is desired.

The creative aspect of art also includes the often-heard phrase "there are no rules in art." This is true. In solving problems visually, there is no list of strict or absolute dos and don'ts to follow. Given the varied objectives of visual art throughout the ages, definite laws are impossible. However, "no rules" may seem to imply that all designs are equally valid and visually successful. This is not true. Artistic practices and criteria have been developed from successful works, of which an artist or designer

should be aware. Thus, guidelines (not rules) exist that usually will assist in the creation of successful designs. These guidelines certainly do not mean the artist is limited to any specific solution.

Form and Content Defined

Discussions of art often distinguish between two aspects, form and **content**. Form is the purely visual aspect, the manipulation of the various elements and principles of design. Content implies the subject matter, story, or information that the artwork seeks to communicate to the viewer. Content is what artists want to say; form is how they say it. The poster in C can be appreciated for a successful relationship between form and content.

Sometimes the aim of a work of art or design is purely aesthetic. Take, for example, adornment such as jewelry where the only "problem" is one of creating visual pleasure. However, even art and design of a decorative nature have the potential to reveal new ways of seeing and communicate a point of view. Art is and always has been a means of visual communication.

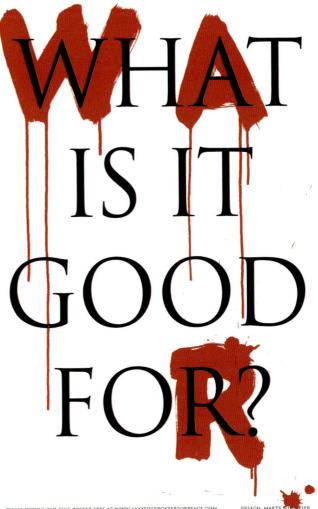

STEPS IN THE PROCESS

We have all heard the cliché "a picture is worth a thousand words." This is true. There is no way to calculate how much each of us has learned through pictures. Communication has always been an essential role for art. Indeed, before letters were invented, written communication consisted of simple pictorial symbols. Today, pictures can function as a sort of international language. A picture can be understood when written words may be unintelligible to the foreigner or the illiterate. We do not need to understand German to grasp immediately that the message of the poster in **A** is pain, suffering, and torture.

Art as Communication

In art, as in communication, the artist or designer is saying something to the viewer. Here the successful solution not only is visually compelling but also communicates an idea. Any of the elements of art can be used in communication. Purely abstract lines, color, and shapes can very effectively express ideas or feelings. Many times communication is achieved through symbols, pictorial images that suggest to the viewer the theme or message. The ingenuity of creative imagination exercised in selecting these images can be important in the finished work's success.

Countless pictures demonstrate that words are not necessary for communication. We can see that in two examples that suggest the idea of balance. In the photograph $Balanced\ Rock$ (B) no words are needed to communicate the idea. In C we read the word, but the concept is conveyed visually. The uppercase E provides a visual balance to the capital B, and the dropped A is used as a visual fulcrum. As in A the concept comes across independent of language.

So we are led to wonder how these artists arrived at their conclusions. Both **B** and **C** are good ideas, but how were they generated? We can appreciate that the process of trial and error would differ between working with rocks and text! Examples on the coming pages will demystify the work behind the results we admire in accomplished artworks.

The Creative Process

These successful design solutions are due, of course, to good ideas. Students often wonder, "How do I get an idea?" Almost everyone shares this dilemma from time to time. Even the professional artist can stare at an empty canvas, the successful writer at a blank page. An idea in art can take many forms, varying from a specific visual effect to an intellectual communication of a definite message. Ideas encompass both content and form.

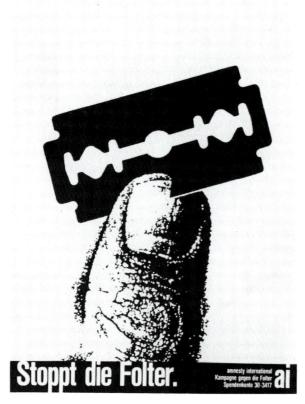

It is doubtful that anyone can truly explain why or how an answer to something we've been puzzling over appears out of the blue. Our ideas can occur when we are in the shower, mowing the lawn, or in countless other seemingly unlikely situations. But we need not be concerned here with sudden solutions. They will continue to occur, but what happens when we have a deadline? What can we consciously do to stimulate the creative process? What sort of activities can promote the likelihood that a solution to a problem will present itself?

The media and the message can vary dramatically, but a process of development can transcend the differences. We suggest three very simple activities with very simple names:

Thinking Looking Doing

These activities are not sequential steps and certainly are not independent procedures. They overlap and may be performed almost simultaneously or by jumping back and forth from one to another. One thing is certain however: a moment of sudden insight (like the idea in the shower) rarely occurs without an investment of energy into the problem. Louis Pasteur said that "chance favors the prepared mind," and the painter Chuck Close tells it like it is: "Inspiration is for amateurs. The rest of us get to work."

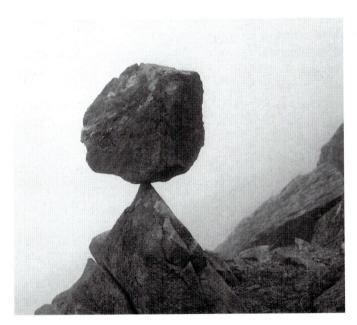

Andy Goldsworthy. Balanced Rock (Misty, Langdale, Cumbria, May 1977). Andy Goldsworthy: A Collaboration with Nature.

The layout of the letters matches the word's meaning to convey the idea.

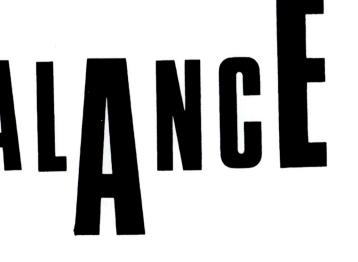

GETTING STARTED

The well-known French artist Georges Braque wrote in his *Cahiers* (notebooks) that "one must not think up a picture." His point is valid; a painting is often a long process that should not be forced or created by formulas to order. However, each day countless designers must indeed "think up" solutions to design problems. Thinking is an essential part of this solution. When confronted by a problem in any aspect of life, the usual first step is to think about it.

Thinking is applicable also to art and visual problems. It is involved in all aspects of the creative process. Every step in creating a design involves choices, and the selections are determined by thinking. Chance or accident is also an element in art. But art cannot be created mindlessly, although some art movements have attempted to eliminate rational thought as a factor in creating art and to stress intuitive or subconscious thought. Even then it is thinking that decides whether the spontaneously created result is worthwhile or acceptable. To say that thinking is somehow outside the artistic process is truly illogical.

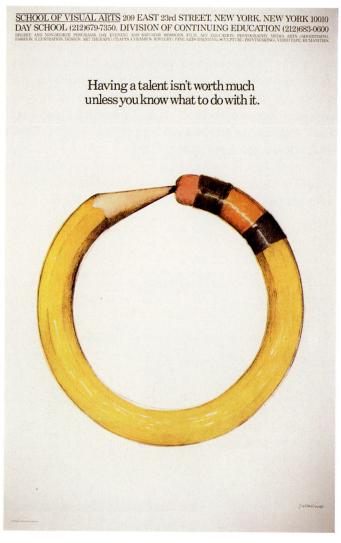

"Having a talent isn't worth much unless you know what to do with it." Poster for the School of Visual Arts. 1978.

Thinking about the Problem

Knowing what you are doing must precede your doing it. So thinking starts with understanding the problem at hand:

Precisely what is to be achieved? (What specific visual or intellectual effect is desired?)

Are there visual stylistic requirements (illustrative, abstract, nonobjective, and so on)?

What physical limitations (size, color, media, and so on) are imposed?

When is the solution needed?

These questions may all seem self-evident, but effort spent on solutions outside the range of these specifications will not be productive. So-called failures can occur simply because the problem was not fully understood at the very beginning.

Tom Friedman. *Untitled.* 1992. Pencil shaving, 1' $111/_2$ " \times $11/_2$ " \times $11/_2$ ", from an edition of two.

Thinking about the Solution

Thinking can be especially important in art that has a specific theme or message. How can the concept be communicated in visual terms? A first step is to think logically of which images or pictures could represent this theme and to list them or, better yet, sketch them quickly, because a visual answer is what you're seeking. Let's take a specific example: What could visually represent the idea of art or design? Some obvious **symbols** appear in the designs on these pages, and you will easily think of more. You might expand the idea by discussing it with others. They may offer suggestions you have not considered. Professional designers often consult reports from market surveys that reveal the ideas of vast numbers of people.

Sketch your ideas to see immediately the visual potential. At this point you do not necessarily decide on one idea. But it's better to narrow a broad list to a few ideas worthy of development. Choosing a visual image is only the first step. How will you use your choice? Three examples shown here all start with a pencil, but take that to unique and memorable conclusions:

A fragment of a pencil becomes the subject of a monumental sculpture. (A)

Wasted talent is symbolized by a distorted and useless pencil. (B)

A carefully sharpened pencil becomes a spiraling ribbon demonstrating art's ability to transform our understanding of form. **(C)**

These designs are imaginative and eye-catching. The image was just the first step. How that image or form was used provided the unique and successful solution.

Thinking about the Audience

Selecting a particular symbol may depend on limitations of size, medium, color, and so on. Even thinking of future viewers may provide an influence. To whom is this visual message addressed? An enormous pencil fragment as a piece of sculpture might serve as a monument to the legions of "pencil pushers" in an office complex. The same sculpture located at an art school could pay tribute to the humblest of art-making tools. The ribbon of pencil shaving **(C)** may not engage an audience as a symbol so much as a simple but extraordinary fact.

FORM AND CONTENT

What will be presented, and how will it be presented? The thinking stage of the design process is often a contest to define this relationship of *form* and *content*. The contest may play itself out in additions and subtractions as a painting is revised or in the drafts and sketches of an evolving design concept. The solution may be found intuitively or may be influenced by cultural values, previous art, or the expectations of clients.

Selecting Content

Raymond Loewy's revised logo for the Greyhound Bus Company is an example of content being clearly communicated by the appropriate image or form. The existing logo in 1933 (A) looked fat to Loewy, and the chief executive at Greyhound agreed. His revised version (B) (based on a thoroughbred greyhound) conveys the concept of speed, and the company adopted the new logo.

Selecting Form

The form an artist or designer selects is brought to an elemental simplicity in the challenge of designing **icons** or **pictograms** for signs, buttons, and web or desktop applications. For these purposes the image must be as simple and unambiguous as possible. The examples shown in **C** communicate a number of activities associated with a picnic area in a park and do so in a playful manner. Beneath the fun appearance though we can recognize that simple shapes such as circles and ovals predominate, and that the number of elements are as few as possible to communicate with an image and no text.

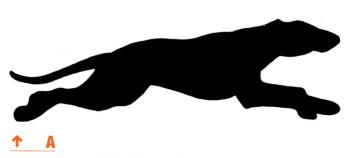

Raymond Loewy. Original logo for Greyhound Bus Co.

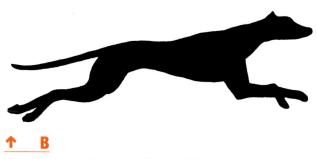

Raymond Loewy. Redesigned logo, 1933.

Form and content issues would certainly be easier to summarize in a monocultural society. Specific symbols may lose meaning when they cross national, ethnic, or religious borders. The *Navigational Chart* from the Marshall Islands shown in **D** communicated currents and navigational landmarks to the island people who knew how to read this. For the rest of us it is a mysterious web of bamboo lines and shells marking a number of points. We may infer a meaning from an impression that the construction is not an arbitrary arrangement, but without more information the visual clues would not communicate to us. We can only guess how successfully the signs in **C** would communicate to the islanders who used the navigational map.

Given these obstacles to understanding, it is a powerful testimony to the meaning inherent in form when artworks do communicate successfully across time and distance. Raymond Loewy's design solution conveys speed and grace with an image that can be understood by many generations and many cultures.

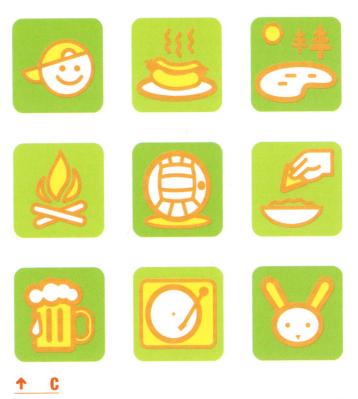

Chris Rooney. *Picnic Icons*. From Blackcoffee Design Inc., editor, *1,000 Icons, Symbols, and Pictograms: Visual Communication for Every Language* (1000 Series) (Beverly, Mass.: Rockport Publishers, 2009).

Navigational Chart. Micronesian, Marshall Islands, Late 19th–early 20th century. Findspot: Marshall Islands. Bamboo, cowrie shells, and twine, 66×63 cm (2' 2" \times 2' $^{13}/_{6}$ "). Chart consisting of thin bamboo rods, tied together into roughly square form, with diagonally-oriented elements and cowrie shells at some intersections. The bamboo elements represent currents; the cowries represent land masses. On view in the Richard B. Carter Gallery (Oceanic Art), Museum of Fine Arts, Boston. Gift of Governor Carlton Skinner and Solange Skinner, 2002.

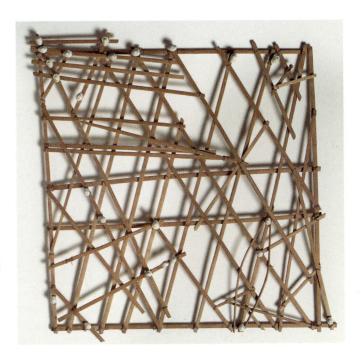

FORM AND FUNCTION

The seaplane shown in $\bf A$ shares a similarity of form to the whale shown in $\bf B$. We can probably assume that the designers of the seaplane did not copy the form of this whale; however, both the plane and whale are streamlined for easy movement through the water. In each case the form follows function.

When we say that form follows function, we say that purpose defines the look and shape of an object, and that efficiency is obvious. This relationship is often easiest to see and acknowledge in utilitarian design, such as the furniture design of the American Shaker movement. The interior presented in **C** reveals a simple, straightforward attitude toward furniture and space

design. All the furnishings are functional and free from extraneous decoration. The ladder back of the chair exhibits a second utility when the chair is hung on the wall. Everything in this space communicates the Shaker value of simplicity.

The meandering bookshelf and curved furniture shown in **D** are also functional but in a playful and surprising way. The forms are not dictated by a strict form-follows-function design approach. The design solution is simple but the forms express a sense of visual delight and humor as well. This may seem whimsical in contrast to the austerity of Shaker design but in fact both offer a satisfying economy and unadorned clarity.

Grumman HU–16 Albatross, post-WWII "utility and rescue amphibian." Bill Gunston, consultant editor, *The Encyclopedia of World Air Power* (London: Aerospace Publishing Limited, 1980), p. 165.

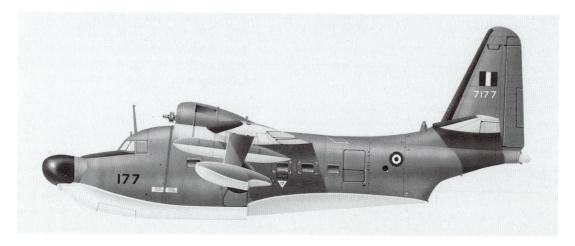

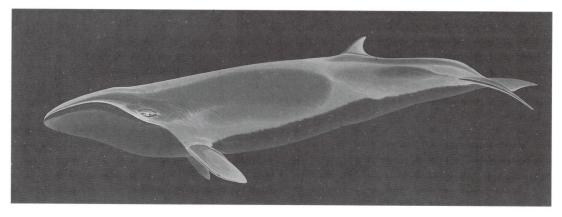

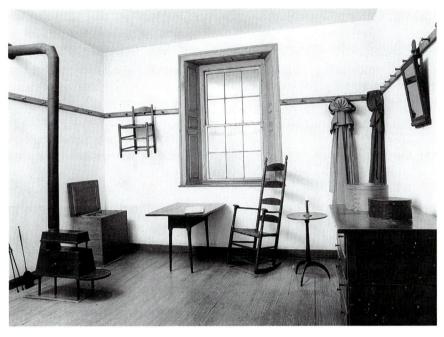

↑ C

Shaker interior. Reproduced by permission of the American Museum in Britain, Bath, U.K. ©

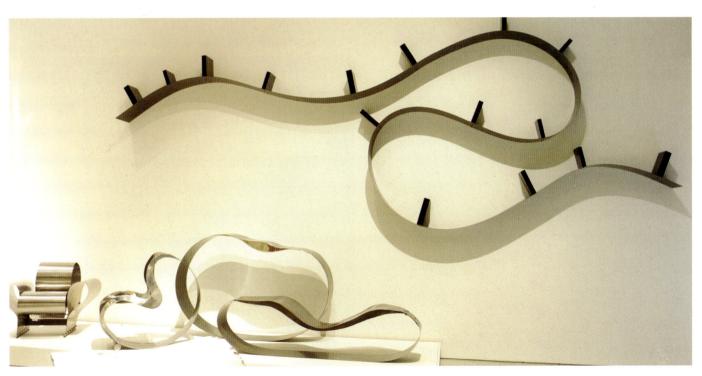

↑ D

Ron Arad. "Restless" Exhibition. The Barbican Centre, London, England.

SOURCES: NATURE

Looking is probably the primary education of any artist. This process includes studying both the natural world and human artifacts. Observing nature reveals the elegant adaptations of plants and animals to their environment. The structures of nature, from beehives to birds' wings, offer models for efficient design and beautiful art.

Source versus Subject

Sources in nature are clearly identifiable in the works of some artists, while less obvious in the works of others—perhaps revealed only when we see drawings or preparatory work. In any case a distinction should be made between source and subject. The source is a stimulus for an image or idea. For example, Arthur Dove's oil painting (A) is titled *Tree Composition*, but the source of this image is significantly abstracted and the subject of the painting is apparently a spiral form and energy that Dove saw in the tree.

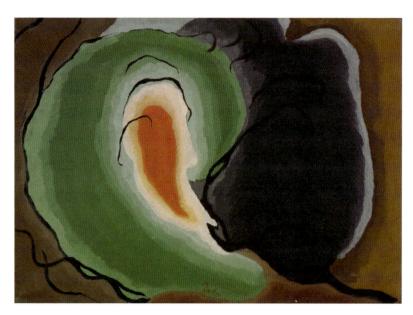

Arthur Dove. *Tree Composition.* 1937. Oil on canvas, 1' 3½" x 1' 9". Edward W. Root Bequest (57.136). Munson-Williams-Proctor Arts Institute, Utica, New York.

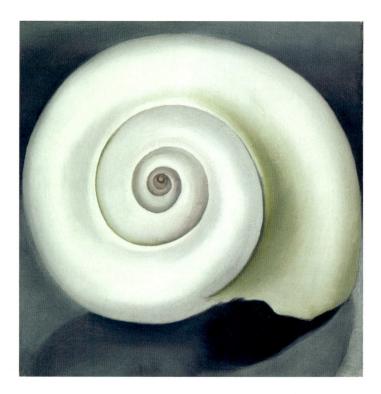

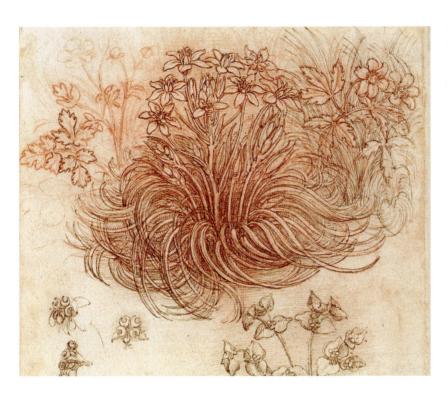

Leonardo da Vinci. Studies of Flowers. c.1509–1511. Drawings, Watercolours and Prints. The Royal Collection. London.

Leonardo da Vinci. *Study of Flowing Water.* c. 1509–1511. The Royal Collection, London.

Georgia O'Keefe's painting of a shell **(B)** is a more realistic depiction of its source or model in the natural world, but clearly she too was interested in the spiral, and in this way her painting has a kinship to that of Arthur Dove (her friend and colleague).

The two sketchbook drawings by Leonardo (**C** and **D**) show how the artist found similar spiral patterns in the way a plant grows and the turbulence of water. Drawing is an artist's means for active looking and learning from the natural world. Leonardo drew upon these observations in both his paintings and machine designs. The plant appears in the painting *Virgin of the Rocks*, and the study of water turbulence was relevant to his ideas on bridge design. For Leonardo "design" was relevant to both painting and engineering.

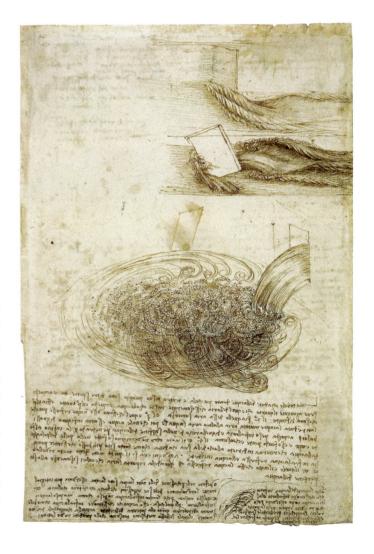

SOURCES: ARTIFACTS

We expect artists and designers to be visually sensitive people who see things in the world that others might overlook and who look with special interest at the history of art and design. Studying art, architecture, craft, and design from all periods, regions, and cultures introduces you to a wealth of visual creations, better equipping you to discover your own solutions.

The painter Sean Scully has long been interested in the arrangements of walls and windows and the light that falls on these surfaces. In fact, he often photographs these subjects. This informs our understanding of the installation of his paintings shown in **A**. What is Scully looking at when he looks at these architectural structures? Evidently he sees a rich world of color

and light and surprising arrangements of rectangles and stripes that challenge him to compose subtle but complex compositions . . . inspired from a seemingly neutral or ordinary source.

This process of looking is extended in the photograph by a Dartmouth College student shown in **B**. This photo is a response to Scully's paintings and is one of a series of "stripes" found in the campus environment.

For better or worse we do not create our design solutions in an information vacuum. We have the benefit of an abundance of visual information coming at us through various media, from books to television, websites, and films. On the plus side, we are treated to images one would previously have had to travel to see.

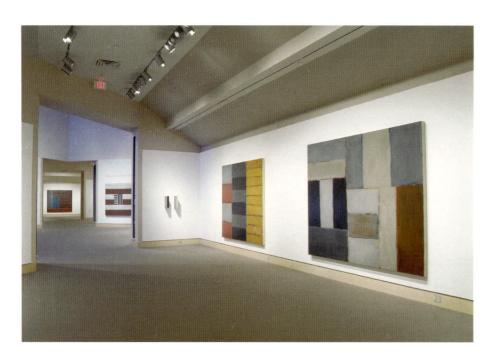

Sean Scully. *Installation View.* Hood Museum, Dartmouth College, New Hampshire.

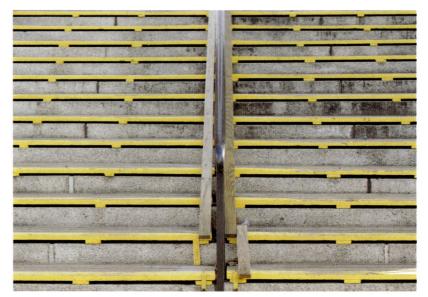

On the minus side, it is easy to overlook that we are often seeing a limited (or altered) aspect of the original artwork in a reproduction. The influence of reproduced images is enriching but potentially superficial. Artists and designers will often travel and study influences firsthand for a deeper understanding of their influences.

Nancy Crow is an artist who mines a rich treasure of cultural influences and creates unique works that are not simply copies gleaned from other cultures. Her travels and research connect her work to artifacts such as Mexican masks **(C)**. The impact can be seen in her quilt shown in **D**.

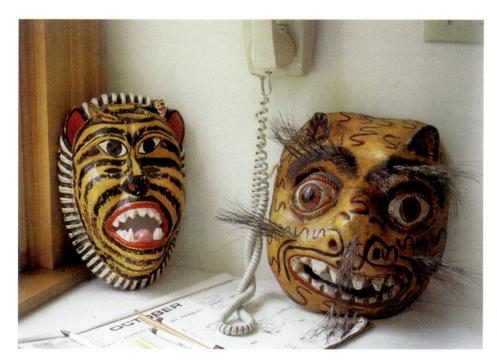

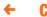

Nancy Crow. *Mexican Tiger Masks*. From the Collection of Nancy Crow.

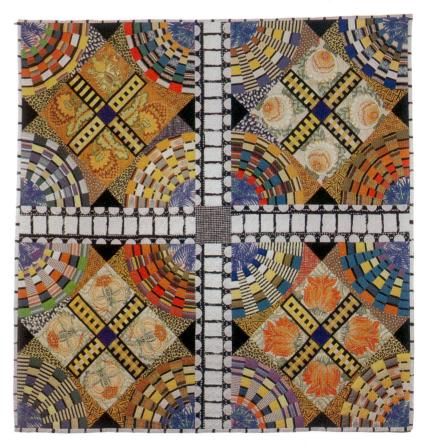

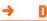

Nancy Crow. Mexican Wheels II. 1988. Quilt, 7' 6" \times 7' 6". From the Collection of Nancy Crow.

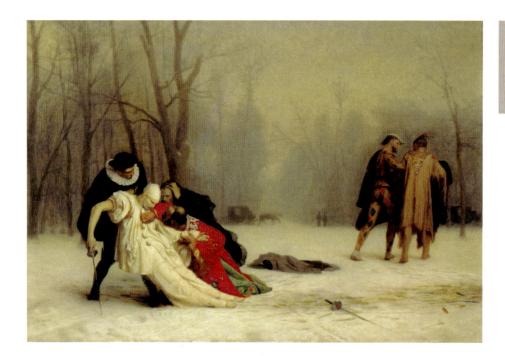

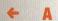

Jean-Léon Gérôme. The Duel after the Masquerade. 1857–1859. Oil on canvas, $1'3\%" \times 1'10\%$ " (39.1 \times 56.3 cm).

SOURCES: HISTORY AND CULTURE

Visual Training and Retraining

The art of looking is not entirely innocent. Long before the training in seeing we get in art and design classes, we are trained by our exposure to mass media. Television, film, Internet, and print images provide examples that can influence our self-image and our personal relationships. The distinction between "news" and "docudrama" is often a blurry one, and viewers are often absorbed into the "reality" of a movie.

At times it seems that visual training demands a retraining of looking on slower, more conscious terms. "Look again" and "see the relationships" are often heard in a beginning drawing class. Part of this looking process involves examining works of art and considering the images of mass media that shape our culture. Many artists actively address these issues in their art by using familiar images or "quoting" past artworks. Although this may seem like an esoteric exercise to the beginning student, an awareness of the power of familiar images is fundamental to understanding visual communication.

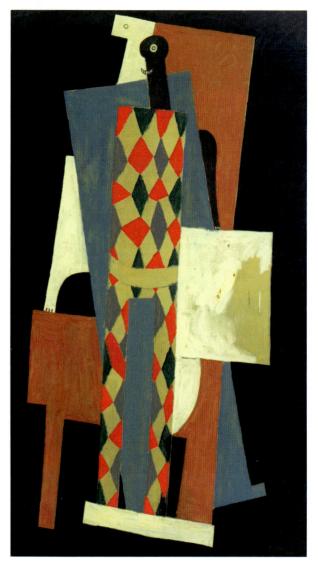

Two paintings separated by a century in time have a common "character" in the Harlequin. The Harlequin pattern can be seen in both A and B, but the visual language of these two paintings is in stark contrast. Picasso references earlier artwork even as he constructs a radically different composition. We will engage both of these images throughout the chapters of this book as we compare and contrast their attributes.

Certain so-called high art images manage to become commonly known, or **vernacular**, through frequent reproduction. In the case of a painting like Washington Crossing the Delaware, the image is almost as universally recognized as a religious icon once was. There is a long tradition of artists paying homage to the masters, and we can understand how an artist might study this or other paintings in an attempt to learn techniques. However, George Washington Carver Crossing the Delaware (C), by the African American artist Robert Colescott, strikes a different relationship to the well-known painting we recognize as a source. Colescott plays with the familiarity of this patriotic image and startles us with a presentation of negative black stereotypes. One American stereotype is laid on top of another, leading the viewer to confront preconceptions about both.

In contrast to the previous fine art examples, the example shown in **D** comes from the world of commercial art. The evolving image of "Betty Crocker" reveals how this icon was visualized at different times. This then reflects where the illustrator looked for a visual model of "American female." Looking, then, can be influenced by commercial and societal forces, which are as real an aspect of our lives as the elements of nature.

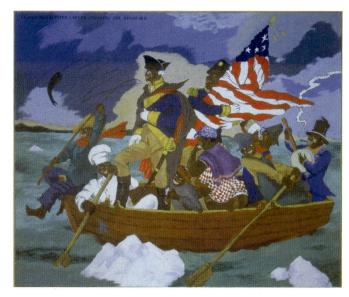

Robert Colescott. George Washington Carver Crossing the Delaware. 1975. Acrylic on canvas, 4' 6" × 9'. Phyllis Kind Gallery, New York.

Looking is a complex blend of conscious searching and visual recollections. This searching includes looking at art, nature, and the vernacular images from the world around us, as well as doing formal research into new or unfamiliar subjects. What we hope to find are the elements that shape our own visual language.

1996

1972

1980

THINKING WITH MATERIALS

Doing starts with visual experimentation. For most artists and designers, this means thinking with the materials. Trial and error, intuition, or deliberate application of a system is set into motion. At this point an idea starts to take form, whether in a sketch or in final materials. The artist Eva Hesse got right to the point with her observation on materials:

Two points of view -

- a. Materials are lifeless til given shape by creator.
- b. Materials by their own potential created their end.*

Eva Hesse is known for embracing apparent contradictions in her work. The studio view **(A)** presents a number of her sculptural works that embody both of the preceding points of view. Hesse gave shape to materials such as papier-mâché, cloth, and wood. Other elements, such as the hanging, looping, and connecting ropes and cords, reflect the inherent potential of the materials.

Sarah Weinstock's drawing shown in **B** is the result both of the forces at play with ink spread on soap bubbles and of the artist's coaxing and encouragement of those materials on the paper. The result suggests two organic forms with one reaching out toward the other.

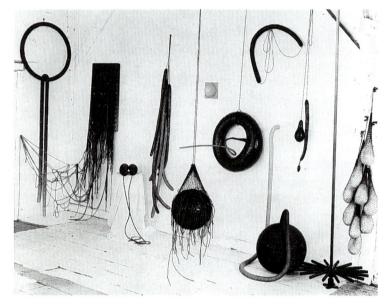

Eva Hesse. *Studio.* 1966. Installation photograph by Gretchen Lambert. Courtesy Robert Miller Gallery.

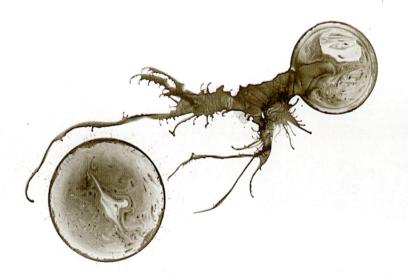

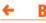

Sarah Weinstock. *Untitled Drawing.* 2006. Ink and soap bubbles on paper, $6\frac{1}{2}$ " \times 9 $\frac{1}{2}$ " (detail).

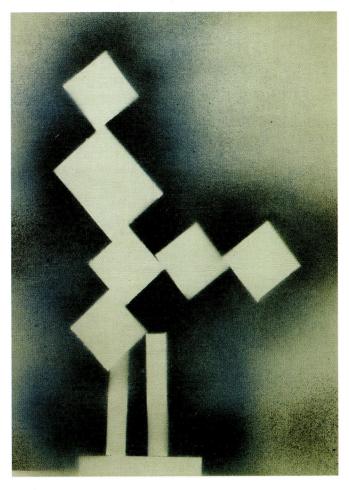

The sculptor David Smith composed spray paintings, and these resemble the stacked arrangements of his sculptures. The playfulness in his approach is obvious and direct in these paintings. We can easily imagine him arranging and rearranging shapes before deciding to accept a certain arrangement and capture that with an over-spray (\mathbf{C} and \mathbf{D}). When we see his stainless steel sculptures, we may not be aware that such physically heavy and abstract work has a playful side—a necessary step in the doing process for this artist.

1 0

David Smith. *Untitled.* 1964. Spray enamel on canvas, 1' 7" × 1' 4". Art © Estate of David Smith. Licensed by VAGA, New York, New York. Courtesy Gagosian Gallery. Photography by Robert McKeever.

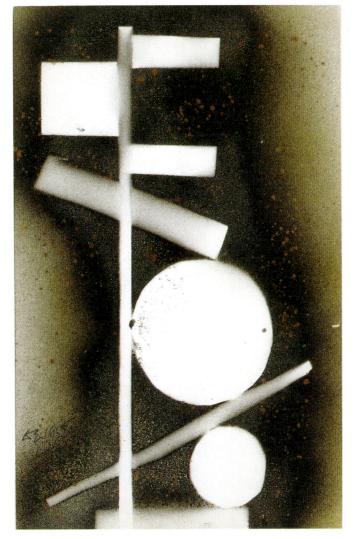

→ []

David Smith. DS 1958. 1958. Spray and stenciled enamel on paper, 1' 5 $\frac{1}{2}$ " \times 11 $\frac{1}{2}$ " (44.5 \times 29.2 cm). Gift of Candida and Rebecca Smith, 1994. Art © Estate of David Smith/Licensed by VAGA, New York, New York. Image copyright © The Metropolitan Museum of Art/Art Resource, New York.

DOING AND REDOING

The art historian Irving Sandler recounts the occasion of watching the painter Willem De Kooning being filmed at work in his studio.

Our camera followed his movements avidly, the flailing brush, the dancing feet. It couldn't be better as film. A few days later I met de Kooning on the street and asked how the painting was going. He said that he had junked it the moment we left. I asked why. "I lost it," he said. "I don't paint that way." Then why the charade? He answered, "You saw that chair in the back of the studio. Well, I spend most of my time sitting on it, studying the picture, and trying to figure out what to do next. You guys bring up all that equipment . . . what was I supposed to do, sit in a chair all night?" "But Bill," I said, "in the future, they'll look at our film and think that's how you painted." He laughed.*

Students tend to underestimate this part of the creative process (the sitting and reflecting) and the value of doing and redoing. Often we have to overcome our attachment to a first idea or reluctance to change, revise, or wipe out first efforts. The painter Henri Matisse did us a favor in recording many stages (A) of his painting *The Pink Nude* (B). Here is an artist at the height of his career. Perhaps any one of the variants would have satisfied an eager collector, but for Matisse, the painting process was a search for a new and striking version of a familiar painting subject. The search by Matisse led to a painting where the whole composition is the subject . . . not just the more obvious focal point that a nude presents.

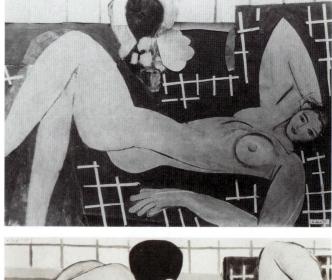

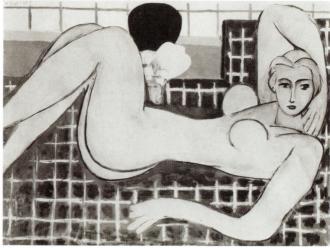

Henri Matisse. Large Reclining Nude/The Pink Nude: Two Stages in Process (two of seventeen photographed by the artist). 1935. Oil on canvas (with cut paper), $2' \ 2'' \times 3'' \ 1/2''' \ (66 \times 92.7 \ cm)$.

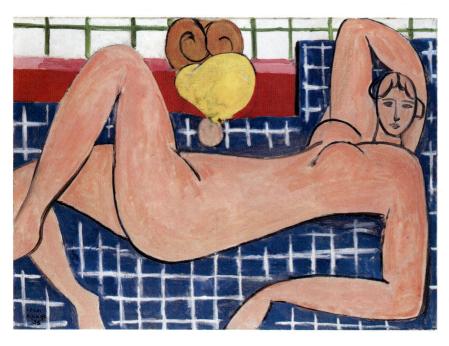

Henri Matisse. Large Reclining Nude/The Pink Nude. 1935. Oil on canvas, 2' $2'' \times 3' \%''$ (66 \times 92.7 cm).

The process board shown in **C** exhibits all the aspects of thinking, looking, and doing. Considerations of marketing are recorded, sources and other symbol solutions are acknowledged, and, finally, the initial idea is shown moving through stages of doing and redoing, leading to finished refinement.

A graphic designer is more likely than a painter to communicate the considerations and steps in the process to a client. A

film of the painter Philip Guston at work ends with him covering his picture with white to begin again. Guston accepted such a setback along the way as normal and even necessary. His experience told him that revision would allow an idea to grow beyond an obvious or familiar starting point. If we examine paintings carefully, we often discover **pentimenti**, or traces of the artist's revisions. This Latin term means "the artist repents."

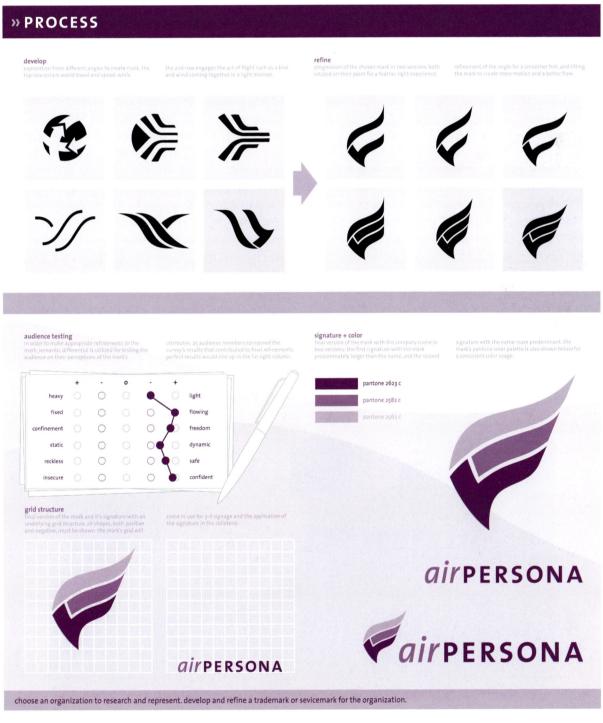

CONSTRUCTIVE CRITICISM

Critique is an integral component of studio education for art students and can take several forms. You could have direct dialogue with a professor in front of a work in progress, or your entire class could review a completed work **(A and B)**. Critique can also be a self-critique and take the form of a journal entry. The goal of a critique is increased understanding through examination of the project's successes and shortcomings. Various creative people, from artists to composers to authors, generally affirm that criticism is best left for *after* the completion of a design or composition. A free and flexible approach to any studio work can be stifled by too much criticism too soon.

The components of a constructive critique can vary, but a critique is most valid when linked to the criteria for the artwork, design, or studio assignment. If a drawing's objective is to present an unusual or unexpected view of an object, then it is appropriate to critique the perspective, size, emphasis, and contrast of the drawing—those elements that contribute to communicating the point of view. Such a critique could also include cultural or historic precedents for how such an object might be depicted. A drawing of an apple that has been sliced in half and is seen from above would offer an unusual point of view. An apple presented alongside a serpent would present a second point of view charged with religious meaning for Jews and Christians. Both approaches would be more than a simple representation and would offer contrasting points of view. Nevertheless, both drawings may be subject to a critique of their composition.

A Model for Critique

A constructive model for critique would include the following:

Description: A verbal account of what is there.

Analysis: A discussion of how things are presented with an emphasis on relationships (for example, "bigger than," "brighter than," "to the left of").

Interpretation: A sense of the meaning, implication, or effect of the piece.

A simple description of a drawing that includes a snake and an apple might lead us to conclude that the drawing is an **illustration** for a biology text. Further description, analysis, and interpretation could lead us to understand other meanings and the emphasis of the drawing. And, in the case of a critique, thoughtful description, analysis, and interpretation might help the artist (or the viewer) see other, more dynamic possibilities for the drawing.

The many sections devoted to principles and elements of art and design in this text are each a potential component for critique. In fact, the authors' observations about an image could be complemented by further critical analysis. For example, the text may point out how color brings emphasis to a composition, and further discussion could reveal the impact of other aspects such as size, placement, and cultural context.

The critique process is an introduction to the critical context in which artists and designers work. Mature artworks are subject

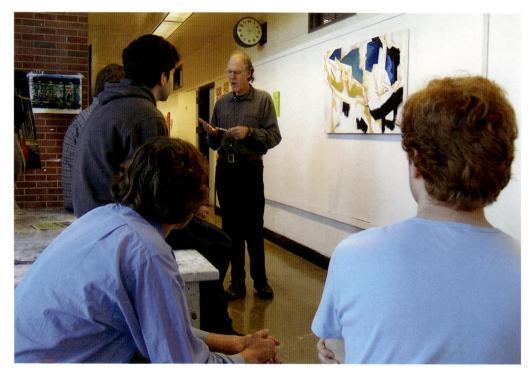

to critical review, and professional designers submit to the review of clients and members of their design teams. Future theory and criticism are pushed along by new designs and artworks.

On a lighter note, the critique process can include the range of responses suggested by Mark Tansey's painting shown in **C**:

You may feel your work has been subjected to an aggressive cleansing process.

You may feel you are butting your head against a wall.

And don't forget that what someone takes from an image or design is a product of what he or she brings to it!

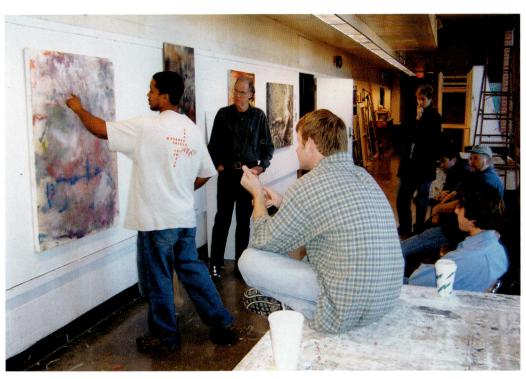

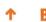

Students review and critique each other's work.

Mark Tansey. A Short History of Modernism. 1982. Oil on canvas, three panels, $4' \cdot 10'' \times 10'$ overall. Collection: Steve and Maura Shapiro. Courtesy Gagosian Gallery, New York, with permission from the estate of Mark Tansey.

"George! Are you in there?"

CHAPTER UNITY

INTRODUCTION

Harmony 28

INTRODUCTION

Visual Unity 30

GESTALT

Visual Perception 32

WAYS TO ACHIEVE UNITY

Proximity 34

WAYS TO ACHIEVE UNITY

Repetition 36

WAYS TO ACHIEVE UNITY

Continuation 38

WAYS TO ACHIEVE UNITY

Continuity and the Grid 40

UNITY WITH VARIETY

The Grid 42

UNITY WITH VARIETY

Varied Repetition 44

UNITY WITH VARIETY

Emphasis on Unity 46

UNITY WITH VARIETY

Emphasis on Variety 48

UNITY WITH VARIETY

Chaos and Control 50

UNITY AT WORK

Figurative and Abstract 52

INTRODUCTION

HARMONY

Unity, the presentation of an integrated image, is perhaps as close to a rule as art can approach. Unity means that a congruity or agreement exists among the elements in a design; they look as though they belong together, as though some visual connection beyond mere chance has caused them to come together. Another term for the same idea is **harmony**. If the various elements are not harmonious, if they appear separate or unrelated, your composition falls apart and lacks unity.

The image in **A** illustrates a high degree of unity. When we look at the elements in this design, we immediately see that they are all somewhat similar. This harmony, or unity, arises not merely from our recognition that all the objects are paint cans. Unity is achieved through the repetition of the oval shapes of the

cans. Linear elements such as the diagonal shadows and paint sticks are also repeated. The subtle grays of the metal cans unify a composition accented by a few bright colors. Such a unity can exist with either **representational** imagery or abstract forms.

The landscape photograph in **B** consists of varied shapes with no exact repetitions, yet all the shapes have a similar irregular jigsaw puzzle quality. The harmonious unity of the shapes is reinforced by a similarity of color throughout this **monochromatic** picture.

Seen simply as cutout shapes, the variety of silhouettes in **C** would be apparent. Alex Katz balances this variation with the unity of the repeated portrait of his wife, Ada. This approach of theme and variation is the essence of the concept of unity.

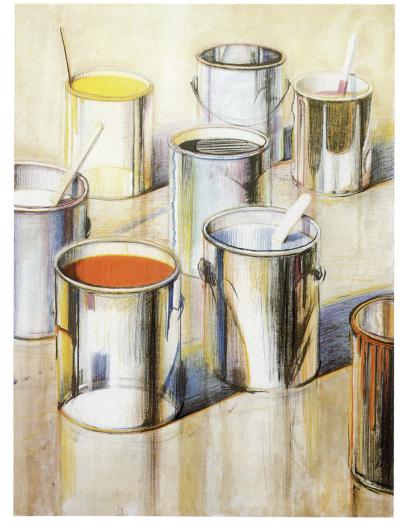

Wayne Thiebaud. Paint Cans. 1990. Lithograph, handworked proof, 75.7 \times 58.8 cm. DeYoung Museum (gift of the Thiebaud Family, 1995.99.12). Art \circledcirc Wayne Thiebaud/ Licensed by VAGA, New York, New York.

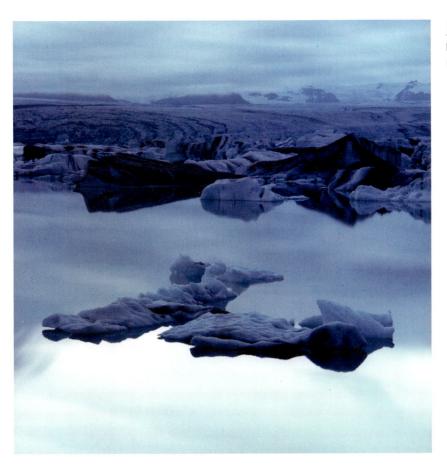

Damon Winter. Personal photograph from Iceland. Communication Arts, May/June 2005.

Where Does Unity Come From?

Unity of design is planned and controlled by an artist. Sometimes it stems naturally from the elements chosen, as in these examples. But more often it reflects the skill of the designer in creating a unified pattern from varied elements. Another term for design is composition, which implies the same feeling of organization. Just as a composition in a writing class is not merely a haphazard collection of words and punctuation marks, so too a visual composition is not a careless scattering of random items around a format.

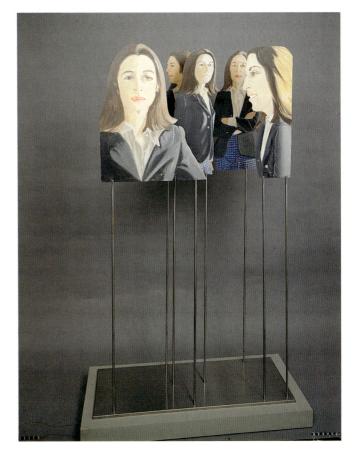

Alex Katz. Black Jacket. 1972. Oil on aluminum (cutout), 5' 2%" imes 3' imes" (159 \times 92 cm). Des Moines Art Center (gift in honor of Mrs. E. T. Meredith, Permanent Collection, 1978.7). Art © Alex Katz/Licensed by VAGA, New York, New York.

INTRODUCTION

VISUAL UNITY

An important aspect of visual unity is that the whole must predominate over the parts: you must first see the whole pattern before you notice the individual elements. Each item may have a meaning and certainly add to the total effect, but if the viewer sees merely a collection of bits and pieces, then visual unity doesn't exist.

This concept differentiates a design from the typical scrapbook page. In a scrapbook each item is meant to be observed and studied individually, to be enjoyed and then forgotten as your eye moves on to the next souvenir. The result may be interesting, but it is not a unified design.

. .

Karl Blossfeldt. *Pumpkin Tendrils*. Works of Karl Blossfeldt by Karl Blossfeldt Archive. Ann and Jürgen Wilde, eds., *Karl Blossfeldt: Working Collages* (Cambridge: MIT Press, 2001), p. 54.

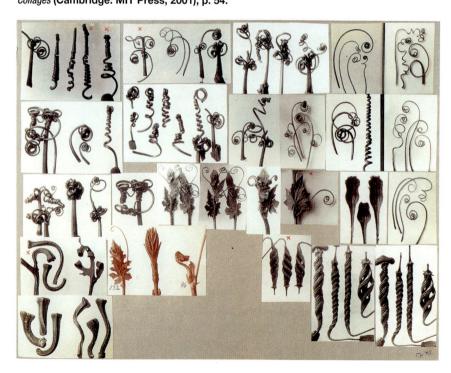

Exploring Visual Unity

The **collage** in **A** is similar to a scrapbook in that it contains many individual images. However, unlike a scrapbook, we are aware first of the pattern the elements make together, and then we begin to enjoy the items separately. A visual unity dominates.

Do not confuse intellectual unity with visual unity. Visual unity denotes some harmony or agreement between the items that is apparent to the eye. To say that a scrapbook page is unified because all the items have a common theme (your family, your wedding, your vacation at the beach) is unity of idea—that is, a conceptual unity not observable by the eye. A unifying idea will not necessarily produce a unified visual composition. The fact that all the elements in **A** are plant forms is interesting, but it is the repetition of curling lines and similarity of color that creates the unity. Within that obvious unity we are invited to compare and contrast the numerous specimens.

The unity in **B** does not derive from the fact that the four girls are sisters (a fact we can take from the title). The repetition of white smocks and a white dress tie the figures together. A recurring blue-gray also unifies the composition. Even an apparently singular element like the red screen has an echo in one girl's red dress. This painting has many individual elements that capture our attention, but the entirety of the composition is unified.

The need for visual unity is nowhere more apparent than in the design of a typeface or **font**. Whether bold, or regular, or italic, the unity of design must be foremost. Letters as divergent as "Q" and "Z" must have a family resemblance. The sample shown in **C** demonstrates one such successful design.

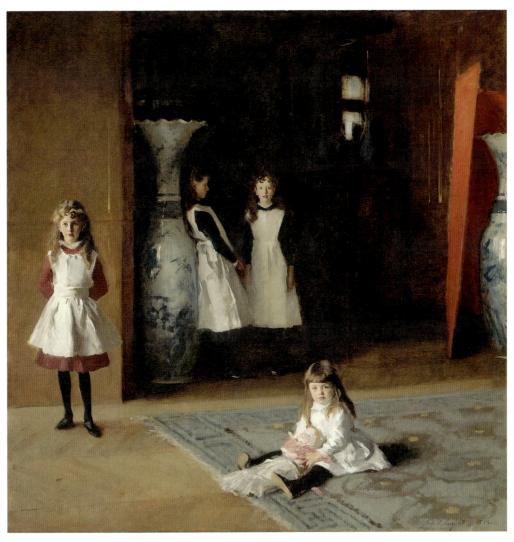

↑ B

John Singer Sargent, *The Daughters of Edward Darley Boit.* 1882. Oil on canvas, 221.93 \times 222.57 cm (7' 3%" \times 7' 3%"). MFA, Boston.

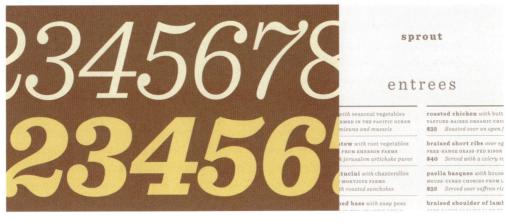

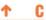

We instantly see two groups of shapes.

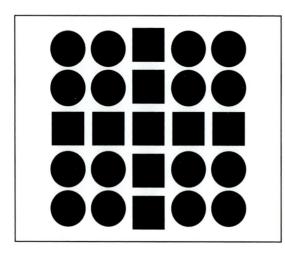

↑ C

Grouping similar shapes makes us see a plus sign in the center.

VISUAL PERCEPTION

The designer's job in creating a visual unity is made easier by the fact that the viewer is actually looking for some sort of organization, something to relate the various elements. The viewer does not want to see confusion or unrelated chaos. The designer must provide some clues, but the viewer is already attempting to find some coherent pattern and unity. Indeed, when such a pattern cannot be found, chances are the viewer will simply ignore the image.

Studies in the area of perception have shown this phenomenon. Since early in the twentieth century, psychologists have done a great deal of research on visual perception, attempting to discover just how the eye and brain function together. Much of this research is, of course, very technical and scientific, but some of the basic findings are useful for the artist or designer. The most widely known of these perception studies is called the **gestalt** theory of visual psychology.

The white diagonal is as obvious as the two groups of rectangles.

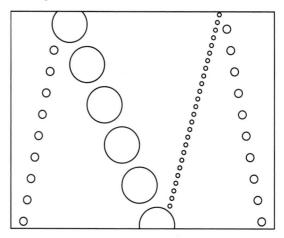

The circles seem to form "lines," and we see an M shape.

How We Look for Unity

Consider a few elementary concepts, which only begin to suggest the range of studies in perception. Researchers have concluded that viewers tend to group objects that are close to each other into a larger unit. Our first impression of **A** is not merely some random squares but two groups of smaller elements.

Negative (or empty) **spaces** will likewise appear organized. In **B** viewers immediately see the many elements as two groups. However, with all the shapes ending on two common boundaries, the impression of the slanted white diagonal shape is as strong as the various rectangles.

Also, our brain will tend to relate and group objects of a similar shape. Hence, in ${\bf C}$ a cross or plus sign is more obvious than the allover pattern of small shapes. In ${\bf D}$ the pattern is not merely many circles of various sizes. Instead our eye will close the spaces between similar circles to form a design of "lines."

These diagonal lines organize themselves to give the impression of an M shape.

We easily identify the elements that make up the Richard Prince painting shown in E as three ellipses and a circle in a white field. The proximity of the four black shapes forms a constellation, and the smaller parts give way to the organization of the larger pattern. In this case it is possible to see this configuration as a startled clownlike face. This reading is assisted by the title (My Funny Valentine) but also reveals how easily we project a "face" onto a pattern.

The impulse to form unity or a visual whole out of a collection of parts can also work on an architectural scale. The Beaubourg (F) is a contemporary art center in Paris. The outer shell of the building is formed from conduits and structural features that are usually hidden. The constant repetition of vertical ducts, square structural framing, and circular openings gives visual unity to a potentially chaotic assortment of pipes and scaffolding. This building's distinct appearance stands in contrast to other buildings in the area, further strengthening its visual identity. Our brain looks for similar elements, and when we recognize them, we see a cohesive design rather than unorganized chaos.

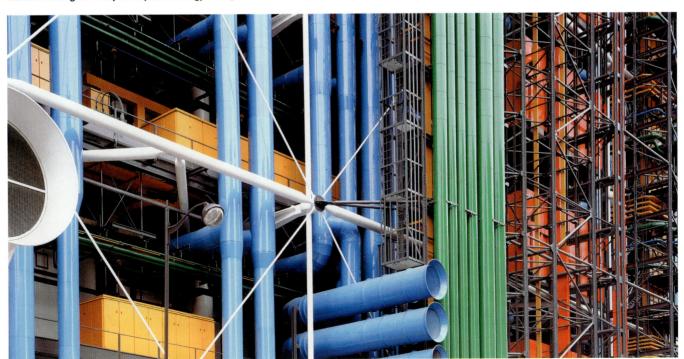

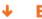

Richard Prince. My Funny Valentine. 2001. Acrylic on silk screen frame, 7' 21/2" × 5' 81/2". Courtesy Barbara Gladstone Gallery, New York. © Richard Prince.

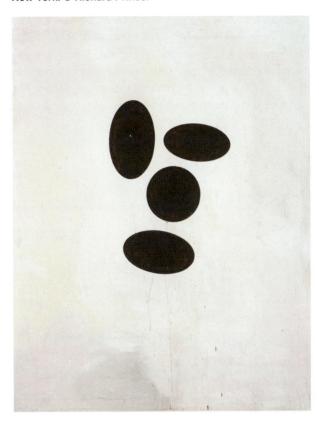

PROXIMITY

An easy way to gain unity—to make separate elements look as if they belong together—is by **proximity**, simply putting the elements close together. The four elements in **A** appear isolated, as floating bits with no relationship to each other. By putting them close together, as in **B**, we begin to see them as a total, related pattern. Proximity is a common unifying factor. Through proximity we recognize constellations in the skies and, in fact, are able to read. Change the proximity scheme that makes letters into words, and reading becomes next to impossible.

Proximity in Composition

Thomas Eakins's painting **(C)** of bathers at a swimming hole shows the idea of proximity in composition. The lighter elements of the swimmers' bodies contrast with the generally darker background. However, these light elements are not placed aimlessly around the composition but, by proximity, are arranged carefully to unite visually. Four of the figures form the apex of an equilateral triangle at the center of the painting. This triangle provides a stable unifying effect.

El Lissitzky's *Here are Two Squares* (**D**) is a **nonobjective** "construction" from a series of related designs. They tell the story of a radical approach to visual communication from early in the twentieth century. In this example (one of six in the series) the black square, tilted red square, and text below the frame are tied together by proximity. Lissitzky takes the principle shown in **B** to unify three parts into a unified cast of characters. This keeps the brash red square in check.

Proximity is the simplest way to achieve unity, and many artworks employ this technique. Without proximity (with largely isolated elements), the artist must put greater stress on other methods to unify an image.

If they are isolated from one another, elements appear unrelated.

Placing items close together makes us see them first as a group.

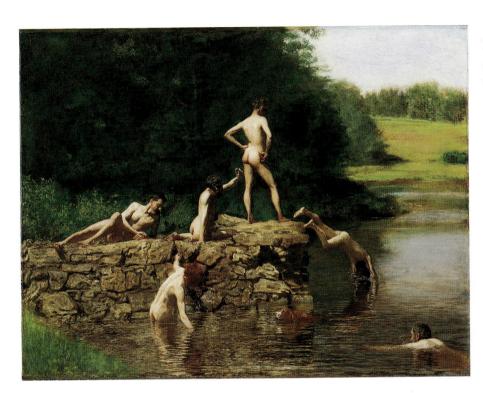

Thomas Eakins. Swimming. 1885. Oil on canvas, 2' 3\%" \times 3' \%". Collection of Amon Carter Museum, Fort Worth, Texas.

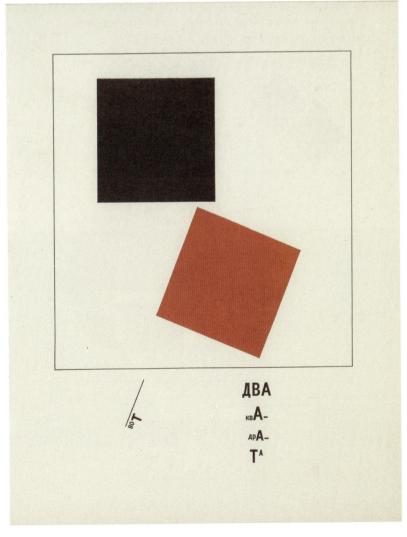

WAYS TO ACHIEVE UNITY

REPETITION

A valuable and widely used device for achieving visual unity is **repetition.** As the term implies, something simply repeats in various parts of the design to relate the parts to each other. The element that repeats may be almost anything: a color, a shape, a texture, a direction, or an angle. In the painting by Sophie Taeuber-Arp (A), the composition is based on one shape: a circle with two circular "bites" removed. This shape is repeated in different sizes and positions. The result is a composition that is unified but not predictable.

Joe Miller's logo design for *space 47* **(B)** also shows unity by repetition. In this case it is not multiple repetitions, but a simple repeat with a twist that differentiates the "4" from the "7." The puzzle created by this is striking and engaging to the viewer resulting in a memorable logo.

Repetition as an element of unity is not limited to geometric shapes. In the ink drawing shown in **C** we see many marks of a similar fast and dynamic stroke. These marks define hair, jacket surface, furrowed brow, and so forth, but their similarity of character unites them into a distinct language. Imagine how different this image would be if these lines were replaced in part with dots in one area and a photographic realism in another. The three approaches would disrupt the strong unity of this portrait.

See also the discussion of Rhythm in Chapter 6.

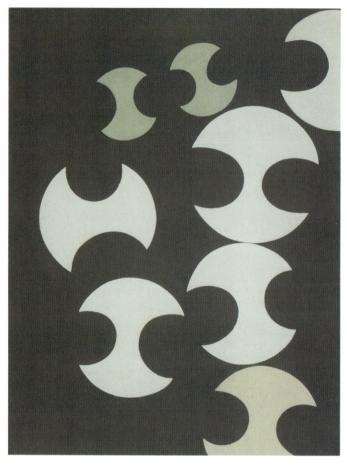

Sophie Taeuber-Arp. Composition with Circles Shaped by Curves. 1935. Gouache on paper, 1' 1%" \times 10%" (35 \times 27 cm). Kunstmuseum Bern (gift of Mrs. Marguerite Arp-Hagenbach).

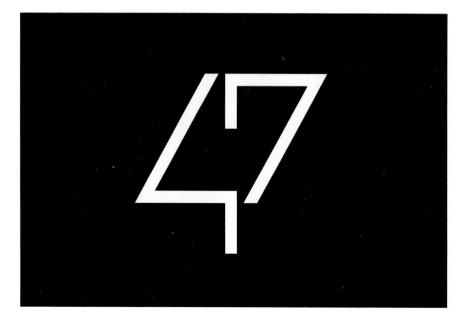

Joe Miller's Design Co. Logo design for space 47. 47 East William Street, San José, California 95112.

Don Bachardy. UNTITLED II. August 19, 1985. Works on paper (drawings, watercolors, etc.). Acrylic on paper, 2' 5.9" \times 1' 10.4" (75.9 \times 56.9 cm).

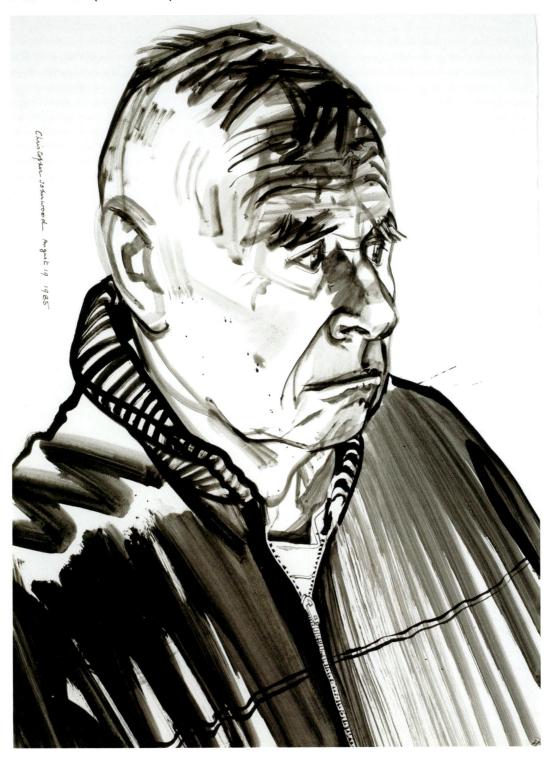

CONTINUATION

A third way to achieve unity is by **continuation,** a more subtle device than proximity or repetition, which are fairly obvious. Continuation, naturally, means that something "continues"—usually a line, an edge, or a direction from one form to another. The viewer's eye is carried smoothly from one element to the next.

The design in **A** is unified by the closeness and the character of the elements. In **B**, though, the shapes seem even more of a unit because they are arranged in such a way that one's vision flows easily from one element to the next. The shapes no longer float casually. They are now organized into a definite, set pattern.

Λ A

Proximity and similarity unify a design.

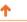

The unity of the same elements is intensified.

Continuation Can Be Subtle or Deliberate

The edge of the sleeping girl's head and her outstretched arm connect to the curving line of the sofa, forming one line of continuity in *The Living Room* (C). Other subtle lines of continuation visually unite the many shapes and colors of what might otherwise be a chaotic composition.

A deliberate or more obvious form of continuation is a striking aspect in many of Jan Groover's photographs. In one series of photographs, she caught passing trucks as an edge of each truck aligned visually with a distant roofline or a foreground pole. This alignment connected these disparate elements for an instant, resulting in a unified image. In **D** Groover employs a more subtle form of continuation, which results in a fluid eye movement around the picture. One shape leads to the next, and alignments are part of this flow.

Three-Dimensional Design

Continuation is an aspect not only of two-dimensional composition. Three-dimensional forms such as the automobile shown in **E** can utilize this design principle. In this case the line of the windshield continues in a downward angle as a line across the fender. A sweeping curve along the top of the fender also connects the headlight and a crease leading to the door handle.

Balthus (Balthasar Klossowski de Rola). *The Living Room.* 1941–1943. Oil on canvas, 3' $8\frac{1}{2}$ " \times 4' $9\frac{3}{4}$ ". The Minneapolis Institute of Arts.

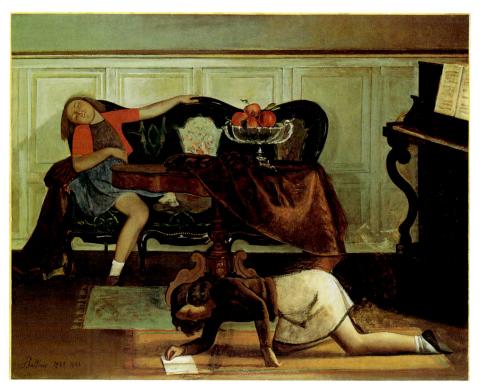

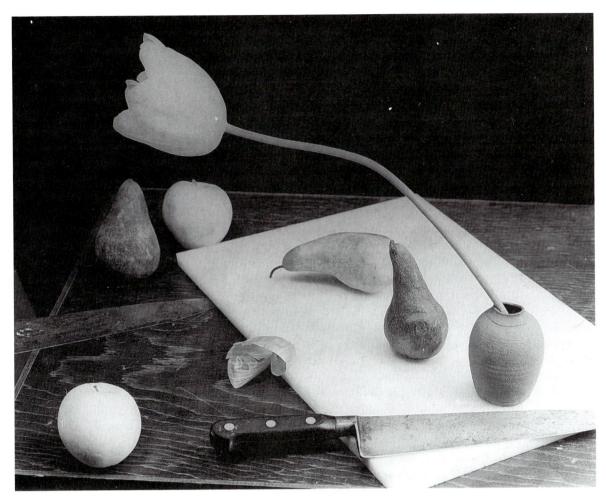

↑ D

Jan Groover. Untitled. 1987. Gelatin-silver print, 11 15 /16 11 \times 1 12 /16 11 (30 \times 38 cm). Janet Borden, Inc.

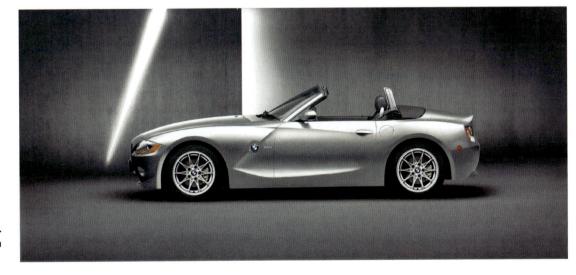

2003 BMW Z4 Roadster. Courtesy BMW of North America, LLC.

CONTINUITY AND THE GRID

As we have learned, continuation is the planned arrangement of various forms so that their edges are lined up-hence, forms are "continuous" from one element to another within a design.

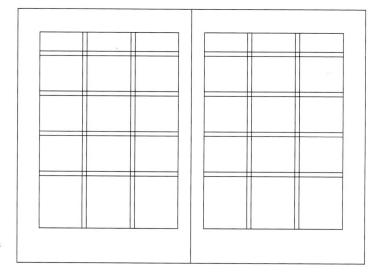

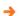

A grid determines page margins and divides the format into areas used on successive layouts.

ARCHITECTURE

Tiollo allouho yla iho <u>yllo oho o ion</u> liot

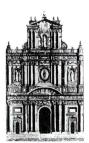

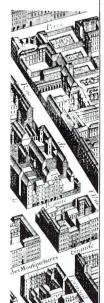

notto ultouho yllo ohou Holchho

tollo c<u>alonho</u> yllo ohor

Serial Design

The artist has almost unlimited choice in how to apply the concept of continuation in a single design. The task changes, however, when there are multiple units. The artist's job now is not only to unify one design but to create several designs that somehow seem to relate to each other. In other words, all the designs must seem part of a "series." In a series the same unifying theme continues in successive designs. This is not an unusual job for a designer. Countless books, catalogs, magazines, pamphlets, and the like all require this designing skill.

Using a Grid

Continuity is the term often used to denote the visual relationship between two or more individual designs. An aid often used in such serial designs is the grid. The artist begins by designing a grid, a network of horizontal and vertical intersecting lines that divide the page and create a framework of areas, such as in A. Then this same "skeleton" is used on all succeeding pages for a consistency of spacing and design results throughout all the units. To divide any format into areas or modules permits, of course, innumerable possibilities, so there is no predetermined pattern or solution. In creating the original grid, there are often numerous technical considerations that would determine the solution. But the basic idea is easily understood.

Using the same grid (or space division) on each successive page might suggest that sameness, and, hence, boring regularity, would result from repetition. This, however, is not necessarily true. A great deal of variety is possible within any framework, as the varied page layouts in **B** show.

Web Design

The grid alone is no guarantee of a successful composition, as can be seen in the range of quality in web page designs. In many cases the grid offers a bland display. On the other hand, C is a simple but refreshing take on the restraining format of banner at the top and columns below. In this case the fluid shape of the company's logo is repeated in the column headings. When you click on a heading, a column drops down (as expected), but it pours out of the heading. The repetition of this fluid theme builds on the unity inherent in the underlying grid.

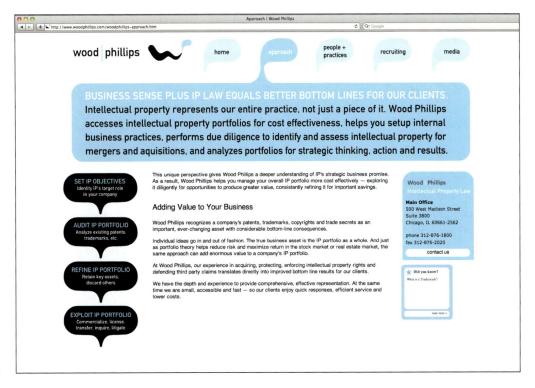

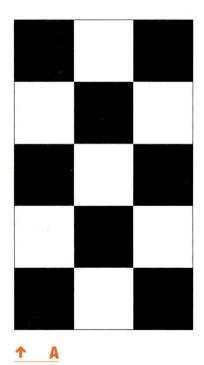

A checkerboard shows perfect unity.

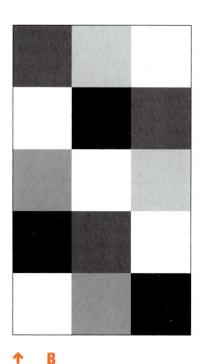

Some variations in the basic pattern increase interest.

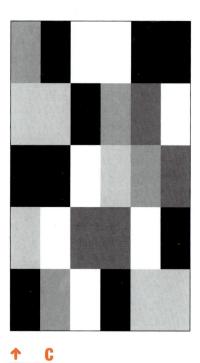

More variation possibilities are endless.

THE GRID

The word *design* implies that the various components of a visual image are organized into a cohesive composition. A design must have visual unity.

Using the Grid Effectively

The checkerboard pattern in **A** has complete unity. We can easily see the constant repetition of shape and the obvious continuation of lined-up edges. Unhappily, the result is also quite boring. The design in **B** has the same repetitive division of space, but it doesn't seem quite as dull. Some changes (or variations) now make this design a bit more interesting to the eye. In **C** the variations have been enlarged, so we can almost forget the dull checkerboard in **A**, but the same underlying elements of unity are still present. This is the basis of the principle of unity with variety. An obvious, underlying feeling of unity exists, yet variations enliven the pattern. Shapes may repeat, but perhaps in different sizes; colors may repeat, but perhaps in different values.

In the painting by Paul Klee **(D)**, an underlying feeling of a checkerboard is again the basic space division. The feeling now is more composed, and the arrangement of colors sets up a predictable **rhythm** of light and dark patches unlike **C**. The complexity of color relationships transforms a structure that could be boring into a painting that has both vivid and subtle passages.

Robert Rauschenberg's lithograph **(E)** also conveys an underlying checkerboard, but the arrangement is deliberately messier with overlaps and colors bleeding through, disrupting the pattern. The format provides a unity to a collage of varied historical art images that seem to compete for attention.

The watercolor depiction of animal designs shown in ${\bf F}$ is organized in a grid but does not resemble a checkerboard. Each design is unique but is unified by similar style and the compositional structure of the grid.

A point to remember is that, with a great variety of elements, a simple layout idea can give needed unity and be very effective.

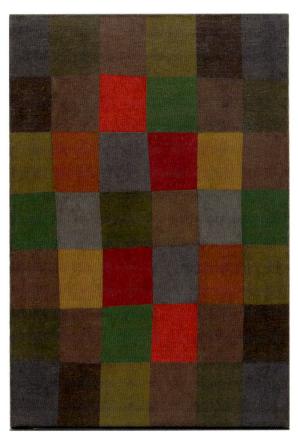

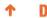

Paul Klee. New Harmony. 1936. Oil on canvas, 3' %" \times 2' 2%". Solomon R. Guggenheim Museum, New York. 71.1960.

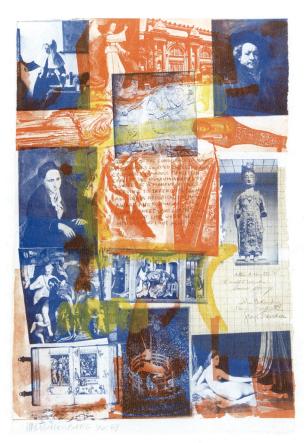

Robert Rauschenberg, Centennial Certificate. 1969. Color lithograph. Art © Robert Rauschenberg/Licensed by VAGA, New York, New York. Digital image © The Metropolitan Museum of Art/Art Resource, New York.

Awa Tsireh. Animal Designs. c. 1917-1920. Watercolor on paper sheet, 1' 8%6" \times $2^{\mbox{\tiny I}}$ 2½" (50.9 \times 66.2 cm). Smithsonian American Art Museum, Corbin-Henderson Collection (gift of Alice H. Rossin).

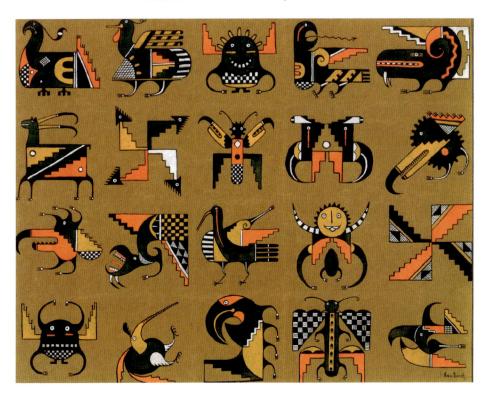

VARIED REPETITION

Is the principle of unity with variety a conscious, planned ingredient supplied by the artist or designer, or is it simply produced automatically by a confident designer? There is no real answer. The only certainty is that we can see the principle in art from every period, culture, and geographic area.

Variety Adds Visual Interest

Charley Harper's painting of a bird working on a sunflower seed (A) employs repetition in two distinct ways. The head repeats in a sequence with geometric clarity. This humorously depicts the characteristic pecking habit of the Tufted Titmouse. The leaves also repeat and are geometric, but in this case variety is emphasized as the shapes fold and pivot. This artwork is typical of Harper's illustrations that are easily recognized because of a geometric unity that is enriched by surprising variations on a theme.

The use of unity with variety displayed in the collection of photographs **(B)** suggests a more rigid approach. The individual subject of industrial buildings might not catch our attention, but the variety displayed in the grid format immediately invites comparison and contrast. The idea of related variations seems to satisfy a basic human need for visual interest that can be achieved without theoretical discussions of aesthetics.

A conscious (or obvious) use of unity with variety does not necessarily lessen our pleasure as viewers. An obvious use of the principle is not a drawback. Unity is immediately apparent in the set of functional ceramicware in **C**. Eva Zeisel's vessels seem to have evolved their forms as naturally as unfurling leaves or swelling seed pods. A similar small element at the top of each piece works to close a handle in one case and provide a spout in another.

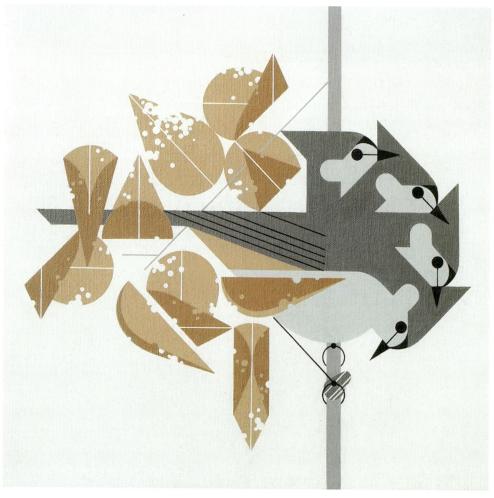

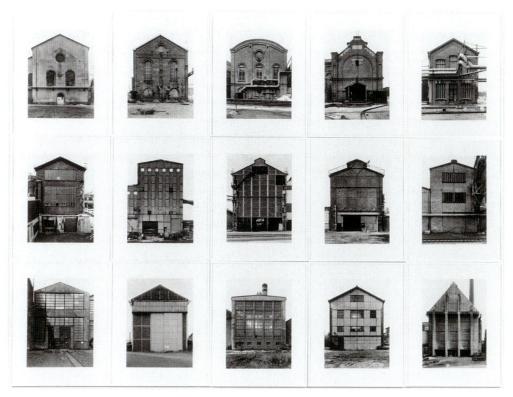

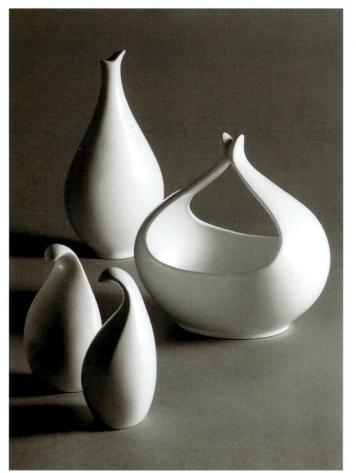

Bernd and Hilla Becher. Industrial Facades. 1970–1992. Fifteen black-and-white photographs, overall: 5' 8¾" × 7' 11" (installed as a group). Albright-Knox Art Gallery, Buffalo, New York (Sarah Norton Goodyear Fund, 1995).

← C

Eva Zeisel. Classic Century: oil pourer, sauce boat, salt and pepper. Ceramic. Produced by Royal Stafford, England.

EMPHASIS ON UNITY

In the application of any art principle, wide flexibility is possible within the general framework of the guideline. So it is in unity with variety. To say a design must contain both the ordered quality of unity and the lively quality of variety does not limit or inhibit the artist. The principle can encompass a wide variety of extremely different visual images and can even be contradicted for expressive purposes.

Unity through Repetition

These pages show successful examples of emphasis on the unifying element of repetition. Variety is present, but admittedly in a subtle, understated way. Photograph **A** shows thousands of pilgrims in Mecca during the Hajj. The multitude of humanity from all races, nations, and walks of life is united by simple white garments.

We know at a glance that all the plants depicted in **B** are irises. As with other Japanese screens from this period, the composition is strongly unified by repetition of natural forms. But this is not wallpaper. No two leaves or flowers are identical, and the eye is rewarded with subtle variation on a constant theme.

The visual unity gained by repetition is obvious in a depiction of twins. In Loretta Lux's photograph **(C)** it is reinforced by the identical polka dot dress. This cliché of twins dressed alike is heightened by the virtually blank background. We are left to search for the subtlest of clues to discern any difference between the two girls. In this case a strong unity produces a strange, even disturbing, challenge to any desire to see these two as individuals.

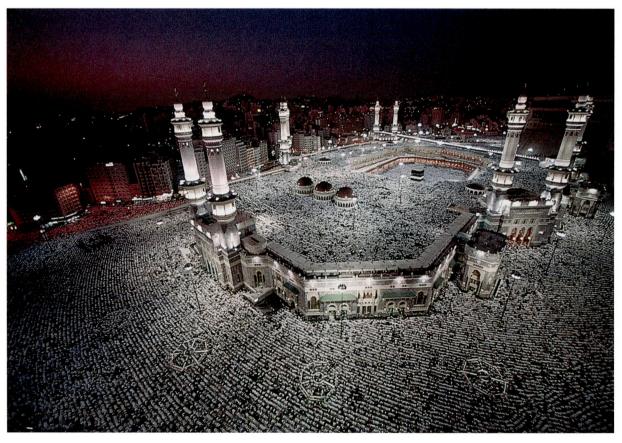

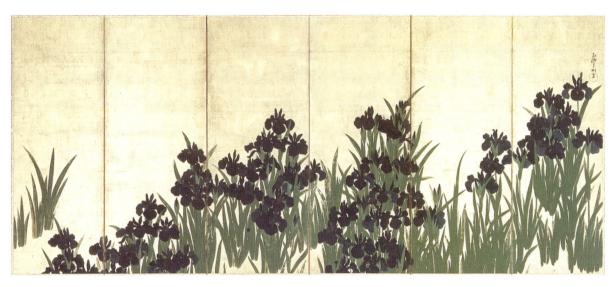

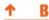

Ogata Korin. *Irises.* Edo period, c. 1705. Sixfold screen (one of pair), 150.9×338.8 cm. Nezu Art Museum, Tokyo.

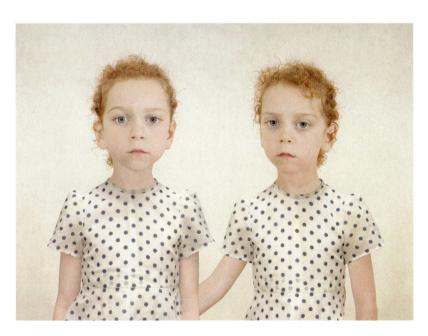

↑ C

Loretta Lux. Sasha and Ruby. 2005. Ilfochrome print.

EMPHASIS ON VARIETY

Two artists argue over a painting:

"This painting is great because of the unity of similar shapes," says the first.

"You're crazy! It is the variety and contrasts that make it great!" says the second.

And both might be right.

Life is not always orderly or rational. To express this aspect of life, many artists have chosen to underplay the unifying components of their work and let the elements appear at least superficially uncontrolled and free of any formal design restraints. The examples here show works in which the element of variety is strong.

Variety in Form, Size, Color, and Gesture

The painting shown in **A** demonstrates unity by an emphasis on serpentine curves flowing through the *Deposition from the Cross*. Continuation is a strong feature as the viewer's eye is led through the complex arrangement of draped clothing and the bodies. Variety is emphasized through color and the almost infinite subtle differences possible in the human form.

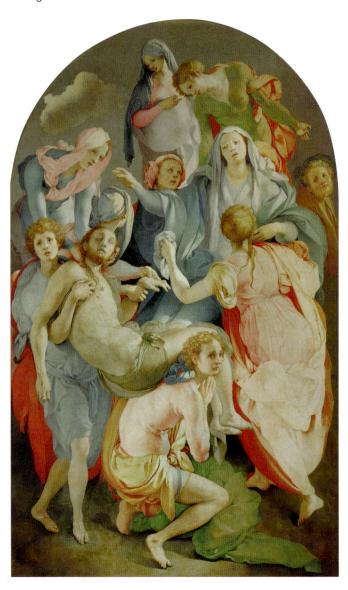

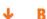

Elizabeth Murray. Painter's Progress. Spring 1981. Oil on canvas, 19 panels, 9' 8" \times 7' 9". Acquired through the Bernhill Fund and gift of Agnes Gund. The Museum of Modern Art, New York, New York.

Jacopo Pontormo. *Deposition from the Cross.* Capponi Chapel. Location: S. Felicita, Florence, Italy.

Elizabeth Murray's whimsical depiction of an artist's palette shown in **B** offers up an unlikely comparison to Pontormo's painting (A). Murray's painting is like an ill-fitting jigsaw puzzle trying to come together. Piercing triangular spaces left over in this assembly and the angular shapes of the pieces offer a contrast to the fluid shape of the palette. A simple arrangement of curves and angles is punctuated by vivid color set off against the surrounding black areas. Seen in this way both artists express

dynamism through variety and rely on unifying elements to hold it all together.

An aggressive near ugliness pervades the chaotic jumble of battered texts in George Herms's assemblage sculpture (C). A first impression might be of materials out of control and barely hanging together. One can find, however, a visual unity is at work in the strong cross-like structure and a limited range of colors dominated by brown, black, and white.

CHAOS AND CONTROL

Without some aspect of unity, an image or design becomes chaotic and quickly "unreadable." Without some elements of variety, an image is lifeless and dull and becomes uninteresting. Neither utter confusion nor utter regularity is satisfying.

The photograph of a commercial strip shown in **A** reveals a conflicting jumble of **graphic** images, each vying for our attention. In this case information overload cancels out the novelty or variety of any single sign and leaves us confused with the chaotic results.

The photo in **B** reveals the bland unity of a housing subdivision. There is an attempt at variety in the facades, but the backs of the homes are identical. After a number of years, personal

variations may show in paint color, landscaping, and sometimes eccentric renovations. Such expressions can bring about conflict between conformity and individuality.

The model for the Frank Gehry-designed Guggenheim Museum at Bilbao **(C)** offers a dramatic but coherent emphasis on variety. The various sweeping curves provide a contrast to the straight and angular architectural features and to the surrounding built environment. Within the curves are various directions, sizes, and shapes. In this case a variety of architectural forms was made possible by the use of computer design software developed for airplane design. Here you can see the power of variety to offer contrast within a unified whole.

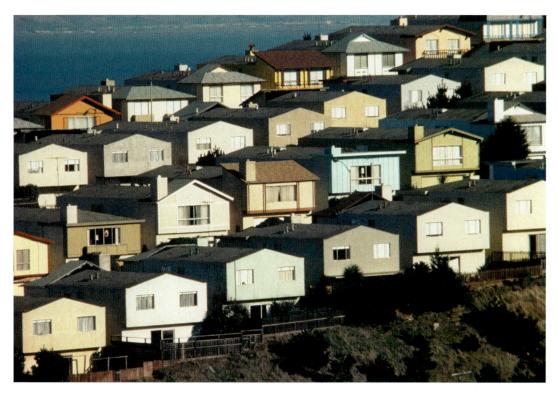

The bland unity of a housing subdivision.

FIGURATIVE AND ABSTRACT

The earlier discussion of the works by Pontormo and Murray (see **A** and **B** on page 48) examined unity and variety within both figurative and abstract artworks. Unity is not simply a property of related organic shapes or of related geometric elements. An apprehension of unity is a simple and immediate sense of connections resonating throughout a composition. The elements that build that unity may be simple as well, or they may be subtle and more complex.

Gérôme's painting **(A)** presents a story: a duel after a masquerade party. The characters are set on a stage-like space of a snowy field. The distant landscape and waiting carriage are as diffuse and simplified as theatrical backdrop. Unity is largely achieved by a narrow range of **analogous colors** that allows the tragic figures to stand out in contrast. Unity is also at work

in the proximity of characters and a line of continuity that flows from the fallen Pierrot to the departing Harlequin. A **narrative** artwork such as this requires the artist to act much like a movie director, and a deft handling of unity is decisive in holding the story together.

Picasso's version of *Harlequin* **(B)** could hardly be more different from Gérôme's. Here is a painting that seems to only share a character, but by no means a style of painting. The Picasso picture appears to be layers of flat geometric shapes more akin to a crazy quilt than Gérôme's idea of a painting. A longer examination of the two paintings will afford us a chance to see more that they have in common, but for now we will confine the discussion to how Picasso achieves his version of a unified composition.

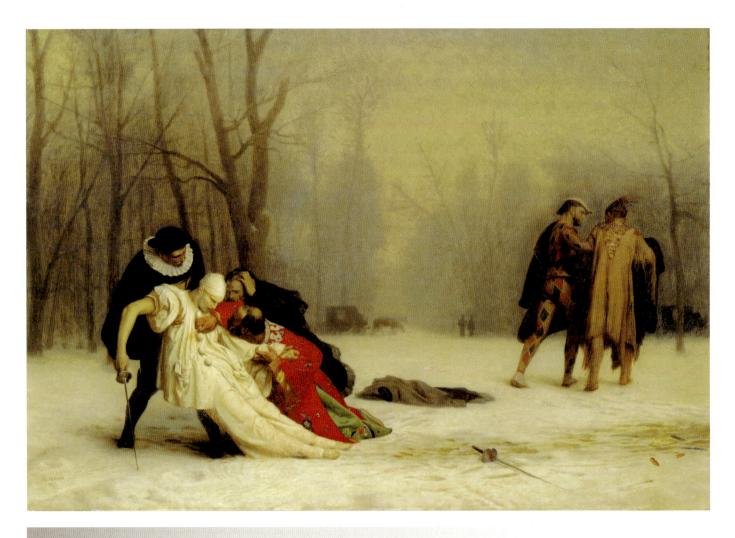

Harlequin may be quilt-like, but it is not crazy. The singular nature of the harlequin pattern (red, blue, and beige diamonds) is integrated into the design by a repetition of the blue color. In fact, every shape and color has an echo or repeats elsewhere in the painting. Repeated directional lines (angles to the left balanced by angles to the right) also unify the arrangement.

Whatever your personal preference between these two contrasting painting styles, one has to acknowledge that both artists composed with an eye for unity.

Pablo Picasso. *Harlequin.* Paris, late 1915. Oil on canvas, 6' $\frac{1}{4}$ " \times 3' 5%" (183.5 \times 105.1 cm).

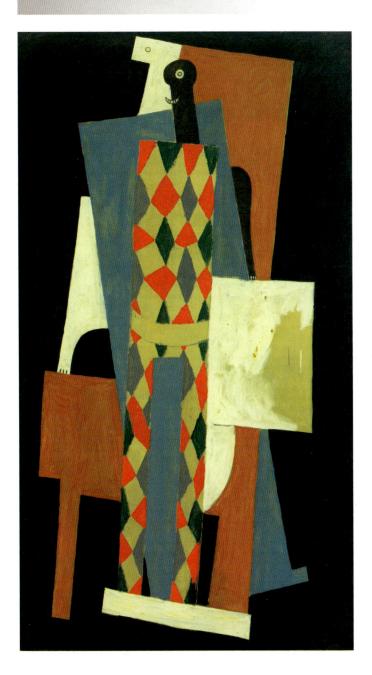

 $"Oh, look! \ I \ think \ I \ see \ a \ little \ bunny."$

INTRODUCTION

Attracting Attention 56

WAYS TO ACHIEVE EMPHASIS

Emphasis by Contrast 58

WAYS TO ACHIEVE EMPHASIS

Emphasis by Isolation 60

WAYS TO ACHIEVE EMPHASIS

Emphasis by Placement 62

DEGREE OF EMPHASIS

One Element 64

ABSENCE OF FOCAL POINT

Emphasizing the Whole over the Parts 66

ATTRACTING ATTENTION

Very few artists or designers do not want people to look at their work. In past centuries, when pictures were rare, almost any image was guaranteed attention. Today, with photography and an abundance of books, magazines, newspapers, signs, and so on, all of us are confronted daily with hundreds of pictures. We take this abundance for granted, but it makes the artist's job more difficult. Without an audience's attention, any messages, any artistic or aesthetic values, are lost.

How does a designer catch a viewer's attention? How does the artist provide a pattern that attracts the eye? Nothing will guarantee success, but one device that can help is a point of emphasis or **focal point.** This emphasized element initially can attract attention and encourage the viewer to look closer.

Using Focal Point for Emphasis

Every aspect of the composition in **A** emphasizes the grapefruit at center stage. The grapefruit shape is large, centered, light, and yellow (compared with darker gray surroundings), and even the lines of the sections point to the center. All these elements bring our focus to the main character or subject. This is the concept of a focal point.

The painting by Henri Matisse **(B)** does not have the central, obvious target that is evident in **A**, but the focal point is unambiguous and even humorous. The small red turtle is emphasized by contrast of size, unique color, and isolation. The figures direct our attention as well as we follow their gaze to the focal point. In this case even a very small area of emphasis is powerful enough to need balancing counterpoints such as the bright hair of the left-hand figure and the abstracted blue stripe of water at the top of the painting.

The photograph in **C** is a view of an ordinary street scene. The large pine tree might go unnoticed in a stroll through the neighborhood. Several things contribute to the emphasis on this tree in the photograph: placement near the center, large size, irregular shape, and dark value against the light sky.

There can be more than one focal point. Sometimes an artwork contains secondary points of emphasis that have less attention value than the focal point. These serve as accents or counterpoints as in the Matisse picture. However, the designer must be careful. Several focal points of equal emphasis can turn the design into a three-ring circus in which the viewer does not know where to look first. Interest is replaced by confusion: When everything is emphasized, nothing is emphasized.

Henri Matisse. Bathers with a Turtle. 1908. Oil on canvas, 179 \times 220 cm. The St. Louis Museum of Art, Missouri.

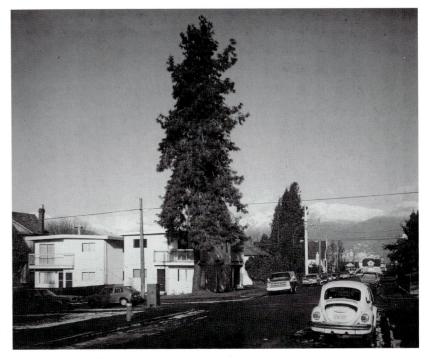

Jeff Wall. The Pine on the Corner. 1990. 3' $10^3\!4" \times 3' 10^4\!4"$ (1.19 \times 1.48 m). Edition of 3. Marian Goodman Gallery, New York.

WAYS TO ACHIEVE EMPHASIS

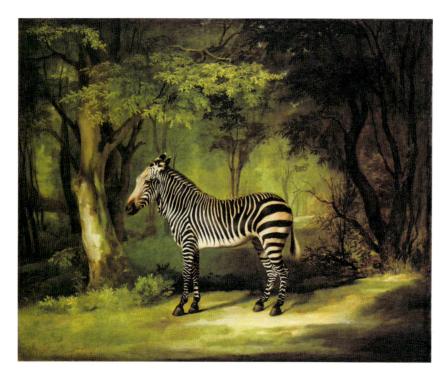

George Stubbs. *Zebra.* 1763. Oil on canvas, $3' 4\frac{1}{2}" \times 4' 2\frac{1}{4}"$.

EMPHASIS BY CONTRAST

Very often in art the pictorial emphasis is clear, and in simple compositions (such as a portrait) the focal point is obvious. But the more complicated the pattern, the more necessary or helpful a focal point may become in organizing the design.

Creating a Focal Point through Contrast

As a rule, a focal point results when one element differs from the others. Whatever interrupts an overall feeling or pattern automatically attracts the eye by this difference. The possibilities are almost endless:

When most of the elements are dark, a light form breaks the pattern and becomes a focal point.

When most of the elements are muted or soft-edged, a bold contrasting pattern will become a focal point (A).

In an overall design of distorted expressionistic forms, the sudden introduction of a naturalistic image **(B)** will draw the eye for its very different style.

Text or graphic symbols will be a focal point (in this case, the eye is drawn to the number 16) **(C)**.

When the majority of elements are black and white, color will stand out as in **D**.

This list could go on and on; many other possibilities will occur to you. Sometimes this idea is called *emphasis by contrast*. The element that contrasts with, rather than continues, the prevailing design scheme becomes the focal point.

See also Devices to Show Depth: Size, page 198; Value as Emphasis, page 248; and Color as Emphasis, page 272.

James Ensor. Self-Portrait Surrounded by Masks. 1899. Oil, 3' $11\frac{1}{2}$ " \times 2' $7\frac{1}{2}$ " (121 \times 80 cm). Sammlung Cleomir Jussiant, Antwerp.

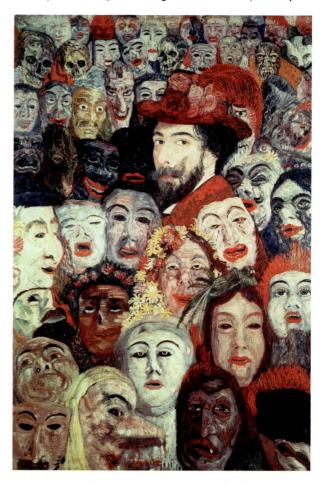

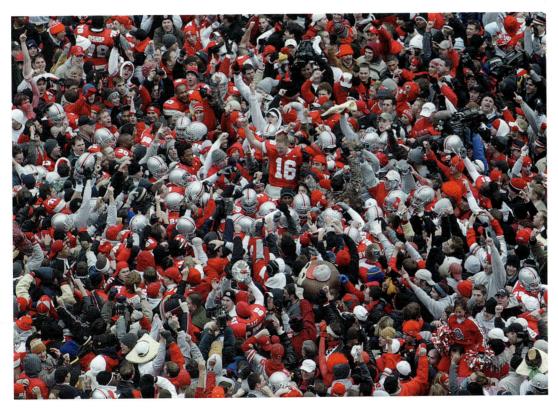

Karl Kuntz (photographer). Columbus Dispatch. Sunday, November 24, 2002.

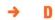

Thomas Nozkowski. Untitled. 2006. Aquatint etching, 1' $9\frac{1}{2}$ " \times 2' $3\frac{1}{2}$ ".

WAYS TO ACHIEVE EMPHASIS

EMPHASIS BY ISOLATION

A variation on the device of emphasis by contrast is the useful technique of emphasis by isolation. There is no way we can look at the design in A and not focus our attention on that element at the bottom. It is identical to all the elements above. But simply by being set off by itself, it grabs our attention. This is contrast, of course, but it is contrast of placement, not form. In such a case, the element, as here, need not be any different from the other elements in the work.

Creating a Focal Point through Isolation

In the painting by Eakins (B) the doctor at left repeats the light value of the other figures in the operating arena. All the figures in this oval stand out in contrast to the darker figures in the background. Isolation gives extra emphasis to this doctor at the left.

Gérôme's painting (C) uses isolation to create a hierarchy of emphasis. The cluster of figures around the dying Pierrot is isolated to the left, the departing Harlequin to the right, and the awaiting carriage in the center background.

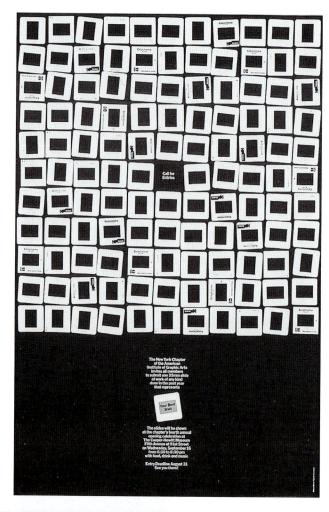

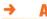

Call for entries for AIGA/New York show, "Take Your Best Shot." Designer: Michael Beirut, Vignelli Associates, New York.

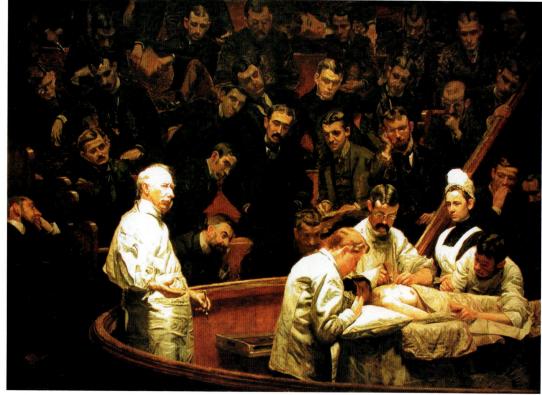

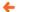

Thomas Eakins. The Agnew Clinic. 1889. Oil on canvas, 6' 21/2" × 10' 101/2" (1.9 \times 3.3 m). University of Pennsylvania Art

Collection, Philadelphia.

In neither of these examples is the focal point directly in the center of the composition. This placement could appear too obvious and contrived. However, it is wise to remember that a focal point placed too close to an edge will tend to pull the viewer's eye right out of the picture. Notice in Eakins's painting **(B)** how the curve of the oval on the left side and the doctor looking toward the action at right keep the isolated figure from directing our gaze out of the picture. In ${\bf C}$ the dramatic cluster of figures on the left is balanced by the departing characters on the right. Even the sword is isolated on the ground for emphasis.

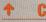

Jean-Léon Gérôme. The Duel after the Masquerade. 1857–1859. Oil on canvas, 1' 3%" \times 1' 10%6" (39.1 \times 56.3 cm).

WAYS TO ACHIEVE EMPHASIS

EMPHASIS BY PLACEMENT

It does not require much in the way of proof to say that putting something at the center of a composition creates emphasis. In fact, it is often a criticism of naïve or boring compositions to notice that the subject is plopped down smack in the center. So then it becomes interesting to see how the center can be used in a subtle way to achieve emphasis.

Susan Moore's portrait of her daughter **(A)** offers a three-quarter view and avoids a frontal "mug shot" composition. The center of the painting is not the center of her face. The central vertical axis of the painting *does* intersect her right eye and acts to draw attention to her gaze at us. We make eye contact through this placement.

The position of the most famous apple of all time is also near the center of **B**. The painting is busy and crowded, and the

passing of the apple takes place at the intersection of the tree trunk and the lines formed by the arms of Adam and Eve. The composition has an equal balance to the left and right of this focal point, and the key element is emphasized. Both $\bf A$ and $\bf B$ succeed because the focal point for each does not have to compete with other elements for prominence.

The bull's-eye of a dartboard would be the simplest illustration of an absolute focal point. This is the essence of a radial design: the center of a circle from which all elements radiate. Radial designs are more common in architecture (temples) or the craft areas (quilts and ceramics) than in two-dimensional art. In pictures, perspective lines can lead to a point of emphasis, and the result can be a radial design. In Vermeer's painting **(C)** the girl is the focal point, and the perspective lines of the interior

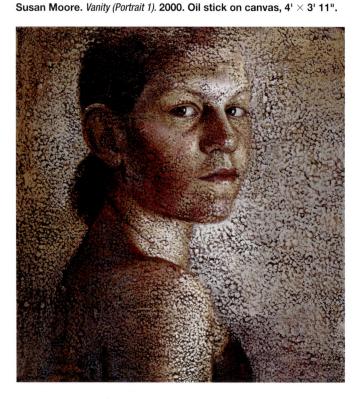

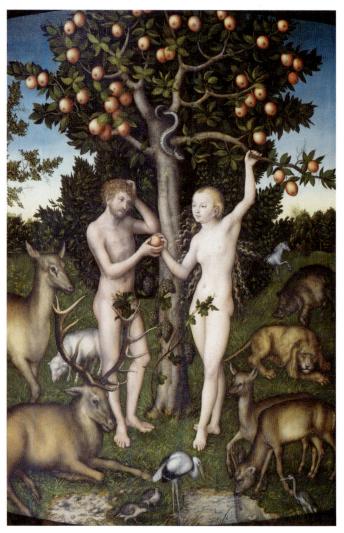

Lucas Cranach the Elder. Adam and Eve. 1526. Oil on panel, 3' 10%" \times 2' 7¾" (117 \times 80 cm). Courtauld Gallery, Courtauld Institute, London.

all direct our eyes back to the figure. It is a mark of the subtlety and complexity of Vermeer's work that the painting is not simply constructed to point to the main figure but also unfolds other areas of interest and keeps our attention and involvement. Notice how the one line on the floor that would lead straight from

the viewer's position to the girl is obscured by the tapestry and the cello. Vermeer employs the power of a radial design without overstating it.

See also *Symmetrical Balance*, pages 92 and 94, and *Radial Balance*, page 106.

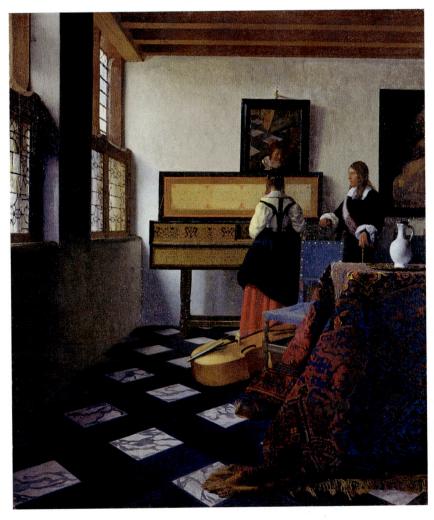

Jan Vermeer. A Lady at the Virginals with a Gentleman (The Music Lesson). 1662–1664. Oil on canvas, 2' 5" \times 2' 1". The Royal Collection, London.

DEGREE OF EMPHASIS

ONE ELEMENT

A specific theme may at times call for a dominant, even visually overwhelming focal point. The use of a strong visual emphasis on one element is not unusual.

In the graphic design of newspaper advertisements, bill-boards, magazine covers, and the like, we often see an obvious emphasis on one element. This emphasis can be necessary to attract the viewer's eye and present the theme (or product) in the few seconds most people look casually at such material. Such increased focus is also needed when an idea is being promoted, as in the illustration for an editorial shown in **A**. Here the intent is to grab our attention in the hope that we will read the commentary. The striking red circle creates a mouth and gives voice to the marginalized subject in a plea for peace.

Lino. Communication Arts, May/June 2005, p. 115. Editorial for Courier International (France). Art Director: Pascal Phillipe.

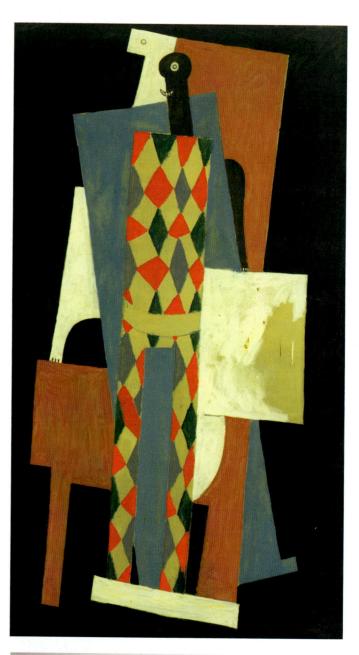

Pablo Picasso. *Harlequin.* Paris, late 1915. Oil on canvas, 6' $\frac{1}{4}$ " \times 3' 5%" (183.5 \times 105.1 cm).

Maurice Vellekoop. Christian Dior Boutique, Valentino. November/December 1997. Watercolor on paper. Wallpaper.

Maintaining Unity with a Focal Point

A focal point, however strong, should remain related to and a part of the overall design. The red circle in **A** is visually strong yet is related to other elements of strong contrast: the black head and white doves. Contrast the effect in **A** with that in **B**. In Picasso's painting (**B**) the singular treatment of the masklike "face" contrasts with the shapes and planes that unify the rest of the painting. In this case the contrast is less robust than in **A**. Two very small circles and an arc are the only elements needed to snap our attention to the "face" of this abstract figure. The position of the white eye as a pivot point for the seesawing planes below it serves to integrate the face into the overall composition.

In general, the principle of unity and the creation of a harmonious pattern with related elements are more important than the injection of a focal point if this point would jeopardize the design's unity. In the playful illustration by Maurice Vellekoop **(C)**, the unusual shape of the orange dress is accentuated by the

blue figure and background. The figure dissolves into the blue, and the dress literally pops! The strength of this focal point is integrated into the unity of the total composition. The established focal point is not a completely unrelated element. The curving shapes are balanced by other similar shapes, and the orange is echoed by the brown of the man's suit.

The concept of a focal point is not limited to two-dimensional compositions. The hearth as a focal point for a room is a standard feature in many homes. The fireplace shown in $\bf D$ is eye-catching in form and accentuated by the sparseness of the space. Nevertheless it is not a domineering focal point since it is placed off center and allows the view through the window to be an alternative focus. The curving lines of the seating echo the curves of the fireplace and help to integrate it into the otherwise rectangular space.

UrbanLab. X House. Urban. Hennepin, Illinois.

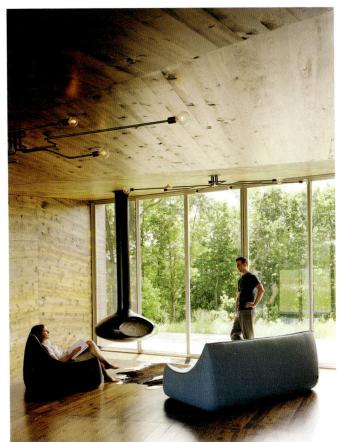

EMPHASIZING THE WHOLE OVER THE PARTS

A definite focal point is not a necessity in creating a successful design. It is a tool that artists may or may not use, depending on their aims. An artist may wish to emphasize the entire surface of a composition over any individual elements. Lee Krasner's painting (A) is an example. Similar shapes and textures are repeated throughout the painting. These shapes and textures form loose rows and columns and a kind of grid. The artist creates an ambiguous visual environment that is puzzling. Dark and light areas repeat over the surface in an even distribution, and no one area stands out. The painting has no real starting point or visual climax. It has the effect of a surface in nature: a rock face, waves on the water, or leaves scattered in the ground.

Lee Krasner. *Untitled.* 1949. Oil on composition board, $4^{1} \times 3^{1}$ 1" (122 \times 94 cm). The Museum of Modern Art, New York (gift of Alfonso A. Ossorio).

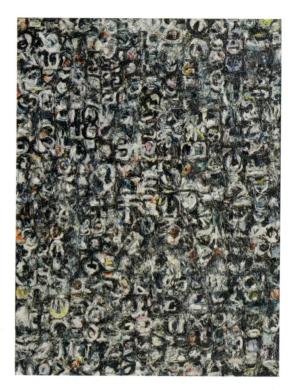

The collage painting by Mark Keffer shown in B is less dense than A, and by comparison it seems open and airy. Here the grid is that of a street map. The added elements of pink shapes and circles punctuate different intersections. If only one shape or circle had been added, it would create a focal point, but the repetition and suggested continuation beyond the edge of the composition emphasize the whole over the parts.

The cover design (C) shows that an emphasis of the whole over any one part is not limited to geometric repeat patterns or something as simple as autumn leaves scattered evenly across a lawn. In this case the very graphic thumbprint serves to absorb or camouflage the zebra. The purpose for this carefully composed alignment of the thumbprint and zebra stripe pattern is to emphasize not the animal, but our effect on its environment. Note how different this is from the zebra in A on page 58!

See also Crystallographic Balance, page 108.

Chaz Maviyane-Davies. IUCN Annual Report 1998.

"You must be terribly proud. It's the finest thing you've done."

James Stevenson

All Rights Reserved.

 $^{@ \}textit{The New Yorker Collection} from cartoonbank.com. \\$

INTRODUCTION

Scale and Proportion 70

SCALE OF ART

Human Scale Reference 72

SCALE WITHIN ART

Internal References 74

SCALE WITHIN ART

Internal Proportions 76

SCALE WITHIN ART

Contrast of Scale 78

MANIPULATING SCALE AND PROPORTION

Surrealism and Fantasy 80

PROPORTION

Geometry and Notions of the Ideal 82

PROPORTION

Root Rectangles 84

SCALE AND PROPORTION

Scale and proportion are related terms: both basically refer to size. Scale is essentially another word for size. "Large scale" is a way of saying big, and "small scale" means small. Big and small, however, are relative. What is big? "Big" is meaningless unless we have some standard of reference. A "big" dog means nothing if we do not know the size of an average dog. This is what distinguishes the two terms. **Proportion** refers to relative size—size measured against other elements or against some mental norm or standard.

The small stool and the clues given by the architecture of the space provide a scale reference for judging the size of the sphere in **A**. Because a sphere has no inherent scale reference, we depend on the context to judge its size. In **A** the sphere is almost oppressively large in proportion to the setting. Imagine the same sphere outdoors seen from an airplane. It might have the same visual impact as a period on this page.

We often think of the word *proportion* in connection with mathematical systems of numerical ratios. It is true that many such systems have been developed over the centuries. Artists have attempted to define the most pleasing size relationships in items as diverse as the width and length of sides of a rectangle to parts of the human body.

Using Scale and Proportion for Emphasis

Scale and proportion are closely tied to emphasis and focal point. The lemon and strawberry depicted in Glen Holland's painting **(B)** are at a one-to-one (1:1) scale, so the painting is obviously small. However, the proportion of these subjects to the rest of the painting and the unusual point of view lend a monumental feeling to these humble subjects.

In past centuries visual scale was often related to thematic importance. The size of figures was based on their symbolic importance in the subject being presented. This use of scale is called **hieratic scaling**. Saint Lawrence is unnaturally large compared with the other figures in the fifteenth-century painting in **C**. The artist thus immediately not only establishes an obvious focal point but also indicates the relative importance of Saint Lawrence to the other figures.

See also Devices to Show Depth: Size, page 198.

Richard Roth. Untitled. 1983. Installation: 11' diameter (3.4 m) sphere with red stool. © 1993 Richard Roth. Photo: Fredrik Marsh.

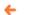

Glen Holland. Sweet & Sour. 1998. Oil on wood, actual size 4' $6^{\prime\prime}\times7^{\prime}.$ Fischbach Gallery, New York.

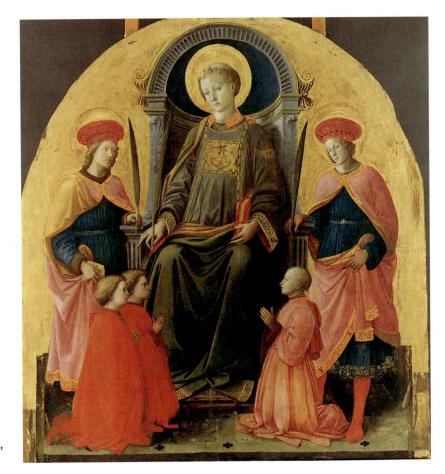

Fra Filippo Lippi. Saint Lawrence Enthroned with Saints and Donors. c. late 1440s. Altarpiece from the church of the Villa Alessandri, Vincigliata Fiesole, central panel only. Tempera on wood, gold ground; overall, with arched top and added strips: 3' $11^{3}\!4\text{"}\times3\text{'}\ 9\%\text{"}$ (121.3 \times 115.6 cm). The Metropolitan Museum of Art, Rogers Fund, 1935.

Chinese medallion. Ming Dynasty, late 16th–early 17th century. Front view: carved in high relief with scene of the return by moonlight of a party from a "spring outing." Ivory, diameter: 3%" (8.6 cm). The Metropolitan Museum of Art, purchase, Friends of Asian Art Gifts, 1993.

Limbourg Brothers. Multiplication of the Loaves and Fishes, from the Book of Hours Les Très Riches Heures du Duc de Berry. 1416. Manuscript illumination, 61/4" \times 4%" (16 \times 11 cm). Musée Condé, Chantilly.

HUMAN SCALE REFERENCE

One way to think of artistic scale is to consider the scale of the work itself—its size in relation to other art, in relation to its surroundings, or in relation to human size. Unhappily, book illustrations cannot show art in its original size or scale. Unusual or unexpected scale is arresting and attention-getting. Sheer size does impress us.

When we are confronted by **frescoes** such as the Sistine Chapel ceiling, our first reaction is simply awe at the enormous scope of the work. Later we study and admire details, but first we are overwhelmed by the magnitude. The reverse effect is illustrated in the Chinese medallion in **A**. A world of details—figures, landscape, and architecture—is compressed into a three-and-one-half-inch-diameter circle. An immensity of information is rendered with delicate precision on an intimate scale.

The Power of Unusual Scale

If large or small size springs naturally from the function, theme, or purpose of a work, an unusual scale is justified. We are acquainted with many such cases. The gigantic pyramids made a political statement of the pharaohs' eternal power. The elegant miniatures of the religious *Book of Hours* (B) served as inspirational illustrations for the private devotionals of medieval nobility. The small scale is appropriate to private reflection.

The scale of C illustrates the opposite approach. Claes Oldenburg has made use of a leap of scale in his Typewriter Eraser (C). As with the work of other pop artists, this piece calls attention to an everyday object not previously considered worthy of aesthetic consideration. Oldenburg transforms the object by elevating it to a monumental scale. A magnification such as this allows us to see the form with fresh eyes, and, as a result, we might discover new associations, such as the graceful strands of the brush, which project upward like a fountain. The children in the photo give us a scale reference, and also an understanding how the object is transformed into a playground feature, perhaps for a game of hide-and-seek. As typewriters and their eraser have faded from use, the eraser form becomes even more abstract to a new generation of viewers.

Earthworks are unique in the grandeur of their scale. The Nazca earth drawing (D) is pre-Columbian in origin. Its original function or meaning has been lost and is the subject of much speculation. With a length of 150 feet it can really only be seen properly from the air! A sense of scale can be determined by the tire tracks around the perimeter of the spider. We can only speculate whether the large scale had a religious importance, or was playful like the Oldenburg.

Claes Oldenburg and Coosje van Bruggen. Typewriter Eraser, Scale X. 1999. Stainless steel and cement, approximately 20' tall. National Gallery of Art, Sculpture Garden, Washington, DC. Gift of The Morris and Gwendolyn Cafritz Foundation.

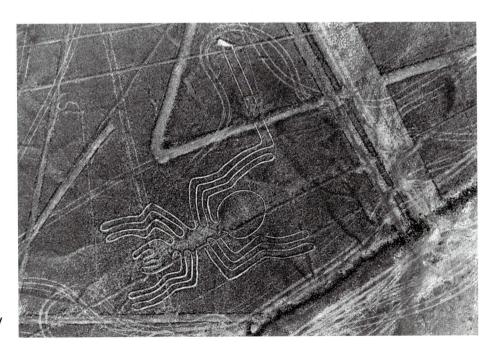

INTERNAL REFERENCES

The scale of artworks can impress or hold our attention through their actual size. Scale within a work of art provides meaning, context, and often a clue to how it is made or how we are meant to interpret the image or object. As we have seen, the most powerful point of reference is our own size. Is it bigger than I am? Is it smaller than I am? Are we the same? Psychologically this can be very powerful.

The painting shown in **A** has no point of reference in terms of imagery or pictorial elements. It is simply composed of brush-strokes. This is a very literal presentation of the elements of painting. These marks organize the surface and even carry over onto the frame. In one sense we can see the brushstrokes as actors on a stage. As we identify the marks as brush strokes we also identify a scale: the size of the tool that made them and the length or reach of the artist's arm. Now we have connected to the creation of this painting.

Andreas Gursky's photograph shown in **B** is, at first glance, as abstract as Howard Hodgkin's painting **(A)**. The black and gray curves resemble inky brush strokes. In fact this photograph is larger than Hodgkin's painting. This is a point that might be overlooked in the context of this book where one might not question the intended size of a photograph.

A second photograph from the series **(C)** gives us more information regarding the context of these striking curves and lines. The inclusion of buildings on the horizon sets the scale within this composition, and our understanding is transformed. The source of these undulating lines and shapes is a desert racetrack. Without the internal scale references, we are left with a puzzle.

Andreas Gursky. Bahrain II. 2005. C-Print, 306 imes 221.5 cm.

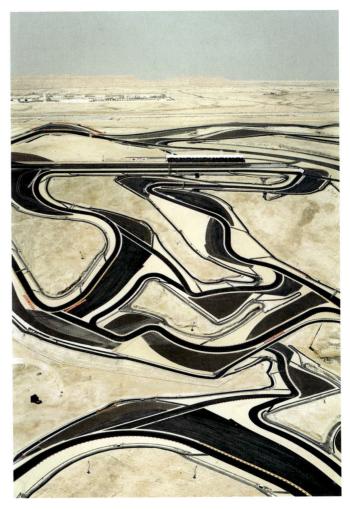

Andreas Gursky. Bahrain I. 2005. C-Print, 306 \times 221.5 cm.

INTERNAL PROPORTIONS

The second way to discuss artistic scale is to consider the size and scale of elements within the design or pattern. The scale here, of course, is relative to the overall area of the format—a big element in one painting might be small in a larger work. Again, we often use the term *proportion* to describe the size relationships between various parts of a unit. To say an element in a composition is "out of proportion" carries a negative feeling, and it is true that such a visual effect is often startling or unsettling. However, it is possible that this reaction is precisely what some artists desire.

The three examples in **A** contain the same elements. But in each design the scale of the items is different, thus altering the proportional relationships between the parts. This variation results in very different visual effects in the same way that altering the proportion of ingredients in a recipe changes the final dish. Which design is best or which we prefer can be argued. The answer would depend on what effect we wish to create.

Using Scale to Effect

Look at the difference scale can make in a painting. The images in **B** and **C** both deal with the same topic: the well-known story of Christ's last supper with His disciples before the crucifixion. In Ghirlandaio's painting (B) all the figures are quite small relative to a large, airy, and open space. The figures are life-size in a 25-foot-long architectural painting. The regular placement of the figures at the table and the geometric, repeating elements of the architecture give a feeling of calm and quiet order. The Last Supper by Nolde (C) is, indeed, in a different style of painting, but a major difference between the two works is the use of scale within the picture. In fact the figures in both paintings are similar in size! However, Nolde's figures are crammed together and overlap in the constricting space of a modest canvas. The result is crowded and claustrophobic. Nolde focuses our attention on the intense emotions of the event. The harsh drawing, agitated brushwork, and distortion of the figures enforce the feeling. Both artists relate the same story, but they have very different goals. The choice of scale is a major factor in achieving each artist's intention.

Changes in scale within a design also change the total effect.

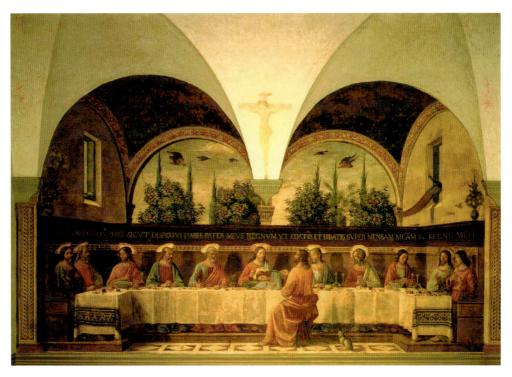

B

Domenico Ghirlandaio. Last Supper. c. 1480. Fresco, 25' 7" (8 m) wide. San Marco, Florence.

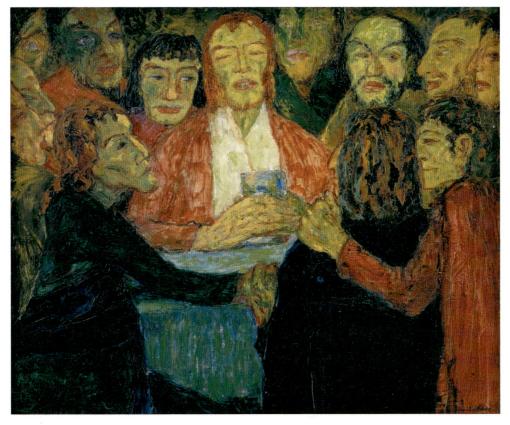

Emil Nolde. The Last Supper. 1909. Oil on canvas, 2' 10%" \times 3' 6%" (88 \times 108 cm). Statens Museum for Kunst, Copenhagen.

Mark Fennessey. Insects IV. 1965–1966. Wash, 2' 5" \times 1' 8" (73.6 imes 50.7 cm). Yale University Art Gallery (transfer from the Yale Art School).

Gilbert Li. Social Insecurity. 2001. 7%" × 10%". Design Firm: Up Inc. (Toronto, Canada). Client: Alphabet City, Inc.

CONTRAST OF SCALE

Unexpected or Exaggerated Scale

An artist may purposely use scale to attract our attention in different ways. For example, we notice the unexpected or exaggerated, as when small objects are magnified or large ones are reduced. The wash drawing in A is startling, here seen enlarged to page-filling size. Just the extreme change in scale attracts our attention. The opposite approach is shown in B. Here the purposeful use of the very tiny figures contrasts with a vast space, evoking anxiety.

Pavel Pepperstein employs the same device found in B to satirical effect in his wash drawing titled Landscapes of Future (C). This rendition of monumental images pokes fun at the utopian ideology of an earlier age, which can be seen in "pure" form in an earlier illustration in this book (page 34, B). Elements that really have no inherent scale (a rectangle, a curve . . . these can be any size) are treated here as symbols of monumental importance, really for the sake of showing the humor in that.

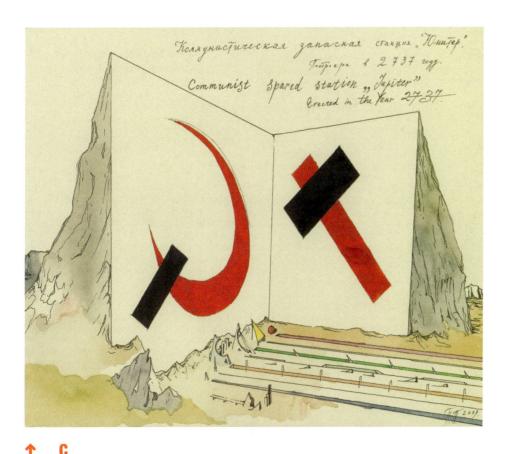

Pavel Pepperstein. *Landscapes of Future.* 2009. Drawings, watercolor, different sizes. Artist's collection, Courtesy of the Multimedia Art Museum, Moscow.

Large and Small Scale Together

Either large or small scale is often employed in painting or design. However, a more common practice is to combine the two for a dramatic contrast. In John Moore's *Blue Stairway* (**D**), a foreground plant is presented in front of a distant building. This juxtaposition results in their similarity of size within the painting and encourages a visual dialogue between these otherwise contrasting forms.

MANIPULATING SCALE AND PROPORTION

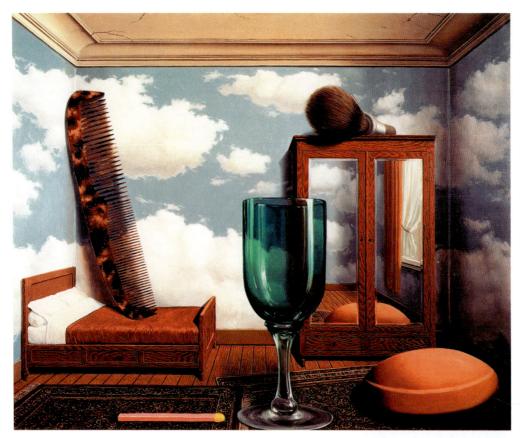

René Magritte. Personal Values (Les Valeurs Personnelles). 1952. Oil on canvas, 2^1 $7\frac{1}{2}^n \times 3^1$ $3\frac{3}{6}^n$ (80.01 \times 100.01 cm).

New York-New York Hotel & Casino. Las Vegas, Nevada.

SURREALISM AND FANTASY

The deliberate changing of natural scale is not unusual in painting. In religious paintings many artists have arbitrarily increased the size of the Christ or Virgin Mary figure to emphasize philosophic and religious importance.

Some artists, however, use scale changes intentionally to intrigue or mystify us rather than to clarify the focal point. **Surrealism** is an art form based on paradox, on images that cannot be explained in rational terms. Artists who work in this manner present the irrational world of the dream or nightmare—recognizable elements in impossible situations. The **enigmatic** painting by Magritte **(A)** challenges the viewer with a confusion of scale. We identify the various elements easily enough, but they are all the wrong size and strange in proportion to each

Charles Ray. Family Romance. 1993. Mixed media, 4' 6" \times 8' \times 2" (137 \times 244 \times 61 cm). Edition of 3. Regen Projects, Los Angeles.

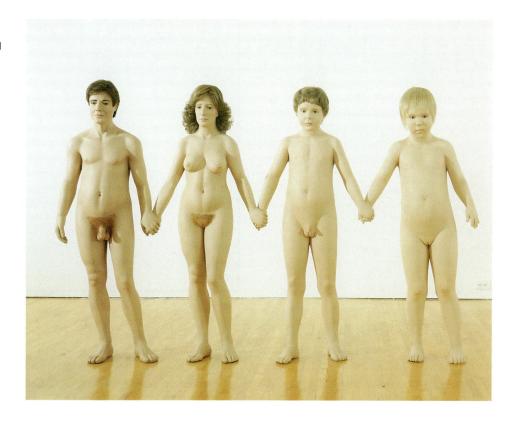

Fernando Botero. *Mona Lisa.* 1977. Oil on canvas, 6' \times 5' 5%" (183 \times 166 cm). © Fernando Botero, courtesy Marlborough Gallery, New York.

other. Does the painting show an impossibly large comb, shaving brush, bar of soap, and other items, or are these normal-size items placed in a dollhouse? Neither explanation makes rational sense.

A scale change can be an element of fantasy like the small door that Alice can't fit through until she shrinks in *Alice in Wonderland*. The city skyline shown in **B** is almost convincing but also more than just a bit "off." In fact, it is the New York-New York Hotel in Las Vegas. The cars in the photograph betray the actual size of this Vegas fantasy.

Charles Ray's Family Romance (C) radically demonstrates the impact of a side-by-side scale change. In this case the adult figures are reduced in scale, and the children are presented at closer to actual scale. This comparison reveals the difference in bodily proportions for adults and children.

A similar manipulation can be observed in Botero's version of *Mona Lisa* **(D)**. The familiarity of this image accounts in part for our reaction to the distortions in proportion. A large head-to-body relationship suggests childlike proportions. However, in this case an iconic image has been inflated like a cheap balloon.

Magritte would say that such artworks provoke a "crisis of the object." They cause us to pause and reconsider how we know things.

A golden rectangle can be created by rotating the diagonal of the half-square.

GEOMETRY AND NOTIONS OF THE IDEAL

Proportion is linked to ratio. That is to say, we judge the proportions of something to be correct if the ratio of one element to another is correct. For example, the ratio of a baby's head to its body is in proportion for an infant but would strike us as out of proportion for an adult. In a life drawing class, you might learn that an adult is about seven and one-half heads tall. Formulas for the ideal figure have at times had the authority of a rule or **canon**. Contemporary art or design seldom seems based on such canons, but you may have noticed the apparent standard of "ten heads tall" in the exaggerated proportions of fashion illustration.

The ancient Greeks desired to discover ideal proportions, and these took the form of mathematical ratios. The Greeks found

the perfect body to be seven heads tall and even idealized the proportions of the parts of the body. In a similar fashion they sought perfect proportions in rectangles employed in architectural design. Among these rectangles the one most often cited as perfect is the **golden rectangle**. Although this is certainly a **subjective** judgment, the golden rectangle has influenced art and design throughout the centuries. The fact that this proportion is found in growth patterns in nature (such as the chambered nautilus shell, plants, and even human anatomy) and lends itself to a modular repetition has given it some authority in the history of design.

George Inness. View of the Tiber near Perugia. 1872–1874. Oil on canvas, 3' $2\%e^u \times 5' 3\%e^u$ (98 \times 161.5 cm). National Gallery of Art, Washington, DC (Ailsa Mellon Bruce Fund).

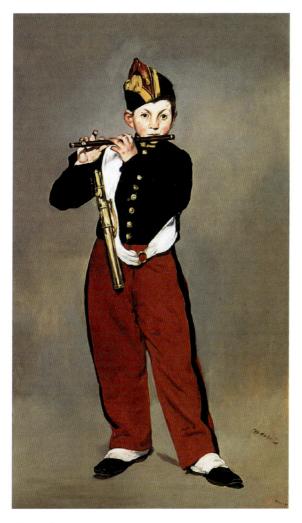

Édouard Manet. *The Fifer.* 1866. Oil on canvas, 5' $3'' \times 3' \times 2\%''$ (160 \times 98 cm). Signed lower right: Manet. Musée d'Orsay, Paris (bequest of Count Isaac de Camondo.

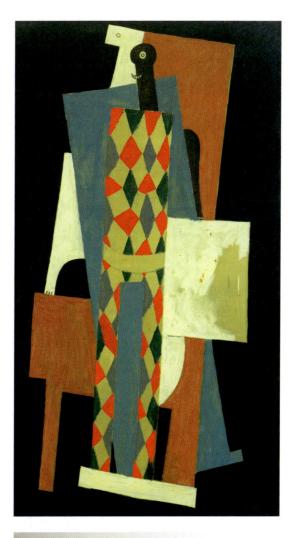

Pablo Picasso. *Harlequin.* Paris, late 1915. Oil on canvas, $6' \%" \times 3' 5\%"$ (183.5 \times 105.1 cm).

Finding the Golden Rectangle

The proportions of the golden rectangle can be expressed in the ratio of the parts to the whole. This ratio (called the ratio of the **golden mean**) is width is to length as length is to length plus width (w:l as l:l + w). This rectangle can be created by rotating the diagonal of a half-square, as shown in $\bf A$. Both the entire rectangle created and the smaller rectangle attached to the original square are golden rectangles in their proportions.

The ratio of the golden mean can be found in the Fibonacci sequence, a counting series where each new number is the sum of the previous two: 1, 1, 2, 3, 5, 8, 13, 21, 34, and so on. The irrational number 21/34 is approximately 0.618 and is represented by the Greek letter F.

In a horizontal orientation the format is classic in landscape painting. In a painting by Inness **(B)**, we can see how the square within the golden rectangle opens up a vista of deep space to the left of the grove of trees.

We see this 3:5 ratio expressed in music (harmonies of thirds, fifths, and octaves), and we find it in growth patterns in nature. With research you can find numerous examples of these proportions in nature, the human body, and design. In art the 3:5 proportion is well suited in a vertical format to the human figure **(C)**. Picasso's abstraction **(D)** relies in part on a vertical rectangle (a "root 3" rectangle: that is a proportion of $1:\sqrt{3}$) to evoke the figure.

ROOT RECTANGLES

Like the golden rectangle, other rectangles are derived from the square. These are called root rectangles and have proportions such as $1:\sqrt{2}$, $1:\sqrt{3}$, and $1:\sqrt{5}$. Exploring the dynamics of these shapes and finding their expression in art and design is interesting.

Rotation of the diagonal of a square produces a $\sqrt{2}$ rectangle. If the square is 1 unit long, for example, the diagonal will be 1.414 or $\sqrt{2}$. Drop this diagonal to create the long side of a new rectangle that is 1:1.414 **(A)**. This is a unique rectangle in that each half of the rectangle is also a $\sqrt{2}$ proportion. In **B** you can see how these two halves create an equal space for the two combatants in *The Duel after the Masquerade*. Each half has the same proportion (but in a vertical orientation) as the whole painting.

Root Five Rectangles

Rotation of the diagonal of the half-square describes a half-circle and creates a new rectangle with a square at the center flanked by two golden rectangles.

This rectangle, a derivative of the golden rectangle, is called a root five $(\sqrt{5})$ rectangle because its proportions are 1: $\sqrt{5}$. This proportion is often observed in the architecture of antiquity such as the façade of the Parthenon. Masaccio's *The Tribute Money* **(C)** exploits the properties of this rectangle in depict-

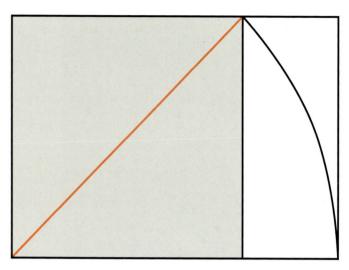

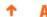

The root 2 rectangle can be created by rotating the diagonal of a square.

ing a three-part narrative with grace and subtlety. In the center area (the square), the tax collector demands the tribute money from Christ, who instructs Peter to get the money from the fish's mouth. On the left Peter kneels to get the money, and on the right he pays the tax collector.

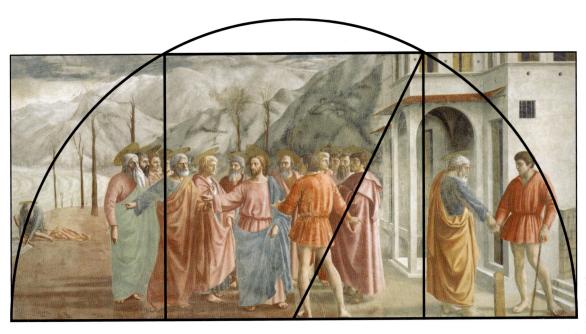

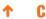

The geometry of root five and golden rectangles divides this three-part painting at significant locations. Masaccio. The Tribute Money. c. 1427. Fresco, 8 $^{\scriptscriptstyle 1}$ 4 $^{\scriptscriptstyle 11}$ \times 19 $^{\scriptscriptstyle 1}$ 8 $^{\scriptscriptstyle 11}$ (2.54 x 5.99 m). Santa Maria del Carmine, Florence, Italy.

Exploring Geometry in Art and Design

The inherent geometry of rectangles such as the golden rectangle and root five rectangle not only provides an agreeable proportion; the diagonals and other interior structural lines often conform to significant features in a composition as is evident in C. These proportions do not provide a formula for design success, however. As with other visual principles, the attributes of the golden mean offer an option for design exploration.

The altered appearance of the "street rod" shown in **D** may seem odd after looking at Masaccio's fresco, and the car was probably not designed with the golden mean in mind. What it does reveal is the power of altered proportions to get our attention and cause us to notice a form. The roofline of this street rod is immediately recognizable as altered in proportion from our expected image of a car. In fact the roof-line bears a striking resemblance to the diagram in C.

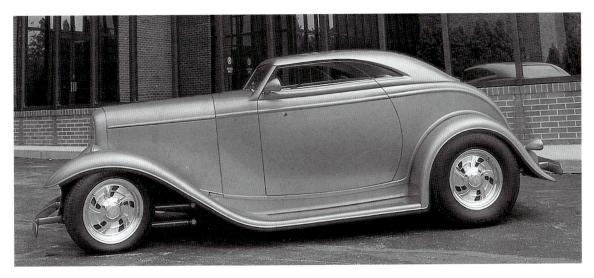

Modified 1932 Ford ("Deuce") Street Rod. Designer: Thom Taylor. Source: Timothy Remus, Ford '32 Deuce Hot Rods and Hiboys: The Classic American Street Rod 1950s-1990s (Motorbooks International Publishers and Wholesalers).

INTRODUCTION 88

IMBALANCE

Horizontal and Vertical Placement 90

SYMMETRICAL BALANCE

Bilateral Symmetry 92

SYMMETRICAL BALANCE

Examples from Various Art Forms 94

ASYMMETRICAL BALANCE

Introduction 96

ASYMMETRICAL BALANCE

Balance by Value and Color 98

ASYMMETRICAL BALANCE

Balance by Texture and Pattern 100

ASYMMETRICAL BALANCE

Balance by Position and Eye Direction 102

ASYMMETRICAL BALANCE

Analysis Summary 104

RADIAL BALANCE

Examples in Nature and Art 106

CRYSTALLOGRAPHIC BALANCE

Allover Pattern 108

INTRODUCTION

Funeral under Umbrellas (A) is a striking picture. What makes it unusual concerns the principle of **balance** or distribution of visual weight within a composition. Here all the figures and visual attention seem concentrated on the right-hand side. The left-hand side is basically empty. The diagonal sweep of the funeral procession is subtly balanced by the driving rain that follows the other diagonal. The effect seems natural and unposed. The result looks like many of the photographs we might see in newspapers or magazines.

← A

Henri Rivière. Funeral under Umbrellas. c. 1895. Etching, $8 \rlap/\!\! 2^n \times 7^n$ (21.5 \times 17.7 cm). Paris, Bibliothèque Nationale de France, Cabinet des Estampes.

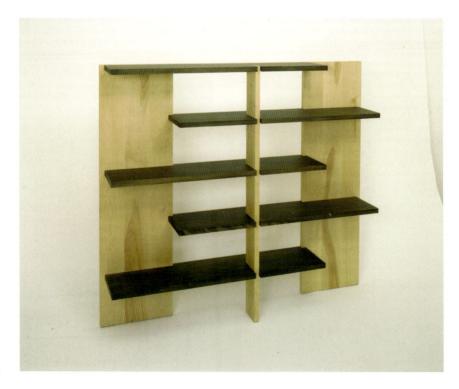

Josef Albers. Bookshelf. 1923. Reproduction by Rupert Deese (1999). Baltic birch, 4' 9%" \times 5' 8%" \times 11%". The Josef and Anni Albers Foundation.

A sense of balance is innate; as children we develop a sense of balance in our bodies and observe balance in the world around us. Lack of balance, or imbalance, disturbs us. We observe momentary imbalance such as bodies engaged in active sports that quickly right themselves or fall. We carefully avoid dangerously leaning trees, rocks, furniture, and ladders. But even where no physical danger is present, as in a design or painting, we still feel more comfortable with a balanced composition. The bookshelf designed by Josef Albers (B) is lively in design as the shelves alternate in their extension left and right. The overall pattern is balanced and lends a sense of stability to the design.

Pictorial Balance

In assessing pictorial balance, we always assume a center vertical axis and usually expect to see some kind of equal weight (visual weight) distribution on either side. This axis functions as the fulcrum on a scale or seesaw, and the two sides should achieve a sense of equilibrium. When this equilibrium is not present, as in C, a certain vague uneasiness or dissatisfaction results. We feel a need to rearrange the elements in the same way that we automatically straighten a tilted picture on the wall. In **D** we can see how a line drawn over the middle of the picture (running through the "eye") reveals the fulcrum of a pendulumlike composition. It is as if the shapes were hung from this point ("the eye") and settled into an equilibrium.

An unbalanced design leaves the viewer with a vague uneasiness.

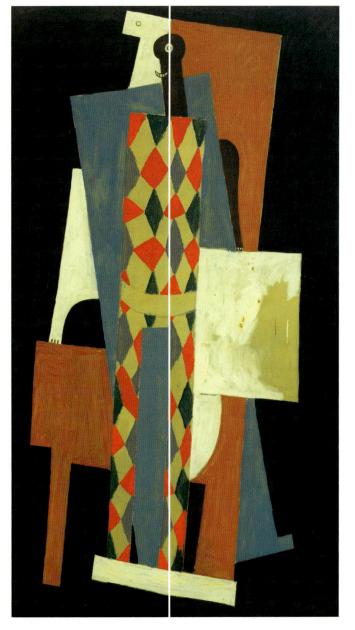

Pablo Picasso. Harlequin. Paris, late 1915. Oil on canvas, 6' $\frac{1}{4}$ " \times 3' 5\%" (183.5 \times 105.1 cm).

HORIZONTAL AND VERTICAL PLACEMENT

Balance—some equal distribution of visual weight—is a universal aim of composition. The vast majority of pictures we see have been consciously balanced by the artist. However, this does not mean there is no place in art for purposeful **imbalance**. An artist may, because of a particular theme or topic, expressly desire that a picture raise uneasy, disquieting responses in the viewer. In this instance imbalance can be a useful tool.

Using Imbalance to Create Tension

Philip Guston's *Transition* (A) is weighted to the right-hand side of the painting. Even the hands of the clock seem to point to the mass of enigmatic forms. The off-balance shift in weight seems in keeping with the title: a body off balance tends to be in transition until balance is reached. This effect is also achieved in **B**, where our attention is focused on the dying figure, and secondarily, our attention turns to the departing figures in a counterpoint to this tension.

In speaking of pictorial balance, we are almost always referring to horizontal balance, the right and left sides of the image.

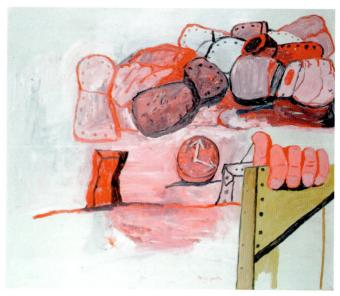

Philip Guston. *Transition.* 1975. Oil on canvas, 5' 6" \times 6' 8½" (167.6 \times 204.5 cm). Smithsonian American Art Museum, Washington, DC. Bequest of Musa Guston.

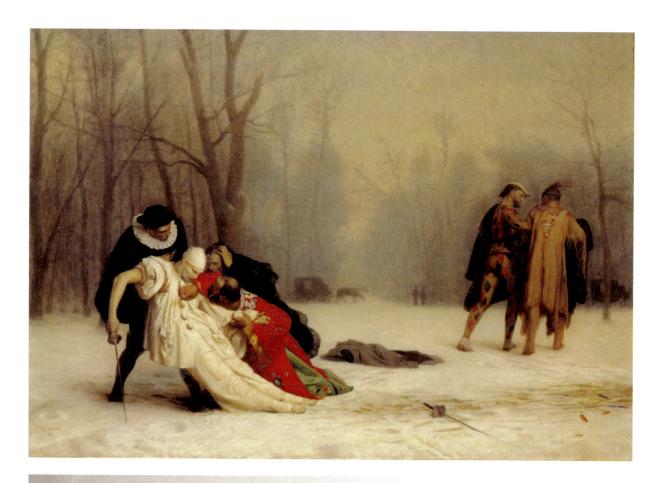

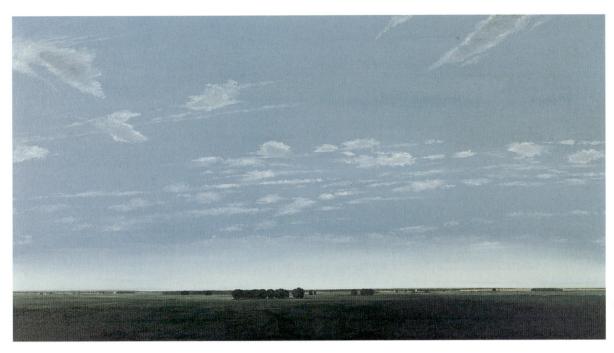

Keith Jacobshagen. *In the Platte River Valley.* 1983. Oil on canvas, 2' 6" × 4' 8½". Sheldon Memorial Art Gallery and Sculpture Garden, University of Nebraska–Lincoln (gift of Wallis, Jaime, Sheri, and Kay in memory of their parents, Joan Farrar Swanson and James Hovland Swanson, 1984.U-3729). Photo: © Sheldon Memorial Art Gallery.

But artists consider vertical balance as well. An imagined horizontal axis divides a work top and bottom. Again, a certain general equilibrium is usually desirable. However, because of our sense of gravity, we are accustomed to seeing more weight toward the bottom, with a resulting stability and calmness. In the landscape painting by Keith Jacobshagen **(C)**, the darkness of the strip of land at the bottom creates this sense of weight. The farther up in the format the main distribution of weight or visual interest occurs, the more unstable and dynamic the image becomes.

The effect of a high center of visual interest can be seen in Guston's *Transition* (A), where the heaviest grouping of shapes is at the top of the painting. In this picture, weight to the right and the top creates the effect of a "transition."

At first glance, **D** appears to be imbalanced with an awkward void in the center and right side of the composition. Our attention is drawn to the graceful white handle depicted on the left and the white lettering in the text at top and bottom. The "empty" area reveals a subtle shadow of the pitcher suggesting that what we see first and most emphatically is not the whole story.

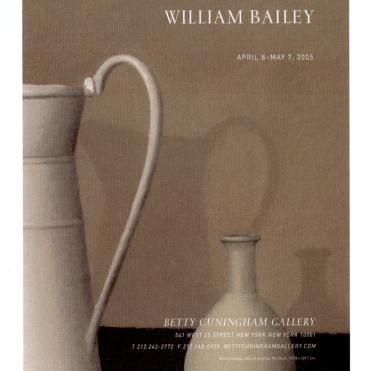

William Bailey. Detail from *TURNING*. 2003. Oil on linen, 5' 10" \times 4' 7" (177.8 \times 139.7 cm). WB10092. Advertisement for Betty Cunningham Gallery. *Art in America*, April 2005.

BILATERAL SYMMETRY

The simplest type of balance, both to create and to recognize, is called *symmetrical balance*. In symmetrical balance, like shapes are repeated in the same positions on either side of a vertical axis. This type of **symmetry** is also called **bilateral symmetry**. One side, in effect, becomes the mirror image of the other side. Symmetrical balance seems to have a basic appeal for us that can be ascribed to the awareness of our bodies' essential symmetry.

Symmetry is high on the list of universally recognized attributes ascribed to beauty. Across cultures, a symmetrical face is perceived as agreeable. This is independent of ethnic or racial characteristics. The photograph of Audrey Hepburn (A) is manipulated in B. Her right side is flipped and replaces her left side (this is apparent in the artificial appearance of her hair). This reveals the near symmetry of her natural features and one reason she was an icon of beauty.

The painting shown in **C** shows a similar facial symmetry ... almost. While the hairstyle is symmetrical, the facial features are regular, and the placement of the figure is centered, there is nonetheless an odd tension to this stiff formal pose. Everything is quite beautiful, and just a bit off. On the one hand this is more natural than a perfect symmetry, but in this case it calls into question the very notion of perfection. The sitter in this portrait is the editor in chief of *Vogue*, a magazine noted for displaying standards of fashion and beauty.

Formal Balance

Conscious symmetrical repetition, while clearly creating perfect balance, can be undeniably **static**, so the term *formal balance* is used to describe the same idea. There is nothing wrong with quiet formality. In fact, this characteristic is often desired in some art, notably in architecture. Countless examples of architecture with symmetrical balance can be found throughout the world, dating from most periods of art history. The continuous popularity of symmetrical design is not hard to understand. The formal quality in symmetry imparts an immediate feeling of permanence, strength, and stability. Such qualities are important in public buildings to suggest the dignity and power of a government. So statehouses, city halls, palaces, courthouses, and other government monuments often exploit the properties of symmetrical balance.

The high altar created by Bernini for St. Peter's **(D)** is situated in perfect symmetry within the architecture of the basilica. Symmetry is often associated with altars and religious artworks where stability and order reinforce enduring values.

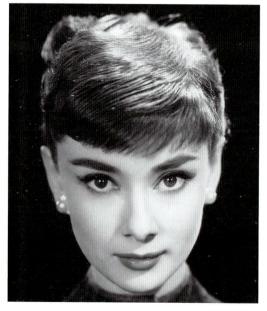

Audrey Hepburn, Cropped.

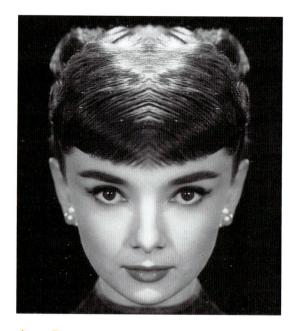

Audrey Hepburn. Symmetry.

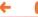

Alex Katz. Anna Wintour, 2009. Art © Alex Katz/Licensed by VAGA, New York, New York. Courtesy Timothy Taylor Gallery.

Symmetry Unifies

The elements of the altar and architecture shown in **D** create an exciting, ornate space. Imagine the effect without symmetrical organization molding the masses of niches, columns, and statuary into a unified and coherent visual pattern. There are undoubtedly countless examples of bilateral symmetry in religious and municipal architecture, and the results range from banal or oppressive, to spectacular and beautiful. Symmetry provides an order but does not guarantee an appreciative human response.

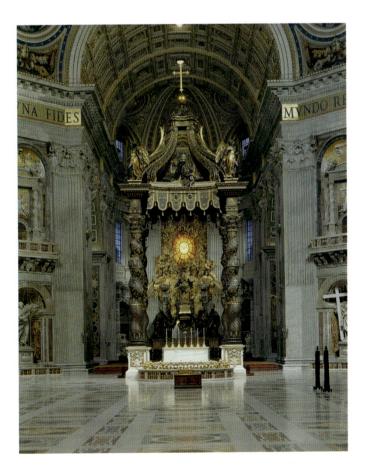

Giovanni Lorenzo Bernini. The Baldacchino, the high altar and the chair of St. Peter. St. Peter's, Vatican, Rome, Italy.

Ed Ruscha. Step on No Pets. 2002. Acrylic on canvas, 5' 4%" \times 6' %". Gagosian Gallery, New York.

EXAMPLES FROM VARIOUS ART FORMS

Symmetrical balance is rarer in painting, photography, or graphic design than in architecture. In fact, relatively few two- or three-dimensional artworks would fit a strict definition of symmetry. When successfully employed, symmetry is used to reinforce the subject, not merely as a crutch for a simple solution.

Symmetry for Emphasis

Symmetry can be found in nature—in the reflected images of a pond, or crystalline structures. However, most images of the landscape reveal a more chaotic world where order emerges in nonlinear patterns like the complexity of a forest or mountain range. An ordered or symmetrical landscape brings to mind formal gardens or an imposition of human intervention. Ed Ruscha turns a mountain landscape (A) into a symmetrical shape like a Rorschach test. Superimposed over this artificial image is a palindrome, the verbal equivalent of bilateral symmetry.

Hiroshi Sugimoto exploits the symmetry of a movie theater to keep the focus on the luminosity of the movie screen **(B)**. This luminosity is achieved by a long exposure while a film is running. The bilateral symmetry reinforces the quiet glow of the image as the interior is subtly illuminated.

Margaret Wharton transforms a wooden chair into a *Mocking Bird* **(C)** through a process of slicing and reassembling. In this case we can, once again, trace the origins of the sculpture's symmetry back to the human figure. The symmetry of the chair derives from the human body for which it is designed. Wharton's cut and reassembled version takes on the winged symmetry of a birdlike form.

Hiroshi Sugimoto. U.A. Play House. 1978.

Margaret Wharton. Mocking Bird. 1981. Partially stained wooden chair, epoxy glue, paint, wooden dowels, 5' \times 5' \times 1' 1" (152 \times 152 \times 33 cm). Courtesy of the artist and Jean Albano Gallery, Chicago.

ASYMMETRICAL BALANCE

INTRODUCTION

The second type of balance is called **asymmetrical balance**. In this case balance is achieved with dissimilar objects that have equal visual weight or equal eye attraction. Remember the children's riddle, "Which weighs more, a pound of feathers or a pound of lead"? Of course, they both weigh a pound, but the amount and mass of each vary radically. This, then, is the essence of asymmetrical balance.

Informal Balance

In Nan Goldin's photograph **(A)** the figure gazes out at us from the right side of the picture. But the composition is not off balance. Left of center are the hand and cigarette, which balance the face as a natural point of interest. Balance is maintained as the two sides of the picture each provide a visual emphasis.

Nan Goldin. Siobhan with a Cigarette. Berlin. 1994. Photograph.

Goldin's photograph shows one advantage of asymmetrical balance: the feeling is more casual than that of a formal symmetrical portrait. Another term for asymmetrical balance is, appropriately, **informal balance**. The human face is a strong target for our attention. Presented in absolute symmetry, the result can be a static or boring portrait. Goldin's use of a more informal balance is in keeping with the delicate sense of balance in the lives of real people.

Symmetry can appear artificial, as our visual experiences in life are rarely symmetrically arranged. Some buildings and interiors are so designed, but even here, unless we stand quietly at dead center, our views are always asymmetrical.

Carefully Planning Asymmetry

Asymmetry appears casual and less planned, although obviously this characteristic is misleading. Asymmetrical balance is actually more intricate and complicated to use than symmetrical balance. Merely repeating similar elements in a mirror image on either side of the center is not a difficult design task. But attempting to balance dissimilar items involves more complex considerations and more subtle factors.

The sculpture by Ham Steinbach **(B)** shows how two can balance three in an asymmetric arrangement. Two black pitchers sit on a red shelf adjacent to three red Bold 3 detergent boxes on a black shelf. This asymmetric pairing invites us to find the visual rhymes and contrasts that exist across the dividing line. The visual interest in comparing the unequal sides results in a balanced composition, and the number of elements feels correct.

Careful planning takes on a different level of significance in the engineering and design of a bridge where function and safety are paramount. The expressive asymmetry of Calatrava's bridge **(C)** confounds our usual expectation of stability, and the result is a dynamic, unforgettable design.

ASYMMETRICAL BALANCE

BALANCE BY VALUE AND COLOR

Value

Asymmetrical balance is based on equal eye attraction—dissimilar objects are equally interesting to the eye. One element that attracts our attention is **value** difference, a contrast of light and dark. As **A** illustrates, black against white gives a stronger contrast than gray against white; therefore, a smaller amount of black is needed to visually balance a larger amount of gray.

The photograph of the cathedral at York **(B)** reverses the values but shows the same balance technique. The left side of the composition shows many details of the angled wall of the church nave. However, the receding arches, piers, columns, and so on are shown in subtle gradations of gray, all very close and related in value. In contrast, on the right side is the large black **silhouette** of a foreground column and the small window area

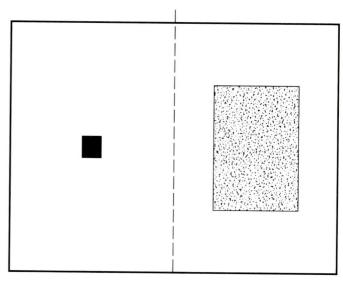

A darker, smaller element is visually equal to a lighter, larger one.

Frederic H. Evans. York Minister, Into the South Transept. 1900. Platinum print, 8% \times 4% (20.9 \times 12.1 cm). The Metropolitan Museum of Art, Alfred Stieglitz Collection, 1933.

Kristian Russell, Art Department. 1998.

of bright white. These two sharp visual accents of white and black balance the many essentially gray elements on the left.

Color

The illustration in **C** suggests motion as the figure exits the left side of the composition. The design is quite abstract and breaks into jigsaw puzzle-like shapes. This dynamic arrangement is countered by the bold expanse of yellow that dominates the right half of the image.

Mary Cassatt's painting **(D)** balances the value of the striking white blouse with a vivid red cape. This shows how value and color are both powerful in creating emphasis and balance in a composition. Balance by value or color is a great tool, allowing a large difference of shapes on either side of the center axis and still achieving equal eye attraction.

See also Color and Balance, page 274, and Ways to Suggest Motion, pages 234, 236, and 238.

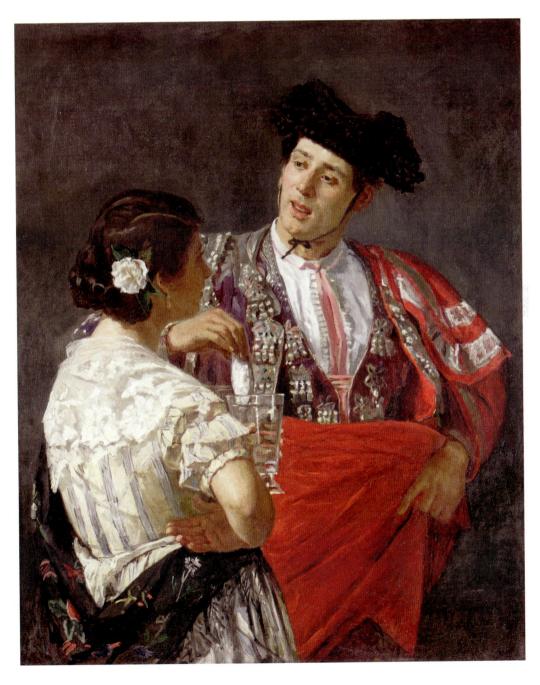

Mary Stevenson Cassatt. Offering the Panale to the Bullfighter. 1873. Oil on canvas, 100.6 \times 85.1 cm. 1955.1. Sterling and Francine Clark Art Institute.

ASYMMETRICAL BALANCE

BALANCE BY TEXTURE AND PATTERN

The diagram in **A** illustrates balance by shape. Here the two elements are exactly the same value and texture. The only difference is their shape. The smaller form attracts the eye because of its more complicated contours. Though small, it is more interesting than the much larger, but duller, rectangle.

Texture Adds Interest

Any visual **texture** with a variegated dark and light pattern holds more interest for the eye than does a smooth, unrelieved surface. The drawing in **B** presents this idea: the smaller, roughtextured area balances the larger, basically untextured area (smoothness is, in a sense, a texture).

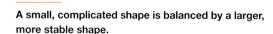

A small, textured shape can balance a larger, untextured one.

Using Texture and Pattern for Balance

The balance of the elements in the Japanese woodcut (C) shows how a large, simple form can be balanced by an intricate pattern or texture. The large, simple triangular mass of the mountain is positioned to the right. The left side is balanced by the pattern of clouds and sky and by a texture that suggests a forest of trees. Pattern and texture balance the strength of the large red moun-

The still-life painting by Henri Fantin-Latour (D) offers a surprising composition. A pitcher sits on top of a broad expanse of white linen, and this focal point is balanced by the intricate pattern of foliage on the right.

Texture in Commercial Design

Printed text consisting of letters and words in effect creates a visual texture. The information is in symbols that we can read, but the visual effect is nothing more than a gray-patterned shape. Depending on the typeface and the layout, this gray area varies in darkness, density, and character, but it is visually textured. Very often in advertisements or editorial page layouts, an area of "textured" printed matter will balance photographs or graphics. The pages of this text are similarly composed.

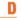

BALANCE BY POSITION AND EYE DIRECTION

A well-known principle in physics says that two items of unequal weight can be brought to equilibrium by moving the heavier inward toward the fulcrum. In design this means that a large item placed closer to the center can be balanced by a smaller item placed out toward the edge. The two seesaw diagrams in **A** illustrate this idea of balance by position.

Achieving Casual Balance

Balance by position often lends an unusual, unexpected quality to the composition. The effect not only appears casual and unplanned but also can make the composition seem, at first glance, to be in imbalance. This casual impression is evident in the illustration by Aubrey Beardsley (B). The three "garçons" are grouped in the left-hand portion of the composition. Notice how much of these figures is actually the white aprons, which lighten the weight of the figure grouping. Two tables, one stacked with plates, on the right-hand edge of the picture provide sufficient balancing lines and shapes to this informal group.

Connecting the Eyes

At first glance, the Annunciation fresco by Fra Angelico **(C)** seems heavily weighted to the left side of the composition. The angel has prominent wings with bright color and darker values. The figure of Mary, on the other hand, is pale, almost dissolving into the background. This imbalance is offset by subtle eye direction. We connect the figures through the line of their gaze and the arches sweeping across the top of the painting.

Although not usually the only technique of balance employed by artists, eye direction is a commonly used device. Eye direction is carefully plotted, not only for balance but also for general compositional unity.

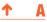

A large shape placed near the middle of a design can be balanced by a smaller shape placed toward the outer edge.

Aubrey Beardsley. Garçons de Café. 1894. Line block drawing originally published in *The Yellow Book*, vol. II, July.

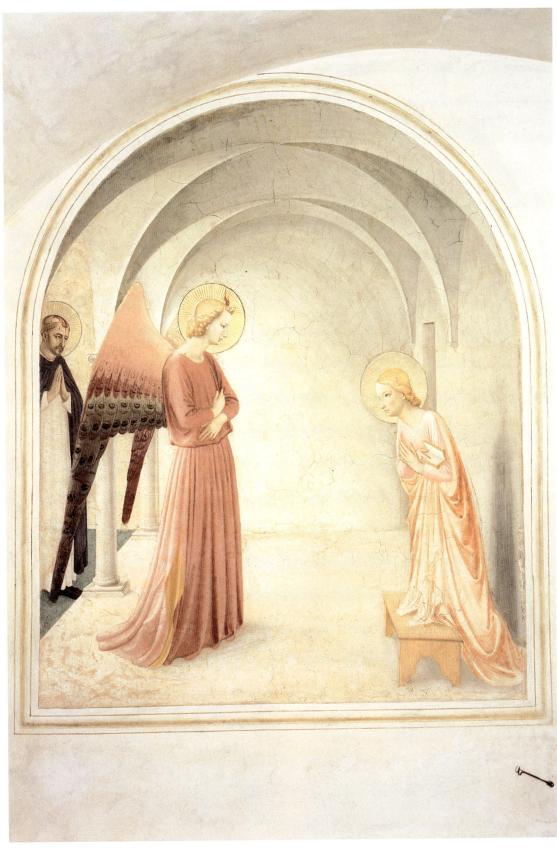

Fra Angelico. *The Annunciation.* 1442. Fresco, 6' $11/2'' \times 5'$ 13/4'' (187 \times 157 cm). Museo di San Marco dell'Angelico. Florence, Italy/The Bridgeman Art Library.

ASYMMETRICAL BALANCE

ANALYSIS SUMMARY

In looking at works of art, you will realize that isolating one technique of asymmetrical balance as we have done is a bit misleading because the vast majority of works employ several of the methods simultaneously. For the sake of clarity, we discuss these methods separately, but the principles often overlap and are frequently used together. Let us look at just a few examples that use several of the factors involved in asymmetrical balance.

Symmetrical and Asymmetrical Balance

MODULE

Awareness of Asymmetry

Van Gogh's Portrait of Dr. Gachet (Man with a Pipe) (A) shows a marked asymmetry and a pronounced slant running along the diagonal from upper left to lower right. This is a print, so the image is reversed. The original drawing on the etching plate would have slanted in the opposite direction. Such a slant or drag is often an indication as to whether the artist is right- or left-handed (a slant to the right indicating a right-handed artist). When working on a portrait (or any composition for that matter), it can be useful to hold the image to a mirror to see the image reversed. This can reveal a tilted bias to the composition that is otherwise "invisible" to your eye.

Vincent van Gogh. Portrait of Dr. Gachet (Man with a Pipe). May 15, 1890. Etching, plate: 7% " \times 51% "(18.1 \times 15.1 cm). Gift of Abby Aldrich Rockefeller. The Museum of Modern Art, New York.

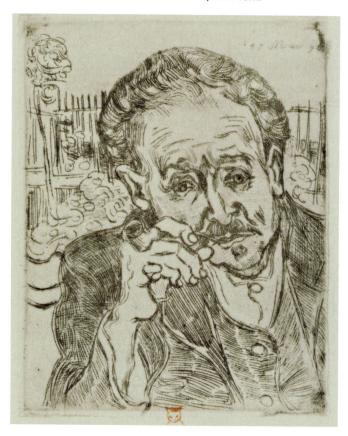

Caravaggio (Michelangelo Merisi da). The Inspiration of Saint Matthew. 1600–1602. Oil on canvas, 9' 7" \times 6' 1" (292 cm x 186 cm). San Luigi dei Francesi, Rome.

Dynamic Combinations of Elements

Caravaggio's *The Calling of St. Matthew* **(B)** presents an example of dynamic asymmetry. The focus is on St. Matthew's face on the left side of the painting in an apparently radical imbalance. The activity is unfurled in a reverse "S" curve, which provides a path for the eye to follow. The almost abstract white and red support a precarious balance between above and below in the composition. The painting depicts a moment of an epiphany for St. Matthew, which is best expressed by a composition that is not in repose or strict balance. In fact, the stool his knee rests on tips precariously as if about to tumble.

Garry Winogrand's photograph **(C)** appears to be essentially symmetrical with elements balanced to the left and right of the center. In fact, it is the asymmetrical aspects of the composition that keep us engaged:

The white car on the left blends into the light sand, while the blue picnic stand on the right echoes the sky.

The open door and figure on the left balance two figures on the right.

The clouds are distributed equally left and right, but the shapes vary.

The Winogrand photograph seems remarkably symmetrical for an unposed, spontaneous moment. The picture is, in fact, a play between the asymmetrical balance of lively casual elements and a symmetry that evokes a staged or artificial quality.

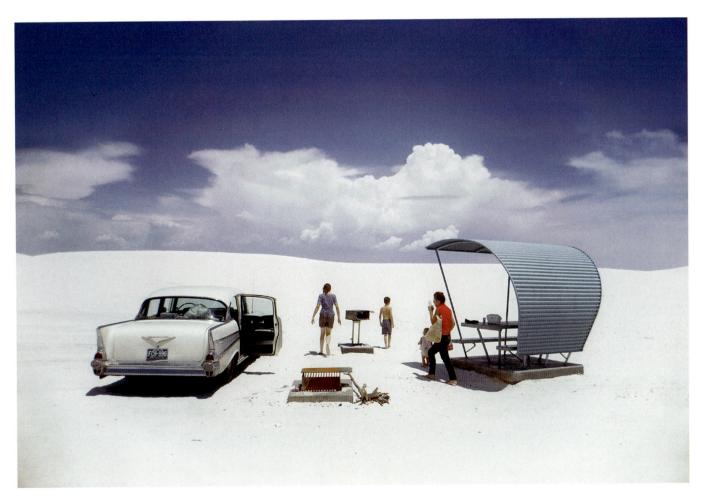

EXAMPLES IN NATURE AND ART

A third variety of balance is called **radial balance**. Here all the elements radiate or circle out from a common central point. The sun with its emanating rays is a familiar symbol that expresses the basic idea. Radial balance is not entirely distinct from symmetrical or asymmetrical balance. It is merely a refinement of one or the other, depending on whether the focus occurs in the middle or off center.

Radial patterns are abundant in the natural world. The form of the flower shown in **A** is a visual expression of its growth outward from the stem. Each small floret echoes this pattern. This

same pattern is seen in Josiah McElheny's sculpture **(B)**, which is modeled on what physicists understand about a certain stage of the big bang.

Circular forms abound in craft areas, where the round shapes of ceramics, basketry, and jewelry often make radial balance a natural choice in decorating such objects. Radial balance can be found in the playful design based on a bicycle wheel in **C**. This whirligig, fashioned from a wheel and funnels to catch the wind, exemplifies a rotational structure also seen in the weather patterns of a hurricane or the vortex of water in a whirlpool.

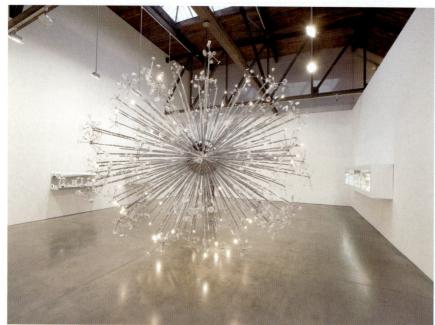

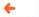

Josiah McElheny. An End to Modernity. 2005. Chrome-plated aluminum, electric lighting, handblown glass, 12' \times 15' \times 15'. Courtesy Donald Yound Gallery, Chicago, and Andrea Rosen Gallery, New York.

Cultural Symbols

Radial balance has been used frequently in architecture. The round form of domed buildings such as the Roman Pantheon or our nation's Capitol will almost automatically give a radial feeling to the interior. Such a design has a symbolic function of giving emphasis to the center as a place of cultural significance. Many cultures employ radial balance as part of their spiritual imagery and designs. These range from Tibetan **mandalas** to the rose windows of Gothic cathedrals. The advantage of such a design is the clear emphasis on the center and the unity that this form of design suggests.

The pull of a radial design even extends to urban planning. The Piazza del Popolo ("literally the plaza of the people") in Rome (D) is a center of activity in the city. Streets radiate from the piazza, and a monument at the center is visible from a distance. Such nodes of emphasis give order to a large city.

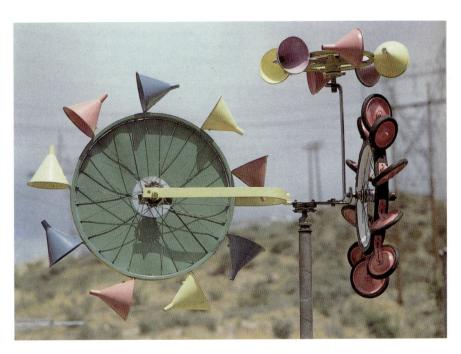

Anonymous. "Whirligig."

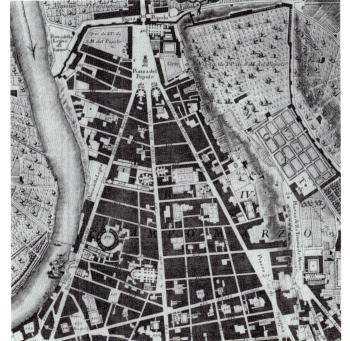

CRYSTALLOGRAPHIC BALANCE

ALLOVER PATTERN

One more specific type of visual effect is often designated as a fourth variety of balance. The examples here illustrate the idea. These works all exhibit an equal emphasis over the whole format—the same weight or eye attraction literally everywhere.

This technique is officially called **crystallographic bal- ance**. Because few people can remember this term—and even fewer can spell it—the more common name is **allover pattern**. This technique is, of course, a rather special refinement of symmetrical balance. The constant repetition of the same quality everywhere on the surface, however, creates an impression truly different from our usual concept of symmetrical balance.

Allover Pattern in Art and Design

In the Signature Quilt (A), emphasis is uniform throughout. The many blocks are the same size, with each defined in the same degree of contrast to the black background. Each signature on each block is accorded the same value, whether that of a president (Lincoln, for example) or a lesser-known individual. There is no beginning, no end, and no focal point—unless, indeed, the whole quilt is the focal point.

An allover pattern may suggest the geometry of a quilt, but the same effect can be achieved with a more irregular structure such as a map. A map may lead us to look for a point of emphasis such as a major city; however, Jasper Johns's map **(B)** has no such emphasis. Shattered patches of color are distributed in similar amounts and defy most boundaries of the map. The result is more raucous than **A** but similarly suggests that the whole composition is the focus.

The wall of photographs shown in **C** is intended for quiet reflection or contemplation. Here are photos of many of the predominantly Jewish residents of an eastern European town. The Jewish community was eliminated by the Nazis, and this wall gives testimony to the loss with each individual having an equal place of commemoration. A balance is present between the unique nature of each photograph and frame, emphasizing the loss of distinct individuals, and the whole collection, which gives some sense of the larger community.

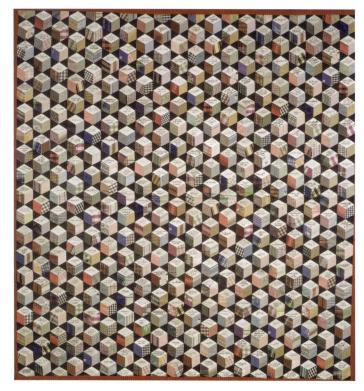

Adeline Harris Sears. Signature Quilt. 1856–1863. Silk with inked signatures, 6¹ 5" \times 6¹ 8" (195.6 \times 203.2 cm). The Metropolitan Museum of Art, purchase, William Cullen Bryant Fellow Gifts, 1996.

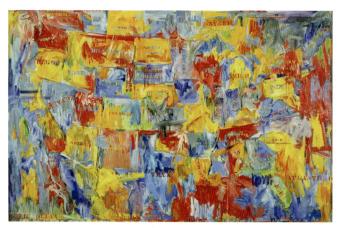

Jasper Johns. *Map.* 1961. Oil on canvas, 6' 6" \times 10' 3%" (198.2 \times 314.7 cm). Gift of Mr. and Mrs. Robert C. Scull. The Museum of Modern Art, New York. Art © Jasper Johns/licensed by VAGA, New York, New York. Digital Image © The Museum of Modern Art/Licensed by SCALA/Art Resource, New York.

Ralph Appelbaum. Hallway in the United States Holocaust/Memorial Museum, Washington, DC.

Frankly, Martha, NO!! It does NOT make me feel like dancing! David Lauer. **INTRODUCTION**

Engaging the Senses 112

INTRODUCTION

Visual Rhythm 114

RHYTHM AND MOTION

Shapes and Repetition 116

ALTERNATING RHYTHM

Patterns and Sequence 118

PROGRESSIVE RHYTHM

Converging Patterns 120

POLYRHYTHMIC STRUCTURES

A Study in Contrast 122

ENGAGING THE SENSES

Rhythmic structures in visual art and design are often described (as they have been here) in terms borrowed from music vocabulary. The connection between visual rhythms and musical rhythms can be more than a simile or metaphor. In some cases the visual rhythms composed by an artist seem to resonate with memories or associations in our other senses. When a visual experience actually stimulates one of our other senses, the effect is called **kinesthetic empathy**.

Evoking Sight, Sound, and Touch

Charles Burchfield's painting **(A)** is, on one level, a depiction of the roofline of a building set among trees and plants. This description does not tell us the subject of *The Insect Chorus*, however. A description of the painting's many rhythmic patterns would come closer to explaining the title. Repeated curves, zigzags, and straight linear elements throughout the picture literally buzz and create the sensation of a hot summer afternoon alive with the sound of cicadas. Even the sensation of heat is evoked by the rhythm of wavering lines above the rooftop.

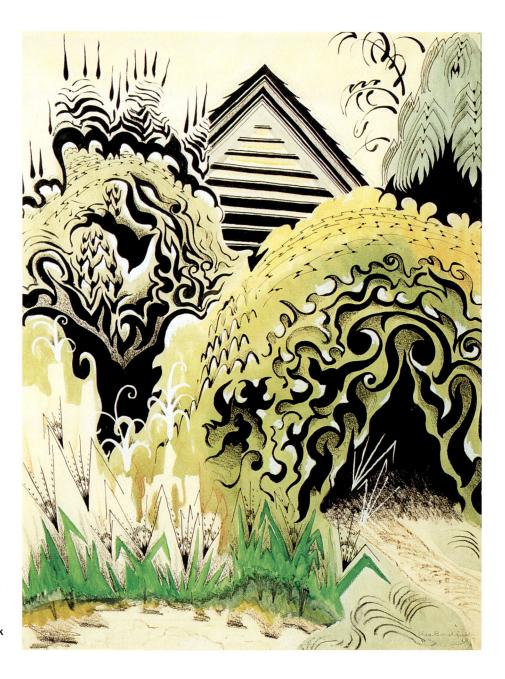

Charles Burchfield. The Insect Chorus. 1917. Opaque and transparent watercolor with ink and crayon on paper, 1' 7%" \times 1' 3%" (50 \times 40 cm). Munson-Williams-Proctor Institute. Museum of Art, Utica, New York (Edward W. Root Bequest).

SHAPES AND REPETITION

We may speak of the rhythmic repetition of colors or textures, but most often we think of rhythm in the context of shapes and their arrangement. In music, some rhythms are called **legato**, or connecting and flowing. The same word could easily be applied to the visual effect in **A**. The photograph of Death Valley shows the sand dune ridges in undulating, flowing, horizontal curves. The dark and light contrast is quite dramatic, but in several places the changes are soft with smooth transitions. The feeling is relaxed and calm.

A similar rhythm occurs in the sixteenth-century illuminated manuscript by Hoefnagel **(B)**. Here the rhythm is faster with more repetitions and more regularity or consistency in the repeated curves. The fluid strokes carry our eye across the text and mark both the beginning and end of the passage with a flourish.

Manipulating Rhythm

If the rhythm of **B** conjures up a baroque fugue, then the poster shown in **C** is well suited to conveying a jittery jazz rift. But, of course, not all jazz can be summarized on one such pattern, and so, **D** expresses another kind of jazz rhythm, perhaps more synthetic in expression. Niklaus Troxler has done many jazz posters, and the variety is remarkable: each has a unique rhythm.

The rhythms of **C** and **D** are indeed different, but the two examples are also alike in that the rhythm initially established is then consistent and regular throughout the composition. This regularity is not present in Alan Crockett's painting *Doodle de Do* **(E)**; however, even the title suggests a playful rhythm. Elements repeat, but in less-predictable ways and always with some variation. This painting is not an illustration for a jazz poster like the previous two, but an analogy can still be made to the dynamic but often unsettling rhythms of improvised jazz.

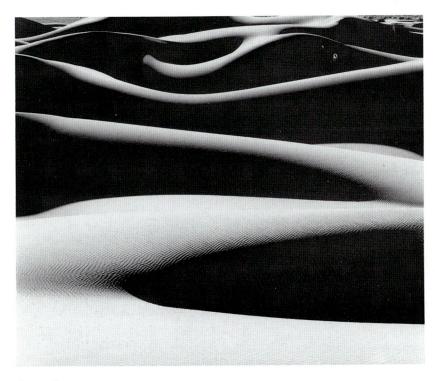

Bruce Barnbaum. Dune Ridges at Sunrise, Death Valley. 1976. Silver gelatin print, $10\%''\times1'$ 1¼" (27.3 \times 33.6 cm). Courtesy of the photographer.

Joris Hoefnagel (illuminator) and Georg Bocskay (scribe). Dianthis and Almond from Mira Calligraphiae Monumenta (Model Book of Calligraphy), folio 21r. 1561–1562. Pen and ink, watercolors on vellum and paper, $6\% 6^{\circ} \times 4^{13} \% (16.6 \times 12.3 \text{ cm})$. The J. Paul Getty Museum, Los Angeles.

Not only **nonobjective** shapes are capable of producing an undulating rhythm. A similar effect is present in the photograph shown in **B**. Here tree trunks produce a sinuous rhythm, but one that is a bit more awkward or "herky-jerky" than that in A.

The chair shown in C offers a contrast to A and B. The chair design has a crisp rhythm in the repetition of vertical slats. The squares formed by crossing horizontals create a rhythmic pattern as well. This second rhythm gains emphasis toward the top of the chair. The curve of the chair's back subtly alters these patterns. In this case a few simple design elements work together to make a dramatic, more complex rhythm.

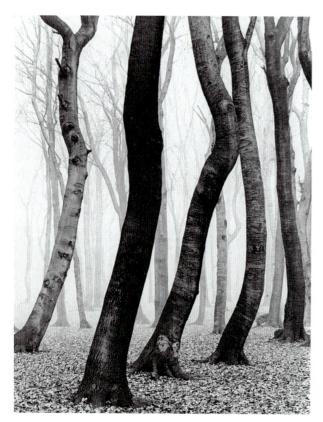

Albert Renger-Patzsch. Buchenwald in Herbst (Beech Forest in *Autumn).* 1936. Silver gelatin print, 8% (22.2 \times 16.2 cm). The Metropolitan Museum of Art, Warner Communications, Inc., purchase fund, 1980.

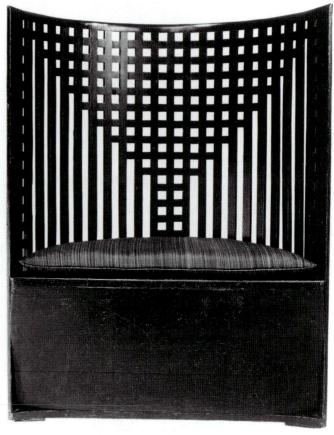

Charles Rennie Mackintosh. Chair. 1904. Ebonized oak, reupholstered with horsehair, 3' 10% " \times 3' $1" \times 1'$ 4%" (118 \times 94 \times 42 cm). Collection of Glasgow School of Art, Glasgow.

VISUAL RHYTHM

Rhythm as a design principle is based on repetition. Repetition, as an element of visual unity, is exhibited in some manner by almost every work of art. However, rhythm involves a clear repetition of elements that are the same or only slightly modified.

In conversation we might refer to Bridget Riley's painting (A) as having a rhythmic feeling. This might seem a strange adjective to use because **rhythm** is a term we most often associate with the sense of hearing. Without words, music can intrigue

us by its pulsating beat, inducing us to tap a foot or perhaps dance. Poetry often has meter, which is a term for measurable rhythm. The pace of words can establish a cadence, a repetitive flow of syllables that makes reading poems aloud a pleasure. But rhythm can also be a visual sensation. We commonly speak of rhythm when watching the movement displayed by athletes, dancers, or some workers performing manual tasks. In a similar way the quality of rhythm can be applied to the visual arts, in which it is again basically related to movement. Here the concept refers to the movement of the viewer's eye, a movement across recurrent motifs providing the repetition inherent in the idea of rhythm.

The painting in **A** has this feeling of repetition in the curved vertical stripes that vary from thick to thin. The contrasts of color enhance the sense of undulation. The senses of sight and hearing are indeed so closely allied that we often relate them by interchanging adjectives (such as "vibrating" colors). Certainly this relationship is shown in Riley's visual rhythm.

Bridget Riley. Series 35. Olive Added to Red and Blue, Violet and Green, Single Reversed Diagonal. 1979. Gouache on paper, $3' 2\%'' \times 2' \%''$.

The drawing shown in **B** attempts to convey the sensation of "metallic" sounds. This early experiment in Russian **Suprematism** from 1915 reflects the interest in industrial subjects of that era. The jumpy arrangement of shapes, almost lacking in any rhythmic pattern, seems to echo the harsh, dynamic sounds of a factory.

A second drawing by Malevich **(C)** is titled *Sensation of Movement and Resistance*. In this case our physical experiences of moving through the world are simulated. The drawing appeals to our sense of touch and "muscle memory" by repeating horizontal lines of varying weight along a curved path. The rhythmic interruption of the heavier, darker rectangles offers the "resistance" referred to in the title.

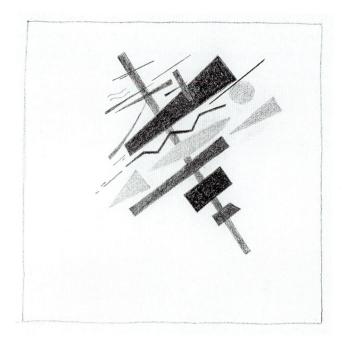

Kasimir Malevich. Suprematist Composition: Sensation of Metallic Sounds. 1916–1918. Crayon on paper, $8" \times 6\%"$ (20.9 \times 16.4 cm). Kupferstichkabinett, Oeffentliche Kunstsammlung Basel.

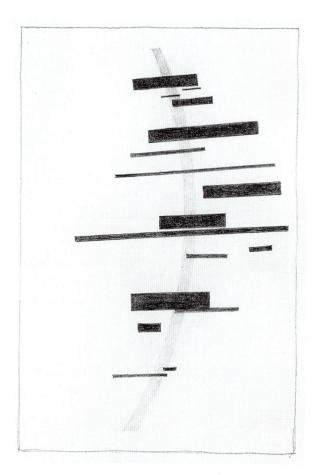

Kasimir Malevich. Suprematist Composition: Sensation of Movement and Resistance. Crayon on paper, $10\%"\times 8"$ (26.5 x 20.5 cm). Kupferstichkabinett, Oeffentliche Kunstsammlung Basel.

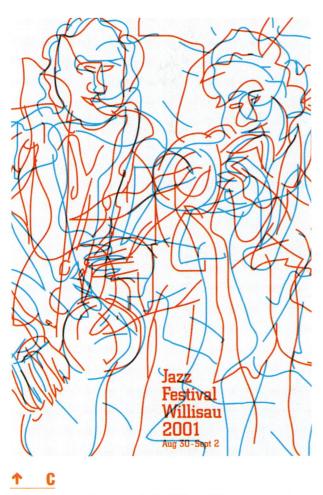

Niklaus Troxler. Poster: Jazz Festival Willisau. 2001.

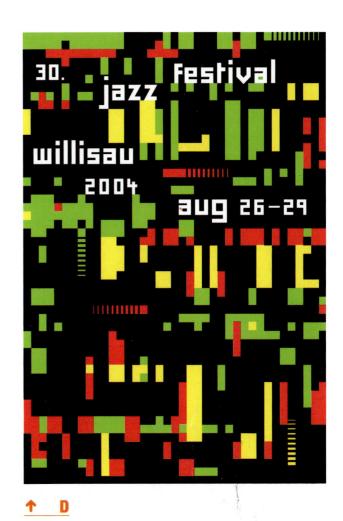

Niklaus Troxler. Poster: Jazz Festival Willsau. 2004.

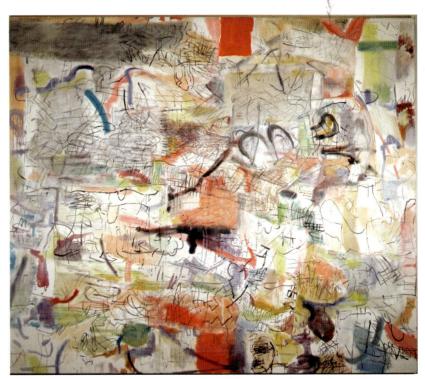

PATTERNS AND SEQUENCE

Rhythm is a basic characteristic of nature. The pattern of the seasons, of day and night, of the tides, and even of the movements of the planets, all exhibit a regular rhythm. This rhythm consists of successive patterns in which the same elements reappear in a regular order. In a design or painting, this would be termed an **alternating rhythm**, as motifs alternate consistently with one another to produce a regular (and anticipated) sequence. This predictable quality of the pattern is necessary, for unless the repetition is fairly obvious, the whole idea of visual rhythm becomes obscure.

The pattern in Edna Andrade's *Interchange* (A) produces a bouncy alternating rhythm. Our eye flips back and forth due to the **vibrating colors** and alternating direction of diagonal lines and circles. A musical term for the "bouncing bow" applied to the violin is *spiccato*. If Troxler's poster (D on page 117) is staccato, then Andrade's is spiccato.

We can see a familiar example of alternating rhythm in a building with columns, such as a Greek temple. The repeating pattern of light columns against darker negative spaces is clearly an alternating rhythm. Architectural critics often speak of the rhythmic placement of windows on a facade. The light and dark areas alternate consistently along the top band of the brick cornice shown in **B**. The lowest decorative band presents an alternating rhythm of X and O blocks. Alternating rhythms and rhythmic variety can relieve the large surface of predictable patterns such as a brick wall.

Notice that exactly the same description of alternating themes could be used for the painting in **C**. The artist, Robert Delaunay, titled this work, appropriately, *Rhythm without End*.

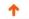

Brick cornice. Published in James Stokoe, *Decorative and Ornamental Brickwork* (New York: Dover Publications, 1982).

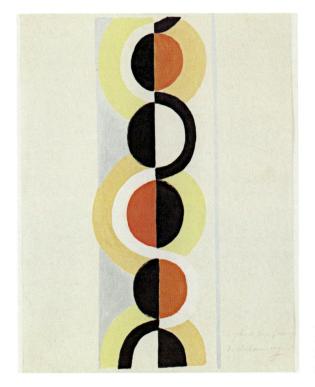

Robert Delaunay. "Rhythme sans fin" (Rhythm without End). 1934. Gouache, brush and ink, on paper, 10½" \times 8½" (27 \times 21 cm). The Museum of Modern Art, New York (given anonymously).

CONVERGING PATTERNS

Another type of rhythm is called progression, or **progressive rhythm**. Again, the rhythm involves repetition, but repetition of a shape that changes in a regular manner. There is a feeling of a sequential pattern. This type of rhythm is most often achieved with a progressive variation of the size of a shape, though its color, value, or texture could be the varying element. Progressive rhythm is extremely familiar to us; we experience it daily when we look at buildings from an angle. The perspective changes the horizontals and verticals into a converging pattern that creates a regular sequence of shapes gradually diminishing in size.

Inherent Rhythm

In **A** the rhythmic sequence of lines moving vertically across the format is immediately obvious. A more subtle progressive rhythm appears when we notice the dark shapes of the oil stains in the parking spaces. These change in size, becoming progressively smaller farther away from the building. In this photograph from an aerial vantage point, a rhythm is revealed in the ordinary pattern of human habits.

Progressive rhythms are rather commonplace in nature, although they may not always be readily apparent. Edward Weston's extreme close-up of an artichoke cut in half **(B)** shows a growth pattern. The gradual increase in size and weight creates a visual movement upward and outward. Other natural forms (such as chambered nautilus shells) cut in cross section would also reveal progressive rhythms.

The photographs in **A** and **B** are quite different, yet they both make visible progressive rhythms from the world around us, whether in the pattern of human activity or in natural forms. It is not surprising, then, that we should sense a growth-like pattern in the abstract sculpture by Louise Bourgeois **(C)**. This piece is more architectural than organic in its individual parts, yet the progression upward and outward from smaller to larger forms is similar to **B**.

Ed Ruscha. Goodyear Tires, 6610 Laurel Canyon, North Hollywood. 1967. Photograph, 81/4" \times 31/6" (21 \times 10 cm). From the book *Thirty-Four Parking Lots in Los Angeles* (1974), published by the author.

Edward Weston. *Artichoke, Halved.* 1930. Silver gelatin print, $7\frac{1}{2}$ " \times 9½" (19 \times 24.1 cm). 1981. Center for Creative Photography, Arizona Board of Regents.

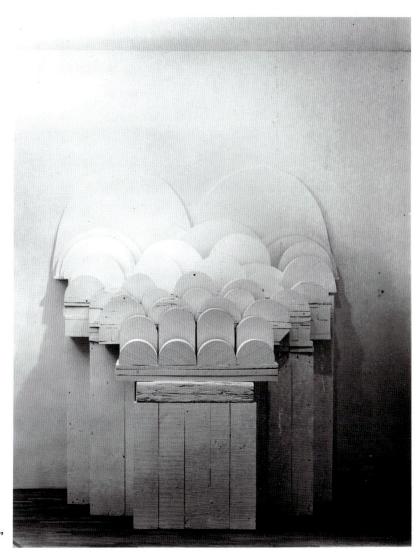

Louise Bourgeois. Partial Recall. 1979. Wood, 9' \times 7' 6" \times 5' 6" (274.3 \times 228.5 \times 167.6 cm). Private collection. Art © Louise Bourgeois/Licensed by VAGA, New York, New York/Photo © Peter Moore.

POLYRHYTHMIC STRUCTURES

A STUDY IN CONTRAST

The most complex rhythmic structure we can ascribe to an artwork, or musical piece for that matter, is a **polyrhythmic structure**. This overlay of perhaps several rhythmic patterns produces a complex result, even if the parts are simple.

The painting by Gérôme (A) shows just such a juxtaposition of different rhythms. The foreground is loud and simple at the left: one strong beat (the cluster of figures), that is then repeated in a diminishing volume with the two figures on the right. The background presents a much softer, subtle rhythm: the quiet beat of the trees on the left, fading to a muffled tone on the right. This background rhythm is like supporting orchestration behind a duet of voices.

The painting by Picasso **(B)** presents a contrast between the regular motif of the harlequin pattern and a more irregular repetition of brown, black, and white in the other planes of this collage-like composition. The contrast in rhythm provides a visual contest between dueling parts . . . more like an argument than a duet.

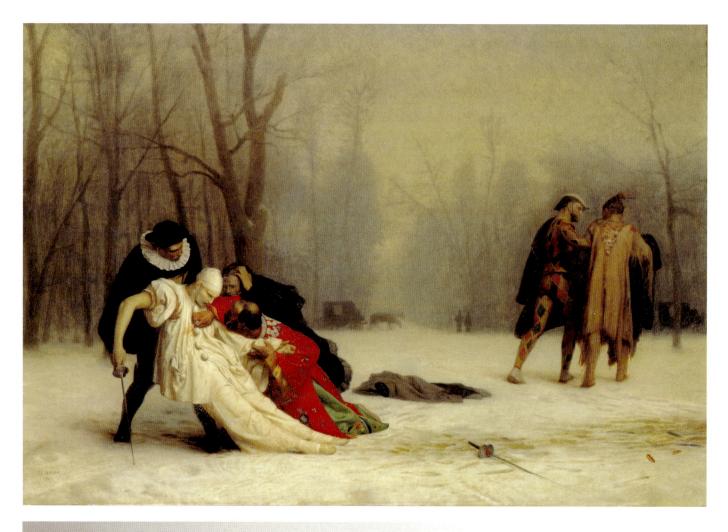

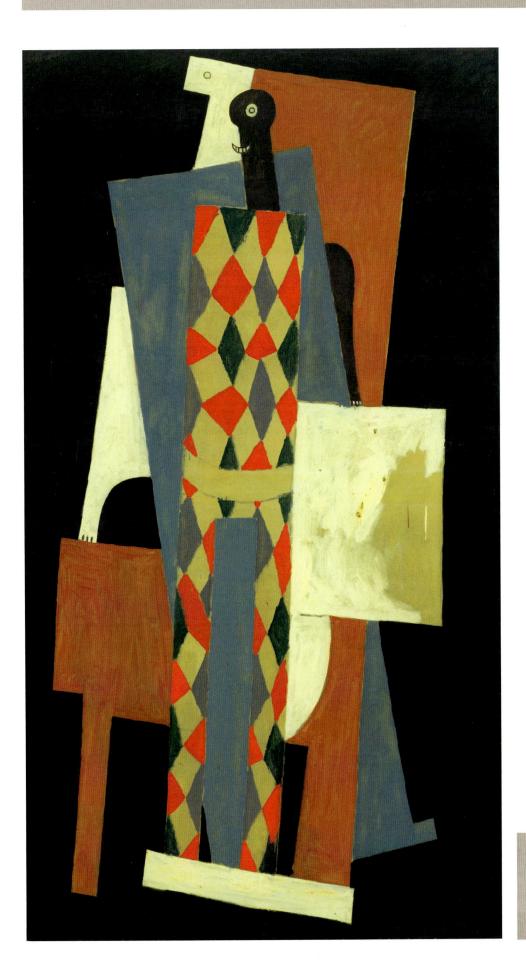

Pablo Picasso. Harlequin. Paris, late 1915. Oil on canvas, 6' 1/4" × 3' 53/8" $(183.5 \times 105.1 \text{ cm}).$

DESIGN ELEMENTS

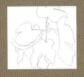

CHAPTER LINE 126

CHAPTER SHAPE 150

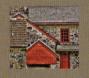

CHAPTER PATTERN AND TEXTURE 178

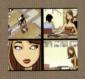

CHAPTER 1 1 ILLUSION OF MOTION 228

CHAPTER 12 VALUE 242

CHAPTER 13 COLOR 254

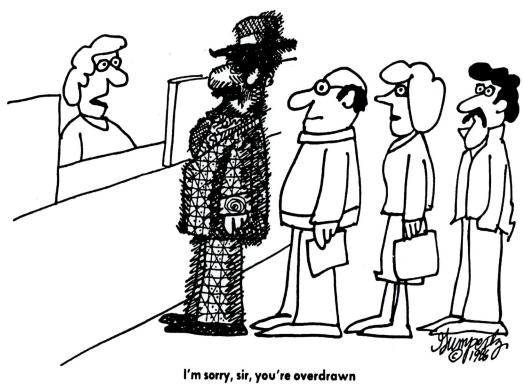

CHAPTER

INTRODUCTION

A Point Set in Motion 128

LINE AND SHAPE

Defining Shape and Form 130

TYPES OF LINE

Actual, Implied, and Psychic Lines 132

LINE DIRECTION

Horizontal, Vertical, and Diagonal Lines 134

CONTOUR AND GESTURE

Precision or Spontaneity 136

LINE QUALITY

Creating Variety and Emphasis 138

LINE AS VALUE

Using Lines to Create Dark and Light 140

LINE IN PAINTING

Outline of Forms 142

LINE IN PAINTING

Explicit Line 144

LOST-AND-FOUND CONTOUR

Suggestions of Form 146

INHERENT LINE

Structure of the Rectangle 148

A POINT SET IN MOTION

What is a **line**? If we think of a point as having no dimensions (neither height nor width), and then we set that point in motion, we create the first dimension: line. This is demonstrated vividly in a famous photograph of Pablo Picasso drawing a centaur in the air with a flashlight **(A)**.

In theory, line consists only of the dimension of its length, but, in terms of art and design, we know line can have varying width as well. The pathways in **B** are fashioned from irregular rocks, yet we instantly perceive the meandering paths as lines. In contrast to the speed expressed in **A**, Richard Long's *Five Paths* marks a slow progress across the terrain.

Of all the elements in art, line is perhaps the most familiar. Most of our writing and drawing tools are pointed, and we have been making lines constantly since we were young children. Our simplest notion of line comes from our first experiences with outlines such as those in coloring books. But line is more than mere border or boundary. Figure **C** is a line drawing describing the many items in the artist's studio and even the view out the window. The use of line is sufficiently descriptive so that we understand the whole scene. We see the brushstrokes as vivid paths in search of the edges of the forms. These lines are loose and free in the spirit of Paul Klee's idea that a line "is a point set in motion."

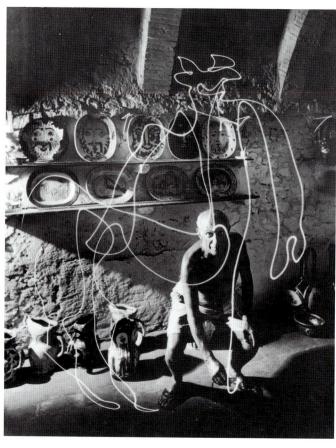

Artist Pablo Picasso drawing a centaur in the air with a flashlight at Madoura Pottery. Pablo Picasso. Flashlight Centaur. 1948.

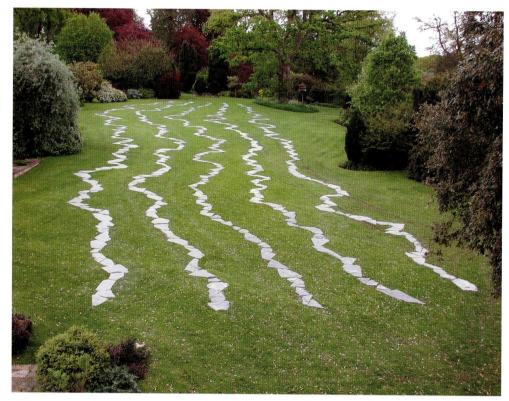

Richard Long. Five Paths. 2002. Delabole slate, 61.1 \times 17.4 m. New Art Centre Sculpture Park & Gallery, Wiltshire, UK.

Lines Convey Mood and Feeling

A curious feature of line is its power of suggestion. What an expressive tool it can be for the artist! Think of all the adjectives we can apply to lines. We often describe lines as being nervous, angry, happy, free, quiet, excited, calm, graceful, or dancing and as having many other qualities. The pathways in **B** are jittery and nervous compared with the fluid grace of Picasso's drawing in the air (A). The power of suggestion of this basic element is great, as **D** makes obvious with a delightful wit.

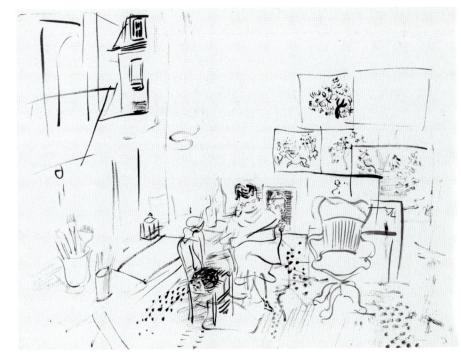

↑ C

Raoul Dufy. The Artist's Studio. c. 1942. Brush and ink on paper, 1' 7%" \times 2' 2" (49.7 \times 66 cm). The Museum of Modern Art, New York (gift of Mr. and Mrs. Peter A. Rubel).

Saul Steinberg. *Untitled.* c. 1959. Ink on paper. Originally published in *The New Yorker*, March 14, 1959. © The Saul Steinberg Foundation/ Artists Rights Society (ARS), New York.

DEFINING SHAPE AND FORM

Artistic Shorthand

Example **A** is a line drawing—a drawing of lines that are not present in the photograph **(B)** or in the original collection of objects. In the photograph, of course, no black line runs around each object. The lines in the drawing actually show edges, whereas in **B** areas of different value (or color) meet, showing the end of one object and the beginning of another. Line is, therefore, artistic shorthand, useful because with comparatively few strokes, an artist can describe and identify shapes through outline and contour.

Cross Contour Describes Form

Contour description in **A** is obvious and defines the visible boundary of the forms and shapes. Contour line can also define a form though **cross contour**, as if following the boundaries of a slice or cross section of a three-dimensional form. This is most obvious in the familiar contour lines of a topographical map **(C)**. The white lines of the fabric billowing in the wind **(D)** similarly reveal the flowing topography of the material. The textural stretch marks on the bark of a gray birch **(E)** suggest lines that go around the limb of this tree. This photograph reveals the cross-contour lines inherent in the cylindrical forms. In these two examples, line defines form by means other than mere outline.

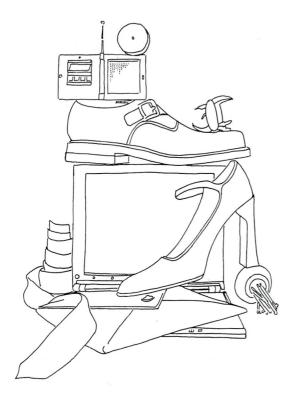

Line, as artistic shorthand, depicts the edges of shapes.

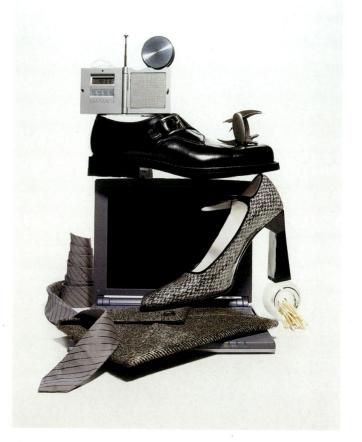

Advertisement from *New York Times* Advertising Supplement, Sunday, November 11, 1998, p. 14A. Photo: Thomas Card. Fashion direction: Donna Berg and Heidi Godoff for Twist Productions. Prop styling: Caroline Morrison. Advertorial produced by Comer & Company.

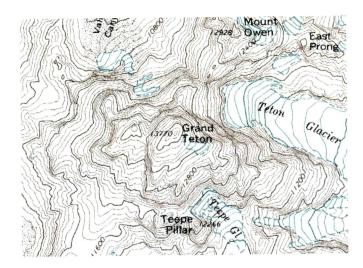

Grand Teton Quadrangle map (detail). U.S. Geological Survey.

Jack Lenor Larsen. Seascape. 1977. Nest Magazine, Winter 2002–2003. Special Section: Jack Lenor Larsen.

Lines in the bark reveal the cross contours of the tree.

ACTUAL, IMPLIED, AND PSYCHIC LINES

Line has served artists as a basic tool ever since cave dwellers drew with charred sticks on the cave walls. In addition to this language of descriptive contour drawing, two other types of line also figure importantly in pictorial composition.

An **implied line** is created by positioning a series of points so that the eye tends automatically to connect them. "Follow the dotted line" is an example familiar to us all. Our eye connects the dots to follow the graceful line of a suspension bridge in **A**.

kptyson. George Washington Bridge.

Germany's goalkeeper Rene Adler points toward England's Jermain Defoe during the Germany versus England international friendly football match at the Olympic stadium in Berlin on November 19, 2008. England won 1–2. AFP Photo/John MacDougall. A **psychic line** is illustrated in **B**. There is no real line, not even intermittent points, yet we feel a line, a mental connection between the two players. Our eyes invariably follow the direction a figure is pointing, and a psychic line results.

Interpreting Lines

All three types of line are present in Georges de La Tour's Fortune Teller (C). Actual lines clearly delineate the edges of figures and garments. An implied line is created between the victim's hand on his hip and the fortune-teller's left hand. Along this line we spy (in the shadows) hands at work relieving the victim of his valuables (D). A second such line is created by the continuation of the pickpocket's arm on the left through the bottom of the victim's jacket and along to the fortune-teller on the right. Psychic lines occur as our eyes follow the direction in which each figure is looking.

Artists have the potential to lead a viewer's eye movement, and the various types of lines can be a valuable tool to that end.

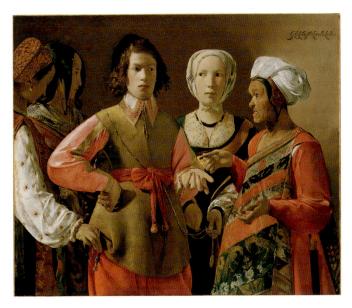

Georges de La Tour. *The Fortune Teller.* Probably 1630s. Oil on canvas, 3' 4%" \times 4' %" (102 \times 123.5 cm). The Metropolitan Museum of Art, Rogers Fund, 1960.

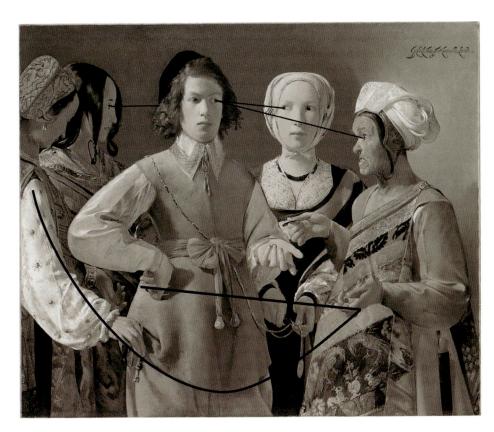

Actual, implied, and psychic lines organize the composition.

HORIZONTAL, VERTICAL, AND DIAGONAL LINES

One important characteristic of line that should be remembered is its direction. A horizontal line implies quiet and repose, probably because we associate a horizontal body posture with rest or sleep. A vertical line, such as a standing body, has more potential of activity. But the diagonal line most strongly suggests

motion. In so many of the active movements of life (skiing, running, swimming, skating) the body is leaning, so we automatically see diagonals as indicating movement. Whereas A is a static, calm pattern, **B** is changing and exciting.

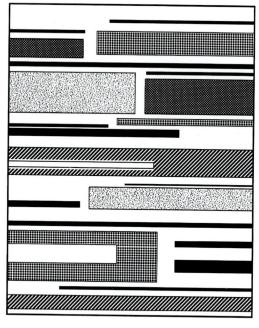

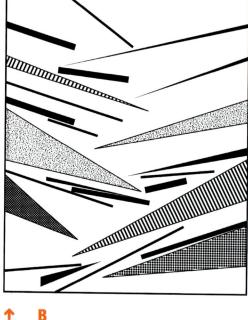

Horizontal lines usually imply rest or lack of motion.

Diagonal lines usually imply movement and action.

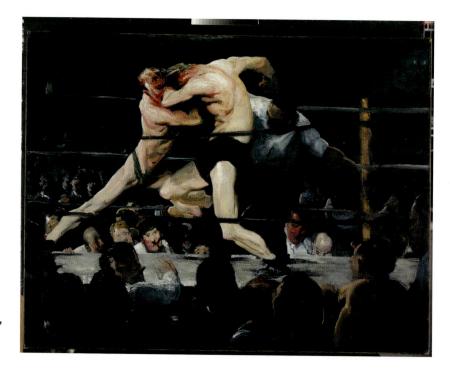

Reinforcing the Format

One other factor is involved in the quality of line direction. The outside format of the vast majority of drawings, designs, paintings, and so forth is rectangular. Therefore, any horizontal or vertical line within the work is parallel to, and repetitive of, an edge of the format. The horizontal and vertical lines within a design are stabilizing elements that reduce any feeling of movement. The lines in **A** are parallel to the top and bottom, but none of the lines in **B** is parallel to any of the edges.

Analyzing Lines in Paintings

George Bellows's painting **(C)** is dominated by a diagonal line that begins with the one fighter's leg on the left and continues through the second fighter's shoulder and arm. Other diagonals within the figures create the dynamism of the fight scene. The diagonal gesture of the referee balances the group of three

figures and completes a triangle. The verticals and horizontals of the fight ring stabilize the composition and provide a counterpoint to the action depicted.

John Moore's Evangeliste (D) has a subtle but strong underlying structure of verticals and horizontals that lend a calm serenity to the scene. The window frame provides the anchor to this pattern, but the table and building seen outside the window repeat vertical and horizontal lines. The more chaotic line directions on the tabletop and other curved and diagonal lines provide a lyric variety within the dominant order of vertical and horizontal.

The painting shown in **D** does not suggest the kind of dynamic movement of the Bellows work **(C)**, but it does show that a composition based on verticals and horizontals does not have to be boring!

PRECISION OR SPONTANEITY

Regardless of the chosen medium, when line is the main element of an image, the result is called a drawing. There are two general types of drawings: **contour** and **gesture**.

Contour Drawing

When line is used to follow the edges of forms, to describe their outlines, the result is called a contour drawing. This is probably the most common use of line in art; **A** is an example: simple, economical, and elegant. Ingres's drawing **(B)** is also a contour drawing; however, in this case a variety of line weight tells us more about the subject. This portrait by Ingres is a precise drawing with extremely delicate lines carefully describing the features and the folds of the clothing. The slightly darker emphasis of the head establishes the focal point. We cannot help admiring the sureness of the drawing, the absolute accuracy of observation.

Ellsworth Kelly. Fig Branch (Figue). 1965–1966. Lithograph on Rives BFK paper, 87.6×61 cm. Edition of 75.

Jean-Auguste-Dominique Ingres. *Portrait of Mme. Hayard and Her Daughter Caroline.* 1815. Graphite on white wove paper, $11\frac{1}{2}$ " \times $8^{\frac{1}{1}}$ " (29.2 \times 22 cm). University of Harvard Art Museums, Fogg Art Museum (bequest of Grenville L. Winthrop) (1943.843).

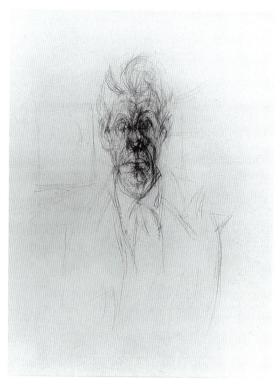

Alberto Giacometti. Self-Portrait. 1954. Pencil, 1' 4" \times 1' (40.5 \times 31 cm).

The self-portrait by Giacometti (C) is not composed of the precise contours we find in A or C. Instead, we see many lines that, taken together, suggest the mass and volume of the head. The result is more active, and we can more readily observe the artist's process of looking and recording. Many of Giacometti's lines follow the topography of the head and find surface contours within the form of the head, not merely at the outer edge.

Gesture Drawings

The other common type of drawing is called a gesture drawing. In this instance, describing shapes is less important than showing the action or the dynamics of a pose. Line does not stay at the edges but moves freely within forms. Gesture drawings are not drawings of objects so much as drawings of movement, weight, and posture. Because of its very nature, this type of drawing is almost always created quickly and spontaneously. It captures the momentary changing aspect of the subject rather than recording nuances of form. Rembrandt's Christ Carrying the Cross (D) is a gesture drawing. Some quickly drawn lines suggest the contours, but most of the lines are concerned with the action of the falling, moving figures.

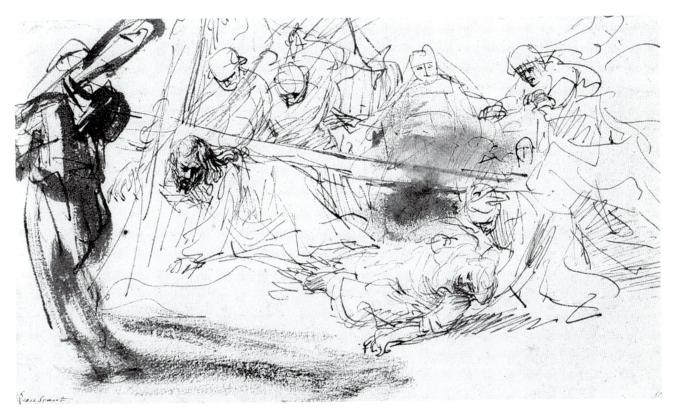

Rembrandt. Christ Carrying the Cross. c. 1635. Pen and ink with wash, 5%" \times 10%" (14 \times 26 cm). Kupferstichkabinett, Staatliche Museen, Berlin.

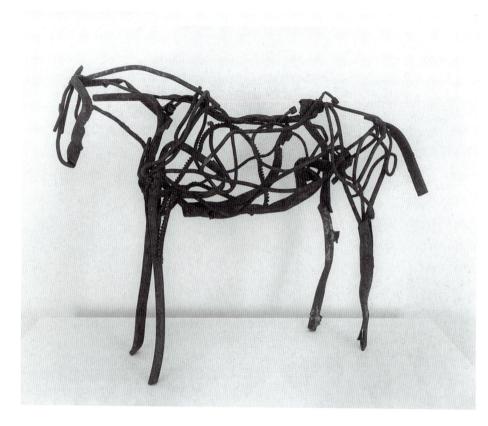

Deborah Butterfield. *Tango.* 1987. Steel, 2' $4\frac{1}{2}$ " \times 3' $6\frac{1}{2}$ " \times 1' 3" (72 \times 107 \times 38 cm). Art © Deborah Butterfield/Licensed by VAGA, New York, New York. Courtesy, Edward Thorp Gallery, New York.

CREATING VARIETY AND EMPHASIS

To state that an artist uses line is not very descriptive of the artist's work because line is capable of infinite variety. To imagine the qualities that a line may have, just think of an adjective you can place before the word *line*, such as *thin*, *thick*, *rough*, or *smooth*. The illustrations on these two pages give only a sampling of the linear possibilities available to the artist or designer.

Volume

Deborah Butterfield's *Tango* (A) is a sculpture that conveys a sense of drawing in three dimensions. The found objects and steel scraps suggest the presence of a horse with almost scribble-like lines. These lines largely define the horse from the inside of the form and the gesture of the pose. Butterfield's work has a spontaneous appearance we would more likely associate with brush and ink than welded steel. When seen in a photograph such as A, the welded pieces work like a line drawing to convey the volume of the form.

Expressing Mood and Motion

The untitled drawing by Susan Rothenberg shown in **B** also depicts a horse, but here the similarity to **A** ends. Rothenberg's drawing is characterized by heavy, blunt contours echoed by thinner, coarse lines. The brutal line quality that describes dismembered horse shapes creates a markedly different expression than we might find in a graceful illustration of a racehorse.

Susan Rothenberg. *Untitled.* 1978. Acrylic, flashe, pencil on paper, 1' 8" \times 1' 8" (51 \times 51 cm). Collection of Walker Art Center, Minneapolis (Art Center Acquisition Fund, 1979).

1 0

Judy Pfaff. Che Cosa è Acqua from Half a Dozen of the Other. 1992. Color drypoint with spit bite and sugar lift aquatints, and soft ground etching, $3^{1} \times 3^{1}$ 9" on 3^{1} 6%" \times 4^{1} 2%" sheet. Edition of 20. Printed by Lawrence Hamlin.

The print by Judy Pfaff **(C)** takes advantage of a variety in line quality from bold to light, from elegant to awkward. Some thin lines perform figures like an ice skater, while the heavier lines sag like the drips of spilled paint. This print does not use line as **calligraphy**, nor is it representational. In this case, line exists for its own expressive qualities.

The lines in **D** quiver and reverberate, suggesting movement. Notice how difference in line weight suggests motion.

The linear technique you choose can produce emotional or expressive qualities in the final pattern. Solid and bold, quiet and flowing, delicate and dainty, jagged and nervous, or countless other possibilities influence the effect on the viewer of your drawing or design.

Honoré Daumier. Frightened Woman. 1828–1879. Charcoal with black crayon, on ivory laid paper, $8" \times 9\%"$ (21 \times 23.9 cm). The Art Institute of Chicago (gift of Robert Allerton).

Pat Oliphant. © 2001 Universal Press Syndicate. Reprinted with permission. All rights reserved.

USING LINES TO CREATE DARK AND LIGHT

A single line can show the shape of objects. But an outlined shape is essentially flat; it does not suggest the volume of the original subject. The artist can, by placing a series of lines close together, create visual areas of gray. By varying the number of lines and their proximity, the artist can produce an almost limitless number of grays. These resulting areas of dark and light (called areas of value) can begin to give the three-dimensional quality lacking in a pure contour line. Again, the specific linear technique and the quality of line can vary a great deal among different artists.

Cross-Hatching

Traditionally, editorial cartoonists have had to make the most of the limitations imposed by black ink on newsprint. This constraint challenged the artists to be inventive in all aspects of their design. Hatching and cross-hatching are techniques often employed by these artists to suggest a broad gamut of values.

Pat Oliphant's cartoon in A shows a light-to-dark gradation on the right side of the composition created by a series of parallel ("hatching") lines that increase in density. To the left, Uncle Sam casts a shadow made up of intersecting patterns of pen strokes - or cross-hatching.

The same cross-hatching technique is clear in B. But in this etching, the artist, Rembrandt, has used the lines in a looser manner. The various densities of line suggest the values and textures of sky and landscape.

Applying Line as Value to Textiles

These techniques are by no means limited to drawings and prints. The woven fabric in C uses fibers as lines to create different values out of differing densities of the dark threads. Our eye reads the weave of darks and lights to create optical mixtures of various values.

See also Value: Techniques, page 252.

Rembrandt. *The Three Trees.* 1643. Etching with drypoint and burin, only state. Courtesy of Wetmore Print Collection of Connecticut College.

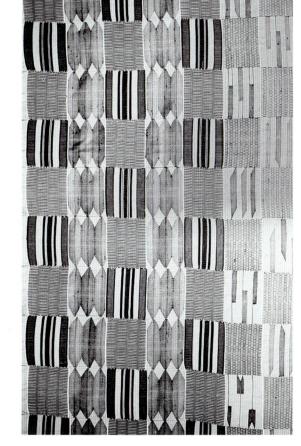

West African Kente cloth. No date. Cotton, 6¹ 10¼" \times 11¹ ½" (23 \times 3.5 m). Anacostia Community Museum, Smithsonian Institution, Washington, DC.

OUTLINE OF FORMS

Line can be an important element in painting. Because painting basically deals with areas of color, its effect is different from that of drawing, which limits the elements involved. Line becomes important to painting when the artist purposely chooses to outline forms, as Alice Neel does in her portrait (A). Dark lines define the edges of the figure and the sofa. The lines are bold and quite obvious.

Line can be seen in the detail of Venus from Botticelli's famous painting **(B)**. The goddess's hair is a beautiful pattern of flowing, graceful, swirling lines. The hand is delineated from the breast by only the slightest value difference; a dark, now quite delicate line clearly outlines the hand.

Adapting Technique to Theme

Compare the use of line in Botticelli's painting with that in **C**. Both works stress the use of line, but the similarity ends there. *Crying Girl*, by Roy Lichtenstein **(C)**, employs the extremely heavy, bold

line—almost a crude line typical of the drawing in comic books. Each artist has adapted his technique to his theme. Compare the treatment of the hair. Venus **(B)** is portrayed as the embodiment of all grace and beauty, her hair a mass of elegant lines in a delicate arabesque pattern. The *Crying Girl*'s hair **(C)**, by contrast, is a flat, colored area boldly outlined, with a few slashing heavy strokes to define its texture.

Dark Line Technique

The use of a black or dark line in a design is often belittled as a crutch. There is no doubt that a dark linear structure can often lend desirable emphasis when the initial color or value pattern seems to provide little excitement. Many artists, both past and present, have purposely chosen to exploit the impact of dark lines to enhance their work. The heavy lines support the theme of construction in *The Builders* (D). Both C and D balance the dark lines with an equally bold red, yellow, and blue color structure.

Sandro Botticelli. *The Birth of Venus.* (Detail), c. 1480. Oil on canvas; entire work: 5' 8%" \times 9' 1%" (1.75 \times 2.79 m). Galleria degli Uffizi, Florence.

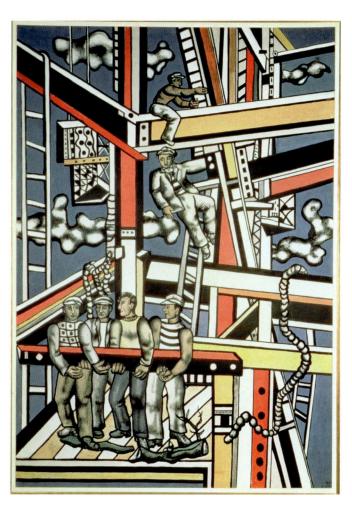

↑ C

Roy Lichtenstein. *Crying Girl.* 1964. Enamel on steel, 3' 10" square. © Roy Lichtenstein.

Fernand Leger. The Builders. 1950. Oil on canvas, 9' 10" \times 6' 7" (3 \times 2 m). Musée National Fernand Leger, Biot, France.

LINE IN PAINTING

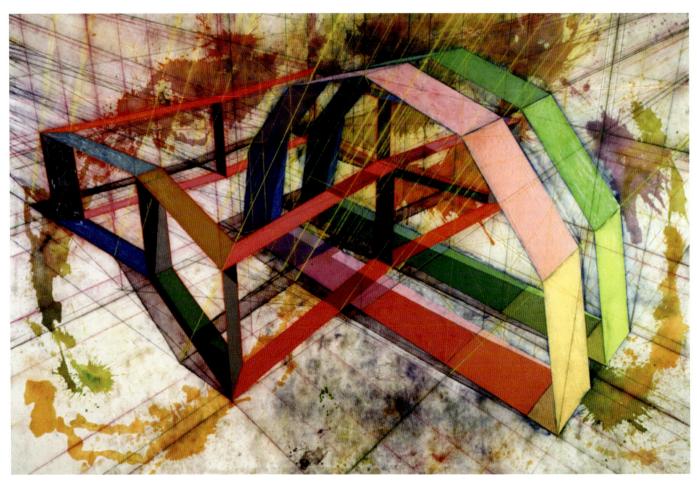

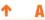

Ronald Davis. Arch Duo and Vented Star. 1976. Painting: acrylic on canvas, 9' 6" in. \times 14' 6%" (289.56 cm \times 443.87 cm). Acquired 1977. Collection SFMOMA. Purchased with the aid of funds from the National Endowment for the Arts and the New Future Fund Drive, © Ronald Davis.

EXPLICIT LINE

Explicit line is obvious in an image such as the acrylic painting by Ron Davis shown in **A**. This painting is as much drawing in color as it is painting. The perspective lines are explicit and left to tell the story of how the colored planes were generated.

Defining Shape and Form

Line becomes important in a painting when the contours of the forms are sharply defined and the viewer's eye is drawn to the edges of the various shapes. The painting by Francesco Salviati **(B)** contains no actual outlines as we can see in **A**. However, the contour edges of the figures, clothing, and landscape not

only define those elements but are also critical to moving the eye through the painting. The detail shown in ${\bf C}$ illustrates how these serpentine lines flow from figure to background.

Karin Davie's painting **(D)** is also composed of serpentine lines that create a complex pattern. In this case they are brushstrokes that act as independent elements devoid of any representational function. The varying color of the lines creates different spatial levels and shifting areas of interest or emphasis. Although these "lines" are wide brushstrokes, they still convey Paul Klee's idea of a "point set in motion."

Francesco Salviati. Virgin and Child with an Angel. (1535–1539). Oil on wood,112.3 \times 83 cm. National Gallery of Canada.

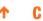

Francesco Salviati. Virgin and Child with an Angel. (1535–1539). Detail. Oil on wood.112.3 \times 83 cm. National Gallery of Canada.

Karin Davie. Between My Eye and Heart No. 12. 2005. Oil on canvas, 5' $6" \times 7$ '. Margulies Warehouse Collection, Miami, Florida.

LOST-AND-FOUND CONTOUR

SUGGESTIONS OF FORM

Salome with the Head of John the Baptist (A) is a painting by Caravaggio that puts more emphasis on color and value than on line. In each of the figures, only part of the body is revealed by a sharp contour, but the edge then disappears into a mysterious darkness. This is termed **lost-and-found contour**: now you see it, now you don't. The artist gives us a few clues, and we fill in the rest. For example, when we see a sharply defined profile, we will automatically assume the rest of the head is there, although we do not see it. A line interpretation (B) of this painting proves that we do not get a complete scene but merely suggestions of form. Bits and pieces float, and it is more difficult to understand the image presented.

Relative Clarity

A strong linear contour structure in a painting provides clarity. Lost-and-found contour gives only relative clarity but is in fact closer to our natural perception of things. Seldom do we see everything before us in equal and vivid contrast. The relief shown in ${\bf C}$ presents a rhythmic linear composition created by only those edges cast in shadow. In this case of a white-on-white relief, it is the illuminated edges that disappear. We can get a better idea of the "lost" contours from the study drawing shown in ${\bf D}$.

Selected Lighting

Photographers often choose the lighting for a subject to exploit the emotional and expressive effects of lost-and-found contour. Illustration **E** is just one of the countless photographs that have used the technique. Here a very beautiful and dramatic image has been produced from a simple architectural detail.

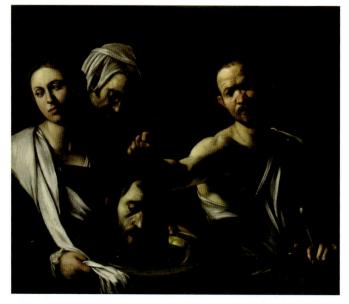

Caravaggio. Salome with the Head of John the Baptist. c. 1609. Oil on canvas, 116 imes 140 cm. National Gallery, London, Great Britain.

Only some contours are visible in the painting.

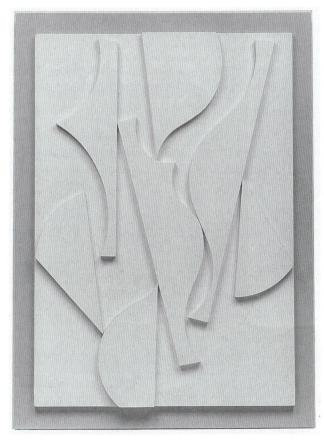

Sophie Taeuber-Arp. Untitled (Study for Parasols). 1937. Black crayon, 1' 1½" \times 10" (34 \times 25 cm). Foundation Jean Arp and Sophie Taeuber-Arp, Rolandseck, Germany.

Sophie Taeuber-Arp. Parasols. 1938. Painted wood relief, 2' 10" \times 2' (86 \times 61 cm). Rijksmuseum Kroller-Muller, Otterlo.

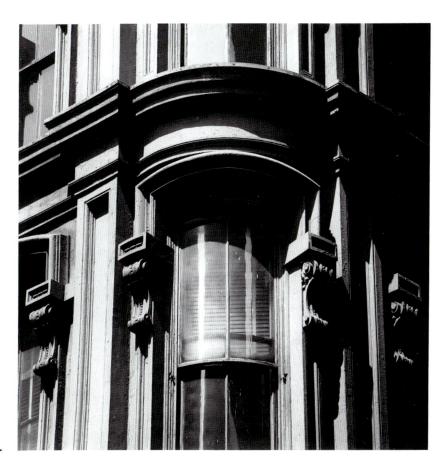

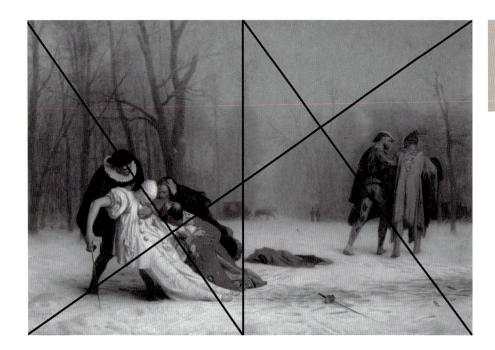

Jean-Léon Gérôme. The Duel after the Masquerade. 1857–1859. Oil on canvas, $1'3\%" \times 1'10\%$ " (39.1 \times 56.3 cm).

STRUCTURE OF THE RECTANGLE

Any rectangular composition has inherent in its format a whole series of lines tied to the geometry of that shape. Take any rectangular piece of paper; fold it in half, then fold it in half again. Now fold from corner to corner, and again from the opposite corners. A whole web of lines will appear, dividing quadrants and tracing diagonals. The intersections of these lines suggest further possible folds and lines. Whether explicitly drawn or implicitly left unmarked, these lines form an underlying structure that can create a foundation for a visual composition.

Returning to our familiar examples, we can see that such a substructure of inherent compositional lines can exist in both figurative and nonfigurative artworks. The vertical midline divides the Gérôme painting (A) in such a way that the diagonals of each half intersect the main diagonal as perpendicular lines. The diagonals of these two halves reinforce the story that is depicted, and this is most prominent along the diagonal of the dying Pierrot.

Picasso's Harlequin (B) is balanced around the various diagonals that intersect the center of the painting creating a radial balance.

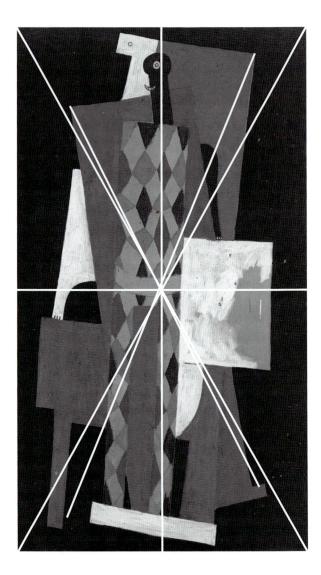

Pablo Picasso. *Harlequin.* Paris, late 1915. Oil on canvas, 6¹ ¼॥ \times 3¹ 5%॥ (183.5 \times 105.1 cm).

Some artists will consciously employ an awareness of geometry. Sol Lewitt's site-specific drawing **(C)** is nothing more than that—a revelation of the complex web of lines that exist between all of the points in the architectural features of a wall.

Others prefer a more intuitive, less conscious approach. In either case we will often find that a riveting composition owes much to the arrangement of elements within the web of inherent lines.

See also Proportion: Root Rectangles, page 84.

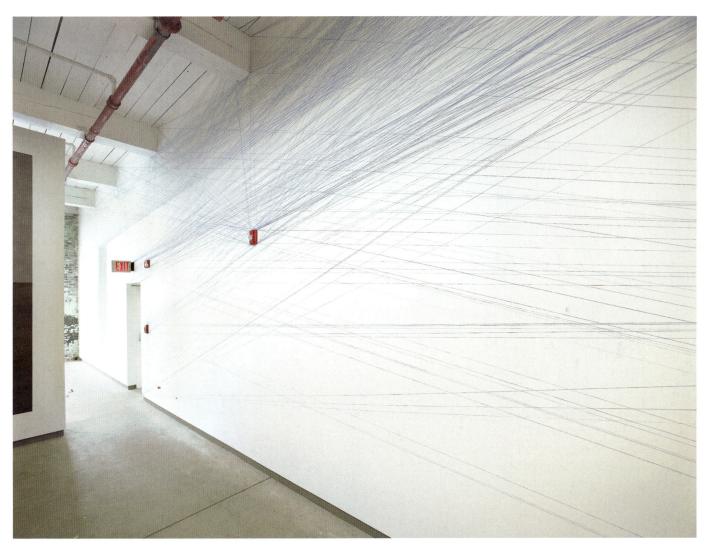

Sol Lewitt. Wall Drawing 51. All architectural points connected by straight lines (detail view). June 1970. Blue snap lines. LeWitt Collection, Chester, Connecticut.

Charles E. Martin. 1968.

© *The New Yorker Collection* from cartoonbank.com.

All Rights Reserved.

INTRODUCTION

Shaping Perception 152

PREDOMINANCE OF SHAPE 154

VOLUME/MASS

Working in Two and Three Dimensions 156

NATURALISM AND DISTORTION

Exaggerated Shapes 158

NATURALISM AND IDEALISM

Nature and Aspiring to Perfection 160

ABSTRACTION

Essence of Shape 162

NONOBJECTIVE SHAPES

Pure Forms 164

CURVILINEAR SHAPES 166

RECTILINEAR SHAPES
AND COMBINATIONS 168

POSITIVE/NEGATIVE SHAPES

Introduction 170

POSITIVE/NEGATIVE SHAPES

Isolation or Integration 172

POSITIVE/NEGATIVE SHAPES

Emphasis on Integration 174

POSITIVE/NEGATIVE SHAPES

Ambiguity 176

INTRODUCTION

A **shape** is a visually perceived area created either by an enclosing line or by color or value changes defining the outer edge. A shape can also be called a **form**. The two terms are generally synonymous and are often used interchangeably. *Shape* is a more precise term because *form* has other meanings in art. For example, *form* may be used in a broad sense to describe the total visual organization of a work, including color, texture, and composition. Thus, to avoid confusion, the term *shape* is more specific.

SHAPING PERCEPTION

Our visual perception is dependent on our ability to recognize borders and boundaries that separate **figure** from **ground**. The shapes we see are either

a figure: an object or foreground element, or the ground: the space or volume between figures or forms. A watercolor by Ellsworth Kelly (A) shows an arrangement of apples. The oval shape is emphasized by one isolated apple, and the constellation of eight apples forms a triangle. Often we can find, even in more complicated subjects, the simple shapes of circle, square, and triangle underlying a composition.

A second artwork by Ellsworth Kelly shows that his eye for shape is not drawn only to the object or "figure," but also to the ground. The black relief shown in **B** seems to have been found in the spaces or "ground" in **A**. The slender shape of **B** offers an unexpected "figure" and in fact bears the title *Black Venus*.

A general rule of perception states that (all other things being equal) our eye tends to read convex shapes as figure and concave shapes as ground. This is affirmed in $\bf A$ by the plump convex shapes of the fruit. The shape featured in $\bf B$ surprises us by contradicting our expectations: in this case the shape, or figure, is largely concave.

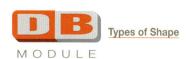

Ellsworth Kelly. *Apples.* 1949. Watercolor and pencil on paper, 2' %" \times 1' 7%" (62.9 \times 49.2 cm). Collection of the artist. © Ellsworth Kelly from the exhibition Cezanne and Beyond, 2009.

The jacket and skirt design seen in $\bf C$ is eye catching and reminiscent of Kelly's relief. It also contradicts our expectation of convex shapes defining a figure. The human figure, even a slender person, is defined by the convex forms of muscle and bone. In the case of $\bf C$, however, most of the edges of the suit are seen as concave black shapes against a lighter background. Both $\bf B$ and $\bf C$ emphasize the figure by contrast of a black shape against a white ground. This is true of the typography of this page as the shapes of the letters are easily read against the white page.

In each of these examples, shape is the defining element. Other elements are simple: a contrast of black and white or a limited color scheme. With few other distractions we can experience our perception of shape at a very elemental level. In the following sections of this chapter, we will see more complex aspects of shape and figure/ground contrasts, also defined as shape and negative shape.

Ellsworth Kelly. Black Venus. 1959. Painted aluminum, 7¹ 1" \times 3¹ \times 2%" (1" off wall) (215.9 \times 91.4 \times 6.7 cm). Private collection.

Francisco Costa for Calvin Klein.

PREDOMINANCE OF SHAPE

Two-dimensional design, or composition, is basically the arrangement of shapes. Scott Noel's painting *Orpheus and Eurydice* (A), with its depiction of objects, a mirror, and a painting within a painting, presents the viewer with a near-overwhelming complexity. Despite this complication, the composition can ultimately be seen as a jigsaw-puzzle-like array of many shapes—some simple and geometric, others more complicated. By contrast Mark Rothko's *Four Darks in Red* (B) has the dramatic impact of a large field of color, but it is first of all a canvas, rectangular in shape. The soft-edged color bars that emerge in this red field are also rectangles.

In representational pictures, only the most diffuse atmospheric images of light can be said to almost dispense with shape. The image in ${\bf C}$ is based on one of Claude Monet's impressions of the Rouen Cathedral that emphasizes light and atmosphere over shape. The artist Roy Lichtenstein further exaggerates these qualities in ${\bf C}$. The shape of the cathedral barely flickers into focus, and the hundreds of dots compete with the shapes of the architectural elements for our attention. If you look closely, you can see that the dots in ${\bf C}$ are small circles, so this image is, after all, composed of shapes.

Scott Noel. Orpheus and Eurydice. Oil on linen, 4' $6" \times 4'$ 2".

The still life painted by the contemporary painter Sydney Licht **(D)** is also composed of round shapes, but in various sizes and combinations. Of course, the color, texture, and value of these shapes are important, but the basic element is shape. The pattern on the tablecloth serves as a simple and more abstract echo of the shapes and negative shapes found in the asparagus bundles. The overall effect may be quite different, but at the level of shape, the two artworks shown in **C** and **D** have a common element.

(

Roy Lichtenstein. Cathedral #2 from the Cathedral Series. 1969. Color lithograph and screen print in red and blue, 4' $\%6''\times2'$ 8%" (123 \times 82.5 cm). Fine Arts Museums of San Francisco, Anderson Graphic Arts Collection (gift of Harry W. and Margaret Anderson Charitable Foundation, 1996.74.239).

WORKING IN TWO AND THREE DIMENSIONS

Shape usually is considered a two-dimensional element, and the words *volume* and *mass* are applied to the three-dimensional equivalent. In simplest terms, paintings have shapes and sculptures have masses. The same terms and distinctions applied to shapes apply to three-dimensional volumes or masses. Although the two concepts are closely related, the design considerations of the artist can differ considerably when working in two- or three-dimensional media.

Angle of Perception

A flat work, such as a painting, is essentially designed for viewing from a single point of view, but three-dimensional works change each time we move: the forms are constantly seen in

different relationships. *Fifteen Pairs of Hands* by Bruce Nauman **(A)** demonstrates that a three-dimensional form such as the human figure offers countless variety of shapes that change with position and point of view.

A painting by Robert Moskowitz **(B)** contrasts the sculptural experience of form and volume with the painter's concern with shape. In Moskowitz's painting, Rodin's *Thinker* is seen as a silhouette. This shape is a recognizable image of the famous sculpture, but only one of the many possible silhouette shapes that could be seen.

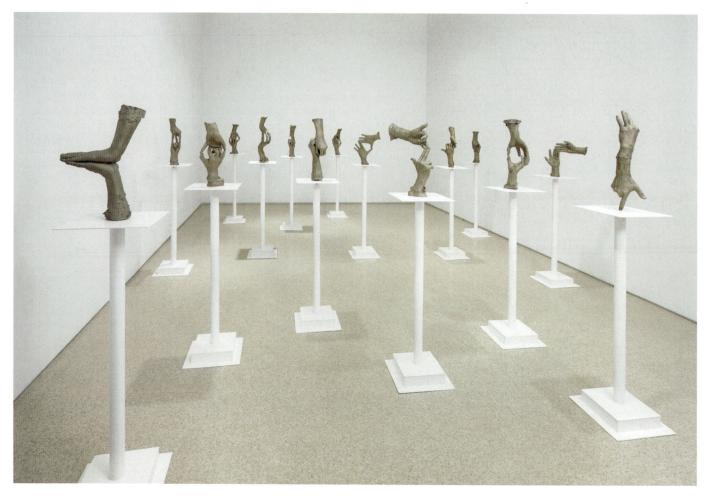

Combining Two- and Three-Dimensional Work

Many artists today attempt to break down the dividing barriers between painting, drawing, sculpture, and architecture. Julian Opie's *Shahnoza* **(C)** accomplishes just this and goes further in breaking down distinctions between "highbrow" and "lowbrow." The vinyl line drawings of a "pole dancer" were placed to interact in a witty dialogue with an installation of Henry Moore's abstracted figures. The Opie drawings are also quite abstract: note the circles for heads. The position of the drawings aligns the poles with the architectural grid of the ceiling, humorously suggesting that, like ancient **caryatids**, they are holding up the building. Opie accomplishes all this with drawings that emphasize flat shapes, not three-dimensional volumes.

Robert Moskowitz. *Thinker.* 1982. Pastel on paper, $9' \times 5'$ 3". Collection of Joslyn Art Museum, Omaha, Nebraska.

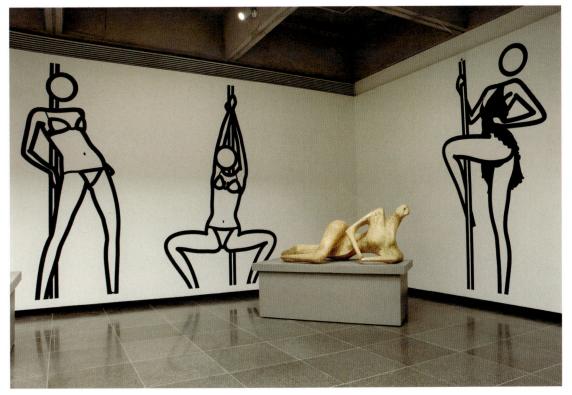

EXAGGERATED SHAPES

Naturalism is self-evident. A portrait painting from the nineteenth century will convince us that it is a likeness even though we have never seen the subject or a photograph of the subject. Reasonable proportion of shapes and attention to the shapes of features such as the eyes and the mouth will create a sense of credibility, and we believe the image.

Distortion, or exaggerated shapes, are familiar to us through caricatures and even the playful effects possible on your laptop's camera. Shapes are stretched and altered in proportion. The deft caricaturist does this and maintains a strong resemblance to the natural subject. The funhouse mirror effect on your computer distorts or exaggerates beyond recognition.

The caricature of President Bill Clinton provides a study of exaggerated shapes that still offers a resemblance to a natural

image. The natural proportions have been altered in a way that exaggerates features we easily recognize including a general puffiness and pursed lips. The body is very small to emphasize the face. It would be possible to place a grid over a photograph of Bill Clinton and distort the grid (narrower or wider spaces) to alter the shapes and see how far that can stretch or compress and still be recognizable.

The caricatures in **B** are also recognizable as John Travolta and Samuel L. Jackson from *Pulp Fiction*. Here the distortion and exaggeration is translated to the simplest possible nearly geometric shapes. This vocabulary of shapes allows the artist, Noma Bar, to use the shapes of guns as stand-ins for features such as eye and eyebrow, nose, mouth, and moustache. An attentive eye for shape allows these distortions and manipulations.

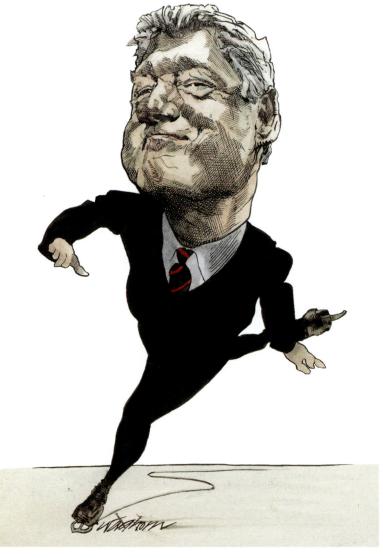

Distortion and Expression

We can see in A and B that distortion and exaggeration are employed for expressive effect relative to the character of the subject. As in literature, exaggeration may have dramatic or humorous effect, or come across as overstatement and hyperbole. A visual example of hyperbole might be the illustrations of puppies with oversized eyes. Such cheap manipulation is the hallmark of kitch.

The illustration for a Nike advertisement (C) employs exaggeration for expressive effect. The form of the human body is distorted through elongation. The result is an image that communicates visually the stretching, leaping, and reaching that are the nature of a basketball game. The distortion puts an emphasis on the action over a naturalistic view of the body. Picasso once said that "art is a lie that reveals the truth," and that can be seen in the manipulated shapes of these examples.

See also Chapter 4: Scale and Proportion.

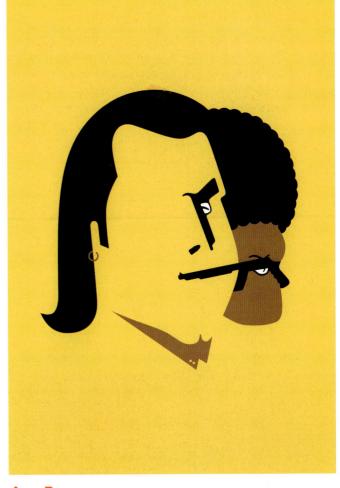

Noma Bar. Pulp Fiction. Three-color screenprint, 59.4 cm height imes42 cm width. Limited edition of 10. Printed in Jerusalem.

Advertisement for Nike Sportswear. 1995. NYC Campaign. Art Director: John C. Jay. Designer: Pao. Illustrator: Javier Michaelski. Creative Directors: Dan Wieden, Susan Hoffman. Source: Print, March/April 1996, p. 87.

NATURE AND ASPIRING TO PERFECTION

Naturalism is concerned with appearance. It gives the true-tolife, honest visual appearance of shapes in the world around us. In contrast, there is a specific type of artistic distortion called **idealism**. Idealism reproduces the world not as it is but as cultural worldview says it should be. Nature is improved on based upon an artificial standard of perfect form. These notions of perfection may come from a geometric order, or an image of perfect health and youth in the human body. All the flaws, accidents, and incongruities of the visual world are corrected.

Catherine Murphy. Self-Portrait. 1970. Oil on canvas, 4¹ $1\frac{1}{2}$ " \times 3¹ $1\frac{1}{6}$ " (125.7 \times 94.3 cm). Museum of Fine Arts, Boston (gift of Michael and Gail Mazur, 1998).

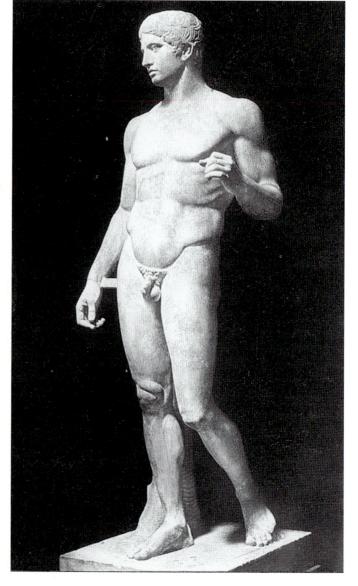

Polyclitus. *Doryphorus (Spear Bearer).* Roman copy after Greek original of c. 450–440 BC. Marble, height 6' 11" (1.98 m). Museo Archeologico Nazionale, Naples, Italy.

Idealism in Art

The self-portrait by Catherine Murphy (A) is naturalistic. Even in painting herself, the artist has indulged in no flattery. The artist's face is in shadow, and the emphasis is less on the portrait than the naturalistic presentation of the artist's studio. The fifth-century-BC statue (B) illustrates the opposite approach—idealism. This statue was a conscious attempt to discover the ideal proportions of the human body. No human figure was copied for this sculpture. The statue represents a visual paragon, a conceptual image of perfection that nature simply does not produce.

Idealism is a recurrent theme in art, as it is in civilized society. We are all idealistic; we all strive for perfection. Despite overwhelming historical evidence, we continue to believe we can create a world without war, poverty, sickness, or social injustice. Obviously, art will periodically reflect this dream of a utopia.

Idealism in Advertising and Propaganda

Today, we are all familiar with a prevalent, if mundane, form of idealism. Large numbers of the advertisements we see daily are basically idealistic. Beautiful people in romantically lit and luxurious settings evoke an atmosphere that is far different from the daily lives of most of us. Fashion illustration suggests body types that are rare or unreal. Governments also often employ idealistic images to convince the world (or themselves) that their particular political system is superior. The heroic "worker" shown in **C** has the idealized muscles of a comic superhero.

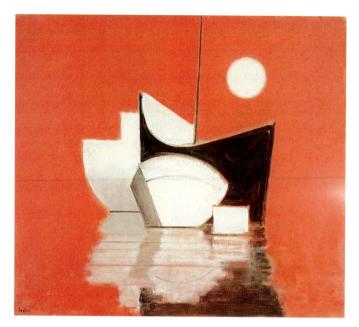

1 A

Paul Resika. July. 2001. Oil on canvas, 4' 4" \times 5'. Alpha Gallery, Boston.

ESSENCE OF SHAPE

A specific kind of artistic distortion is called **abstraction**. Abstraction implies a simplification of natural shapes to their essential, basic character. Details are ignored as the shapes are reduced to their simplest terms. The painting in **A** is an example of abstraction.

Abstraction for Effect

Because no artist, no matter how skilled or careful, can possibly reproduce every detail of a natural subject, any painting could be called an abstraction. But the term *abstraction* is most often applied to works in which simplification is visually obvious and important to the final pictorial effect. Of course, the degree of abstraction can vary. In **A** all the elements have been abstracted to some extent. Most details have been omitted in reducing the boats to basic geometric shapes (primarily sections of circles, triangles, and rectangles). Still, the subject matter is immediately recognizable, even though we are several steps removed from a naturalistic image. This form of abstraction, where elements are simplified to building blocks, is sometimes called "reductive."

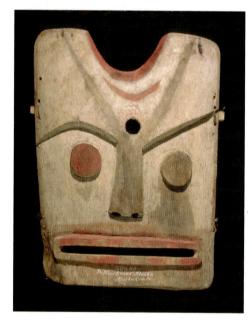

Alutiiq mask. c. 1875. Painted wood, 38 cm high. National Museum of Natural History, Smithsonian Institution.

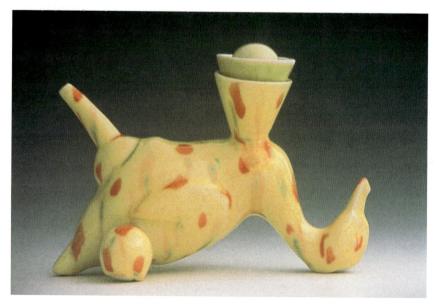

For the Love of Shapes

Abstraction is not a new technique; artists have employed this device for centuries. If anything, the desire for naturalism in art is the more recent development. The Alutiiq mask in B clearly shows abstracted forms. Although the result is quite different from A, many of the shapes in this mask are similar. This aspect illustrates a widely accepted principle: all form, however complex, is essentially based on, and can be reduced to, a few geometric shapes.

Abstracted form does not always lead simply to an alternative representation of a naturalistic form. Abstraction often arises from a love of shape and form for its own sake and from a delight in manipulating form. The teapot shown in C transforms a given mold form of a duck in an unexpected way. This reflects the artist's ability to see the potential in a shape or form beyond its literal name. That is the essence of abstract thinking and seeing.

Biomorphic Shapes

Not all abstraction necessarily results in a geometric conclusion, and abstraction can result in imagery that is not as directly derived from natural references as the previous examples. The simple petal-like shapes in Arshile Gorky's Garden in Sochi (D) suggest plants, and even human anatomy, without explicitly resembling anything nameable. Abstract shapes such as these, which allude to natural, organic forms, are called **biomorphic**.

Arshile Gorky. Garden in Sochi. c. 1943. Oil on canvas, 2' $7" \times 3' \ 3"$ (78.7 imes 99 cm). The Museum of Modern Art, New York (acquired through the Lillie P. Bliss Bequest, 1969).

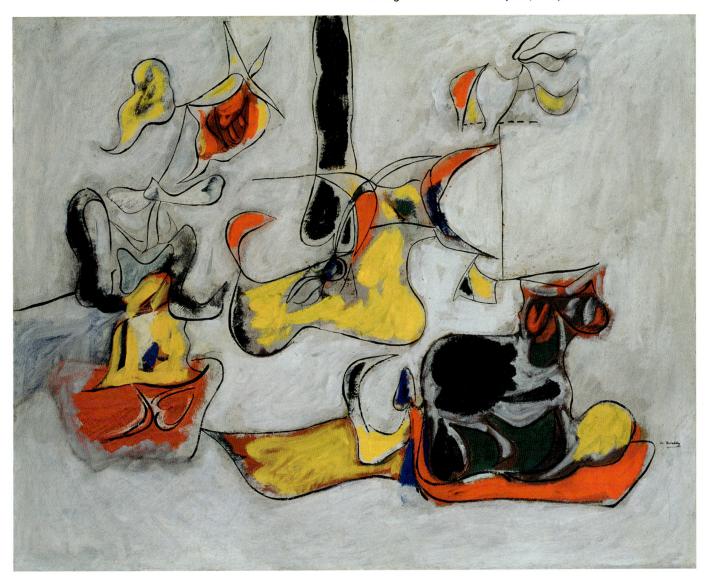

PURE FORMS

According to common usage, the term abstraction might be applied to Auguste Herbin's painting Jour (Day) (A). This would be misleading, however, because the shapes in this work are not natural forms that have been artistically simplified. They do not represent anything other than the geometric forms we see. Rather, they are pure forms. A better term to describe these shapes is **nonobjective**—that is, shapes with no object reference and no subject matter suggestion.

Visual Design

Most of the original design drawings in this book are nonobjective patterns. Often, it is easier to see an artistic principle or element without a distracting veneer of subject matter. In a similar way, many twenty-first-century artists are forcing us to observe their works as visual patterns, not storytelling narratives. Without a story, subject, or even identifiable shapes, a painting must be appreciated solely as a visual design. Paintings such as A present purely nonobjective, geometric shapes that are, as Plato said, "free from the sting of desire."

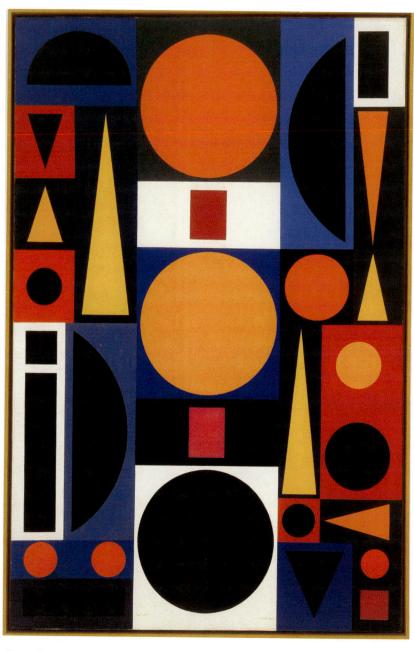

The collage by Anne Ryan **(B)** is nearly a geometric as Herbin's painting, yet we sense another factor at play. Ryan's shapes seem to come naturally from the scraps of a sewing room floor. Helen Frankenthaler's painting **(C)** is equally non-objective, but the shapes are not geometric and seem to have developed from the inherently fluid quality of the paint. The canvas seems to be a record of the paint flowing and pooling under the artist's direction. In both of these examples, the shapes are nonobjective but derive from the process.

Lack of a referent subject matter does not necessarily eliminate emotional content in the image. Compare the three examples on these two pages for the tone that they convey from serious to playful to dramatic.

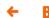

Anne Ryan. No. 74. Between 1948 and 1954. Fabric and paper collage, $8" \times 7"$ unframed. Walker Art Center (gift of Elizabeth McFadden, 1979).

Helen Frankenthaler. *Over the Circle.* 1961. Oil on canvas, 7' $\frac{1}{6}$ " \times 7' $\frac{3}{6}$ " (2.13 \times 2.21 m). Jack S. Blanton Museum of Art, The University of Texas at Austin (gift of Mari and James A. Michener, 1991).

CURVILINEAR SHAPES

The Miata roadster shown in **A** is a form composed of many compound curves. It is said that there is nowhere for a drop of water to rest on the surface: it will flow along a curved plane. Such a **curvilinear** design may be functional and aerodynamic, but it is not the only possibility for a car. More recent cars affect the chiseled angles of a stealth fighter. Style sometimes trumps function in consumer products.

The poster in **B** shows a similar emphasis on curvilinear shapes. There is barely a straight line to be found. This poster is a product of a late nineteenth-century style called **art nouveau**, which put total pictorial emphasis on curvilinear or natural shapes.

We have seen previous examples of curvilinear shapes in fine art examples such as the paintings shown earlier in this chapter. Such shapes will obviously be found in still life and figure painting but are also ubiquitous in pop culture, animation, and illustration. The Walt Disney preparatory drawings for the film *Snow White* (C) show the underlying ovals that create the curvilinear shapes of the character. Such shapes predominate in Disney animation and can be found at the root of every character.

The artwork shown in **D** is a witty contemporary deconstruction of another Disney character that displays the curvilinear elements as separate pieces. Even in this condition, Mickey is still recognizable! Like much of pop art, this artwork reveals the visual language shared by fine art, graphic design, and popular forms.

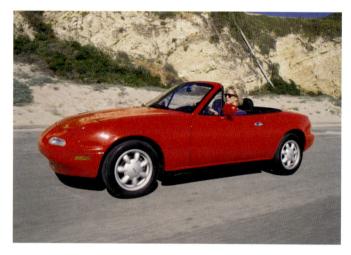

Mazda Miata. 1990

RECTILINEAR SHAPES AND COMBINATIONS

The prefabricated house **(A)** offers a sharp contrast to the examples of the preceding section on curvilinear shapes. The architecture emphasizes right angles and rectangular planes—all the forms have straight edges, giving a sharp, angular feeling. **Rectilinear** is the term to describe this visual effect. This may be a practical concern transporting and fabricating the components to the house, but it is certainly not the only form possible. A clean rectilinear design offers a simplicity and clarity that has been a modernist ideal.

The painting by Yeardley Leonard **(B)** is clearly a rectilinear design. The emphasis of this painting is on color intervals and relationships. A rectilinear composition keeps the focus on planes of color, and these planes repeat the overall format of a rectangular painting.

↑ A

Rocio Romero. Prefabricated Home ("LV Home," designed as a second vacation home).

We do think of curvilinear shapes as natural, reflecting the soft, flowing shapes found in nature. Rectilinear shapes, being more regular and precise, suggest geometry and, hence, appear more rational and manufactured. Of course, these are very broad conclusions. In fact, rectilinear shapes abound in nature, for example in crystalline minerals, and the curvilinear architecture of a city like Barcelona reflects a sensuous environment and culture.

Shapes in Combination

These rectilinear examples and the curvilinear examples shown in the previous section all concentrate exclusively on a single type of shape. Most art and design combine both curvilinear and rectilinear shapes. In architecture we may think of rectilinear design dominating, with the verticals and horizontals of doors, windows, and walls. The simple curve of an arch can provide visual relief. Or, as in **C**, a dramatically curved section of the building seems to send a ripple or wave through the design of the rest of the building, even affecting the pattern of rectangular windows.

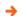

C

Nationale-Nederlanden Building. Prague. 1996. Architects: Vladimir Milunic, Frank Gehry. The Metropolitan Museum of Art (1984). Photo: Tim Griffith/Esto.

POSITIVE/NEGATIVE SHAPES

INTRODUCTION

The four examples in **A** illustrate an important design consideration that is sometimes overlooked. In each of these patterns, the black shape is identical. The very different visual effects are caused solely by its placement within the format—the location of the black shape immediately organizes the empty space into various shapes. We often refer to these as **positive** and **negative shapes**. The black shape is a positive element; the white empty space is the negative shape or shapes. *Figure* and *ground* are other terms used to describe the same idea, the black shape being the figure.

Negative Spaces Are Carefully Planned

In representational paintings, the distinction between object and background is usually clear. It is important to remember that both elements have been thoughtfully designed and planned by the artist. The subject is the focal point, but the negative areas created are equally important in the final pictorial effect. Japanese art often intrigues the Western viewer because of its unusual design of negative spaces. In the Japanese print **(B)**, the unusual bend of the central figure and the flow of the robes to touch the edges of the picture create two varied and interesting negative spaces. A more usual vertical pose for this figure would have formed more regular, symmetrical shapes in the negative areas. In this composition the dominant shapes are actually the hair and black borders on the robe. The light ground blends with the face and head; only a delicate line marks the boundary of figure and ground here.

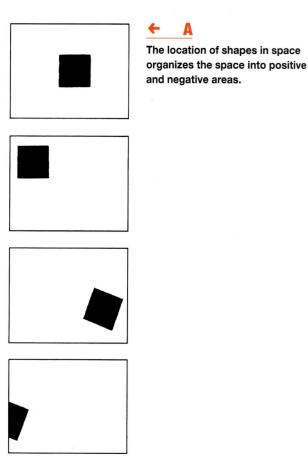

Kitagawa Utamaro. Ten looks of women's physiognomy/enjoyable looks. The Japan Ukiyo-e Museum, Matsumoto, Japan.

Negative shapes are also an aspect of letter design and typography. In this case a black letter may be the "figure" and the white page, the "ground." Aaron Siskind's photograph *Chicago 30* **(C)** is apparently a sideways letter *R*. By cropping in on his subject, Siskind has given almost equal weight to the white negative areas, thus giving emphasis to the shapes of both. The play of light and dark or figure and ground is similar to the print by Utamaro **(B)**.

Using Negative Space in Three Dimensions

The same positive/negative concept is applicable to three-dimensional art forms. The sculpture shown in **D** is first perceived as large arcs of steel. As you move about the labyrinth-like arrangement, the space becomes not a mere leftover but a positive component of the composition. A view skyward reveals the power of the negative shapes.

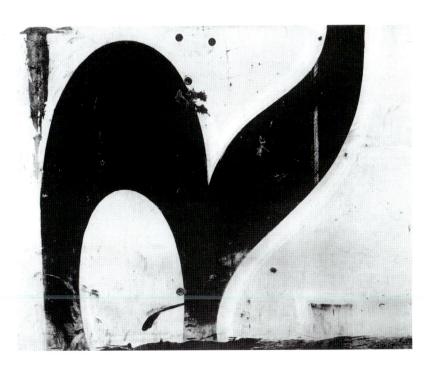

Aaron Siskind. *Chicago 30.* 1949. Silver gelatin, 1' 1%" \times 1' 5%". International Center of Photography, New York.

ISOLATION OR INTEGRATION

Design themes and purposes vary, but some integration between positive and negative shapes is generally thought desirable. In **A** the shapes and their placement are interesting enough, but they seem to float aimlessly within the format. They also have what we call a "pasted-on" look, because there is little back-and-forth visual movement between the positive shapes and the negative white background. An unrelieved silhouette of every shape is usually not the most interesting spatial solution.

The image in **B** shows similar shapes in the same positions as those in **A**, but the "background" is now broken into areas of value that lend interest as well as greater positive/negative integration. The division into positive and negative is flexible—that is, some squares serve *both* as a ground (negative) that hosts smaller square shapes and as a figure (positive) within the larger ground of the entire composition.

Picasso's Harlequin **(C)** closely resembles the dynamics of **B**. Although black surrounds the central shapes on four sides, there is a variety of overlap in the central shapes and variety in the size and shape of the black areas around the perimeter. Furthermore, black shapes also appear with the interior of the composition, and the pendulum-like black shape at center top moves to the foreground as other black shapes retreat. In fact, all the planes or shapes of color advance in some areas and retreat in others. This weaving of the shapes creates an integrated composition.

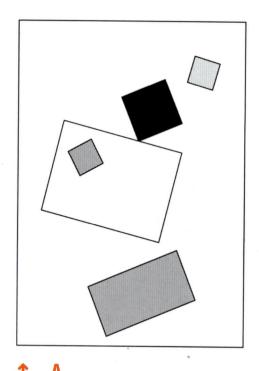

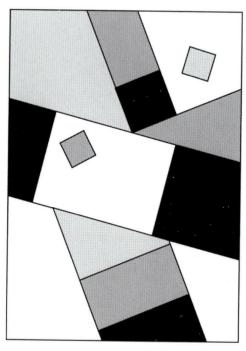

If the negative areas are made more interesting, the positive-negative integration improves.

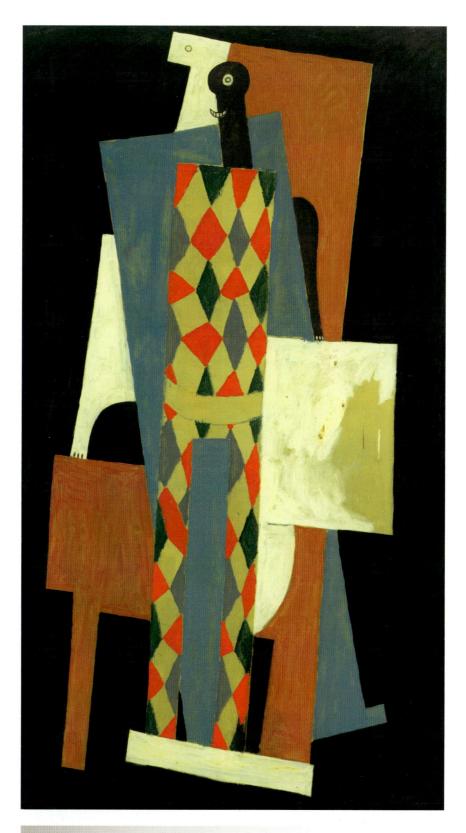

Pablo Picasso. Harlequin. Paris, late 1915. Oil on canvas, 6' 14° \times 3' 5% (183.5 \times 105.1 cm).

EMPHASIS ON INTEGRATION

Three drawings by Georges Seurat demonstrate three degrees of positive/negative integration. The drawing of the female figure shown in **A** presents the figure as a dark shape against a lighter background. For the most part this is a silhouette; positive and negative (figure and ground) are presented as a simple contrast.

The relationship of positive and negative is more complex in **B**. The left side of the figure is dark against a lighter ground, and the right side of the figure is light against a darker ground. This alternation of dark and light makes us aware of the negative shapes, and they take on a stronger visual interest than in **A**.

The composition of **C** presents the most complex integration of positive and negative shapes of the three Seurat drawings. Here, dark, light, and middle values are present as both figure and ground. There are areas of sharp distinction, such as the edge of the arm against the background, and there are areas of soft or melting transitions where the eye moves smoothly from foreground to middle ground to background. The soft boundaries of the hair melt into the surrounding background shapes.

Gérôme's painting **(D)** offers a very rich example of figure/ ground or positive/negative integration. At first glance it is a simplistic presentation: the snowy field provides a stage for the actors, and the landscape provides a rather flat backdrop. To make matters "worse," the focus is the dying Pierrot—a white figure against a white (snowy) ground! Sounds like a recipe for a failed composition. But look again. Pierrot is framed by figures in black and red, which serve to advance the dying figure. In a reciprocal fashion the white Pierrot pushes back the red figure. So attention is drawn to the main actor while not overwhelming the composition. We don't fixate on the red. Meanwhile the departing Harlequin resides more subtly within the surrounding space. Gérôme deftly integrates shape and negative shape in a theatrical but complex composition.

See also Lost-and-Found Contour, page 146.

Georges Seurat. Silhouette of a Woman. 1882–1884. Conté crayon on paper, 1' \times 8%" (30.5 \times 22.5 cm). Collection of McNay Art Museum, San Antonio, Texas (bequest of Marion Koogler McNay).

个 E

Georges Seurat. *The Black Bow.* c. 1882. Conté crayon, 1' $^{3}/_{6}$ " \times 9 $^{4}/_{6}$ " (31 \times 23 cm). Musée d'Orsay, Paris.

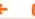

Georges Seurat. Embroidery: The Artist's Mother (Woman Sewing). 1882–1883. Conté crayon, 1 1 %" \times 9% $^{\shortparallel}$ (31.2 \times 24 cm). Metropolitan Museum of Art (Purchase, Joseph Pulitzer Bequest, 1951; acquired from The Museum of Modern Art, Lillie P. Bliss Collection).

Jean-Léon Gérôme. The Duel after the Masquerade. 1857–1859. Oil on canvas, 1' 3%" \times 1' 10%6" (39.1 \times 56.3 cm).

POSITIVE/NEGATIVE SHAPES

AMBIGUITY

Sometimes positive and negative shapes are integrated to such an extent that there is truly no visual distinction. When we look at the painting in A, we are conflicted in our response to the bulbous central shape. The convex curves suggest a positive form or figure framed by a yellow border. The small wedges of dark color along the edge of the painting can visually connect with the dark center shape, and then it becomes possible to see the dark area as a space, like a dark entryway. The artist has purposely made the positive/negative relationship ambiguous. The big shape can be both figure and ground.

The film poster in **B** has this same quality, as our eyes must shift back and forth from dark to light in seeking the positive element. We may at first see two black heads, one in top hat, silhouetted against a light shape. Then we notice the light area is a woman's profile. The image is appropriate for the title, The Bartered Bride.

Deliberate Blending of Positive/Negative Shapes

In most paintings of the past, the separation of object and background was easily seen, even if selected areas merged visually. But several twentieth-century styles literally did away with the distinction. We can see that the subject matter of the painting in C is a figure. Despite the cubist abstractions of natural forms into geometric planes, we can discern the theme. But it is difficult to determine just which areas are part of the figure and which are background. The artist, Picasso, also broke up the space in the same cubist manner. There is no clear delineation of the positive from the negative.

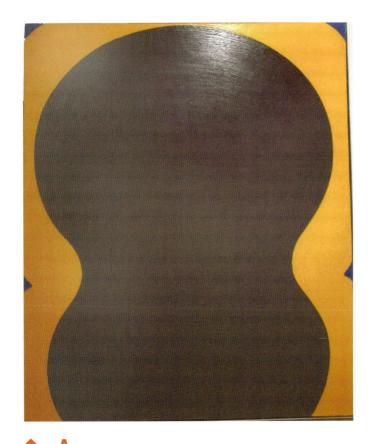

Mit Jarmila Novotna

Annemarie Sörensen

Willy Domgraff-Fassbänder

Paul Kemp Karl Valentin

Liesl Karlstadt Max Schreck

Regie: Max Ophüls Die erste deutsche Filmoper

eine Kostbarkeit des Films der 30er Jahre

Deliberate Delineation of Positive/ **Negative Shapes**

Picasso's painting invites the viewer to a slow reading of figure and ground relationships. In graphic design the goal more often is to make a quicker impact. An integration of positive and negative shapes not only is a way to get a viewer's attention with high-contrast simple forms, but often it can present surprising or memorable results. The logo for Multicanal, an Argentine cable company (D), takes advantage of an alternating figure ground reading. Our attention is captured by the back-and-forth reading of stars and M.

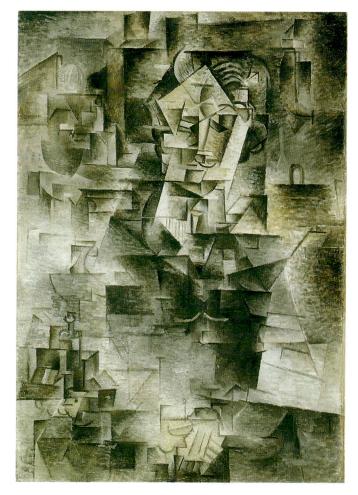

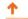

Pablo Picasso. Daniel-Henry Kahnweiler. 1910. Oil on canvas, 3' 3%" \times 2' 4%" (101.1 \times 73.3 cm). Photograph courtesy of The Art Institute of Chicago (gift of Mrs. Gilbert W. Chapman, 1948).

 $"Oh, for\ Pete's\ sake,\ lady!\ Go\ ahead\ and\ touch\ it."$

PATTERN

Creating Visual Interest 180

PATTERN

Order and Variety 182

TEXTURE AND PATTERN

Similarities and Differences 184

TEXTURE

Creating Visual Interest 186

TACTILE TEXTURE

Actual and Implied 188

TACTILE TEXTURE

Collage 190

VISUAL TEXTURE

Verisimilitude and Trompe L'oeil 192

CREATING VISUAL INTEREST

Pattern is a term ubiquitous to design. It has one meaning when we think of a "dress pattern" or template, and it has another, more general meaning referring to repetition of a design motif. This latter meaning is intrinsic to the human thought process. We say we need to change our patterns of thought or actions when we want to break a habit. We speak of "pattern recognition" when we search for meaning in facts or information. Humankind's earliest discoveries relating to the cosmos came with the recognition of the patterns of seasons and lunar cycles. Though "pattern"—in the visual sense of the word—is often linked to a superficial idea of decoration, our very human interest in pattern clearly has deeper roots.

Psychologists speak of "horror vacui" or a need to fill up empty spaces, and that is a basic human impulse. This explains a desire to add visual interest to an empty surface or space. When this surface activation is accomplished through repeated marks or shapes, we have the beginnings of pattern. The photograph in **A** shows the walls of a young man's room filled with photos similar enough to create a "wallpaper" effect and form an ad hoc pattern.

Pattern can be intricate or simple. The pattern being created in **B** is both simple and bold. Further, it echoes the pattern of the woman's dress, suggesting her preference for such motifs.

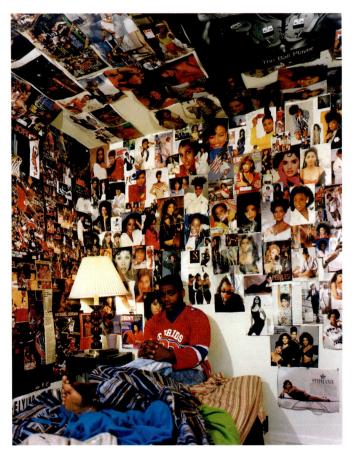

Adrienne Salinger. Fred H. Photograph from Teenagers in Their Bedrooms (Chronicle Books, 1995).

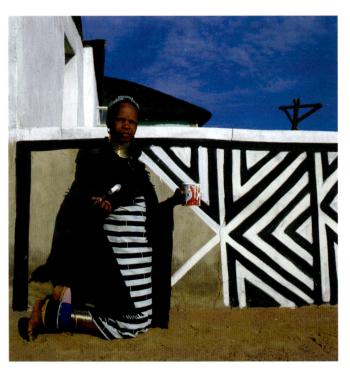

Margaret Courtney-Clarke. *Anna Mahlangu Painting Her Home for a Ceremonial Occasion.* 1985. Photograph. Mabhokho, Kwandebele, South Africa.

Pattern is a dynamic way of capturing visual interest as we can appreciate in Picasso's *Harlequin* painting. The detail shown in **C** is from the center of the painting, and seen in isolation we see how striking it is. The red diamonds fairly pop and create a jazzy rhythm.

The pattern worn by the harlequin character in Gérôme's painting **(D)** is the same as the Picasso version, but notice how toned down it is as the figure retreats into the fog. This pattern would surely compete for attention with the dying figure (not shown in this detail) if Gérôme did not use this device to diminish the effect.

See also Introduction: Visual Rhythm, Rhythm and Motion, and Alternating Rhythm, pages 114, 116, and 118.

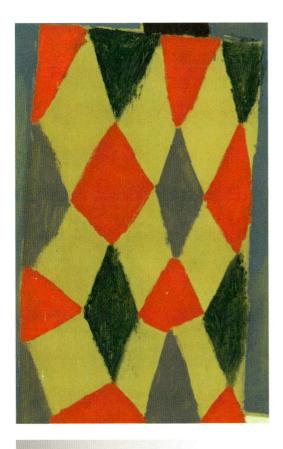

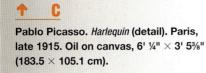

Jean-Léon Gérôme. The Duel after the Masquerade (detail). 1857–1859. Oil on canvas, 1' 3%" \times 1' 10%" (39.1 \times 56.3 cm).

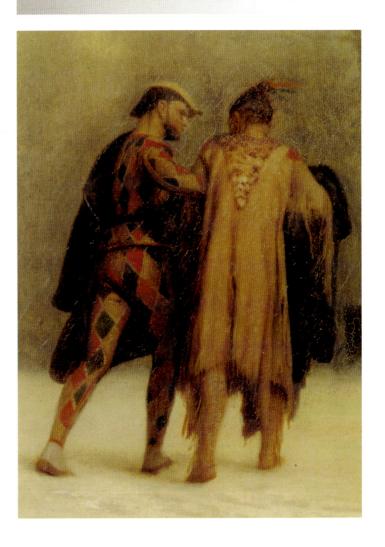

ORDER AND VARIETY

Pattern begins with a unit or shape that is repeated. It is common to find pattern based on floral designs evoking the richness of a garden. Such floral motifs can be representational and flow like a rambling vine, or more abstract and geometric as in example $\bf A$.

Most patterns can be reduced to a grid of some sort, and the result is a crystallographic balance or order. A highly disciplined version of this is seen in the Alhambra tiles shown in **B**. Here we can see both the individual units or tiles and the larger expanse of the patterns. Such elaborate patterns are built on complex symmetries, repetitions, and rotations.

The drawings of M.C. Escher continue the tradition of highly mathematical pattern-making we see in the Alhambra. Figure **C** shows the basic triangular unit that is the core of one such pattern. Notice the order along lines formed by each side of the triangle. Each curve or shape has an equal and opposite curve or

shape balanced by radial symmetry around the midpoint of the line. Example **D** reveals the hexagon that orders the pattern of fish shapes. Slide the hexagon down and to the right on a thirty-degree axis, and the pattern is created. Each point of pinwheel-like rotation conforms to a radial symmetry. The magic of such a pattern is a complete unity of figure and ground. Every space is also a fish!

The examples we have seen thus far are closely related to architecture or graphics. In painting, an artist may include pattern as one element among others such as line or shape or color. Gustav Klimt gains some of the dazzle of the Alhambra in his juxtaposition of two patterns in the painting *Hope, II* (E). The patterns in this case are distinct from each other and do not conform to a strict order (you can find variety in each).

See also *Positive/Negative Shapes*, pages 170, 172, 174, and 176, and *Radial Balance*, page 106.

Yellow and blue ceramic tiles (azulejos) from Portugal.

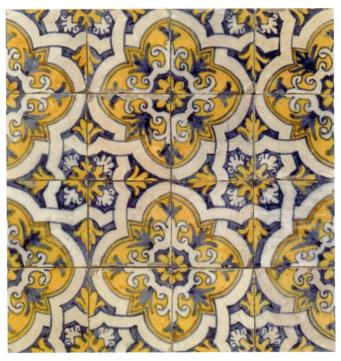

Tile patterns from the Alhambra, Granada, Spain. Close-up of ornamental mosaic.

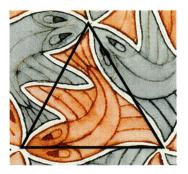

M.C. Escher. Pattern Drawing (detail). Triangular module. M.C. Escher's Symmetry Drawing E94 © 2007 The M.C. Escher Company, Holland. All rights reserved. www.mcescher.com.

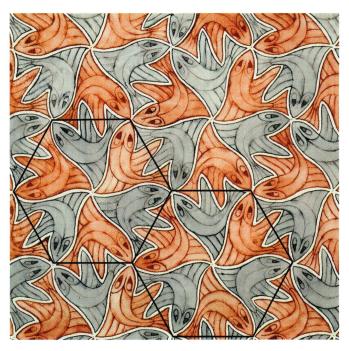

M.C. Escher. Pattern Drawing (detail). Hexagon repeat. M.C. Escher's Symmetry Drawing E94 © 2007 The M.C. Escher Company, Holland. All rights reserved. www.mcescher.com.

Gustav Klimt. Die Hoffnung II (Hope, II). 1907-1908. Oil and gold paint on canvas, 3' $7\frac{1}{2}$ " \times 3' $7\frac{1}{2}$ " (110.5 \times 110.5 cm). Museum of Modern Art.

SIMILARITIES AND DIFFERENCES

It would be difficult to draw a strict line between texture and pattern. Pattern is usually defined as a repetitive design, with the same motif appearing again and again. Texture, too, often repeats, but its variations usually do not involve such perfect regularity. The difference in the two terms is admittedly slight. The texture of a material such as burlap would be readily identified by touch, yet the surface design is repetitive enough that a photograph of burlap could be called pattern.

The essential distinction between texture and pattern seems to be whether the surface arouses our sense of touch or merely provides designs appealing to the eye. In other words, although every texture makes a sort of pattern, not every pattern could be considered a texture. Some suggestion of a three-dimensional aspect to the surface, such as shadows or glossiness, no matter how subtle, will visually evoke texture.

Evoking Our Sense of Touch

This distinction between what the eye takes to be simply pattern and the qualities that evoke our sense of touch can be seen in the three examples beginning with **A**. This decorative motif is regular, high in contrast, and representational of a plant. It is clearly a pattern. The image in **B** is also a Victorian-era decorative motif, but its irregular pattern and lack of a representational image allow it to be read as a series of ridges, and thus it has some textural associations. The image in **C** is a close-up of pleated silk. The pattern is again rippled, but there is also a variety of grays. It is more complex than **B** and more suggestive of texture. An irony is that the resulting image in **C** is rather like tree bark and might not be recognized as silk due to this close-up view.

The small, intricate designs that dominate the illustration in **D** create both patterns and textures. The peacock's tail offers a pattern of repeated shapes and the texture of the feathers. The many small marks in the background suggest the texture of foliage. This illustration shows a rich vocabulary of pattern and texture possible with just black and white.

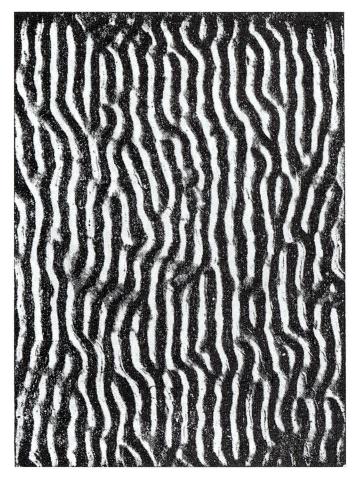

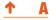

Figured glass.

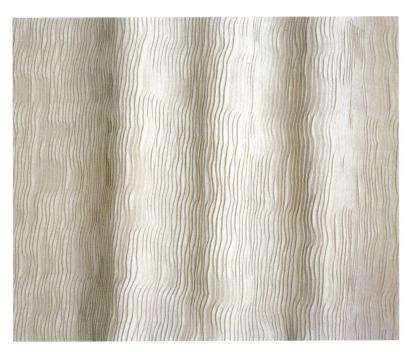

Gretchen Belinger (textile designer). Isadora® (pleated silk). 1981. From Contemporary Designers (London: St. James Press, 1990).

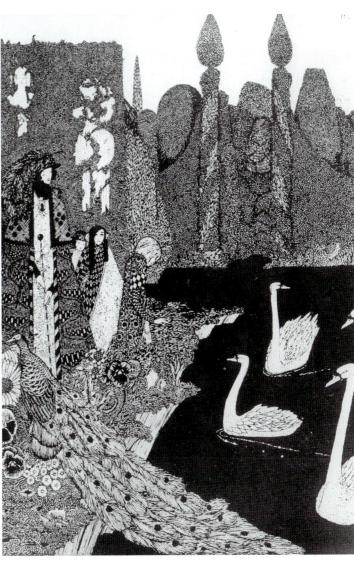

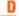

Harry Clarke. The Most Beautiful of All, illustration for "The Ugly Duckling" from Fairy Tales by Hans Christian Andersen. c.1910. Half-tone engraving.

CREATING VISUAL INTEREST

Texture refers to the surface quality of objects. Texture appeals to our sense of touch. Even when we do not actually feel an object, our memory provides a sensory reaction or sensation of touch. In effect, the various light and dark patterns of different textures give visual clues so that we can enjoy the textures vicariously. Of course, all objects have some surface quality, even if it is only an unrelieved smooth flatness. The element of texture is illustrated in art when an artist purposely exploits contrasts in surface to provide visual interest.

Texture in Craft Forms

Many art forms have a basic concern with texture and its visual effects. In most of the craft areas, texture is an important consideration. Ceramics, jewelry, and furniture design often rely heavily on the texture of the materials to enhance the design effect. In weaving and the textile arts, texture is a primary consideration. The interior designer must be sensitive to the visual effects that textural contrasts can achieve.

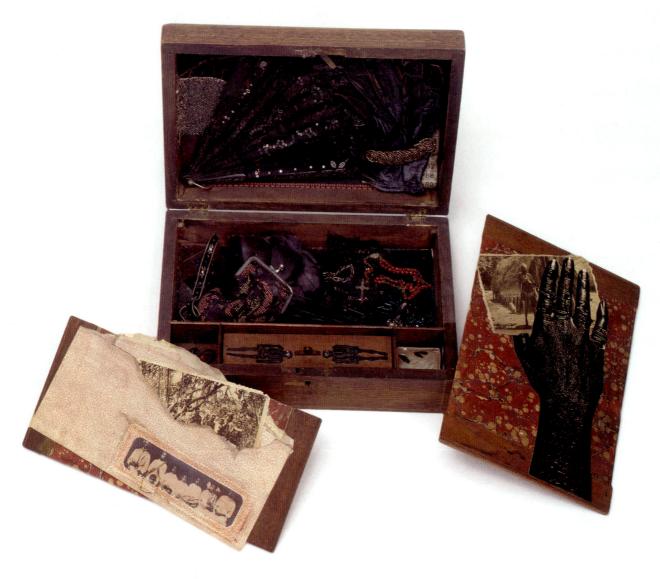

Texture in Sculpture

In sculpture exhibits, Do Not Touch signs are a practical (if unhappy) necessity, for so many sculptures appeal to our enjoyment of texture that we almost instinctively want to touch. The smooth translucence of marble, the rough grain of wood, the polish or patina of bronze, the irregular drop of molten soldereach adds a distinctive textural quality.

Textural Variety

Betye Saar's The Time Inbetween (A) contains a variety of textures and seems to invite us to explore this intimate collection by handling it. Beads, feathers, bone, and velvet provide a variety of tactile sensations. A photocopy of the artist's hand underscores the primacy of the sense of touch for this artwork.

The photograph in **B** shows how a variety of textures create sustained interest in the image. Our eye may be initially drawn to the red architectural details, but our attention would soon fade were it not for the contrasts of stone, shingle, and wood. The photographer's decision to crop the image keeps our focus on these details.

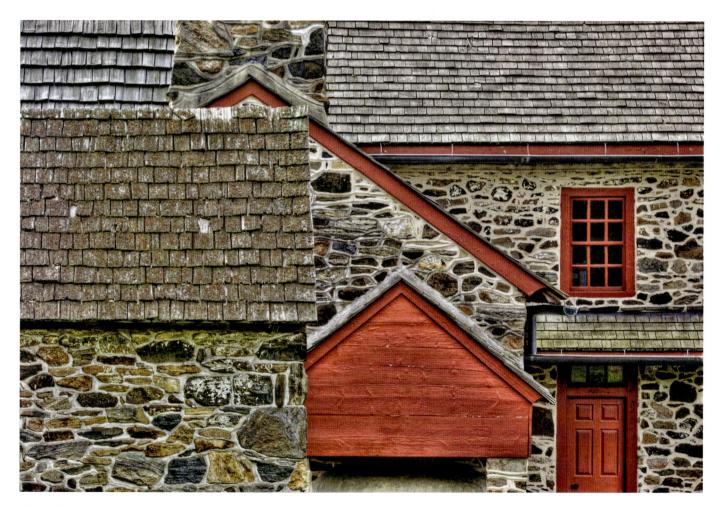

TACTILE TEXTURE

ACTUAL AND IMPLIED

There are two categories of artistic texture—tactile and visual. Architecture and sculpture have what is called tactile texture-texture that can actually be felt. In painting, the same term describes an uneven paint surface, produced when an artist uses thick pigment (a technique called impasto) to create a rough, three-dimensional paint surface.

Texture as Paint on Canvas

As the need and desire for illusionism in art faded, tactile texture became a more common aspect of painting. Paintings now could look like what they truly were-paint on canvas. Calling attention to the painting's surface became another option available to the artist. Van Gogh was an early proponent of the application of paint as an expressive element. The detail in A shows how short brushstrokes of thick, undiluted paint are used. The ridges and raised edges of the paint strokes are obvious to the viewer's eye. On the figure they follow the form, and in the background these strokes form a more abstract pattern akin to the sky and cypress trees of his landscape paintings.

The Next Step

The "relief painting" by Thornton Dial (B) shows a next step in bringing tactile texture into a painting. This painting is so complex with contrasts of value (light and dark) and added materials that we have to look closely at some parts to determine what is tactile texture and what is implied texture. In this case materials include cans, bottles, and a desiccated cat! The surprising result is one of paint and other materials working together to create a unified composition. The dividing line between painting and sculpture disappears in many such contemporary works when physical items are attached to the painted surface.

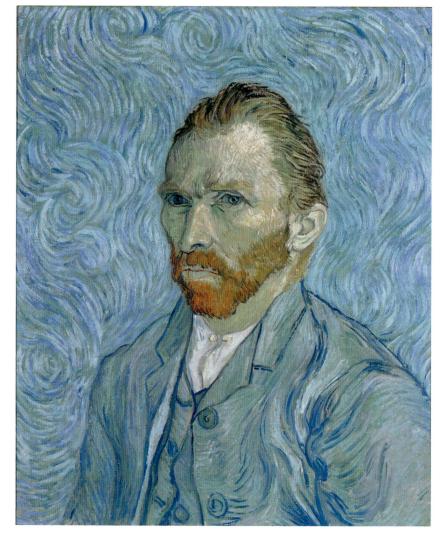

Implied Texture

The actual texture of thick strokes records the process of van Gogh's portrait. Texture becomes a visual history of the painting's creation. In contrast to this, the image of brushstrokes in Lichtenstein's print **(C)** is only an implied texture. In fact, the texture of a screen print is as flat and smooth as can be.

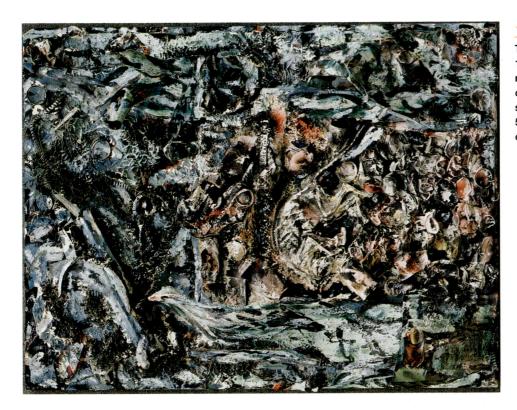

Thornton Dial. Contaminated Drifting Blues. 1994. Desiccated cat, driftwood, aluminum cans, glass bottle, found metal, canvas, enamel, spray paint, industrial sealing compound on surplus plywood, 5' $7'' \times 4'$ $1'' \times 1'$ 5'/2'' (170 \times 124 \times 44 cm). Collection of William S. Arnett.

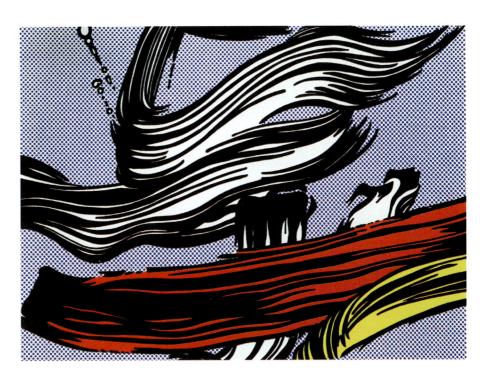

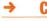

Roy Lichtenstein, <code>Brushstrokes</code>. 1967. Color screen print, 1' 10" \times 2' 6" (55.88 \times 76.2 cm) (image) 1' 11" \times 2' 7" (58.42 \times 78.74 cm). © Estate of Roy Lichtenstein.

TACTILE TEXTURE

COLLAGE

Creating a design by pasting down bits and pieces of colored and textured papers, cloth, or other materials is called **collage**. This artistic technique has been popular for centuries, mainly in the area of **folk art**. Only since the twentieth century has collage been seriously considered a legitimate medium of the fine arts.

Why Collage?

The collage method is a very serviceable one. It saves the artist the painstaking, often tedious task of carefully reproducing textures in paint. Collage is an excellent **medium** for beginners. Forms can be altered or reshaped quickly and easily with scissors. Also, compositional arrangements can more easily be tested (before pasting) than when the design is indelibly rendered in paint.

Creating a Range of Tactile Sensations

Mary Bauermeister's collage titled *Progressions* (A) is composed of stones and sand on board. Even in the reproduction, one can imagine a range of tactile sensations, from bumpy to rough. Bauermeister has emphasized the textural qualities of her materials by reducing the composition to a few squares of progressively larger size. Within two of the squares there is also a progression in the size of the pebbles, creating a gradation in texture from fine to coarse. The physical presence of the materials can be seen in the shadows cast by this collage.

Anne Ryan, an American, worked mainly in collages of cloth. Her untitled collage in **B** shows various bits of cloth in contrasting weaves and textures interspersed with some scraps of printed papers. The dark and light pattern is interesting, but our attention is drawn mainly to the contrast of tactile textures.

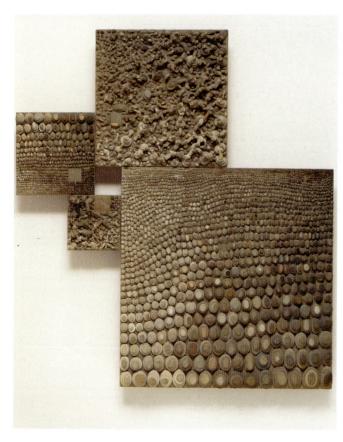

Mary Bauermeister. *Progressions.* 1963. Pebbles and sand on four plywood panes, 4' 3%" \times 3' 11%" \times 4%" (130.1 \times 120.4 \times 12 cm). The Museum of Modern Art, New York (Matthew T. Mellon Foundation Fund).

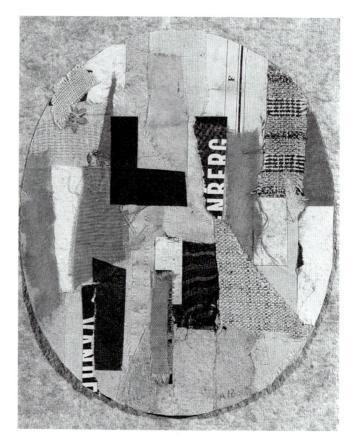

Anne Ryan. <code>Untitled, No. 129. c. 1948–1954. Collage on paper, $43/4"\times41/4"$ (12.1 \times 10.8 cm). Courtesy Joan T. Washburn Gallery, New York.</code>

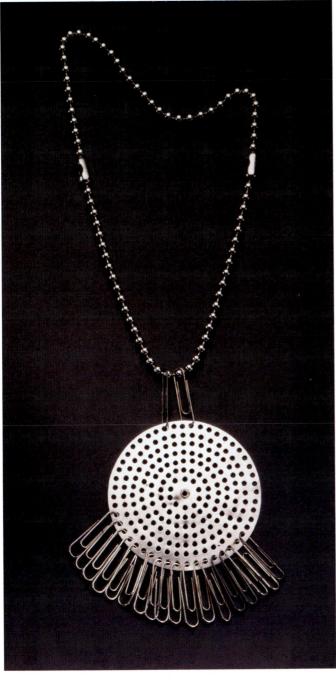

ተ (

Anni Albers and Alex Reed. *Neck piece.* c. 1940. Aluminum strainer, paper clips, and chain, $4\%"\times3\%"$ (10.8 \times 8 cm). © 2003 The Josef and Anni Albers Foundation/Artists Rights Society (ARS), New York. The Josef and Anni Albers Foundation, Bethany, Connecticut.

Using Found Materials

Folk art is often characterized by an inventive use of found materials and may be considered one of the oldest forms of collage. Such a spirit is also seen in a necklace created from found materials **(C)**. We instinctively sense the metallic feel of clips and chain and tea strainer that were transformed into jewelry. The same artist, Anni Albers, also anticipated (many decades ago) our current interest in recycling materials for new uses. Her wall covering material shown in **D** consists of cotton and cellophane. Today we may be surprised that a soft shopping bag may be made from recycled plastic bottles. In these examples a potentially unpleasant material is transformed into a pleasing texture.

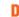

Anni Albers. Wall covering material. 1929. Cotton and cellophane, 9" \times 5" (22.9 \times 12.7 cm). © 2003 The Josef and Anni Albers Foundation/Artists Rights Society (ARS), New York. The Josef and Anni Albers Foundation, Bethany, Connecticut.

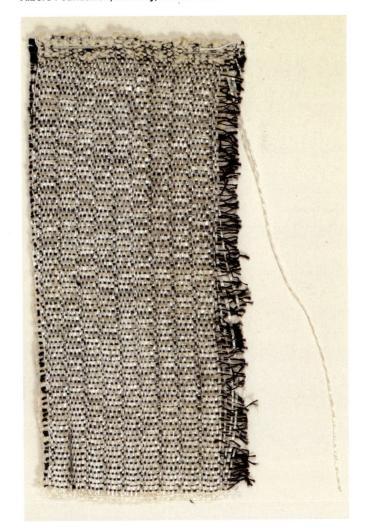

VERISIMILITUDE AND TROMPE L'OEIL

In painting, artists can create the impression of texture on a flat, smooth painted surface. This is called **verisimilitude**, or an appearance that is "truly the same." By reproducing the color and value patterns of familiar textures, painters encourage us to see textures where none actually exist. **Visual texture** is the impression of texture as purely visual; it cannot be felt or enjoyed by touch. It is only suggested to our eyes.

Choosing Subject Matter Rich in Texture

One of the pleasures of still-life paintings is the contrast of visual textures. These works, even when they lack symbolism or emotional content, can be purely visual delights as the artist plays one simulated texture against another. Pieter Claesz's painting (A) evokes the cold hardness of stone, the moist surface of fruit, and the feel of metal and glass. This painting appears to have been painted with fluid paint and a soft brush. No physical mark is made by the paint.

In contrast to the method used by Peter Claesz, Max Ernst creates an eerie landscape texture through processes like **frottage** or rubbings **(B)**. This **surrealist** artist exploits equivalence between the depicted texture and the technique that creates it. Leonardo da Vinci observed that the prepared mind is capable of seeing a battle scene in the stains on a wall. This describes an artist's ability to convert smears, stains, and marks into implied textures and representations.

Pieter Claesz. Still Life with Two Lemons, a Façon de Venise Glass, Roemer, Knife and Olives on a Table. 1629. Oil on panel, 1' 4%" \times 1' 11%" (42.8 \times 59.3 cm). Anonymous loan.

Trompe L'oeil

The ultimate point in portraying visual texture is called **trompe l'oeil**, a French term meaning "to fool the eye." This style is commonly defined as "deceptive painting." In trompe l'oeil, the objects, in sharp focus, are delineated with meticulous care. The artist copies the exact visual color and value pattern of each surface.

What is meant by visual color as the term is used here? The artist Neil Welliver once observed that the color he mixes to represent a rock in his landscape painting is *not* the color of the rock, but the color the rock *appears* to be when presented in the context of the painting. Perhaps it has to be lighter or bluer, for example. This will look right in the painting, but if the paint was applied to the rock, it would not match it. Set painters understand this as they exaggerate contrast in painting sets for the theater so that implied texture can be perceived from a distance. A deception occurs because the *appearance* of objects is so skillfully reproduced that we are momentarily fooled. We look closer, even though our rational brain identifies the image as a painting and not the actual object.

Textural trompe l'oeil is most convincing when the image is shallow or almost two dimensional. When a three-dimensional object is represented in a painting, no matter how skillfully, our binocular vision will soon betray the deception. Both ${\bf C}$ and ${\bf D}$ succeed in their deception, not only because of a skillful attention to detail but also because the subjects depicted are low relief textures. An ordinary bridge underpass is transformed into elaborate masonry through trompe l'oeil painting in ${\bf D}$.

↑ C

Ed Ruscha. Rancho. 1968. Oil on canvas, 5' height \times 4' 6" width.

"JUST GO DOWN TO THE VANISHING POINT AND TAKE A LEFT,"

CHAPTER OILLUSION OF SPACE

INTRODUCTION

Translating Space to Two Dimensions 196

DEVICES TO SHOW DEPTH

Size 198

DEVICES TO SHOW DEPTH

Overlapping 200

DEVICES TO SHOW DEPTH

Vertical Location 202

DEVICES TO SHOW DEPTH

Aerial Perspective 204

DEVICES TO SHOW DEPTH

Plan, Elevation, Perspective 206

DEVICES TO SHOW DEPTH

Linear Perspective 208

DEVICES TO SHOW DEPTH

One-Point Perspective 210

DEVICES TO SHOW DEPTH

Two-Point Perspective 212

DEVICES TO SHOW DEPTH

Multipoint Perspective 214

AMPLIFIED PERSPECTIVE

A Different Point of View 216

MULTIPLE PERSPECTIVE

A Pictorial Device 218

ISOMETRIC PROJECTION

A Spatial Illusion 220

OPEN FORM/CLOSED FORM

The Concept of Enclosure 222

TRANSPARENCY

Equivocal Space 224

CONCLUSION

Complexity and Subtlety 226

TRANSLATING SPACE TO TWO DIMENSIONS

Many art forms are three-dimensional and therefore occupy space: ceramics, jewelry and metalwork, and sculpture, to name a few. In creating or viewing traditional figurative sculpture or in purely abstract forms, it is important for us to move about to fully take in the changing spatial experience from various angles. Architecture, of course, is an art form mainly preoccupied with the enclosure of three-dimensional space and our movement within those spaces.

In art forms, such as drawings, paintings, and prints, the artist who wants to convey a feeling of space or depth must translate clues from a three-dimensional experience to a two-dimensional plane. In this case space is an illusion, for the images rendered on paper, canvas, or boards are essentially flat.

↑ A

Michel Taupin. Rhythm Study. 2006. Digital photograph.

Surface and Depth

Many artists throughout the centuries have accepted an essential flatness and worked with primarily surface considerations of design. In contrast to that approach, some periods and cultures have emphasized spatial illusion. The contemporary artist and designer is conscious of *both* the two-dimensional plane and the many ways to suggest three-dimensional space. The photograph in **A** emphasizes the rhythm of trees on a hillside and is most interesting as a flat pattern. A different photograph by the same photographer taken the same day in the same region emphasizes the space of the Western landscape **(B)**. *Gros Ventre #3* **(B)** creates a sense of this space with many spatial clues: overlap, diminishing size, and effects of atmosphere.

The photograph in **A** and the painting in **C** have a surprising commonality: a vertical line at the center, which taken alone would tend to flatten the space. In **A** this line is suggested by the continuation of a few light tree trunks. In **C** a lamppost divides the painting into two rectangular areas. Nevertheless, Gustave Caillebotte's painting **(C)** pierces the **picture plane**. We are encouraged to forget that a painting is merely a flat piece of canvas. Instead, we are almost standing with the figures in the painting, and our eyes are led to the distant buildings across the plaza and down the streets that radiate from the intersection. Caillebotte's images suggest three-dimensional forms in a real space. The picture plane no longer exists as a plane, but becomes a window into a simulated three-dimensional world created by the artist. A very convincing illusion is created.

Artists throughout the centuries have studied this problem of presenting a visual illusion of space and depth. The engraving by Albrecht Durer from the sixteenth century **(D)** offers an early explanation of how the image we see in space—as if through a window—can be plotted as a series of points on the picture plane that records the view from a single, fixed vantage point. This establishes the meaning of "picture plane" and a basis for dealing with **foreshortening**, depth and space.

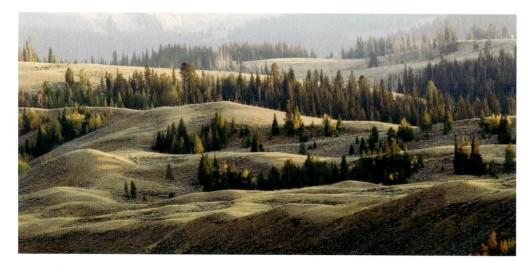

Gustave Caillebotte. Rue de Paris; Temps de Pluie (Paris Street, Rainy Day). 1877. Oil on canvas, 6' 11½" x 9' ¾" (212.2 \times 276.2 cm). The Art Institute of Chicago (Charles H. and Mary F. S. Worcester Fund Collection, 1964).

Albrecht Durer. Method of Perspective Drawing. c. 1530. Published in an 1878 history of the Middle Ages. Digital restoration by Steven Wynn Photography.

DEVICES TO SHOW DEPTH

SIZE

The easiest way to create an illusion of space or distance is through size. Very early in life we observe the visual phenomenon that as objects get farther away they appear to become smaller. Complex naturalistic artworks will employ many spatial clues, but it is possible to find artworks that choose a more limited vocabulary effectively. Abraham Walkowitz's painting (A) relies primarily on contrast of size. In this case the elements of the landscape are painted as flatter shapes; however, the foreground figures are larger than those in the middle and far distance. Size difference conforms with our understanding of how we perceive space, yet the artist is able to emphasize the shapes of rocks and figures and even glimpses of the ocean by playing down other effects of space.

Spatial Effect with Abstract Shapes

Notice that the size factor can be effective even with abstract shapes, when the forms have no literal meaning or representational quality **(B)**. The smaller squares automatically begin to recede, and we see a spatial pattern. With abstract figures, the spatial effect is more pronounced if the same shape is repeated in various sizes. The device is less effective when different shapes are used. The repetition of figures and rocks in **A** is consistent with the example shown in **B**.

Exaggerated Scale

Using relative sizes to give a feeling of space or depth is very common to many periods and styles of art. Some artists have taken this basic idea and exaggerated it by increasing the size differences. In the Japanese woodcut **(C)**, the one fish kite is very large and hence seems quite close. By contrast, the other smaller kites and the tiny figures, trees, and hills seem far in the distance. There are two advantages to this practice. First, seeing a kite drawn larger than human figures automatically forces us to imagine the great distance involved. Second, this very contrast of large and tiny elements can create a dynamic visual pattern.

The circus scene by Demuth **(D)** uses the same idea. One performer is shown very large and, hence, is in the foreground. The other trapeze artists are shown smaller and, therefore, recede into the background.

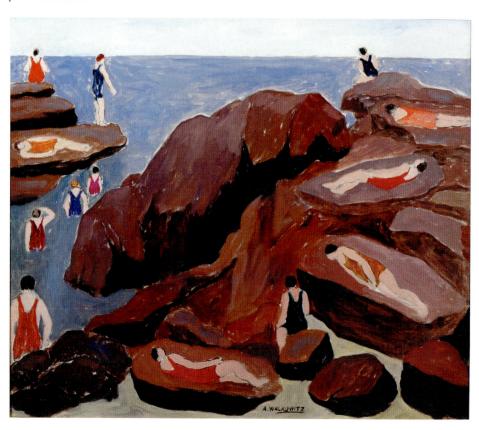

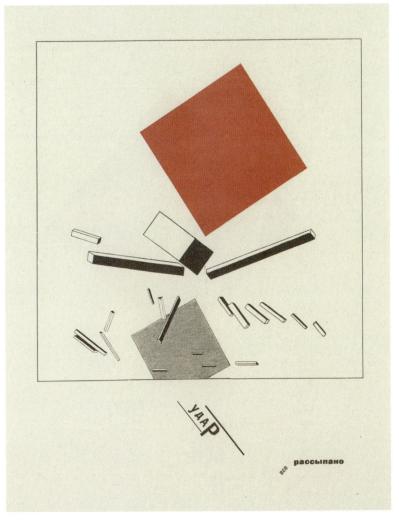

1

Ando Hiroshige. Suido Bridge and Surugadai (Suidobashi Surugadai) No. 48 from Famous Views of Edo. Edo Period, Ansei Era, published May 1857. Color woodblock print. Hiroshige, Ando or Utagawa (1797–1858). Brooklyn Museum of Art, New York, gift of Anna Ferris/The Bridgeman Art Library.

El Lissitzky. Of Two Squares: A Suprematist Tale in Six Constructions. 1922. Illustrated book with letterpress cover and six letter-press illustrations, $10^{15/6}$ " \times 8%" (27.8 \times 22.5 cm). Publisher: Skify, Berlin. Gift of the Judith Rothschild Foundation.

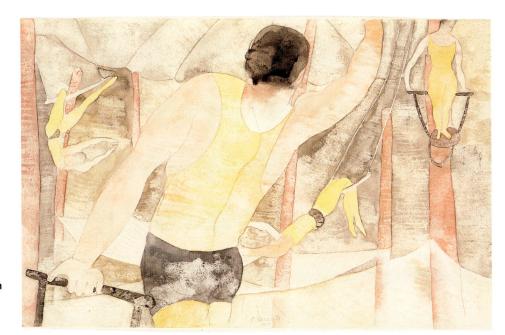

Charles Henry Demuth. Circus. 1917. Watercolor and pencil on paper, 8%6" \times 1' 1" (20.5 \times 33 cm). Hirshhorn Museum and Sculpture Garden, Smithsonian Institution, gift of Joseph H. Hirshhorn Foundation, 1966.

DEVICES TO SHOW DEPTH

OVERLAPPING

Overlapping is a simple device for creating an illusion of depth. When we look at the design in **A**, we see four elements and have no way to judge their spatial relationships. In **B** the relationships

are immediately clear due to overlapping. Each shape hides part of another because it is on top of or in front of the other. A sense of depth is established.

No real feeling of space or depth can be discerned.

t B

Simple overlapping of the shapes establishes the spatial relationships.

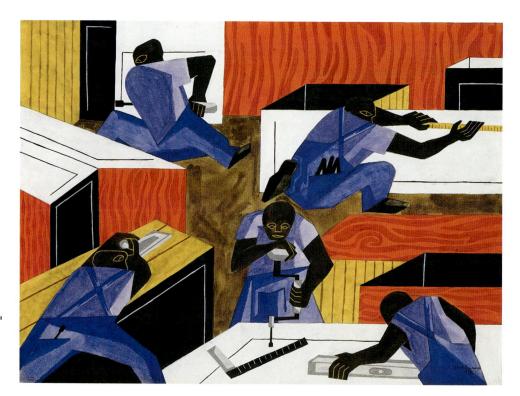

→ 0

Jacob Lawrence. Cabinet Makers. 1946. Gouache with pencil underdrawing on paper; sheet: 1' $10^{\text{\tiny II}} \times 2'$ $6\%_6^{\text{\tiny II}}$ (55.9 \times 76.6 cm), image: 1' $9\%'' \times 2'$ 6" (55.2 \times 76.1 cm). Hirshhorn Museum and Sculpture Garden, Smithsonian Institution, gift of Joseph H. Hirshhorn, 1966.

Overlapping with and without Size Differences

In Jacob Lawrence's painting **(6)**, there is no size difference between the cabinetmakers in the front and those in back. But we do understand their respective positions because of the overlapping that hides portions of the figures. Because overlapping is the primary spatial device used, the space created is admittedly very shallow. The pattern of two-dimensional shapes is stronger than an illusion of depth. Notice that when overlapping is combined with size differences, as in Hayllar's painting **(D)**, the spatial sensation is greatly increased.

Spatial Depth with Abstract Shapes

The same principle can be illustrated with abstract shapes, as the designs in **E** show. The design on top, which combines overlapping and size differences, gives a much more effective feeling of spatial recession.

See also Transparency, page 224.

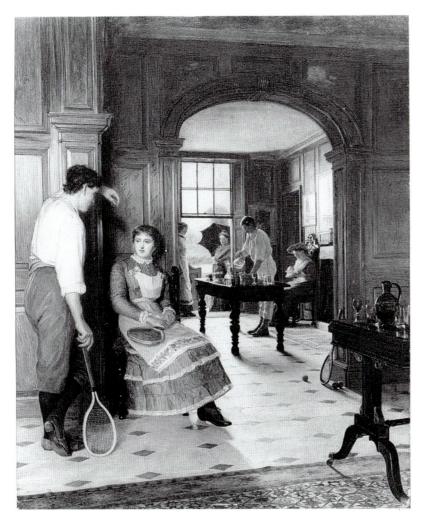

The design on the bottom does not give as much feeling of spatial depth as the one on top.

Edith Hayllar. A Summer Shower. 1883. Oil on panel, 1' 9" \times 1' 5%" (53.4 \times 44.2 cm). The Bridgeman Art Library.

VERTICAL LOCATION

Vertical location is a spatial device in which elevation on the page or format indicates a recession into depth. The higher an object, the farther back it is assumed to be. In the painting shown in **A**, the artist is relying mainly on vertical location to give us a sense of recession into depth. To our eyes, the effect, though charming and decorative, seems to have little suggestion of depth. The figures appear to sit almost on top of each other all in one plane. However, this device was used widely in Near Eastern and Asian Art and was immediately understandable in those cultures.

Emphasizing Figures and Objects

As the image in **B** shows, the use of vertical location in a composition can emphasize the figures, objects, and architectural features. These elements—the figures on a blanket, the card table, and the bridge—are given more importance than an accurate depiction of spatial relationships. This format is well suited for quilts, where other decorative elements may have significance along with the pictorial elements (for example, the text in the quilt's border).

The painting and collage by Tom Wesselmann **(C)** shows that this device can be effective even when aspects of the work are photo-realistic. In this painting we can see an arrangement based on a flat grid evident in the tablecloth pattern and other verticals and horizontals. Objects are arranged within this grid, and we sense the space presented based mainly on vertical location.

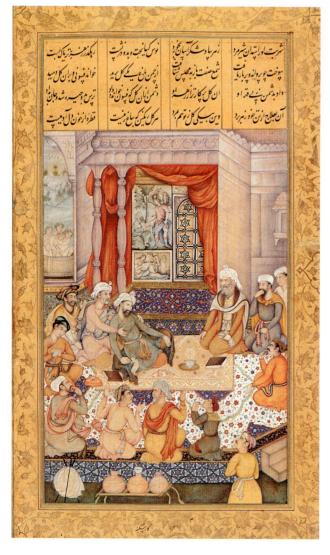

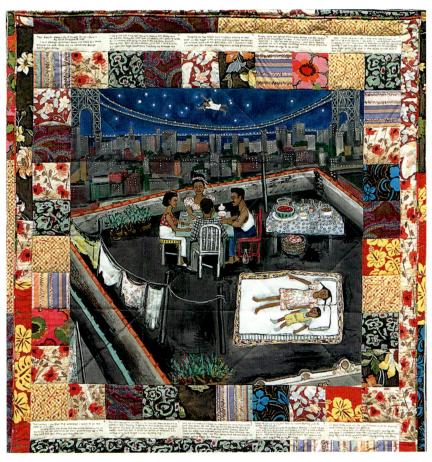

Faith Ringgold. *Tar Beach.* 1988. Acrylic paint on canvas and pieced tie-dyed fabric, 6' $2'' \times 5'$ 8'/2''. Collection of the Solomon R. Guggenheim Museum, New York.

Tom Wesselmann. Still Life #12. 1962. Acrylic and collage of fabric, photogravure, metal, etc., on fiberboard, $4" \times 4"$ (1.22 \times 1.22 m). Art © Estate of Tom Wesselmann. Licensed by VAGA, New York, New York. Smithsonian American Art Museum, Washington, DC/Art Resource, New York.

DEVICES TO SHOW DEPTH

AERIAL PERSPECTIVE

Aerial, or atmospheric, **perspective** describes the use of color or value (dark and light) to show depth. The photograph in **A** illustrates the idea: The value contrast between distant objects gradually lessens, and contours become less distinct. Greater contrast advances, diminished contrast retreats. Color changes also, with objects that are far away appearing less distinct and showing less contrast. The distant hills take on the bluish hue of the sky **(B)**.

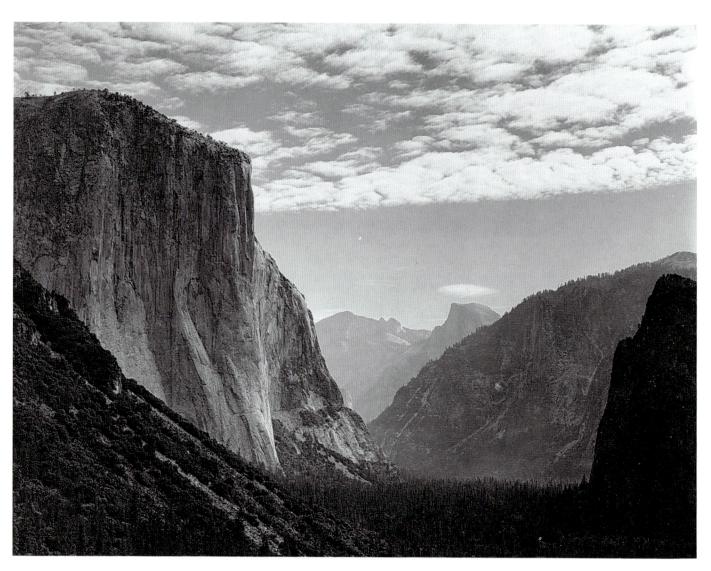

Ansel Adams. Yosemite Valley from Inspiration Point. c. 1936. Photograph. Copyright © 1993 by the Trustees of the Ansel Adams Publishing Rights Trust. All rights reserved.

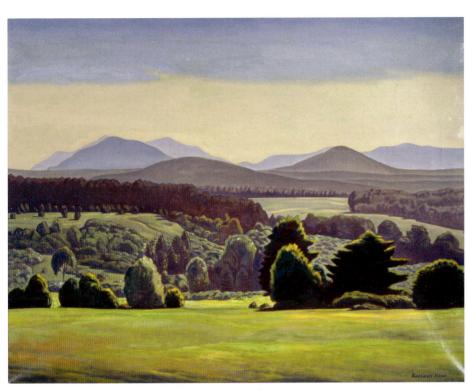

Rockwell Kent. Asgaard. 1950. Oil on canvas, 86×112 cm.

Mary Cassatt. The Fitting. 1890-1891. Drypoint and aquatint on laid paper; plate: 1' 2%" imes 10" (37.5 \times 25.4 cm), sheet: 1' $6^{13}/16$ " \times 1' 1/8" (47.8 imes 30.8 cm). National Gallery of Art, Washington, DC, (Chester Dale Collection, 1963).

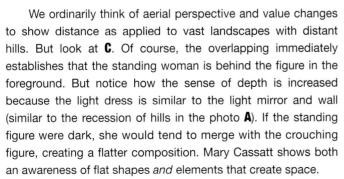

See also Value and Space, page 250, and Color and Space, page 276.

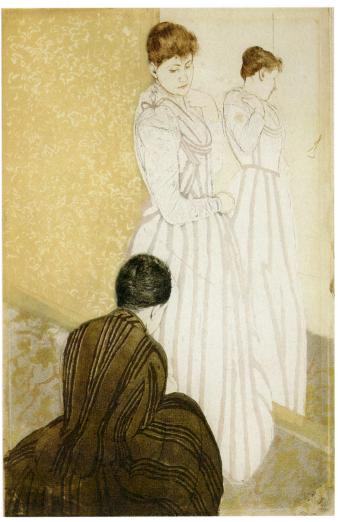

PLAN, ELEVATION, PERSPECTIVE

The architect's job includes communicating a proposed building to a client so that the spatial relationships can be understood. It is not surprising that many aspects of spatial illusion were first utilized by architects and then adapted by painters and other

artists. The necessity for more than one way to describe a space (or the inadequacy of any one method to tell a complete story) is the reason for three different kinds of drawing being used for communication.

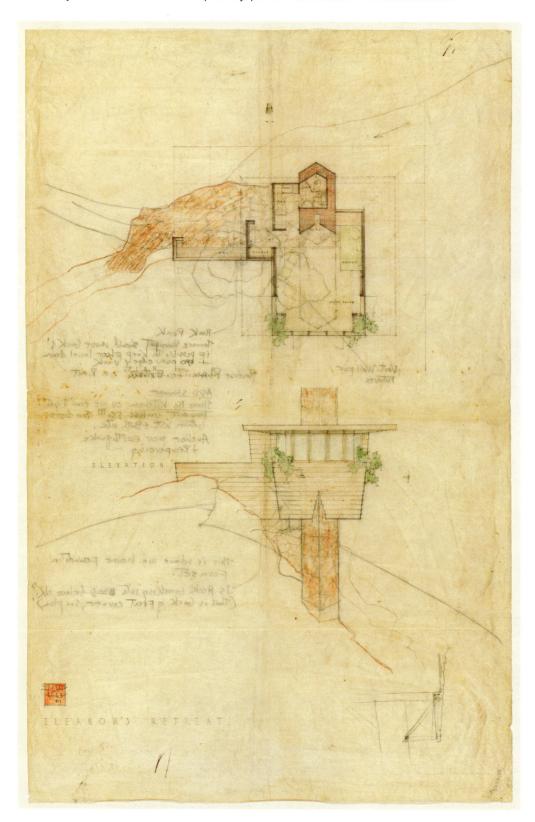

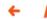

Frank Lloyd Wright. Arch Oboler Guest House (Eleanor's Retreat), project, Malibu, California, plan and elevation. 1941. Graphite and colored pencil on tracing paper, 2' 6%" × 2' ½" (78.1 × 51.1 cm). Arthur Drexler Fund. © 2009 Frank Lloyd Wright Foundation/Artists Rights Society (ARS), New York. 111.1992. The Museum of Modern Art, New York.

↑ E

Frank Lloyd Wright. Arch Oboler Guest House (Eleanor's Retreat), project, Malibu, California, perspective. 1941. Colored pencil, graphite, and color ink on tracing paper, 1' $4^{15}/6^{11} \times 1^{11} 7/4^{11}$ (43.1 \times 48.9 cm). Arthur Drexler Fund. © 2009 Frank Lloyd Wright Foundation/Artists Rights Society (ARS), New York. The Museum of Modern Art, New York.

A drawing from Frank Lloyd Wright actually shows two kinds of drawing; **A** includes both a **plan** and an **elevation**. The plan shows a map of the floor and wall arrangement and is a scale interpretation of the placement of features such as doors and windows. The elevation shows one facade of the structure or the appearance from the outside from one viewpoint (again, to scale).

The **perspective** view in **B** allows us to visualize the building from a unique vantage point. This illustrates the foreshortened planes and recession in space we would observe. A perspective drawing may be more accurate in describing appearance, but without the other two views our understanding of this structure in space would be incomplete.

DEVICES TO SHOW DEPTH

LINEAR PERSPECTIVE

Linear perspective is a complex spatial system based on a relatively simple visual phenomenon: as parallel lines recede, they appear to converge and to meet on an imaginary line called the horizon, or eye level. We have all noticed this effect with railroad tracks or a highway stretching away into the distance. From this everyday visual effect, the whole science of linear perspective has developed. Artists had long noted this convergence of

receding parallel lines, but not until the Renaissance was the idea introduced that parallel lines on parallel planes all converge at the same place (a **vanishing point**) on the horizon. Piero della Francesca was an early proponent of this spatial system, which can be seen in **A**. The perfection of this ideal city shown in perspective shows the origins of this method in architecture and the arts of that period.

1 A

Piero della Francesca. View of an Ideal City. Galleria Nazionale delle Marche, Urbino, Italy.

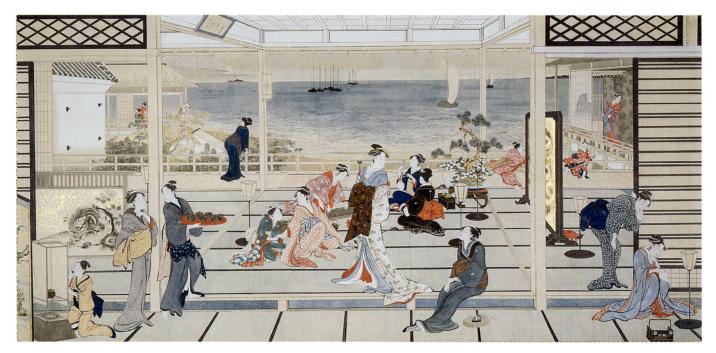

Although linear perspective is based on our perception, it is limited to a single fixed vantage point, or a **monocular** depth clue. It is not based on the **parallax** of our two-eyed perception of depth. A strong use of linear perspective can therefore have an artificial quality as seen both in the della Francesca and the Japanese woodcut in **B**. The edges of the room's floor, walls, and ceiling are clearly receding to a common vanishing point, and the setting is like a stage presented directly in front of us. This print combines a Western system of spatial depiction with the Japanese emphasis on two-dimensional shapes and patterns.

The distance between horizontal lines that are parallel to the picture plane also show a consistent pattern of recession **(B)**. The spaces between them appear to diminish as we look back into the space. This is evident in an obvious and simple way as we notice the foreshortening of spaces between horizontal lines in **C**, which demonstrates another effect of linear perspective. Circles foreshorten to ellipses as we can see with the center circle of the playing field. The height and width of this ellipse are parallel to the vertical and horizontal borders of the picture plane.

Still life paintings, drawings, and photographs are often anchored by elliptical shapes. Our mind understands that the bowl depicted in **D** is circular although the shape we see is actually an ellipse.

Linear perspective tells us our angle of perception and our position as an observer. In this regard perspective is credited with recognizing the viewer as a specific unique individual in a distinct place with a point of view.

Andreas Gursky. *EM Arena II.* 2000, C-print, 9' $\frac{1}{3}$ " \times 6' $9\frac{1}{10}$ " (275 \times 206 cm).

Lowell Tolstedt. *Bowl with Candy and Shadow.* 2008. Color pencil, 6%" × 10%".

DEVICES TO SHOW DEPTH

Leonardo da Vinci. Adoration of the Magi. 1482. Unfinished. Tempura mixed with oil on wood, 8' 1" \times 8' (246 cm \times 243 cm). Uffizi, Florence, Italy.

ONE-POINT PERSPECTIVE

The complete study of linear perspective is a complicated task. Entire books are devoted to this one subject alone, and it cannot be fully described here. The procedures for using linear perspective were rediscovered and developed during the Renaissance. From drawings, we see that in the fifteenth and sixteenth centuries many artists preceded paintings with careful perspective studies of the space involved.

Few recent painters have made such a strict use of linear perspective. For the architect, city planner, interior designer, set designer, and so on, an ability to do perspective drawing is essential for presenting their ideas. But it is important for any designer or artist to know the general principles of linear perspective, for it is a valuable tool for representing an illusion of depth.

Positioning the Horizon

The concept of linear perspective starts with the placement of a horizontal line, the "horizon," that corresponds to the "eye level" of the artist. On this line is located the needed number of vanishing points to which lines or edges will be directed. It might seem that working by a "formula" such as linear perspective provides would lead to a certain sameness and monotony in pictures. This is not true, because the artist's choice in the placement of

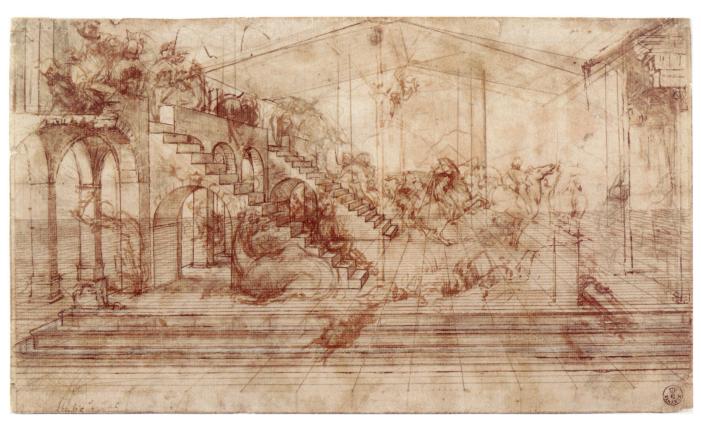

the horizon and vanishing points within the picture (or outside it) is almost unlimited. The same scene drawn by the same artist would result in radically different visual compositions by altering these initial choices. This is simply the artist choosing the point of view, whether at a predictable eye level, or perhaps from below or above.

Exploring One-Point Perspective

Leonardo's unfinished painting (A) is an example of one-point perspective. The preparatory drawing (B) shows how a single point has been placed on the horizon line, and all the lines at right angles to the plane of the canvas converge toward that point. The drawing and the unfinished painting taken together offer us the chance to see the artist's process of placing the figures within the space created for them.

The horizon is another term for eye level. Often the eye level is coincident with the eyes in the depicted figures. In the Leonardo painting, we can observe that our vantage point is slightly elevated (the horizon line is higher than the eyes of the foreground figures), and we are looking down on the scene of the Madonna and the surrounding figures. It is informative to see that Leonardo took care to structure this space in strict onepoint perspective even though the architecture is relegated to the background and most of the painting is a landscape setting.

No diagram is needed to illustrate the one-point perspective used in **C**. This poster, commemorating the flight of Danish Jews to Sweden, transforms one triangle of the Star of David into receding lines suggestive of movement to the distance.

The rules of one-point perspective can also be used to manipulate our experience of actual space. This is the case with Borromini's Arcade for the Palazzo Spada in Rome (D). The columns decrease in size, their spacing gets shorter, and the pavement narrows down the arcade. This very short corridor appears longer due to these systematic reductions in size. shape, and spacing all focused on a single vanishing point of one-point perspective.

Per Arnoldi (Denmark). Poster commemorating the 50th anniversary of the Danish Jews' flight to Sweden. 1993. Client: Thanks to Scandinavia, New York.

Francesco Borromini. Arcade, Palazzo Spada, Rome. c. 1635-1650.

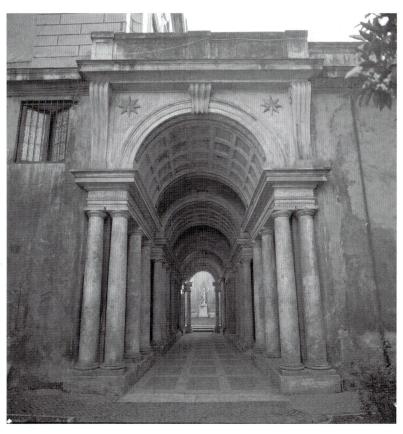

DEVICES TO SHOW DEPTH

TWO-POINT PERSPECTIVE

One-point perspective presents a very organized and unified spatial image. **Two-point perspective** probably appears to us as more natural and lifelike. Here we are not looking head-on at the scene. Now, it is being viewed from an angle. No objects are

parallel to the picture plane, and all edges recede to two points on the horizon line. This more nearly approximates our usual visual experience.

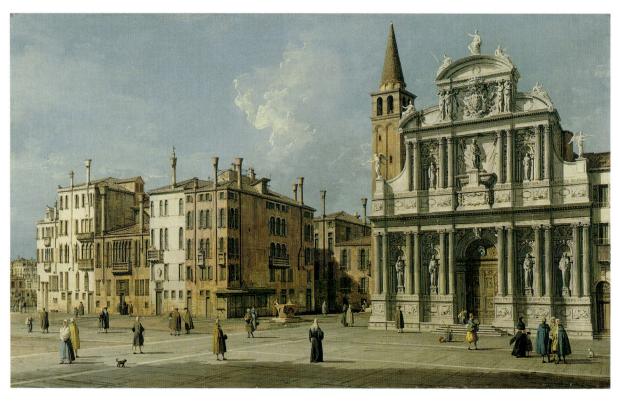

Giovanni Antonio Canal, known as Canaletto (1697–1798). Campo Santa Maria Zobenigo. Venice, Italy. Oil on canvas, $1'6\%''\times 2'6\%''$ (47 × 78.1 cm). Private collection, New York.

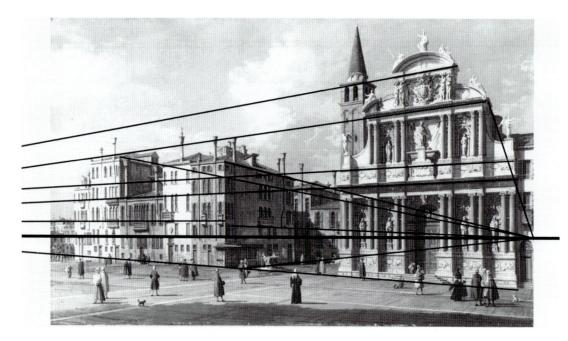

Diagram superimposed over painting A. The angled lines of the architecture would meet at two points on the horizon.

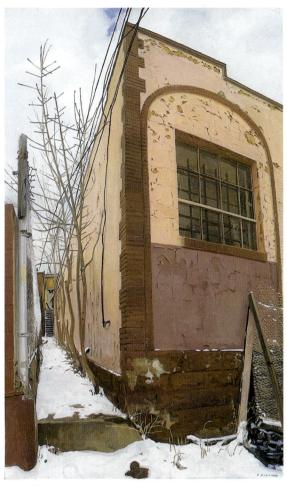

Felix de la Concha. Así en el cielo (As in Heaven). 2001. Oil on canvas on board, 4' \times 2' 5½" (121.9 \times 74.9 cm). Karl and Jennifer Salatka Collection, Concept Art Gallery, Pittsburgh, Pennsylvania.

The painting by Canaletto (A) illustrates the idea. In the diagram (B) the horizon line is shown on which there are two points, and the various architectural lines of the different buildings recede to them.

A Static Effect Can Be a Dramatic Element

In a perspective drawing or painting, strict two-point perspective can appear a bit posed and artificial. It assumes we are standing still and looking without moving. This is possible and does happen but is not typical of our daily lives. Our visual knowledge is gained by looking at objects or scenes from many changing viewpoints. Photography can capture a still view, and film and video have conditioned us to rapidly changing points of view. Perhaps for these reasons linear perspective is not as frequently used in painting today as it was for centuries.

However, painting and drawing still have the power to share a still and careful observation. The contemporary painting by Felix de la Concha (C) shows how two-point perspective can be a dramatic element of composition and can resonate with our daily experience. An alleyway may seem to be a banal subject, but de la Concha's attention to the narrow space and surprising facade is extraordinary.

Ed Ruscha's Standard Station, Amarillo, Texas (**D**) exploits the more artificial aspect of two-point perspective to give drama to the subject and celebrate highway culture. Billboard architecture seeks our attention, and in the American west we are offered a view to infinity across the vast, flat landscape.

Ed Ruscha. Standard Station, Amarillo, Texas. 1963. Oil on canvas, 5' $4\%e^{\shortparallel} \times 10' 113\%e^{\shortparallel}$ (1.65 \times 3.09 m). Hood Museum of Art, Dartmouth College, Hanover, NH (gift of James J. Meeker, Class of 1958, in memory of Lee English).

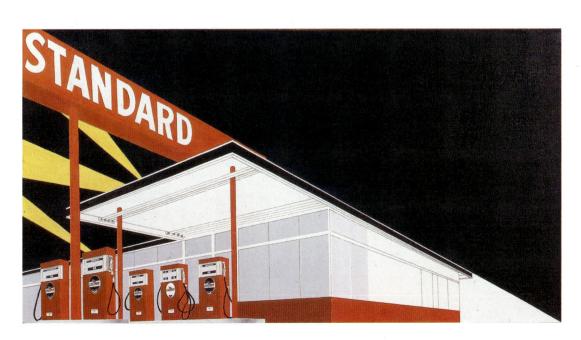

MULTIPOINT PERSPECTIVE

In perspective drawing the vertical edges of forms generally remain vertical. Sometimes a third vanishing point is added above (or below) the horizon so that the vertical parallels also taper and converge. This technique is useful to suggest great height, such as looking up at (or down from) a city skyscraper (A).

Although city streets or a line of buildings might be laid out in orderly rectangular rows of parallel lines, often in real life a variety of angles will be present. This entails the use of **multipoint perspective**. Different objects will have separate

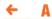

Berenice Abbott. Wall Street, Showing East River from Roof of Irving Trust Company. 1938. Photograph. Museum of the City of New York.

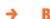

George Tooker. *The Subway.* 1950. Egg tempera on composition board; sight: 1' $6\%" \times 3'$ %" $(46 \times 91.8$ cm), frame: 2' $2" \times 3'$ 8" $(66 \times 111.8$ cm). Whitney Museum of American Art, New York, 50.23. By permission of the artist c/o DC Moore Gallery, New York.

→ 0

Diagram superimposed over painting B.

sets of vanishing points if they are not parallel to each other. If they are all on a plane parallel to the ground plane, all vanishing points will still be on a common horizon line. This can reproduce our visual experience where rarely in any scene are all the elements in neat, parallel placement. In the painting by Tooker (B), the long corridors of the subway recede at several different angles from the center foreground. Each area thus has a different vanishing point (C). The anxiety-producing feeling of the subway as a maze is clearly presented.

For Dynamic Spatial Effect

Multiple vanishing points create a dynamic spatial effect in a two-dimensional composition even when the composition is as abstract as the example seen in D. The source of this image may be architectural, but there are no representational details. The linear perspective leading to three vanishing points conveys the sense of space. Two vanishing points are on the horizon line. A third vanishing point (below the bottom of the picture) is implied by the converging vertical lines, suggesting a downward view.

Sarah Morris. Pools-Crystal House (Miami). 2002. Gloss household paint on canvas, 7' ¼" × 7' ¼" (214 × 214 cm). Courtesy Friedrich Petzel Gallery, New York.

AMPLIFIED PERSPECTIVE

A DIFFERENT POINT OF VIEW

To introduce a dramatic, dynamic quality into their pictures, many artists have used what is called **amplified perspective**. This device reproduces the visual image but in the very special view that occurs when an item is pointed directly at the viewer.

Playing with Perspective

A familiar example is the old Army recruiting poster in which Uncle Sam's pointing finger is thrust forward ("I Want You") and right at the viewer. The same effect can be seen in **A**, in which the figure's legs are thrust directly at us. In this exaggerated example we are presented with the image of the feet being unbelievably large in **juxtaposition** with the body. The photograph heightens a phenomenon that we see in less-dramatic terms every day but to which we unconsciously adjust to conform to our knowledge of the human figure.

In Tony Mendoza's photograph **(B)**, we are presented with an unusual vantage point on a familiar subject. Here the stems of the plants, rather than the flowers, come toward the viewer. This camera angle from below gives us a fresh view and a "bug's-eye" glimpse of the garden.

The contrast of size we see in Yvonne Jacquette's painting in **C** creates an amplified space in a composition that might first capture our attention for its color, pattern, or shapes. The river and harbor make a large, essentially flat shape. The pattern of lights and shadows creates a jewel-like decorative effect. Against this surface composition an amplified perspective evokes a deep space. Individual windows on the foreground tower are as large as the distant image of the Statue of Liberty. This juxtaposition might be hard to hold in one view in actual experience, but a painting can render it visible.

Tony Mendoza. Yellow Flowers. Photograph on 100% rag paper, 1' 9" \times 2' 8".

MULTIPLE PERSPECTIVE

A PICTORIAL DEVICE

Looking at a figure or object from more than one vantage point simultaneously is called **multiple perspective**. Several different views are combined in one image. This device has been used widely in twentieth- and twenty-first-century art, although the idea is centuries old.

Multiple Perspective in Ancient Art

Multiple perspective was a basic pictorial device in Egyptian art, as illustrated in a typical Egyptian painted figure (A). The artist's aim was not necessarily to reproduce the visual image but to give a composite image, combining the most descriptive or characteristic view of each part of the body. The Egyptians solved this problem by combining a side view of the head with a front view of the eye. Each body part is thus presented in its most characteristic aspect: a front view of the torso, a side view of the legs, and so forth.

The cubist painting by Ozenfant **(B)** is a more recent example of this approach. This modernist interpretation of a still life offers both the characteristic view of an oval opening for a cylindrical container, and the silhouette or "profile" view of a pot or decanter. Both views would not be possible from a single vantage point.

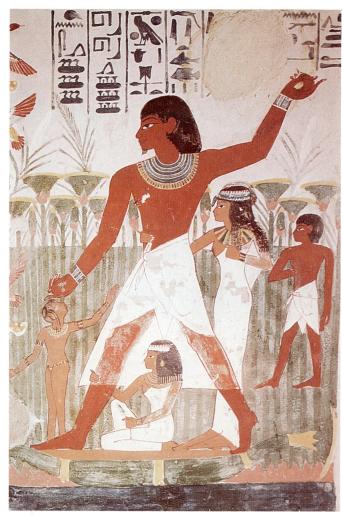

Detail of Wall Painting in the Tomb of Nakht, Thebes. c. 1410 BC. Victor R. Boswell, Jr., National Geographic photographer.

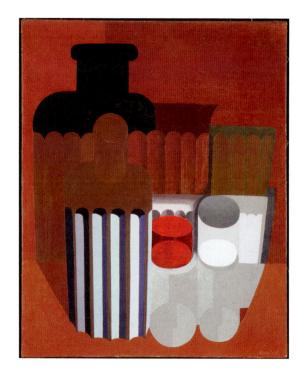

Douglas Cooper. Portion of Senator John Heinz Regional History Center Mural. (1992-1993). Courtesy of the artist.

David Hockney. Brooklyn Bridge, November 28, 1982. Photographic collage, 9' 1" \times 4' 10". Collection © David Hockney.

Since the twentieth century, with the camera able to effortlessly give the fixed visual ("realistic") view, artists have been free to explore other avenues of perception, including multiple perspective. Douglas Cooper employs multiple perspectives to capture a dramatic breadth of experiences in one twodimensional composition (C). The hilly, winding river valley of Pittsburgh is brought together in a mural where the space seems to bend and curve. The straight lines of linear perspective curve when a two-dimensional picture expands to hold more than the view of a single picture plane.

Straight lines yielding to a curved pattern are evident in David Hockney's photographic montage of the Brooklyn Bridge (D). The point of view shifts from downward to forward to upward, creating multiple picture planes and multiple perspectives.

As you have noticed, multiple perspective does not give a clear spatial pattern of the position occupied by each element. This aspect has been sacrificed to give a more subjective, conceptual view of forms.

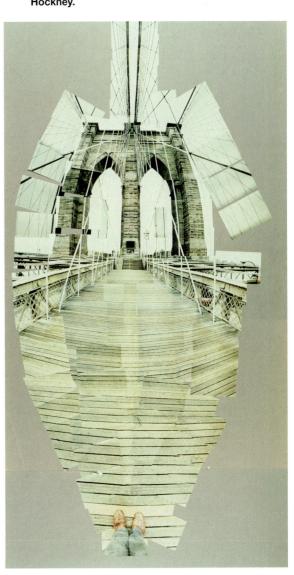

ISOMETRIC PROJECTION

A SPATIAL ILLUSION

For centuries Asian artists did not make wide use of linear perspective. Another spatial convention was satisfactory for their pictorial purposes. In Oriental art, planes recede on the diagonal, but the lines, instead of converging to a vanishing point, remain parallel. Traditional Japanese prints such as **A** illustrate this device. The effect is different from Western perspective but certainly not disturbing. The order of parallel diagonals and many parallelogram shapes complements the flowing lines of the figures and robes. The space is clear to us with the use of overlap to reinforce our view.

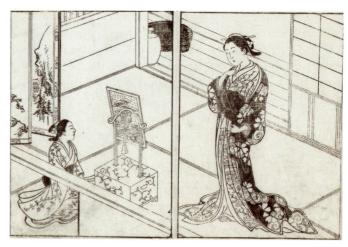

Nishikawa Sukenobu. Woman and Child beside a Mirror Stand. c. 1740. Color woodblock print, sheet: 10%6" \times 141%6" (25.6 cm \times 37.4 cm).

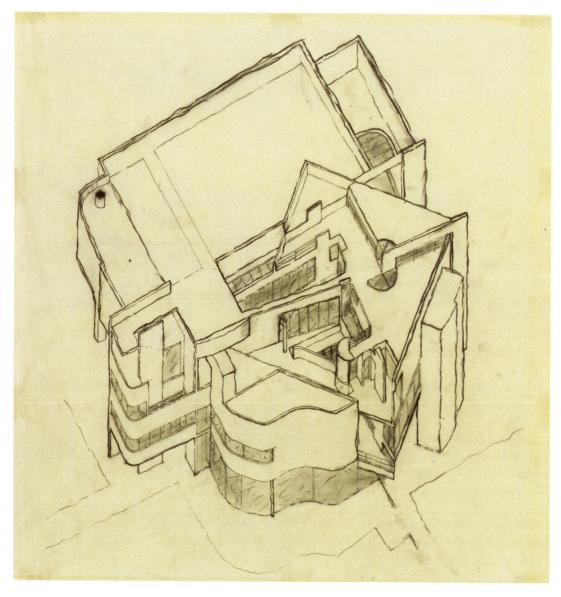

Richard Meier. The Atheneum, New Harmony, Indiana. Axonometric. Graphite on tracing paper, 1' 9¼" × 1' 9" (54 × 53.3 cm). Gift of the architect. © 2009 Richard Meier.

Isometric Projection in the West

Isometric projection is used extensively in engineering and mechanical drawings. The drawing by Richard Meier **(B)** shows how an isometric drawing can give a sense of the three-dimensional form and space without the foreshortening or converging lines of perspective. Here the goal is to present the measurements along three axes. The lines do not recede to vanishing points (they remain parallel), and the spatial intervals do not foreshorten. So this gives some sense of three-dimensional space while maintaining the dimensions we would see in a plan or elevation.

An isometric projection is less commonly used among contemporary artists. The self-portrait by David Hockney **(C)** uses this device, and the change from the linear perspective is fresh and intriguing. Hockney has explored virtually every method of spatial organization mentioned in this chapter in prints, drawings, paintings, and photography.

The work by Josef Albers **(D)** uses this idea in a purely abstract way. The artist creates a geometric shape drawn in an isometric-type view. The interesting aspect of the design, however, is the shifting, puzzling spatial pattern that emerges. The direction of any plane seems to advance, then recede, then to be flat in a fascinating **ambiguity**.

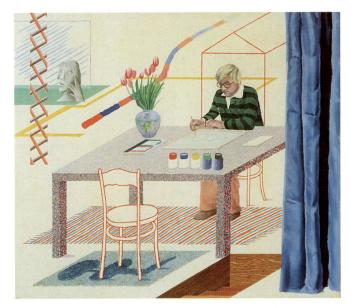

David Hockney. Self-Portrait with Blue Guitar. 1977. Oil on canvas, $5^{\iota} \times 6^{\iota}$ (1.52 \times 1.83 m).

Josef Albers. Structural Constellation II. c. 1950. Machine-engraved vinylite mounted on board, 1' $5" \times 1'$ $10\frac{1}{2}"$ (43.2 \times 57.1 cm). Collection, The Josef Albers Foundation.

Jean-Baptiste-Siméon Chardin. The Attributes of Music. 1765. Oil on canvas, 2' 11½" imes 4' 8½" (91 imes 145 cm). Musée du Louvre, Paris, France.

THE CONCEPT OF ENCLOSURE

One other aspect of pictorial space is of concern to the artist or designer. This is the concept of enclosure, the use of what is referred to as **open form** or **closed form**. The artist has the choice of giving us a complete scene or merely a partial glimpse of a portion of a scene that continues beyond the format.

Exploring Closed Form

In **A** Chardin puts the focal point in the center of the composition; thus our eyes are not led out of the painting. The still life of musical instruments and sheet music is effectively framed by the curved border of the picture, which echoes the many ovals in the composition. The book on the left and the candle on the right bracket the composition and keep our attention within the picture. This is called closed form.

Picasso demonstrates that closed form is not a concept limited to representational subject matter. All of the shapes are contained within **B**, and just as Chardin's painting is composed of oval shapes within an oval frame, Picasso's is dominated by rectilinear shapes within a rectilinear frame.

Exploring Open Form

The ultimate extension of the open-form concept is illustrated in **C**. This painting breaks out of a rectangular format and effectively destroys any framed, or contained, feeling. In fact, shapes within the painting extend outward, and the white wall creates shapes that cut into the painting but also expand to include a field well beyond the painting's boundary. This painting has much in common with Picasso's but seems to have burst out of conventional containment.

It may be most surprising to encounter open form when the subject is the human figure. Figures are often cropped in the action photographs of athletes, and this suggests the dynamics of sports. A cropped figure can also simply suggest a unique point of view. The print by Alex Katz shown in **D** is cropped to form an unexpected composition. The open form implies a figure beyond the picture, while emphasis is given to an unusual focus on the feet.

As you can see, closed form generally gives a rather formal, structured appearance, whereas open form creates a casual, momentary feeling, with elements moving on and off the format in an informal manner.

Elizabeth Murray. Keyhole. 1982. Oil on canvas, 8' $3 \ensuremath{\ensuremath{\%^{\prime\prime}}}\xspace \times$ 9' $2 \ensuremath{\ensuremath{\%^{\prime\prime}}}\xspace$ ". Agnes Gund Collection, New York.

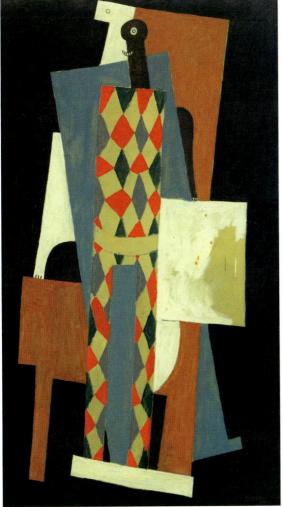

Pablo Picasso. Harlequin. Paris, late 1915. Oil on canvas, 6' $\frac{1}{4}$ " \times 3' 5%" (183.5 \times 105.1 cm).

Alex Katz. Ada's Red Sandals. 1987. Oil on canvas, 4' \times 5'. Alex Katz Studio II, New York. Art © Alex Katz/Licensed by VAGA, New York, New York.

EQUIVOCAL SPACE

Most art in the twentieth and twenty-first centuries has not been concerned with a purely naturalistic reproduction of the world around us. Photography has provided a way we can all record appearance in a picture. This is true in the area of spatial and depth representation also. Many artists have chosen to ignore the device of overlapping. Instead, they have used what is called **transparency**. When two forms overlap and both are seen completely, the figures are assumed to be "transparent" (A).

Interest in Ambiguity

Transparency does not give us a clear spatial pattern. In **B** we are not sure which plane is on top and which behind. The spatial pattern can change as we look at it. This purposeful ambiguity is called **equivocal space**, and many artists find it a more interesting visual pattern than the immediately clear spatial organization provided by overlapping in a design.

There is another rationale for the use of transparency. Just because one item is in front of and hides another object does not mean the item in back has ceased to exist. In **B** a bowl of fruit is depicted with the customary visual device of overlapping. In **C** the same bowl of fruit is shown with transparency, and we discover another piece of fruit in the bottom of the bowl. It was always there, simply hidden from our view. So, which design is more realistic? By what standards do you decide?

The use of overlapping with transparency confuses our perception of depth.

Overlapping sometimes can be deceptive.

The use of transparency reveals what is hidden by overlapping.

Exploring Equivocal Space

The sweatshirt design in **D** was created to celebrate a fifth anniversary. The letters spelling "Five" are clear, but they overlap and become transparent with differing patterns and values. The design takes a simple theme and creates an interesting pattern from a few elements.

Spatial ambiguity can also be suggested through the use of open form. A large X seems to expand beyond the boundaries of the rectangle in \mathbf{E} . The same composition can be seen in a moment of figure/ground reversal to be four small triangular shapes against a yellow ground. A spatial ambiguity is created in this reversal.

→ |

Sweatshirt design for a fifth anniversary. 1990. Designer: Jennifer C. Bartlett. Design firm: Vickerman-Zachary-Miller (VZM Transystems), Oakland, California.

4

Al Held. Yellow. 1956. Acrylic on paper mounted on board, 57.5 × 77.5 cm. Kunstmuseum Basel, Kupferstichkabinett. (Legat Anne-Marie and Ernst Vischer-Wadler, 1995). Art © Al Held Foundation/Licensed by VAGA, New York, New York. Photo: Oeffentliche Kunstsaammlung Basel, Martin Buhler.

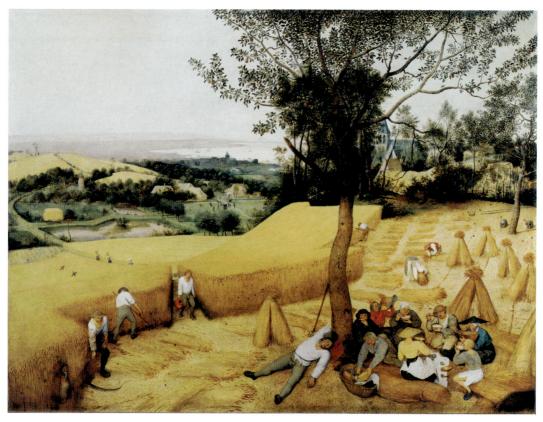

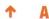

Pieter Bruegel the Elder. *The Harvesters.* 1565. Oil on wood; overall, including added strips at top, bottom, and right: 3' $10\%" \times 5'$ 3%" (119 \times 162 cm), original painted surface: 3' $9\%" \times 5'$ 2%" (116.5 \times 159.5 cm). The Metropolitan Museum of Art, Rogers Fund, 1919.

COMPLEXITY AND SUBTLETY

Two-dimensional art and design are by definition flat. Unlike the realms of sculpture and architecture, space in two-dimensional art forms can only be implied. This leaves the artist and designer with a range of spatial clues and techniques with a similar range of expressive potential. A flat graphic design may pack a punch for a poster or abstract painting. A complex space may lead a viewer into the subtle depths of a landscape painting.

When we look at the painting by Bruegel (A), we are drawn into space that moves from intimate to vast and deep. In the foreground we observe the details of a scene of workers at leisure. Nearly every spatial device we can think of leads us back through an unfolding and interesting landscape:

As we move up the picture plane we also move back in space. Foreground figures and trees are larger.

The trimmed edges of the hayfield follow the rules of linear perspective.

The rolling ground plane offers many instances of overlapping. The atmosphere softens forms in the distance: value contrast diminishes, and colors become cool and subtle.

Bruegel's painting tells us much about life in the sixteenth century, but it also tells us much about the potential for painting to evoke space.

Gérôme's painting **(B)** offers a similar list of spatial devices but in a much more staged tableau. In fact we sense this deliberate orchestration of the space, as though a director is at work on his production. The use of red to grab foreground attention is theatrical and almost abstract. We may even sense some kinship between this figurative painting and the nonobjective painting **C** in the way that black, white, and red contrast with muted grays.

John McLaughlin's painting **(C)** offers a stunning contrast to pictorial representation. By the mid-twentieth century, painting had been long liberated from illustrative space by photography. That does not mean that a crisply two-dimensional and geometric composition can't offer an experience akin to that of space and depth. The planes can suggest overlap, horizon, boldly advancing color, subtly dissolving values, and a shifting sense of which plane advances or retreats. This reading of the relationships occurs over time, and movement or change over time implies space.

Jean-Léon Gérôme. The Duel after the Masquerade. 1857–1859. Oil on canvas, 1' 3%" \times 1' 10%6" (39.1 \times 56.3 cm).

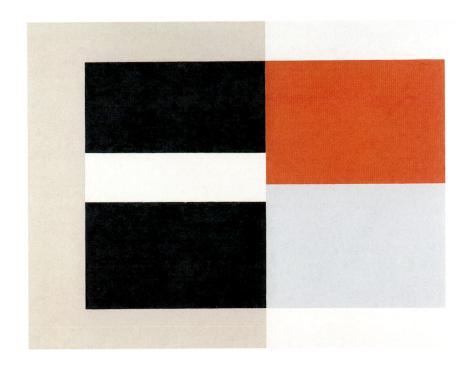

John McLaughlin. Y-1958. 1958. Oil on canvas, 2' $8\ensuremath{^{"}}\times4\ensuremath{^{"}}.$ Addison Gallery of American Art, Phillips Academy, Andover, Massachusetts (1995).

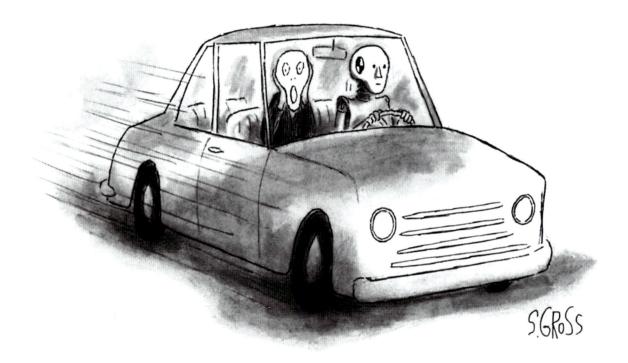

Sam Gross.

The Museum of Modern Art Book of Cartoons. In association with The Cartoon Bank: A New Yorker Magazine Company.

CHAPTER ILLUSION OF MOTION

INTRODUCTION

Stillness and Arrested Action 230

ANTICIPATED MOTION

Seeing and Feeling Impending Action 232

WAYS TO SUGGEST MOTION

Figure Repeated, Figure Cropped 234

WAYS TO SUGGEST MOTION

Blurred Outlines and Fast Shapes 236

WAYS TO SUGGEST MOTION

Multiple Image 238

OPTICAL MOVEMENT

Afterimage and Eye Movement 240

STILLNESS AND ARRESTED ACTION

Relative Stillness

Almost every aspect of life involves constant change. We humans cannot sit or stand motionless for more than a moment or so; even in sleep we turn and change position. But if we could stop our body movements, the world about us would continue to change. Thus motion is an important consideration in art.

A deceptive stillness characterizes Vermeer's painting *Kitchen Maid* (A). This might (at first glance) be seen as the equivalent of a photograph taken at a fast shutter speed, say, 125th of a second. Now consider that the milk is *moving* as the woman pours it, and we sense that the duration of the picture might be a brief interval of time longer than a split second.

Gérôme's painting **(B)** is certainly not a quiet moment shared by the viewer. In this stage-like tableau the artist picks an important moment from an unfolding drama that encapsulates the story. The Harlequin character and his companion move off, while Pierrot is caught as he collapses.

Johannes Vermeer. The Kitchen Maid. c. 1658. Oil on canvas, 45.5×41 cm. Rijksmuseum, Amsterdam.

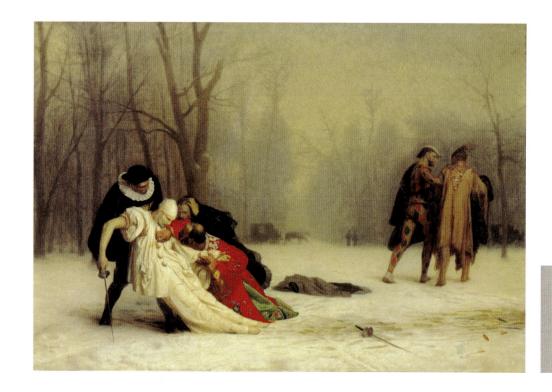

Jean-Léon Gérôme. The Duel after the Masquerade. 1857–1859. Oil on canvas, 1' 3%" \times 1' 10%e" (39.1 \times 56.3 cm).

Harold Edgerton. *Making Applesauce at MIT* (.30 Bullet Piercing an Apple). 1964. Photograph. © Harold & Ester Edgerton Foundation, 2007, courtesy of Palm Press, Inc.

Henri Cartier-Bresson. 1932. Paris, France. Place de l'Europe. Gare Saint Lazare.

Depicting the Transient

Photography has made visible images that are otherwise invisible to us due to a motion too rapid for the eye to perceive. Now an event that exists for a millisecond can be revealed to us. Harold Edgerton's photograph of a bullet piercing an apple **(C)** is one such example. Edgerton pioneered techniques of strobe lighting, which coordinates the camera with an instant of light to capture such images.

Photography also makes possible the imagery of a "decisive moment." This is the term Henri Cartier-Bresson used to describe the moment captured in photographs such as **D**. While film and video may satisfy our desire for experiencing rapid or graceful movement, painting and photography offer a singular moment—one that lingers on for our continued inspection and appreciation.

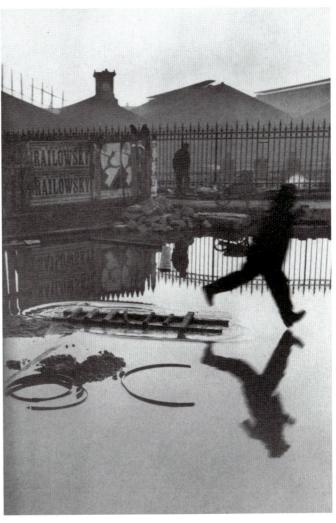

SEEING AND FEELING IMPENDING ACTION

Much of the implication of movement present in art is caused by our memory and experience. We recognize temporary, unstable body positions and realize that change must be imminent. This anticipation is not limited to images of the human figure. The red square in **A** is in a dynamic position poised at an angle as if ready to tumble. Example **B** (a later step in Lissitzky's series) shows that this is what the artist had in mind as all the forms have changed or moved and new ones have entered the space.

Kinesthetic Empathy

In a process called **kinesthetic empathy**, we tend to re-create unconsciously in our own bodies the actions we observe. We actually "feel" in our muscles the exertions of the athlete or dancer; we simultaneously stretch, push, or lean, though we are only watching. This involuntary reaction also applies to static images in art, where it can enhance the feeling of movement.

A feeling of **anticipated movement** can be enhanced by implied lines and gestures. Thus in **C** the figures are about to complete their actions, and the dynamics are accentuated by the diagonal (active) lines in the composition.

In each of the preceding examples, a tense space is left unresolved. A small space separates the tumbling square in **A**, and a similar small space separates foot-from-base, and ball-from-glove in **C**. A desire for resolution triggers our response.

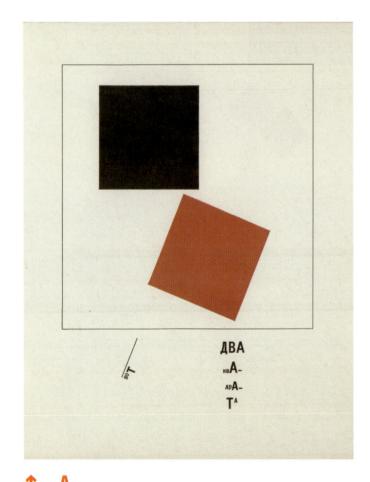

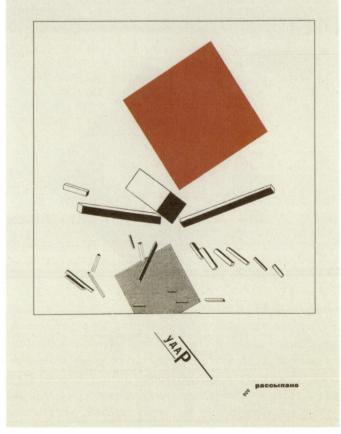

El Lissitzky. Of Two Squares: A Suprematist Tale in Six Constructions. 1922. Illustrated book with letterpress cover and six letterpress illustrations, 10^{15} /₆" \times 8%" (27.8 \times 22.5 cm). Publisher: Skify, Berlin.

Baseball photo.

Krishna Revealing His Nature as Vishnu. Miniature from Malwa, India. c. 1730. Gouache or watercolor on paper, $8" \times 1' 2\%"$ (20×38 cm). Victoria and Albert Museum, London. Crown Copyright.

FIGURE REPEATED, FIGURE CROPPED

Figure Repeated

Over the centuries artists have devised various conventions to present an illusion of motion in art. One of the oldest devices is the **repeated figure**. The figure of Krishna appears over and over in different positions and situations in the Indian miniature **(A)**. This convention has been used in many cultures to form a "storyboard" that conveys a narrative over time (and the implied movement.) In fact, storyboards are still used by filmmakers and animators as a step in planning a production. One such contemporary example is **B** where the artist not only repeats the figure but varies our viewpoint to heighten the sense of movement.

Figure Cropped

A second dramatic way to express motion is by cropping the figure. The composition in **C** effectively crops the lunging basketball player to enhance the feeling of movement. The head and basketball are barely contained in the frame and form a tense line spanning the picture. The forward leg is cropped, heightening the sense of the player bursting through the confines of the frame. In this case the framing rectangle is essential to the suggestion of motion.

Comic strips employ both techniques of figure repetition and figure cropping to create a sense of motion. Bill Watterson's *Calvin and Hobbes* was rich and varied in the application of these devices to bring life to Calvin's real and imagined worlds **(D)**.

Taliek Brown of the University of Connecticut. December 10, 2002. Photograph.

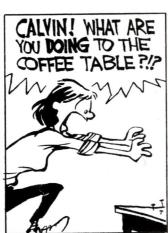

WAYS TO SUGGEST MOTION

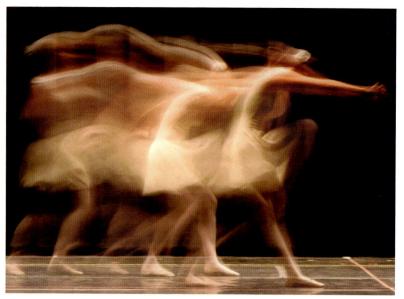

Elliot Barnathan. Study in Motion. Digital photograph.

BLURRED OUTLINES AND FAST SHAPES

We readily interpret a photograph such as **A** to be signifying movement because of the **blurred outlines**. With a fast shutter speed, moving images are frozen in "stop-action" photographs. When the shutter speed is relatively slow, the figure becomes a blurred image that we read as an indication of the subject's movement. This is an everyday visual experience. When objects move through our field of vision quickly, we do not get a clear mental picture of them. A car will pass us on the highway so fast that we perceive only a colored blur. Details and edges of the form are lost in the rapidity of the movement. In the case of **A**, this effect is used to convey a sense of grace associated with dance.

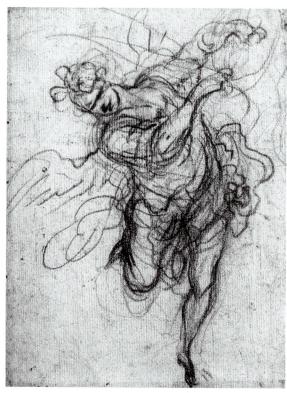

Anonymous (Italian or Spanish). Angel (Dancing Figure). 16th century. Red chalk on cream paper, $634" \times 5\%6"$ (17.1 \times 13.5 cm). The Metropolitan Museum of Art, gift of Cornelius Vanderbilt, 1880.

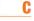

The figure in the sixteenth-century Italian drawing in ${\bf B}$ also suggests movement in this way. The dancing figure is drawn with sketchy, incomplete, and overlapping lines to define her form and evoke the gestures of the movements.

Graphic design is also compelled to suggest movement in two dimensional and static media. Not all solutions are for the TV, film, or touch-screen audiences. Posters and print media still require solutions that evoke movement and a sense of strong visual dynamics. One obvious client requiring such solutions is a sports team. Both **C** and **D** convey speed through shapes that tail off like a streaking comet. In this case the mascots do not suggest speed (a Saint Bernard or a Patriot) but the shapes do!

Shapes that evoke speed are a staple of car design—especially the exaggerated features of a custom car **(E)**. The Italian Futurists, as early as the 1920s, said that the speeding automobile had replaced Venus de Milo as a standard of beauty. Even when parked at the curb, a "street rod" such as the one in **E** expresses speed through its long, sweeping lines. Positioning the car on the diagonal in this photograph emphasizes these lines. This romance with movement and technology led to the streamlining of even utilitarian objects such as toasters and telephones, which would never speed down a highway or fly through the sky.

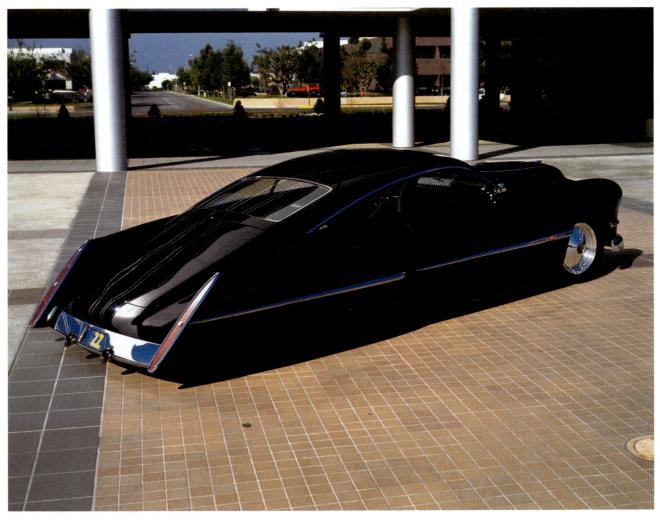

MULTIPLE IMAGE

Another device for suggesting movement, called **multiple image**, is illustrated in **A**. When we see one figure in an overlapping sequence of poses, the slight change in each successive position suggests movement taking place. The photograph in **A** is from the 1880s. The photographer, Thomas Eakins, was intrigued with the camera's capabilities for answering the visual problem of showing movement and analyzing it.

In **B** multiple figures suggest motion in a single instant. In this case the repetition and overlap of many very similar and synchronized figures create the illusion. The foreground figures seem to emerge from the light, and the rhythm of repeated shadows and faces sets a pulse or beat to the parade.

Lines of Force

Painters of the twentieth and twenty-first centuries have often been concerned with finding a visual language to express the increasingly dynamic quality of the world around us. Although at first glance very different, Duchamp's famous *Nude Descending a Staircase* (C) is much like the two photographs. Again, multiple images of a figure are shown to suggest a body's movement in progress. Now the body forms are abstracted into simple geometric forms that repeat diagonally down the canvas as the nude "descends." Many curved lines (called **lines of force**) are added to show the pathway of movement.

Grouping Multiple Images

The group of photographs in **D** is a collection of six similar subjects from different sources. They have the effect of a "multiple image" and create movement across the grid. A sense of motion is created like that of an old film or a flicker book.

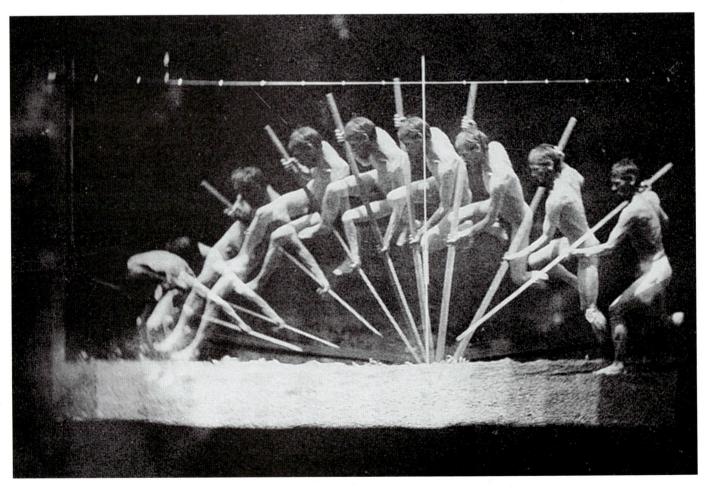

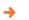

Feng Li. Beijing Celebrates the 60th Anniversary of New China.

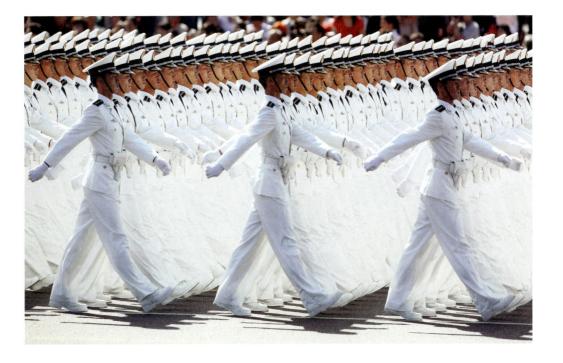

Marcel Duchamp. Nude Descending a Staircase, No. 2. 1912. Oil on canvas, 4' 10" \times 2' 11" (1.47 \times 0.89 m). Philadelphia Museum of Art (Louise and Walter Arensberg Collection).

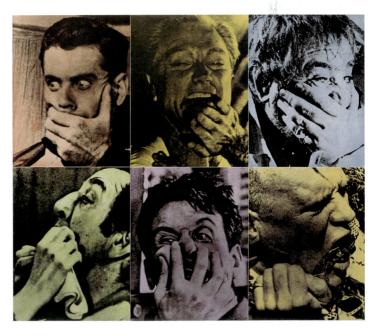

John Baldessari. Six Colorful Gags (Male). 1991. Photogravure with color aquatint and spit bite aquatint, 3' 11" \times 4' 6". Edition 25. Crown Point Press, San Francisco.

1 A

Unknown Chinese artist. A Wave under the Moon. 12th century. Ink on silk, detail of a scroll.

AFTERIMAGE AND EYE MOVEMENT

Several techniques have been presented for capturing movement or depicting it in two-dimensional media. The understanding is that static art and design forms such as drawing, painting, prints, and graphic design *can't* actually move—*but* the eye can move, or the image on the retina can flicker, and graphic elements can induce these movements.

As early as the twelfth century, a Chinese artist understood how to create movement for the restless eye. The tapering and undulating lines and spaces in **A** trigger just such a visual effect. Flowing water and other natural forces are part of a rich vocabulary for Chinese landscape art.

A poster for a jazz festival **(B)** is a striking example of optical movement through the flickering effects of afterimage. The intersections of the grid are literally light circles. So why does our eye jump around in search of black circles we *think* we are seeing? The intersections of a grid create a flashbulb-like afterimage. This effect is well suited to the scale of the pages of this book and should be easy to see.

Intense colors can also induce such eye movement as our eye struggles to focus on different colors simultaneously. In addition to that, the retina will fatigue from exposure to a strong color, and as we glance away an afterimage will flicker. This creates a jumpy movement in the quilt shown in C. Since this is a crib quilt we can only hope the baby wasn't looking at it while trying to fall asleep! Picasso's painting (D) bears a striking similarity to the quilt, and we can imagine the tumbling movement set off by the harlequin pattern were we standing in front of the painting at full size.

See also Chapter 6: Rhythm.

Pablo Picasso. Harlequin. Paris, late 1915. Oil on canvas, 6' 1/4" imes 3' 5%" (183.5 imes 105.1 cm).

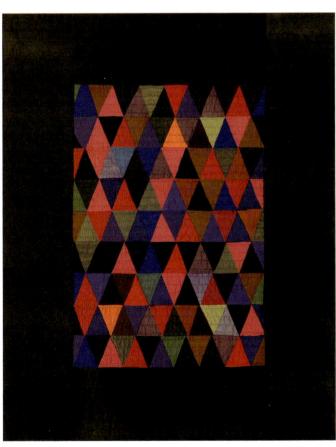

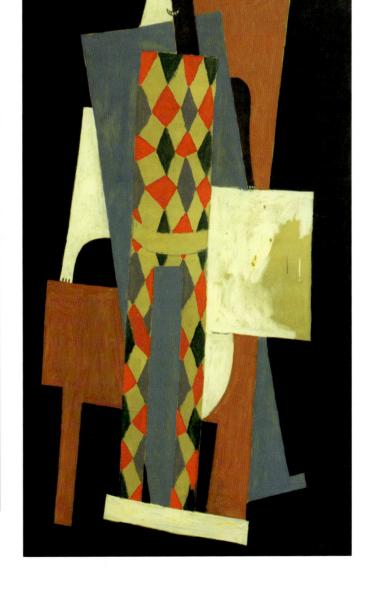

William O'Brian.

The Museum of Modern Art Book of Cartoons. In association with The Cartoon Bank: A New Yorker Magazine Company.

CHAPTER VALUE

INTRODUCTION

Light and Dark 244

VALUE PATTERN

Variations in Light and Dark 246

VALUE AS EMPHASIS

Creating a Focal Point 248

VALUE AND SPACE

Using Value to Suggest Space 250

TECHNIQUES

An Overview 252

A value scale of gray. The center circles are identical in value.

Ardine Nelson. DoubleFrame Diana #2103. Hand colored black and white silver print, 1' 8" imes 2' 6".

LIGHT AND DARK

Value is simply the art and design term for light and dark. Our perception of figure and ground depends on relationships of light and dark. The page you are reading now is legible only because the darkness of the type contrasts with the lightness of the background paper. In reduced light our visual perception is more dependent on value than color.

Illustration **A** is a scale of seven values of gray. These are termed **achromatic** grays, as they are mixtures of only black and white; no color is used.

The Relationship between Light and Dark Areas

The term **value contrast** refers to the relationship between areas of dark and light. Because the scale in **A** is sequential, the contrast between any two adjoining areas is rather slight and is termed low-value contrast. The center gray circles are all the same middle value. It is interesting to note how this consistent center gray *seems* to change depending on the background. Indeed, it is hard to believe that the circles on the far left and

far right are precisely the same value. The surrounding value influences our perception of the middle gray: against the light it appears relatively dark, and against the dark it appears relatively light.

The scale in **A** shows only seven steps. Theoretically, between black and white there could be an almost unlimited number of steps. Studies have shown that the average eye can discern about forty variations in value. The artist may use as many or as few values as her or his artistic purposes dictate, though at times the nature of the chosen medium may influence the result. The photograph of architectural details by Ardine Nelson (**B**) demonstrates a rich range of values between the extremes of light and dark. This is the result of the right subject perceived under optimum lighting and the artist's skills. The exposure, the relationship between the limits of the film and the lens, and the developing process all are controlled. To achieve such a rich value range (possible with even a simple camera), a photograph is not merely "taken"; it is made.

The wash drawing shown in C reveals the artist's hand through evident brushstrokes. A full range of values and many subtle transitions as well as strong contrasts are registered. The white paper acts as both light on the figure and the space enveloping the figure. The values of wash pull the figure out of the surrounding ground.

Notice the striking contrast **D** offers to **C**. Here the value contrasts are extremely close and at the limits of our perception. This sets a different tone demanding an attentive audience and slow viewing in keeping with this artist's lifelong project. Earlier paintings from this series offered more contrast. The series has evolved over the decades and the white numbers are now painted on a nearly white ground as he continues the counting sequence. Roman Opalka considers all of the paintings to be one work in many parts. When seen this way, the artwork actually embraces a full range of values with perhaps more steps and gradations than B, or C.

VARIATIONS IN LIGHT AND DARK

In describing paintings or designs, we speak often of their value pattern. This term refers to the arrangement and the amount of variation in light and dark, independent of the colors used.

For the purpose of seeing the dramatic value pattern in Artemisia Gentileschi's painting (A), a black and white photograph is revealing. The emphasis on a dark ground and slashing diagonal light shapes is perfectly tuned to the dramatic subject matter and consistent with the theatricality of Baroque painting.

Balance by Value Distribution

Despite their obvious difference in style, the paintings we have been returning to by Gérôme and Picasso (B and C) have a common value range. Both run the scale from nearly white to black. Gérôme's Duel after the Masquerade (B) seems to play each note of the scale, where Picasso's Harlequin (C) offers fewer (but relatively equal) steps between the extremes. The Picasso painting is very balanced in the distribution of values, and the Gérôme painting is weighted to the left where the greatest contrast exists. Picasso's painting does not feel unbalanced, however, as the action depicted moves from left to right and diminishes like a piece of music that ends quietly rather than with a bang. What a difference this pattern makes in contrast with the drama of A!

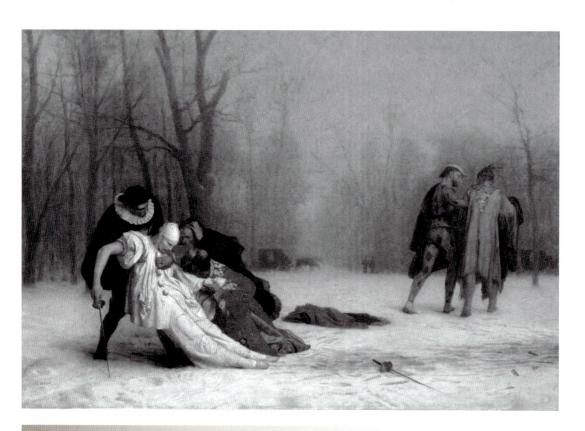

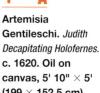

canvas, 5' 10" \times 5' $(199 \times 152.5 \text{ cm}).$ Galleria degli Uffizi, Florence, Italy.

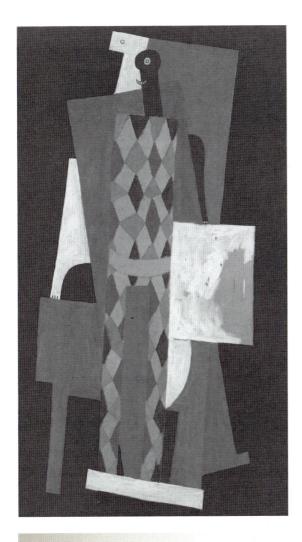

The Relationship between Value and Color

Value and color are related. Every color is, in itself, also simultaneously a certain value. Pure yellow is a light (high-value) color corresponding to a very light gray in terms of light reflection. Purple is basically a dark, low-value color that would match a very dark gray. A pure red will fall in the middle of the value scale.

The painting by Henri Matisse appears to be decidedly unbalanced if we view it in black and white **(D)**. A large part of the painting melts into middle gray. The color reproduction **(E)** reveals strong greens and pinks and a balanced composition. These contrasts disappear in the black and white photograph because of the colors' similar middle values.

See also Properties of Color: Value, page 262.

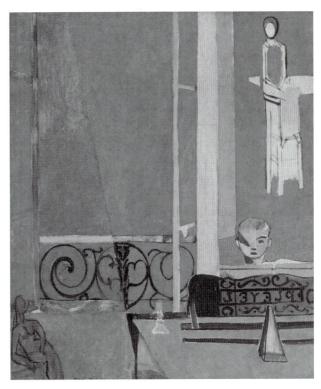

1 D

The values of the pink and green shapes are close to the value of the expanse of gray.

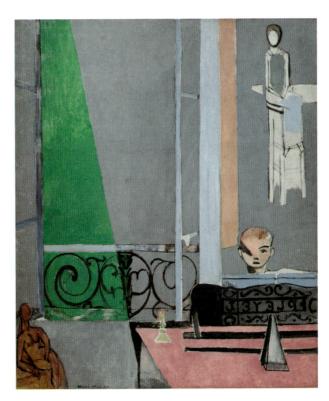

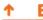

Henri Matisse. *The Piano Lesson.* 1916. 8' $1/2'' \times 6'$ 113/4'' (245.1 \times 212.7 cm).The Museum of Modern Art, New York.

CREATING A FOCAL POINT

A valuable use of dark-and-light contrast is to create a focal point or center of attention in a design. A visual emphasis or "starting point" is often desired. A thematically important character or feature can be visually emphasized by value contrast. High dark-and-light contrast instantly attracts our attention because of **value emphasis**. By planning high contrast in one area and subdued contrast elsewhere, the artist can ensure where the viewer's eye will be directed first.

Homer's watercolor of a leaping trout (A) emphasizes the trout through value contrast. The light underbelly stands out against the dark background, and the darker tail stands out against the backdrop of reflected light on the water.

The etching in **B** places emphasis on the light window at the right-hand side of the composition. Our eye follows the path of the gentle light to the softly illuminated figure grouping of the Holy Family. All other features of the interior melt into the darkness as we move away from that spot.

An Experiment in Value Contrast

Strong contrast of value creates an equal emphasis in both **C** and **D**. These photographs have precisely the same vantage point and appear almost like a positive and negative of the same image. In reality the artist has collaborated with nature to produce two striking images of contrast. In **C** a wet sycamore stick is seen against the snow. The photograph in **D** shows the same stick the next day, stripped of its bark, against the ground after the snow has melted away. In each case the form of the branch stands in contrast to the ground, but for very different reasons!

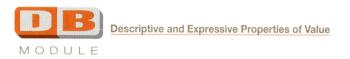

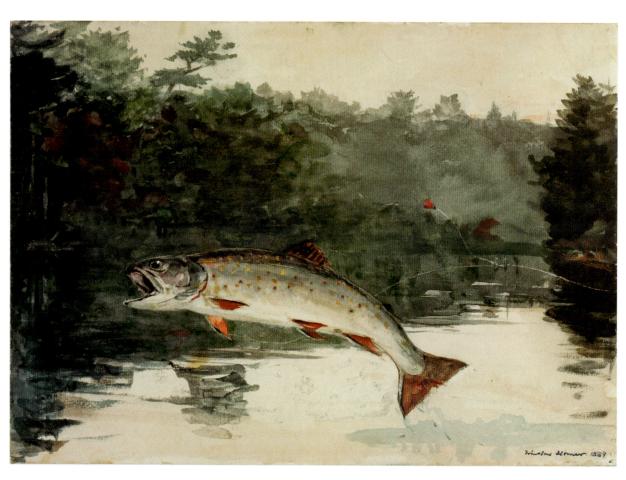

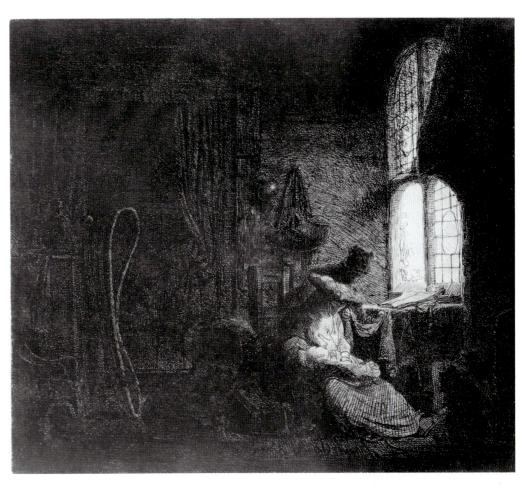

Ferdinand Bol. *Holy Family in an Interior.* 1643. Etching, drypoint and engraving; sheet: $7\%e^{\parallel} \times 8\%e^{\parallel}$ (18.21 \times 21.59 cm). The Metropolitan Museum of Art, The Elisha Whittelsey Collection, The Elisha Whittelsey Fund, 1995.

C

Andy Goldsworthy. Photograph, January 1981. Sycamore stick placed on snow/raining heavily. Middleton Woods, Yorkshire. From Andy Goldsworthy: A Collaboration with Nature (New York: Harry N. Abrams, 1990).

Andy Goldsworthy. Photograph, January 1981. Snow gone by next day, bark stripped, chewed and scraped off. Middleton Woods, Yorkshire. From Andy Goldsworthy: A Collaboration with Nature (New York: Harry N. Abrams, 1990).

USING VALUE TO SUGGEST SPACE

One of the most important uses of gradations of dark and light is to suggest volume or space.

On a flat surface, value can be used to impart a threedimensional quality to shapes. During the Renaissance the word chiaroscuro was coined to describe the artistic device of using light and dark to imply depth and volume in a painting or drawing. Chiaroscuro is a combination of the Italian words for "light" and "dark." A drawing using only line is very effective in showing shapes. By varying the weight of the line, an artist may imply dimension or solidity, but the effect is subtle. When areas of dark and light are added, we begin to feel the three-dimensional quality of forms. This is apparent in Sidney Goodman's figure drawing (A). The top portion of the figure is fully modeled with the light falling across the upraised arms revealing a roundness of form in contrast to the flat linear quality of the lower portion of the drawing. The watercolor in **B** shows how effectively the feeling of volume and space can be presented. Here the representational source is undulating paper, but the subject is space and light. Paper and wall interchange in relationships of lighter-than and darker-than.

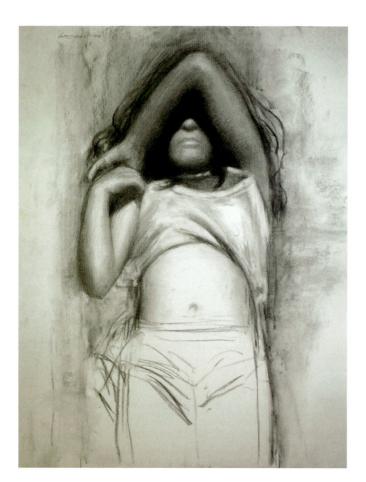

Sidney Goodman. Maia with Raised Arm. 2000. Charcoal on paper, 2' 5" \times 1' 11".

Value and Atmospheric Perspective

Far-off objects visually become less distinct and are absorbed into the atmosphere as the distance increases. In art this is called **aerial**, or atmospheric, **perspective**. High-value contrast seems to come forward, to be actually closer, whereas areas of lesser contrast recede or stay back, suggesting distance. This effect is commonly illustrated with sweeping landscape paintings (as it is in this book in other sections), but the photograph seen in **C** shows this effect to be true in other more unconventional circumstances. Notice how the foreground objects have very dark values unlike those in the middle and far distances as objects are affected by the white haze.

Physical Space and Psychological Space

In **D** the artist Sue Coe has used the values to create zones of light and darkness. Coe creates both the literal space of the hotel room and the troubled psychological space that Charlie Parker occupied in his short life. Although the composition is divided into two contrasting areas, there is a remarkable range of values in each.

Sue Hettmansperger. Untitled Drawing. 1975. Watercolor and pencil, 1¹ 11" \times 2¹ 1" (58 \times 64 cm). Collection of North Carolina National Bank.

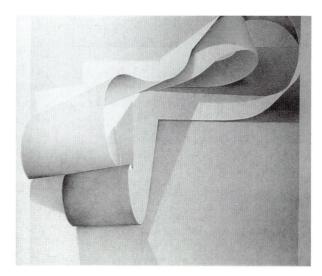

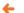

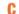

Edward Burtynsky. Shipbreaking #10, Chittagong, Bangladesh. 2000. Photograph. Charles Cowles Gallery, New York.

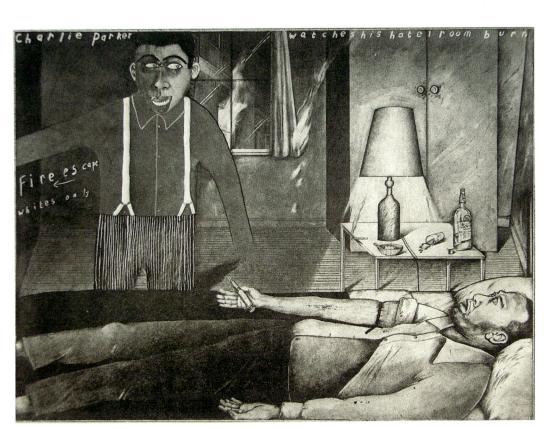

Sue Coe. Charlie Parker Watches His Hotel Room Burn. 1984. Photo etching, 10½" \times 1' 2". © 1984 Sue Coe. Courtesy Galerie St. Etienne, New York.

AN OVERVIEW

The use of value in a work of representational art is commonly called **shading**. However, to say that an artist uses shading does little to describe the final work, as there are so many techniques and hence many visual effects available. Artistic aims vary from producing a naturalistic rendition of some visual image to creating a completely nonobjective work that uses dark and

light simply to provide added visual interest to the design. Even with a similar purpose, works about the same subject done by the same artist will be very different depending on the chosen medium and technique. These examples can show you just a few of the almost unlimited possibilities.

Walter Hatke. Self-Portrait. 1973. Graphite on paper.

Giorgio Morandi. Striped Vase with Flowers. 1924. Etching on zinc, 23.9×20.4 cm. Museo Morandi, Bologna, Italy.

Giovanni Domenico Tiepolo. *St. Ambrose Addressing the Young St. Augustine.* c. 1747–1750. Black chalk, pen, and brown ink with brown wash on paper, 7%" × 10%". Arkansas Arts Center Foundation Collection: Purchased with a gift from Helen Porter and James T. Dyke, 1993.

Choosing the Medium

Pencil, charcoal, chalk, and Conté crayon are familiar media to art students. Being soft media, they are capable of providing (if desired) gradual changes of dark to light. The Walter Hatke drawing (A) shows the subtle and gradual transitions possible. Areas of contrast sit alongside subtle shifts in value, and the artist leads us gracefully from a predominantly light ground to the darkest values in the shadow.

Experimenting with Technique

A medium such as black ink, by its nature, gives decidedly sharp value contrast. But this can be altered in several ways. The artist may use what is called **cross-hatching** (black lines of various densities that, seen against the white background, can give the impression of different grays). Again, variations are possible. These lines may be done with careful, repetitive precision or in a more atmospheric manner as in **B**.

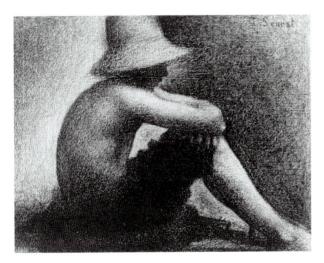

An artist may also choose the technique of wash drawing, in which dark ink or watercolor is mixed with water, diluting the medium to produce desired shades of gray (or brown). The **mixed-media** drawing shown in **C** creates value shapes in this manner. The value created by the wash contrasts with the bright lighter values. Darker values are created by combining parallel hatching of dark ink lines within the middle value wash.

Visual Grays

The use of dots to create visual grays is a very common procedure, though we may not realize it. All the black-and-white halftones we see daily in newspapers, books, and magazines are actually areas of tiny black dots in various concentrations to produce visual grays. This is a photomechanical process, but the same effect can be seen in Seurat's drawing **(D)**. Here the dots are created by the artist scraping a soft Conté crayon over a heavily textured white paper. Again, dots of black produce visual grays.

Using the same concept, **E** presents a definite visual feeling of grays and, hence, dimension and volume. But this "drawing" is accomplished by digital manipulation of a photograph. The grays are created by the positioning of hundreds of small numerals of various densities that combine with the white background to give us the impression of many different grays.

In past centuries visual media was dominated by black and white: prints, drawings, photography, even film and video were essentially black and white at one time. In contemporary media such a limited palette is a creative choice, but a sensitivity to value relationships remains an important skill for the artist and designer.

Georges Seurat. Seated Boy with Straw Hat (Study for The Bathers). 1882. Conté crayon, $9\frac{1}{4}$ " \times 1' $\frac{1}{4}$ " (24.13 \times 31.1 cm). Yale University Art Gallery, New Haven (Everett V. Meeks Fund).

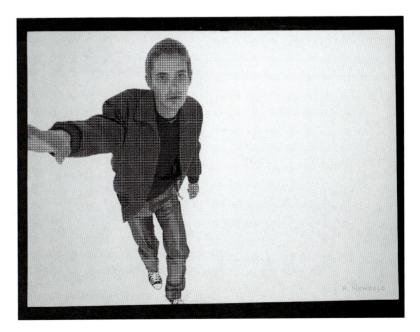

Spread from catalog featuring fashion by R. Newbold, a Paul Smith subsidiary, Autumn/Winter 1996. Art Director: Alan Aboud. Photographer: Sandro Sodano. Computer Manipulation: Nick Livesey, Alan Aboud, Sandro Sodano.

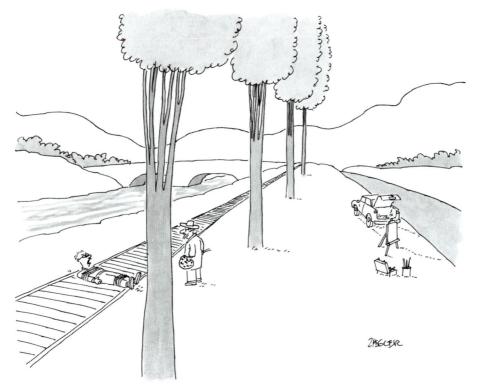

"Damn it, man, do I look like I have any yellow ochre?"

Jack Ziegler.

The Museum of Modern Art Book of Cartoons. In association with The Cartoon Bank: A New Yorker Magazine Company.

CHAPTER 3 COLOR

INTRODUCTION

Color Theory 256

COLOR CHARACTERISTICS

Color Perception 258

PROPERTIES OF COLOR

Hue and the Three Dimensions of Color Perception 260

PROPERTIES OF COLOR

Value 262

PROPERTIES OF COLOR

Intensity/Complementary Colors 264

PALETTES

Mixing Light and Mixing Pigments 266

VISUAL COLOR MIXING

Techniques That Suggest Light 268

COOL/WARM COLORS

Identifying Color with the Senses 270

COLOR AS EMPHASIS

Color Dominance 272

COLOR AND BALANCE

Achieving Balance within Asymmetrical Composition 274

COLOR AND SPACE

Color's Spatial Properties 276

COLOR SCHEMES

Monochromatic/Analogous 278

COLOR SCHEMES

Complementary/Triadic 280

COLOR DISCORD AND VIBRATING COLORS

Unexpected Combinations 282

COLOR USES

Local, Optical, Arbitrary 284

EMOTIONAL COLOR

Color Evokes a Response 286

COLOR SYMBOLISM

Conceptual Qualities of Color 288

COLOR THEORY

It is not only the professional artist or designer who deals with color. All of us make color decisions almost every day. We constantly choose items to purchase of which the color is a major factor. Our world today is marked by bold uses of color in every area of ordinary living. We can make color choices for everything from home appliances to bank checks—it seems that most things we use have blossomed into bright colors. Fashion design, interior design, architecture, industrial design—all fields in art are now increasingly concerned with color.

Therefore, everyone can profit by knowing some basic color principles. Unfortunately, the study of color can be rather complex. The word *color* has so many aspects that it means different things to a physicist, optician, psychiatrist, poet, lighting engineer, and painter; and the analysis of color becomes a multifaceted report in which many experts competently describe their findings. Shelves of books in the library on the topic attest that a comprehensive study of color from all viewpoints is impossible in a limited space.

The Essentials

However, any study of color must start with a few important, basic facts. The essential fact of color theory is that color is a property of light, not an object itself. Sir Isaac Newton illustrated this property of light in the seventeenth century when he put white light through a prism. The prism broke up white light into the familiar rainbow of hues (A). This presents the spectrum of wavelengths visible to the human eye. Objects have no color of their own but merely the ability to reflect certain wavelengths of light. Blue objects absorb all the wavelengths except the blue ones, and these are reflected to our eyes. Black objects absorb all the wavelengths; white objects reflect all of them. The significance of this fact for the artist is that as light changes, color will change.

Color Mixing

But although color indeed comes from light, the guidelines of color mixing and usage are different depending on whether the color source is light or pigments and dyes. Rays of light are direct light, whereas the color of paint is reflected light. Color from light combines and forms new visual sensations based on what is called the **additive system**. On the other hand, pigments combine in the **subtractive system**. This term is appropriate. Blue paint is "blue" because when light hits its surface, the pigment absorbs (or "subtracts") all the color components except the blue that is reflected to our eyes. Artists should be aware of both systems. The painter, of course, will be mainly concerned with the subtractive, whereas the stage lighting designer, photographer, and often the interior designer will be concerned with the additive.

Lights projected from different sources mix according to the additive method. The diagram in **B** shows the three **primary colors** of light—red, green, and blue—and the colors produced where two hues overlap. The three primaries combined will produce white light. Complementary (or opposite) hues in light (red/cyan, blue/yellow, green/magenta) when mixed will again produce an achromatic (neutral) gray or white. Where light from a cyan (blue-green) spotlight overlaps with light from a red spotlight, the visual sensation is basically white. Combining these two colors in paint would produce a dark neutral gray or black, anything but white.

This latter mixture of pigments functions according to the subtractive system. The red paint reflects little or no "blue-green" (or cyan), and the blue-green paint reflects little or no red. When mixed together, they act like two filters that now combine to reflect less light, thus approaching black (or a dark neutral) as the result. All paint mixture is to some degree subtractive; that is, the mixture is always weaker than at least one of the parent colors.

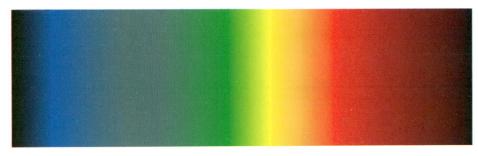

The spectrum of colors is created by passing white light through a prism.

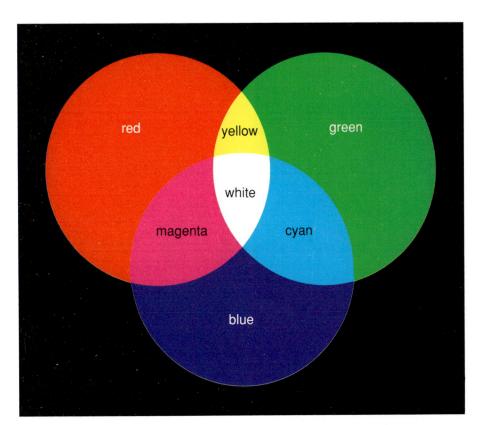

Colors of light mix according to the additive process.

COLOR PERCEPTION

Light

In any discussion of color, it is important to acknowledge that color is a product of light. Therefore, as light changes, the color we observe will change. What color is grass? Green? Grass may be almost gray at dawn, yellow-green at noon, and blue-black at midnight. The colors of things are constantly changing with the light. Though this is a simple visual fact, our mind insists that the grass is green despite the visual evidence to the contrary, a psychological compensation called **color constancy**. This **constancy effect** is useful from the standpoint of human adaptation and survival. Imagine the problems if we questioned the colors of things with each new perception. Yet it is just this kind of questioning that has led artists such as Monet to reveal the range of color sensations around us. Monet's two paintings of poplars

along the River Epte (A and B) are typical of this artist's reinvestigation of the same setting under different circumstances. Season, time of day, and weather conditions all contribute to different light and a difference in the color we perceive.

Influence of Context

Today's artists and students (and authors) owe a great debt to the twentieth-century artist Josef Albers, who as a painter and teacher devoted a career to the study of color and color relationships. His books and paintings have contributed invaluably to our knowledge of color. Many of the concepts in this discussion are reflections of his research and teaching.

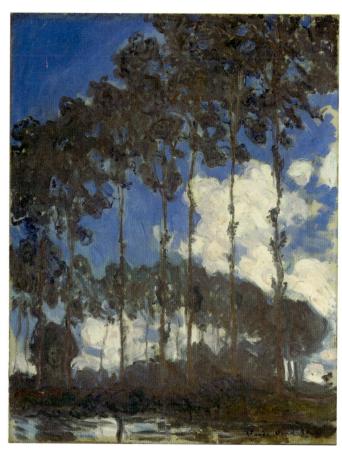

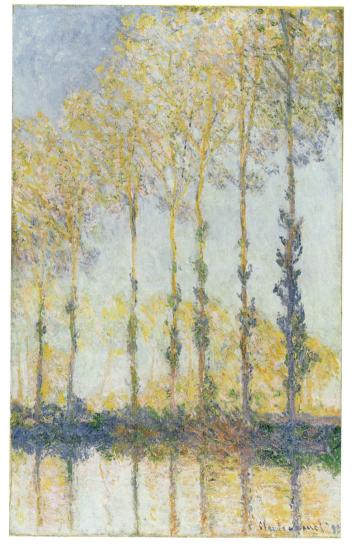

Color and Its Surroundings

Related to the concept of color changing with the light is one other important color phenomenon: our perception of colors changes according to their surroundings. Even in the same light, a color will appear different depending on the colors that are adjacent to it. Rarely do we see a color by itself. Normally colors are seen in conjunction with others, and the visual differences are often amazing. The impact of context on perception is dramatically demonstrated in a situation like that seen in **C**. The

simultaneous contrast of a nearly neutral color with a magenta and a green background alters our perception of this "muddy" color. We see it appear more pink against the green and more green against the pink.

These manipulations of our perception are not mere "tricks." Illustration **C** is not an exception to our everyday experience: this is an example of contextual influences that surround our every perception (and we will see others in coming sections).

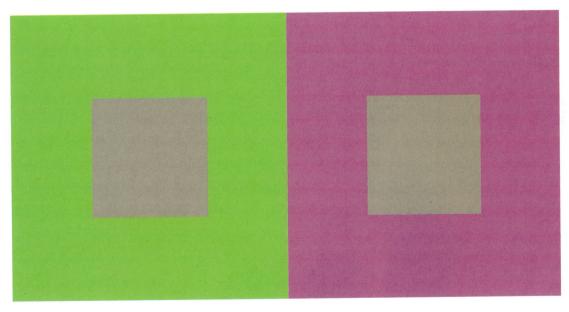

1 0

The gray sample looks different against the two background colors.

HUE AND THE THREE DIMENSIONS OF COLOR PERCEPTION

The first property of color is what we call hue. Hue simply refers to the name of the color. Red, orange, green, and purple are hues. Although the words hue and color are often used as synonyms, there is a distinction between the two terms. Hue describes the visual sensation of the different parts of the color spectrum. However, one hue can be varied to produce many colors. So even though there are relatively few hues, there can be an almost unlimited number of colors. Pink, rose, scarlet, maroon, and crimson are all colors, but the hue in each case is red. We are all aware that in the world of commercial products, color names abound; plum, adobe, colonial blue, desert sunset, Mayan gold, and avocado are a few examples. These often romantic images are extremely inexact terms that mean only what the manufacturers think they mean. The same hue (or color) can have dozens of different commercial names. You will even notice that the same hue can have different names in different color systems. "Blue," for instance, may be a blueviolet in one system and a cyan in another. One system may use the term purple and another violet. Try to see past the names given to the colors and look instead at the relationships.

The Color Wheel

The most common organization for the relationships of the basic colors is the color wheel shown in A. The wheel system dates to the early eighteenth century, and this version is one updated by Johannes Itten in the twentieth century. This particular organization uses twelve hues, which are divided into three categories.

The three primary colors are red, yellow, and blue. From these, all other colors can theoretically be mixed. The three secondary colors are mixtures of the two primaries: red and yellow make orange; yellow and blue make green; blue and red make violet. The six tertiary colors are mixtures of a primary and an adjacent secondary: blue and green make blue-green, red and violet make red-violet, and so on. This offers the most basic starting point for understanding the relationships of the color wheel, but we may recall childhood experiences of mixing such simple primaries and being disappointed at the muddy results. We will see that in application cyan, yellow, and magenta are the closest to pigment primaries, and as we have noted red, blue, and green are the primaries of light.

The color wheel of twelve hues is the one still most commonly used. If you look closely, however, you will notice that the complements are not perfectly consistent with those shown in

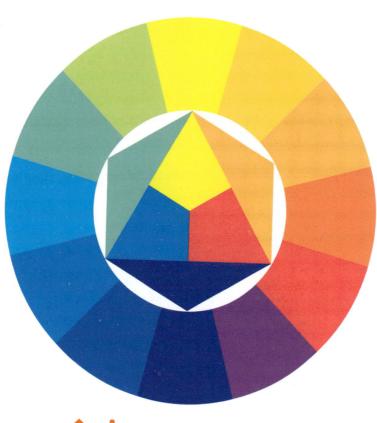

the illustration of additive and subtractive primaries seen earlier. Furthermore, if you try mixing colors based on this wheel (such as blue and red to make violet), you will find the results to be dull and unsatisfactory.

Color in Three Dimensions

The color wheel shown in ${\bf B}$ is from the Munsell Color System and is based on equal visual steps. Mixtures of complements on this wheel will more closely produce neutrals (when tested as light mixtures, for example), and the positions of the colors are more useful in predicting paint mixtures as well. The other charts show the full dimension of perceived color relationships:

Hue: The colors of the spectrum or color wheel

Value: The relative lightness or darkness of a color

Intensity (or **chroma** as it is called by Munsell): the relative saturation of hue perceived in a color

These three attributes of color ultimately form a three-dimensional model or color space, which has been constructed by Munsell as a complete color reference.

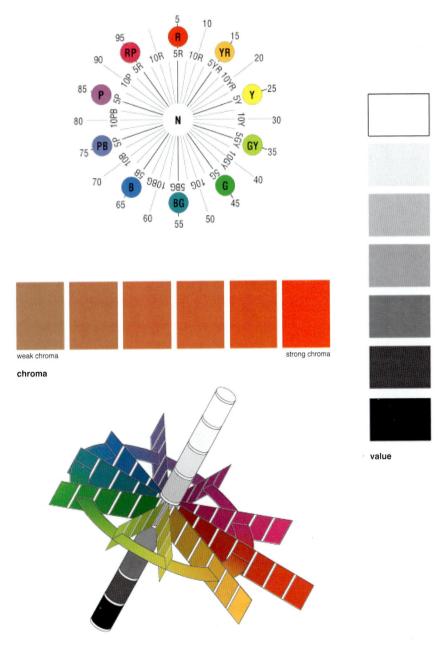

PROPERTIES OF COLOR

VALUE

The second property of color is **value**, which refers to the lightness or darkness of the hue. In pigment, adding white or black paint to the color alters value. Adding white lightens the color and produces a **tint**, or high-value color. Adding black darkens the color and produces a **shade**, or low-value color. Individual perception varies, but most people can distinguish at least forty tints and shades of any color.

"Normal" Color Values Differ

The colors on the color wheel are shown at their inherent values. This inherent, or normal, value is the pure color unmixed and undiluted. The normal values of yellow and of blue, for example, are radically different **(A)**. Because yellow is a light, or high-value, color, a yellow value scale shows many more shades than tints. The blue scale shows more tints, because normal blue is darker than a middle value. The inherent value of a hue is based on our perception—that is, the way the human eye reads the values of colors. We can see this as we compare the value scales for blue and yellow to the adjacent gray scale.

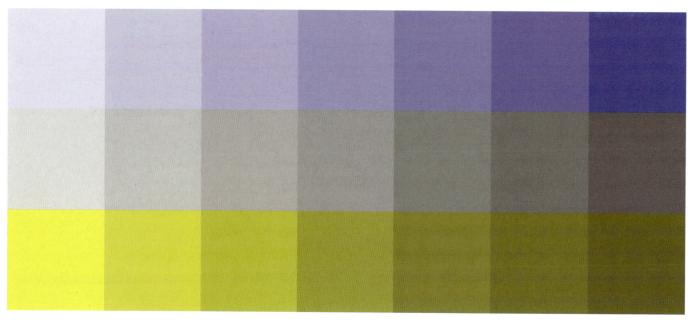

↑ A

Value scales for blue, gray, and yellow with equal visual steps.

Changing Color Values

When working with paint and pigments, the value of a color can be altered by thinning the color with medium. The more transparent color will be a lighter value when applied over a white background. The value of a color can also be altered by mixture with other hues: a naturally dark violet will darken a yellow, for example.

Value, like color itself, is variable and depends on surrounding hues for its visual sensation. In ${\bf B}$ the center green area appears much lighter and more luminous on the black background than on the white.

Color Interaction

It is well known that colors are changed by their context. Amounts and repetition are also critical factors in color interaction. The same green shown in **B** takes on a different complexion when it is "woven" through the black or white as shown in **C**. In this case the white and green interact in a mixture effect (best perceived from a distance), producing a lighter value field of color than the green and black pattern.

The same color will appear to change in value, depending upon the surrounding color.

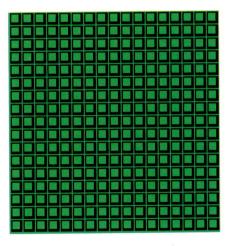

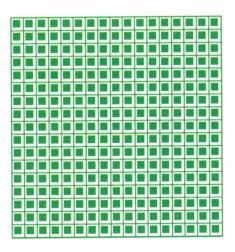

The visual mixture of green with black and white.

PROPERTIES OF COLOR

INTENSITY/ COMPLEMENTARY COLORS

The third property of color is **intensity** (sometimes called chroma), which refers to the saturation of a color. Because a color is at full intensity only when pure and unmixed, a relationship exists between value and intensity. Mixing black or white with a color changes its value and at the same time affects its intensity. To see the distinction between the two terms, look at the two tints (high value) of red in example **A**. The tints have about the same degree of lightness, yet one might be called "rose," the other "shocking pink." The two colors have very different visual effects, and the difference we perceive is their relative intensity.

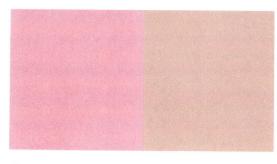

Two tints of red at the same value have different intensities.

C

Mixtures Lower Intensity

There are two ways to lower the intensity of a color, to make a color less saturated, more neutral, or duller. One way is to mix gray with the color. Depending on the gray used, you can dull a color without changing its value. The second way is to mix a color with its complement-the color directly across from it on the color wheel. Illustration B shows an intensity scale involving complementary colors blue and orange. Neutralized (lowintensity) versions of a color are often called tones. In B we see two intensity levels of blue and two intensity levels of orange with gray in the middle. As progressively more orange is added to the blue, the blue becomes duller, more grayed. The same is true of the orange, which becomes browner when blue is added. Note this effect in the photograph of orange chairs seen through the blue glass table (C). In paint mixtures, complements neutralize toward gray or black, acting in a filter-like effect akin to viewing the chair through colored glass (a subtractive mixture.) In light mixtures, complements mix to produce white light (an additive mixture). In both cases the effect is neutralizing.

The Degas painting in **D** is characterized by varying intensities of a single hue. The warm red-orange ranges in intensity to include flesh tones and browns. When other hues are not present, the effect of intensity is even more obvious.

Afterimage and Simultaneous Contrast

Another phenomenon that defines complementary color is the **afterimage** effect. Stare at an area of intense color for a minute or so, and then glance away at a white piece of paper or wall. Suddenly, an area of the complementary color will seem to appear. For example, when you look at a white wall after staring at a red shape, a blue-green shape will seem to appear. This is a result of **retinal fatigue**. Prolonged exposure to a single strong hue will cause the receptors for that hue to fatigue while the complement is still perceived.

Mixing complementary colors together neutralizes them, as we have seen. But, when complementary colors are placed next to each other, they intensify each other's appearance through simultaneous contrast. Artists use this visual effect when they wish to emphasize brilliant color.

See also Color Schemes. Complementary/Triadic, page 280.

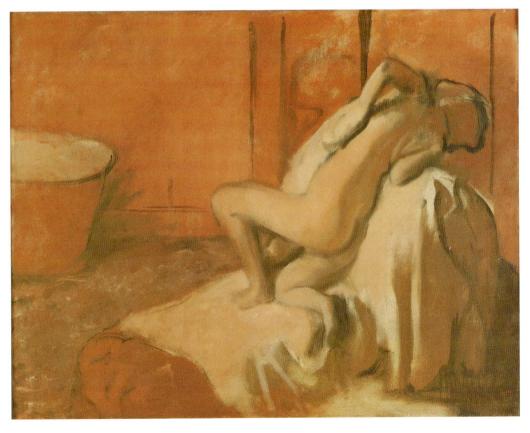

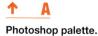

MIXING LIGHT AND MIXING PIGMENTS

It is probably as common for a young art student to have had some experience with a digital palette as a painter's palette (perhaps more likely!). This relatively recent development brings light into the discussion right alongside traditional pigments.

The mixing window from Adobe Photoshop shown in **A** lays out all of the elements we have discussed previously. The continuous scale of hues could be closed in a circle to make the color wheel, and complements would be opposite on this wheel. This relationship is noted by the 360 degrees of hue difference; 180 degrees (or half a circle) separates complements. The hue is given a position number on this scale (letter *H*) and a lightness level (letter *B*) and a saturation or intensity (letter *S*). Mixture amounts are shown for red, blue, and green (R, B, G) as well as cyan, magenta, yellow, and black (C, M, Y, K). The first set of numbers is relevant to the screen, and the second set is relevant for the printer and inks. This palette can be used to identify a color by sampling from a picture, or for altering a color through manipulation of the variables.

Three palettes are shown (courtesy of Gamblin Paints) that chart the evolution of the painter's palette. The image in **B** shows the mineral pigments available to artists from the period of the Renaissance and on into the nineteenth century. We can appreciate the exotic appeal of those rare minerals that produced intense hues! These were the "special effects" of an earlier era.

The second image **(C)** shows how that palette grew with the addition of cadmiums and other heavy metals. This enhanced the opportunity for the Impressionists to develop more saturated paintings with a greater variety of hues and attempts to capture luminous and fugitive color sensations. Finally, **D** is a modern palette that has grown greatly to include organic dyes. These new pigments offer more saturated hues and more steps on the color wheel. The result is the potential for more saturated mixtures: the closer the colors on the wheel, the more intense their mixture.

Some modern paint producers offer the artist information regarding the hue, value, and intensity (or chroma) of a color. It is important to realize that a paint's pigment saturation is not synonymous with *visual* saturation. In fact, a paint that looks black coming out of the tube (such as a dioxazine purple) and is very saturated with pigment will actually become more *visually* saturated when it is thinned with a transparent medium. This is because light can then enter the paint and illuminate it like stained glass. A color that looks saturated right from the tube (with a name like "bright purple" typical of some student-grade paints) may in fact be a mixture of more than one pigment and white. This color will have more limited mixing potential since you can always add white to a dioxazine purple, but you can't remove it from the "bright purple."

The increased steps available to the painter's palette, and the palette employed by digital applications such as Photoshop, present the student with a more sophisticated and interrelated understanding of color mixing than that available to past generations. It is important to observe that this does not guarantee success in the application of color. In fact, it appears that Vermeer and Rembrandt did quite well with their limited palettes.

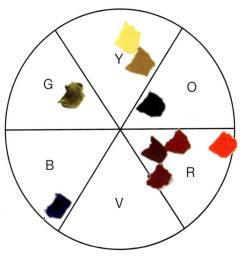

Classical Palette in Color Space

Classic artist's palette: Naples Yellow (Hue), Yellow Ochre, Raw Umber, Vermillion (Napthol Scarlet shown here), Venetian Red, Burnt Sienna, Indian Red, Ultramarine Blue (lapis), and Terre Verte. Courtesy Gamblin Paints.

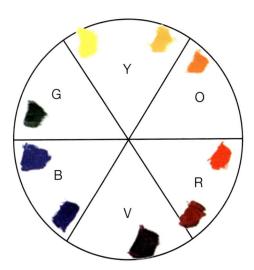

Impressionist Palette in Color Space

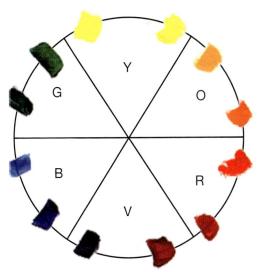

Modern/Spectral Palette in Color Space

Impressionist's palette: Cadmium Yellow Light, Cadmium Yellow Deep, Cadmium Orange, Cadmium Red Light, Alizarin Crimson, Cobalt Violet, Ultramarine Blue, Cerulean Blue, and Viridian. Courtesy Gamblin Paints.

Modern/Spectral Palette: Hansa Yellow Light, Hansa Yellow Medium, Hansa Yellow Deep, Mono Orange, Napthol Scarlet, Quinacridone Red, Quinacridone Violet, Dioxazine Purple, Phthalo Blue, Manganese Blue Hue, Phthalo Green, and Phthalo Emerald. Courtesy Gamblin Paints.

TECHNIQUES THAT SUGGEST LIGHT

Pigments combine along certain guidelines to create new colors. However, muddy or dull colors are often the result. Even when mixing adjacent colors on the color wheel, you may find the results to be less intense than you anticipated, and the farther apart the hues, the more subtractive (darker and duller) the mixture. To understand this process, think of the pigments as acting like filters, which in combination (or mixture) allow less light or color to reflect off the colored surface to the viewer's eye.

Chuck Close. April. 1990–1991. Oil on canvas, 8' 4" \times 7'. Courtesy Pace Wildenstein, New York.

Visual Color Mixing Techniques

Pigment simply will never reproduce the luminous and brilliant quality of light. Recognizing this, artists (painters, printmakers, and fiber artists) have struggled with the problem and tried various techniques to overcome it. One attempt is called **visual color mixing** or **optical mixture**. Rather than mixing two colors on the palette, artists place two pure colors side by side in small areas so the viewer's eye (at a certain distance) will do the mixing. Or perhaps they drag a brush of thick pigment of one color loosely across a field of another color. The uneven paint application allows bits and pieces of the background to show through. Again, the pure colors are mixed in our perception, not on the canvas.

Visual mixing is often associated with the post-Impressionist era of the late nineteenth century and can be observed in the works of artists such as Seurat and van Gogh. The techniques of **pointillism** and *divisionism* both use small bits of juxtaposed color to produce different color sensations. In a way, these artists anticipated the truly additive color mixing that occurs on a screen. Your laptop's screen is composed of thousands of luminous

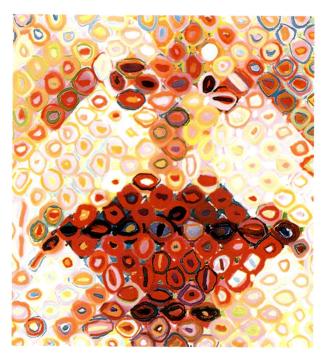

Chuck Close. April (detail). 1990–1991. Oil on canvas, 8' 4" \times 7'. Courtesy Pace Wildenstein, New York.

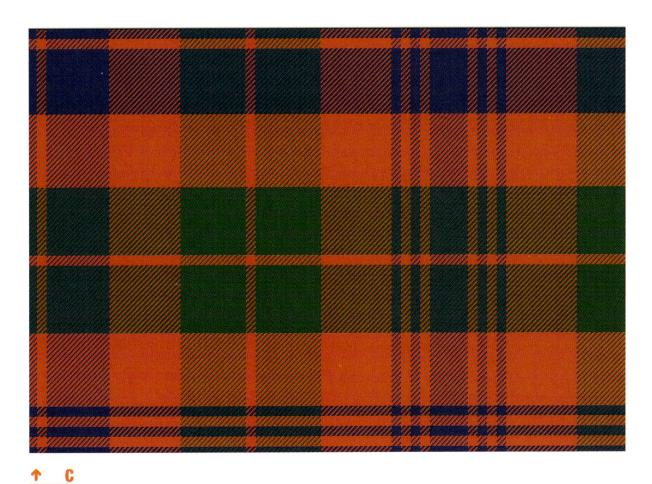

Black Watch Plaid for Band Regimental Tartan (#396). House of Tartan, Ltd., Perthshire, Scotland.

pixels. The colors we see are a visual mix of the light primaries red, blue, and green. Such luminosity is not possible with the surface of painting. Still, artists continue to explore the possibilities of visual mixture, as can be seen in *April* (A) by the contemporary painter Chuck Close. The large scale of this portrait assures that we will always be aware of the pattern of color bits and that they will not absolutely merge into a mixture. In fact, this technique is usually most luminous when that is the case.

This particular painting by Close has large, obvious units of color, as can be seen in the detail **(B)**. Earlier paintings by the artist employed smaller, more subtle dots and dashes. The larger marks in the newer work allow us to easily see the components of the "mixture." It is evident that the closer the value of the color bits, the more easily they merge.

Visual Mixing in Other Art Forms

The basic idea of visual mixing is used in many areas. In creating mosaics, stirring a bowl of red and blue tiles will not, of course,

produce purple tesserae. Instead, small pieces of pure-colored tiles are interspersed to produce the effect of many other intermediate colors. The same process is employed in creating tapestries. Weavers working with a limited number of colored yarns or threads can intermingle them so that at a distance the eye merges them and creates an impression of many hues, values, or intensities. Illustration **C** is a plaid, or tartan, fabric that demonstrates this phenomenon. From a distance the material can seem to be a pattern of many colors and values. Close inspection might reveal that just three colored threads have been woven in various densities to produce all the visual variations.

A version of the pointillist technique is now used every day in a photomechanical adaptation in the printing of color pictures. The numerous colors we see in printed reproductions, such as those on these pages, are usually produced by just four basic colors in a small dot pattern. The dots in this case are so tiny that we are totally unaware of them unless we use a magnifying glass to visually enlarge them.

IDENTIFYING COLOR WITH THE SENSES

"Cool" colors? "Warm" colors? These may seem odd adjectives to apply to the visual sensation of color, as cool and warm are sensations of touch, not sight. Nevertheless, we are all familiar with the terms and continually refer to colors this way. Because of the learned association of color with objects, we continue to relate colors to physical sensations. Hence, red and orange (fire) and yellow (sunlight) become identified as warm colors. Similarly, blue and sea-green colors (sky, water) evoke coolness.

A Psychological Effect

Touching an area of red will assuredly not burn your hand, but looking at red will indeed induce a feeling of warmth. The effect may be purely psychological, but the results are very real. Perhaps you have read of the workers in an office painted blue complaining of the chill and actually getting colds. The problem was solved not by raising the thermostat but by repainting the office in warm tones of brown.

An architectural installation by James Turrell (A) shows such a striking warm/cool contrast. The cutaway in the roof that opens to the sky is subtle and reveals none of the expected architectural details, only the expanse of sky. This blue contrasts with the warm interior lighting. Incandescent lighting, for example, has such a warm glow (associated with "hearth and home") that it has been a psychological obstacle for people to accept the more neutral florescent lighting despite the economic and environmental benefits.

James Turrell. Meeting. 1986.

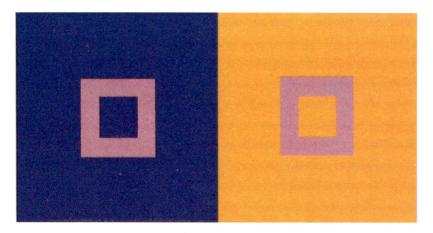

Color Context Makes a Difference

We generally think of the colors yellow through red-violet as the warm side of the color wheel and yellow-green through violet as the cool segment. The visual effects are quite variable, however, and again depend a great deal on the context in which we see the color. In ${\bf B}$ the magenta shape appears very warm surrounded by a background of blue, but this same hue appears very cool against the orange background. Josef Albers described it like this: When you take your hands from hot water and place them in room-temperature water, it feels cool. When you take your hands from ice water and place them in the same room-temperature water, it feels warm-same water, different sensation.

Light and Shadow

Because warm colors tend to advance whereas cool colors seem to recede, the artist may use the warm/cool relationship to establish a feeling of depth and volume. This is most evident in the receding blue hills of a landscape. The influence of the blue sky can also be seen in the shadows on a sunny day. Neil Welliver's winter landscape shown in C makes this evident. The bright snow is illuminated by the intense sunlight, and the shadows reflect the blue sky. In fact, these shadows are close in color to the bit of sky reflected in the pool of water.

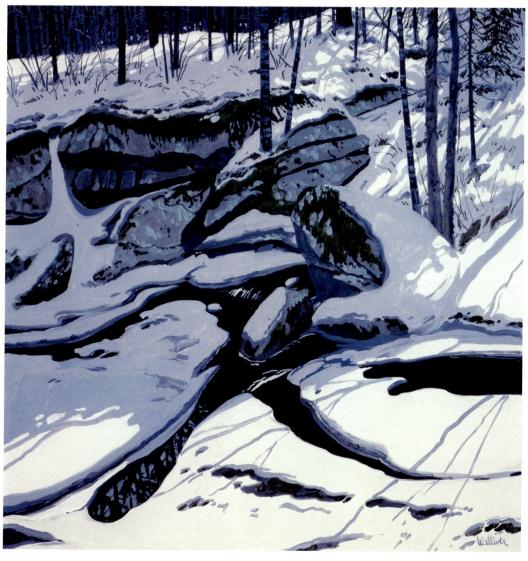

COLOR DOMINANCE

Areas of emphasis in a work of art create visual interest and, naturally, have been carefully planned by the artist. Color is very often the means chosen to provide this emphasis—color is probably the most direct device to use. When planning emphasis, we might think of using a larger size somewhere, or perhaps changing a shape, or isolating one element by itself. As the diagrams in **A** show, the use of color dominates these other devices. You will notice that the accented color is not a radically different hue or very different in value or intensity. Such contrasts, of course, would heighten the effect. But **A** shows that color by its very character commands attention.

Color is so strong a visual element that it will dominate other devices to establish emphasis.

"Music." P&G Glide Dental Floss Campaign. Saatchi & Saatchi, New York. Creative director: Tony Granger, Jan Jacobs, Leo Premutico. Art director: Menno Kluin. Copywriter: Icaro Doria. Photo: Jenny van Sommers.

Color as Attention-Grabber

Sometimes the artist or designer may wish to create a definite focal point or center of attention that the observer will see first. A bright or vivid color, such as the yellow in the dental floss advertisement **(B)** creates an emphasis that the shape or position of the words "boy bands" would not achieve in black and white. In this case the focus is not on the product, which is more subtly presented in the foreground. A memorable and humorous reference to dental floss is suggested by emphasizing an irritant to be flossed out.

The unusual arrangement of autumn leaves in *Elm* by Andy Goldsworthy in **C** shows how color can create an emphasis so strong that it dominates other elements. In this case Goldsworthy tore similar dark and yellow leaves and mated a dark half to a yellow half of another similarly shaped leaf. These mated leaves form the boundary, which contains many other yellow leaves set off against the field of darker and duller leaves. The result emphasizes the yellow shape and gives the appearance of the dark leaves having been painted within that rough circle.

In each of the preceding examples, yellow is the dominant hue and attention grabber. In $\bf A$ yellow provides emphasis in a cluster of green shapes. In $\bf B$ yellow dominates a predominantly light valued composition, and in $\bf C$ the fact that yellow is a light hue asserts dominance in an otherwise dark composition.

ACHIEVING BALANCE WITHIN ASYMMETRICAL COMPOSITION

Unlike symmetrical balance, asymmetry is based on the concept of using differing elements on either side of the center axis. But to create visual balance, these elements must have equal weight or attraction. Color is often used to achieve this effect.

The use of color to balance a composition is very common and seen in many different periods and different styles of art. Wayne Thiebaud's *Rabbit* (A) is at first glance the simplest of compositions: a white rabbit placed in the center of a white field. The rabbit's head is the natural focus of the composition, and this directs our attention to the left side of the painting. The intense blue shadow on the right-hand side of the composition provides the balance.

Wayne Thiebaud. *Rabbit.* 1966. Pastel on paper, 1' 2%" \times 1' $7\frac{1}{2}$ " (37 \times 50 cm). Courtesy collection of Mrs. Edwin A. Bergman and the artist. Art © Wayne Thiebaud/Licensed by VAGA, New York, New York.

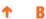

Joan Miró. The Birth of the World. Montroig, summer 1925. Oil on canvas, 8 $^{\rm l}$ 2 $^{\rm ll}$ \times 6 $^{\rm l}$ 6 $^{\rm ll}$ " (250.8 \times 200 cm). The Museum of Modern Art, New York (acquired through an anonymous fund, the Mr. and Mrs. Joseph Slifka and Armand G. Erpf funds, and by gift of the artist).

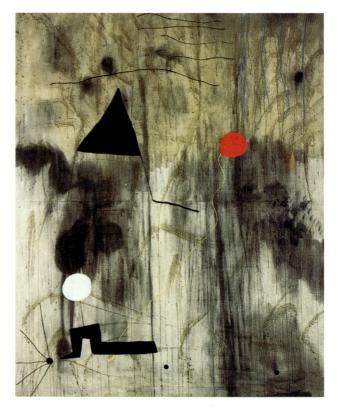

r C

Seeing B in color shows us how color achieves the balance.

Color in Balance with Value

A comparison of **B** and **C** will illustrate the idea. In **B** Joan Miró's painting is shown just in black and white. In this reproduction, the composition might appear off balance. The left side, with the contrasting white circle, solid black triangle, and notched rectangle, seems to have more visual interest than the right side where there is less delineation of the shapes and little value contrast. But when the same painting is seen in color (C), the balance is immediately clear. The circular shape on the right is actually a brilliant red. This very vivid color note in a predominantly neutral painting attracts our eye and can balance the elements on the left.

Dynamics of Balance and Imbalance

Picasso's Harlequin (D) demonstrates a particular kind of balancing act. The two sides of the composition seem to rock back and forth around a vertical axis that runs through the "eye" or pivot point at the center and top of the painting. The opposing tilt of the brown and blue planes also suggests a radial balance. The alternating colors (including black and white) are repeated in a balanced but asymmetrical pattern.

The Gérôme painting (E) shows an opposite effect to that of Miró's painting (C). The small amount of red that provides balance for Miro creates a dynamic imbalance for Gérôme. In E red brings emphasis to the culmination of the drama on the left. Although this composition is balanced by the interest created in the departing figures on the right, there is no question that the red contributes to a weighted emphasis on the left.

Pablo Picasso. Harlequin. Paris, late 1915. Oil on canvas, 6' 1/4" × 3' 53/8" (183.5 × 105.1 cm).

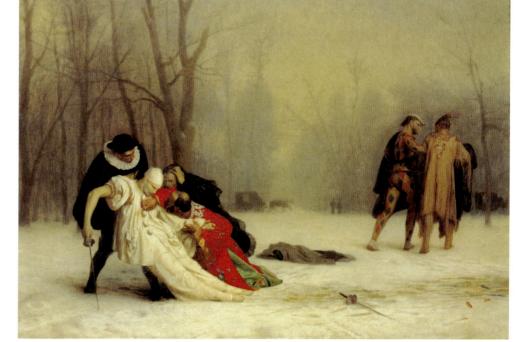

Jean-Léon Gérôme. The Duel after the Masquerade. 1857-1859. Oil on canvas, 1' 3%" × 1' 103/16" (39.1 × 56.3 cm).

COLOR'S SPATIAL PROPERTIES

Atmospheric Perspective

The earth's atmosphere disperses the shorter wavelengths of blue coloring the sky and objects that recede into the atmosphere **(A)**. As objects recede, any brilliance of color becomes more neutral, finally seeming to be gray-blue. Value and color contrasts are more pronounced in the foreground and more subtle in the distance. This is such a common experience in our lives that we are inclined to interpret cool colors as receding even in abstract designs.

Spatial experience is not limited to the clues of a representational subject such as the landscape. Alan Cotes's diptych painting **(B)** presents two spatial realities side-by-side in a non-objective composition. The left panel has greater hue variety: tints of red and blue against a yellow ground. The right panel is limited in hue but varied in value and intensity. The red parallelograms on the right float and appear to advance from the darker space. On the left, the pinks and pale blues exist in a shallow space and seem to vibrate against the yellow ground. It may take a moment to notice that there are two yellows on the left and two dark reds on the right. These subtle distinctions that emerge slowly in our perception enhance the spatial experience. For example, the dark red behind the floating shapes is cooler and emphasizes the warmth of the parallelograms.

Using Color to Emphasize Flatness

David Hockney in *Mulholland Drive: The Road to the Studio* (C) offers a contrast to both **A** and **B**. Hockney consciously flattens and compresses space by his use of color. Hills, groves of trees, and the towers of power lines are obvious images from the landscape, but the shapes, colors, and patterns are laid out like a crazy quilt. Even the map-like patterns at the top add emphasis to the essential flatness of the arrangement. In this case, hot oranges work as both foreground and background. You can see blue along the bottom or "foreground" of the painting as well as farther up or "back" in the landscape.

See also Devices to Show Depth: Aerial Perspective, page 204, and Value and Space, page 250.

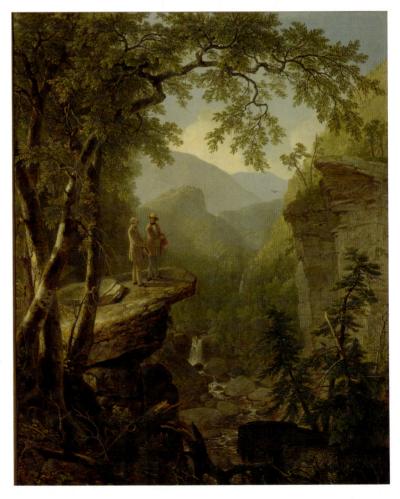

↑ B

Alan Cote. Untitled. 2007. Acrylic on canvas, 6' 9" x 8'.

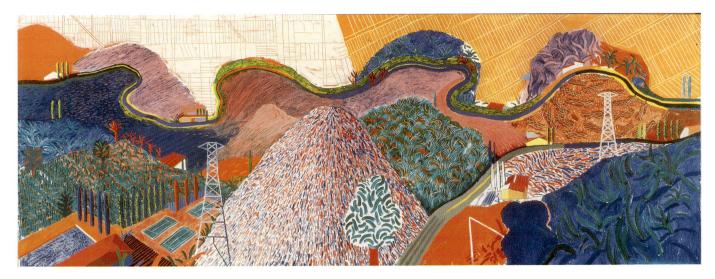

MONOCHROMATIC/ANALOGOUS

Certain color schemes are thought of as **color harmonies**. These schemes are organized by simple color relationships. They may explain relationships and often recur in nature, but they are not *the* formula for design success that the word harmony might imply. In fact, music that relies only on harmony as an element usually makes us think of "elevator music." Similarly, color harmony can be simplistic or part of a more complex composition.

Monochromatic Color Scheme

A **monochromatic** color scheme involves the use of only one hue. The hue can vary in value, and pure black or white may be included. The image in **A** is a monochromatic painting. Mark Tansey explains that his use of monochrome unifies an image that is created from a montage of photographs. The disparate sources are united by a palette of just one hue. Monochrome also serves to heighten an emphasis on shape and texture. In Tansey's case it also evokes a photographic quality suggesting a cyanotype or sepia-toned photograph.

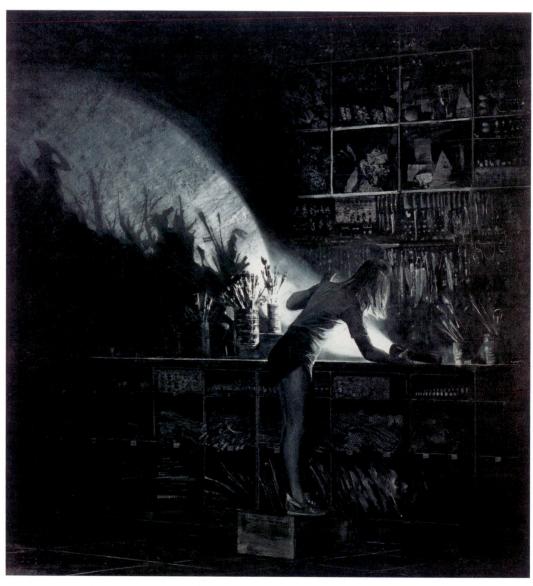

Analogous Color Scheme

An **analogous** color scheme combines several hues that sit next to each other on the color wheel. Again, the hues may vary in value. The Navajo textile **(B)** shows the related, harmonious feeling that analogous color lends to a design. This blanket includes colors adjacent to red on the color wheel.

Tonality

Color unity is described by another term. We often speak of the *tonality* of a design or painting. **Tonality** refers to the dominance of a single color or the visual importance of a hue that seems to pervade the whole color structure despite the presence of other colors. Analogous color schemes can produce a dominant tonality, as **C** shows. In this case the tonality suggests a strong red light source.

Navajo blanket/rug. c. 1885–1895. 4' 7" \times 6' 10" (140.5 \times 207.8 cm). Natural History Museum of Los Angeles County (William Randolph Hearst Collection).

Elizabeth Peyton. *Julian.* 2005–2006. Fifty-five-color handprinted ukiyo-e woodcut, 1' 5" \times 1' %" (43.2 \times 32.8 cm).

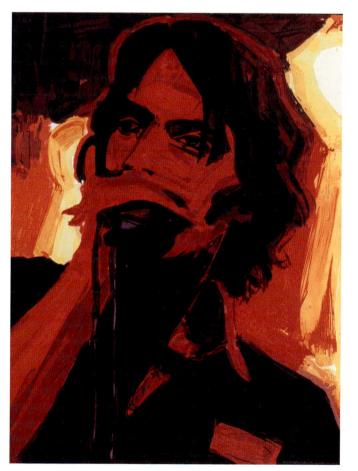

COMPLEMENTARY/TRIADIC

A **complementary** color scheme, as the term implies, joins colors opposite each other on the color wheel. This combination produces a heightened sense of contrast, as in Stuart Davis's painting titled *Visa* (A). This painting has the graphic qualities of a billboard or sign. The complementary contrast of magenta letters and green background makes use of the eye-catching devices of advertising.

Split Complementary Color Scheme

A split complementary color scheme is related to the complementary scheme but employs colors adjacent to one of the complementary pairs. For example, the sky in $\bf B$ is balanced by a range of yellows and oranges near the complementary opposite of the blue. It is more common to find a complex solution such as $\bf B$ than a simple complementary pair.

Triadic Color Scheme

A **triadic** color scheme involves three hues equally spaced on the color wheel. Red, yellow, and blue would be the most common example. These hues form a triangle on the color wheel and suggest balance. This is true even when the red, yellow, and blue are subtle as in Vermeer's painting *Girl with a Pearl Earring* **(C)**. Red, yellow, and blue often appear in combination with the simple contrast of black and white as they do in this picture.

Planning Color Schemes

These color schemes or harmonies are probably more common to such design areas as interiors, posters, and packaging than to painting. In painting, color often is used intuitively, and many artists would reject the idea that they work by formula. But knowing these harmonies can help designers consciously plan the visual effects they want a finished pattern to have. Moreover, color can easily provide a visual unity that might not be obvious in the initial pattern of shapes. Even though design aims vary, often the more complicated and busy the pattern of shapes is, the more useful will be a strict control of the color. The reverse is also true.

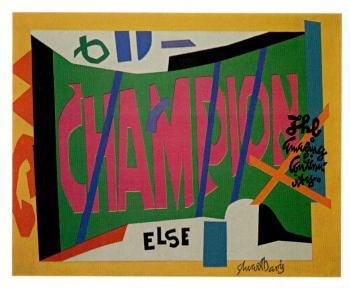

Stuart Davis. Visa. 1951. Oil on canvas, 3' 4" \times 4' 4". The Museum of Modern Art, New York (gift of Mrs. Gertrud A. Mellon). Art © Estate of Stuart Davis/Licensed by VAGA, New York, New York. Digital Image © The Museum of Modern Art/Licensed by SCALA/Art Resource, New York.

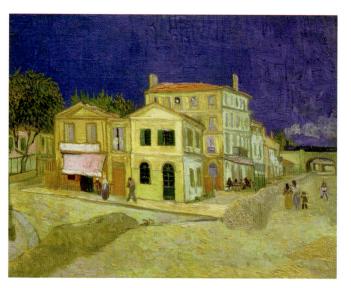

Vincent van Gogh. The Yellow House. 1888. Oil on canvas, 72 \times 91.5 cm. \circledcirc Van Gogh Museum, Amsterdam, The Netherlands/The Bridgeman Art Library.

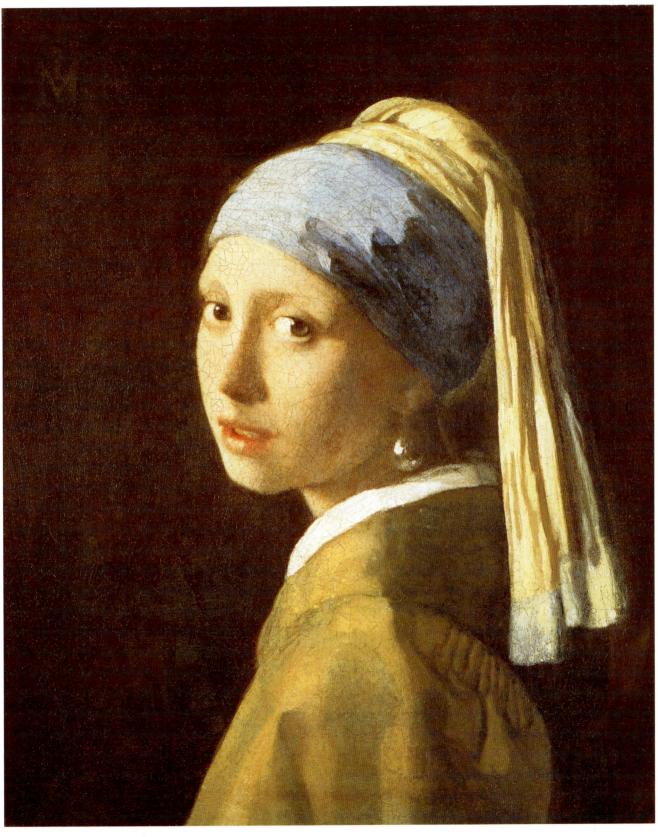

Jan Vermeer. Girl with a Pearl Earring. c. 1665–1666. Oil on canvas, 1' 51/2" \times 1' 31/8" (44.5 \times 39 cm). Royal Cabinet of Paintings, Mauritshuis, The Hague.

COLOR DISCORD AND VIBRATING COLORS

UNEXPECTED COMBINATIONS

Color discord is the opposite of color harmony. A combination of discordant colors can be visually disturbing. Discordant colors have no basic affinity for each other (as you would find with analogous colors) nor do they seem to balance each other (as with a complementary contrast).

The term *discord* conveys an immediate negative impression. Discord in life, in a personal relationship, for example, may not be pleasant, but it often provides a stimulus or excitement. In the same manner, discord can be extremely useful in art and design.

Pure orange and red-purple.

Using Discord to Add Interest

Mild discord results in exciting, eye-catching color combinations. The world of fashion has exploited the idea to the point that mildly discordant combinations are almost commonplace. A discordant color note in a painting or design may contribute visual surprise and also may better express certain themes or ideas. A poster may better attract attention by its startling colors.

Once, rules were taught about just which color combinations were harmonious and which were definitely to be avoided because the colors did not "go together." A combination of pink and orange was unthinkable; even blue and green patterns were suspect. Today these rules seem silly, and we approach color more freely, seeking unexpected combinations.

The same colors with closer values.

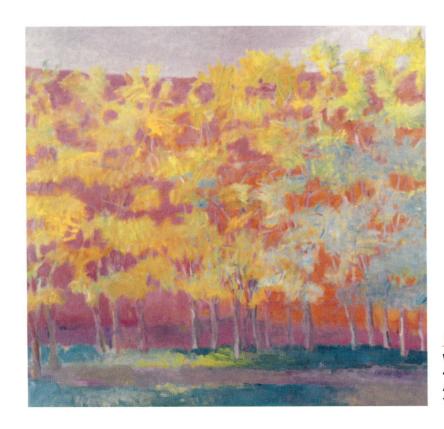

Wolf Kahn. *Color/Tree Symphony.* 1994. Oil on canvas, 4' 3½" × 4' 8½". Grace Borgenicht Gallery, New York. Art © Estate of Wolf Kahn/Licensed by VAGA, New York, New York.

The color pair of orange and red-purple shown in $\bf A$ is one that has been called discordant. This is typical of color pairings that are widely separated on the color wheel but not complements. In $\bf B$ the effect is even more discordant when the red-purple is lightened to the same value as the orange.

Wolf Kahn **(C)** takes full advantage of this red-purple and orange color pairing to create *Color/Tree Symphony*. The colors conjure the intense impact of autumn foliage and seem to create light.

Colors in Conflict

Certain color pairings are almost difficult to look at. In fact, our eye experiences a conflict in trying to perceive them simultaneously. Red and cyan literally have a vibrating edge when their values are equal and their intensities are high **(D)**. You will find this to be true for a range of colors when they are paired at equal value, but the **vibrating color** effect is strongest with reds opposed to blues and greens. Note that the quilt shown in **E** is an homage to Paul Klee, whose painting is reproduced on page 43 in Chapter 2. Paul Klee's painting pairs a red and a green. It is interesting to compare the two color worlds of the similar grid designs.

Red and cyan will have a vibrating edge when values are equal and intensities are high.

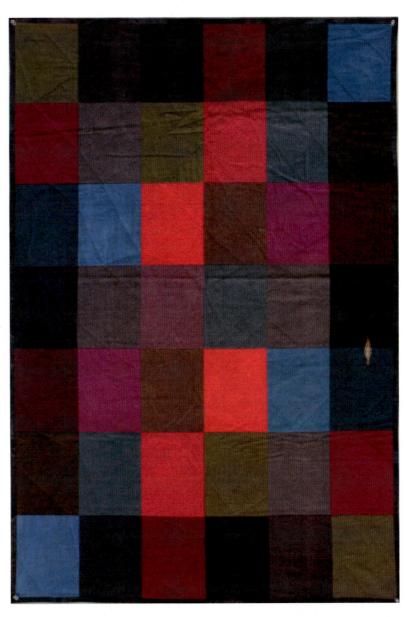

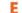

Giorgio Morandi. Still Life. 1939. Oil on canvas, 41.5 imes 47.3 cm. Museo Morandi, Bologna.

LOCAL, OPTICAL, ARBITRARY

There are three basic ways in which color can be used in painting. An artist may use what is called **local color**. This refers to identifying the color of an object under ordinary daylight. Local color is the **objective** color that we "know" objects are: grass is green, bananas are yellow, apples are red. The use of local color reinforces, or takes advantage of, our preconceptions of an object's color, and because of this we associate this approach with children's books, naïve painting, and other simple presentations.

Light Affects Color

Visually, the red of an apple can change radically, depending on the illumination. Because color is a property of light, the color of any object changes at sunset, under moonlight, or by artificial lighting. An artist reproducing these visual effects is using optical color, that is, what we see, not what we think we see.

Giorgio Morandi was acutely sensitive to the color he actually saw. A number of the objects in **A** might be dismissed as merely "white" when seen in isolation. In this still life grouping we are invited to notice subtle hues within these neutrals. Under a different lighting this might all change as we would see in his other paintings. Morandi shows that a colorist is not someone bound to the vividness of the spectrum or color wheel.

Lighting directors for theater and dance consciously manipulate lighting to evoke mood, create space, and give emphasis to principal actors as in **B**. Lighting can compensate for the lack of visual information an audience can see at a distance from the stage. Local color is consumed in the lighting seen in **B**.

Subjective Use of Color

In arbitrary color, the color choices are subjective rather than based on the colors seen in nature. The artist selects colors for design, aesthetic, or emotional reasons. Large patches of color make up the composition of Milton Avery's White Rooster (C). The blue tree and salmon-colored sky are bold subjective color choices. Arbitrary color is sometimes difficult to pinpoint, because many painters take some artistic liberties in using color. Has the artist disregarded the colors he saw, or has he merely intensified and exaggerated the visual reference? This latter use is termed heightened color. The pink hills and green tree line might be heightened color while the blue tree may be the subjective decision to move blue from the sky and place it in the foliage.

Scene from Candide by Leonard Bernstein and Richard Wilbur. The Ohio State University Department of Theatre.

EMOTIONAL COLOR

COLOR EVOKES A RESPONSE

- "Ever since our argument, I've been blue."
- "I saw red when she lied to me."
- "You're certainly in a black mood today."
- "I was green with envy when I saw their new house."

These statements are emotional. The speakers are expressing an emotional reaction, and somehow a color reference makes the meaning clearer, because color appeals to our emotions and feelings. For artists who wish to arouse an emotional response in the viewer, **emotional color** is the most effective device. Even before we "read" the subject matter or identify the forms, the color creates an atmosphere to which we respond.

Colors Evoke Emotions

In a very basic instance, we commonly recognize so-called warm and cool colors. Yellows, oranges, and reds give us an instinctive feeling of warmth and evoke warm, happy, cheerful reactions. Cooler blues and greens are automatically associated with quieter, less-outgoing feelings and can express melancholy (A) or depression. These examples are generalities, of course, for the combination of colors is vital, and the artist can also influence our reactions by the values and intensities of the colors selected. Archibald Motley's Gettin' Religion (B) shows how a predominantly blue painting can suggest a festival at night.

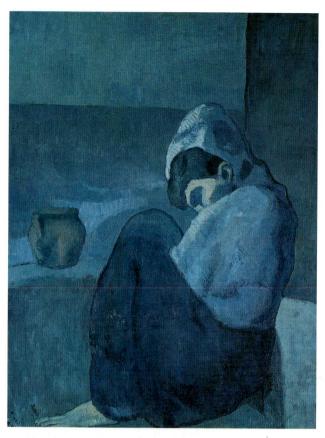

Pablo Picasso. *Crouching Woman.* 1902. Oil on canvas, 2' 11" \times 2' 4" (90 \times 71 cm). Staatsgalerie, Stuttgart.

Archibald J. Motley Jr. Gettin' Religion. 1948. Oil on canvas, 2' 7%" \times 3' 3%". Collection Archie Motley and Valerie Gerrard Browne, Evanston, Illinois. Chicago History Museum.

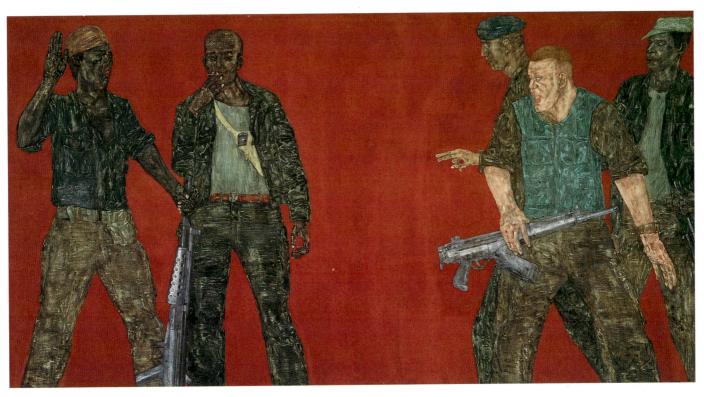

Leon Golub. Mercenaries IV. 1980. Acrylic on linen, $10^{1} \times 19^{1}$ 2½" (3 \times 6 m). Private collection, courtesy of the artist. Art © Estate of Leon Golub/Licensed by VAGA, New York, New York. Photo, Courtesy Ronald Feldman Fine Arts.

Theme and Context

Paintings in which color causes an emotional reaction and relates to the thematic subject matter are very common. The flat red background in Leon Golub's *Mercenaries IV* (**C**) is evocative of blood and impending violence associated with the threatening image of the mercenaries. The intense red seems to push these figures at us, heightening our emotional response to the subject matter. The "dirty" colors and complementary greens also contribute to the emphasis on conflict and violence.

With a change of context, the same hue can evoke a different response. Red is also a dominant color in Hans Hofmann's *The Golden Wall* **(D)**, and once again the red seems to push the other shapes toward us. The nonobjective shapes of intense color and modulations in the red field create a vibrant, joyous quality in this painting quite different from Golub's *Mercenaries IV*.

The power of color to evoke an emotional response is undeniable. The context or situation the artist creates in a composition determines whether the effect is inventive or merely a cliché.

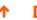

Hans Hofmann. *The Golden Wall.* 1961. Oil on canvas, 5' \times 6' $\frac{1}{2}$ " (151 \times 182 cm). Photograph © 1993. The Art Institute of Chicago (Mr. and Mrs. Frank G. Logan Prize Fund, 1962). All rights reserved.

CONCEPTUAL QUALITIES OF COLOR

- "Don't worry, he's true-blue."
- "I caught him red-handed."
- "So I told her a little white lie."
- "Why not just admit you're too yellow to do it?"

We frequently utter statements that employ color references to describe character traits or human behavior. These color references are symbolic. The colors in the preceding statements symbolize abstract concepts or ideas: fidelity, sin, innocence, and cowardice. The colors do not stand for tangibles like fire, grass, water, or even sunlight. They represent mental, conceptual qualities. The colors chosen to symbolize various ideas are often arbitrary, or the initial reasons for their choice have become so deeply buried in history we no longer remember them. Can we really explain why green means "go" and red signifies "stop"?

Cultural Differences

A main point to remember is that symbolic color references are cultural; they are not the same worldwide but vary from one society to another. What is the color of mourning that one associates with a funeral? Our reply might be black, but the answer would be white in India, violet in Turkey, brown in Ethiopia, and yellow in Burma. What is the color of royalty? We think of purple (dating back to the Egyptians), but the royal color was yellow in dynastic China and red in ancient Rome (a custom continued today in the cardinals' robes of the Catholic Church). What color does a bride wear? White is our response, but yellow is the choice in Hindu India, and red is the choice in China.

Different eras and different cultures invent different color symbols. The symbolic use of color was very important in ancient art for identifying specific figures or deities to an illiterate public. Not only the ancients used color in this manner—in the countless pictures of the Virgin Mary throughout centuries of Western art, she is almost always shown in a blue robe over a red or white garment.

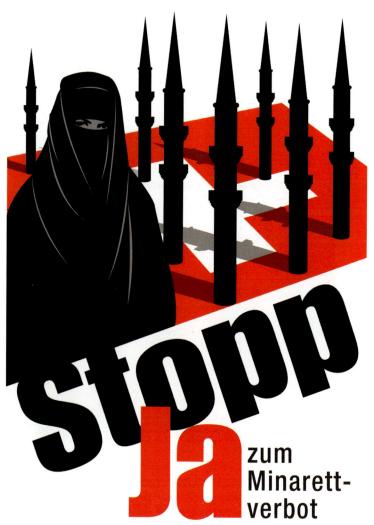

Symbolic Color Today

Symbolic color designations are associated with political, religious, and commercial messages in the current era. In advertising, green may evoke an association with environmental responsibility, or black is often used to connote sophistication. Until recently black was taboo for food packaging—now it may suggest a premium product.

Color symbolism can still be powerful. Think of Ukraine's "Orange Revolution" or the millions of people from all countries on a pilgrimage to Mecca for the Hajj, all dressed in white.

The poster shown in **A** uses the color of the Swiss flag in a xenophobic message seeking to outlaw the presence of minarets in Switzerland. A contrary message **(B)** depicts the presence of white light evoking a divine illumination to express the message "The sky above Switzerland is big enough."

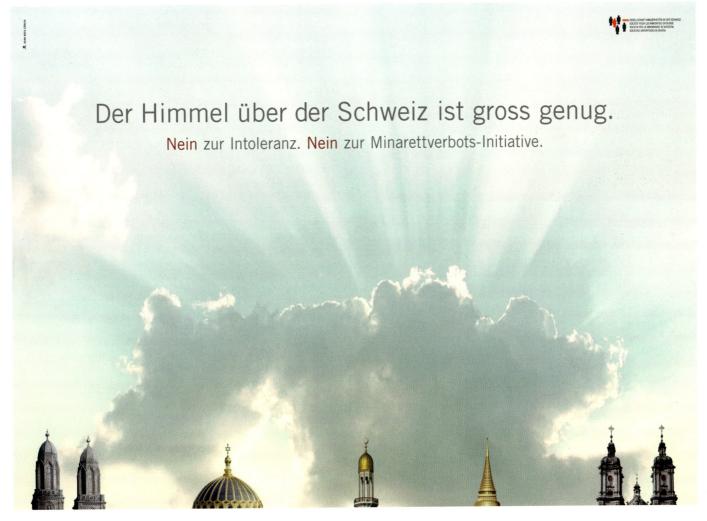

GLOSSARY

- **Abstraction** A visual representation that may have little resemblance to the real world. Abstraction can occur through a process of simplification or distortion in an attempt to communicate an essential aspect of a form or concept.
- Achromatic Black, gray, or white with no distinctive hues.
 Additive system A color mixing system in which combinations of different wavelengths of light create visual sensations of color.
- **Aerial perspective** The perception of less-distinct contours and value contrasts as forms recede into the background. Colors appear to be washed out in the distance or take on the color of the atmosphere. Also called *atmospheric perspective*.
- **Aesthetics** A branch of philosophy concerned with the beautiful in art and how the viewer experiences it.
- Afterimage Occurs after staring at an area of intense color for a certain amount of time and then quickly glancing away toward a white surface, where the complementary color seems to appear.
- **Allover pattern** A composition that distributes emphasis uniformly throughout the two-dimensional surface by repetition of similar elements.
- **Alternating rhythm** A rhythm that consists of successive patterns in which the same elements reappear in a regular order. The motifs alternate consistently with one another to produce a regular (and anticipated) sequence.
- Ambiguity Obscurity of motif or meaning.
- Amplified perspective A dynamic and dramatic illusionistic effect created when an object is pointed directly at the viewer.
- **Analogous colors** A color scheme that combines several hues located next to each other on the color wheel.
- Analysis A measure of the attributes and relationships of an artwork or design.
- **Anamorphic** Term used to describe an image that has been optically distorted.
- **Anticipated movement** The implication of movement on a static two-dimensional surface caused by the viewer's past experience with a similar situation.
- **Art deco** A decorative style, popular in the 1920s, characterized by its geometric patterns and reflecting the rise of industry and mass production in the early twentieth century.
- Art nouveau A late nineteenth-century style that emphasized organic shapes.
- **Assemblage** An assembly of found objects composed as a piece of sculpture. See **Collage**.
- Asymmetrical balance Balance achieved with dissimilar objects that have equal visual weight or equal eye attraction.
- Axis A line of reference around which a form or composition is balanced.
- **Balance** The equilibrium of opposing or interacting forces in a pictorial composition.
- Bilateral symmetry Balance with respect to a vertical axis.

 Biomorphic Describes shapes derived from organic or natural forms.
- **Blurred outline** A visual device in which most details and the edges of a form are lost in the rapidity of the implied movement
- **Calligraphy** Elegant, flowing lines suggestive of writing with an aesthetic value separate from its literal content.
- Canon A law or accepted code that prescribes a set of standards.
- Caryatid An architectural column in the form of a human figure.

 Chiaroscuro The use of light and dark values to imply depth and volume in a two-dimensional work of art.
- Chroma See Intensity.

- Chromatic Relating to the hue or saturation of color.
- **Classical** Suggestive of Greek and Roman ideals of beauty and purity of form, style, or technique.
- **Closed form** The placement of objects by which a composition keeps the viewer's attention within the picture.
- **Collage** An artwork created by assembling and pasting a variety of materials onto a two-dimensional surface.
- **Color constancy** A psychological compensation for changes in light when observing a color. A viewer interprets the color to be the same under various light conditions.
- **Color discord** A perception of dissonance in a color relationship.
- Color harmony Any one of a number of color relationships based on groupings within the color wheel. See also Analogous colors, Color triad, and Complementary.
- **Color symbolism** Employing color to signify human character traits or concepts.
- Color triad Three colors equidistant on the color wheel.

 Color wheel An arrangement of colors based on the sequent
- **Color wheel** An arrangement of colors based on the sequence of hues in the visible spectrum.
- **Complementary** A color scheme incorporating opposite hues on the color wheel. Complementary colors accentuate each other in juxtaposition and neutralize each other in mixture.
- **Composition** The overall arrangement and organization of visual elements on the two-dimensional surface.
- Conceptual Artwork based on an idea. An art movement in which the idea is more important than the two- or threedimensional artwork.
- **Constancy effect** An aspect of human perception that allows us to see size or color or form as consistent even if circumstances change appearances.
- **Content** An idea conveyed through the artwork that implies the subject matter, story, or information the artist communicates to the viewer.
- **Continuation** A line or edge that continues from one form to another, allowing the eye to move smoothly through a composition.
- **Continuity** The visual relationship between two or more individual designs.
- **Contour** A line used to follow the edges of forms and thus describe their outlines.
- Cool color A color closer to blue on the color wheel.
- **Critique** A process of criticism for the purpose of evaluating and improving art and design.
- **Cross contour** Lines that appear to wrap around a form in a pattern that is at an angle to the outline of the form.
- **Cross-hatching** A drawing technique in which a series of lines are layered over each other to build up value and to suggest form and volume.
- **Crystallographic balance** Balance with equal emphasis over an entire two-dimensional surface so that there is always the same visual weight or attraction wherever you may look. Also called *allover pattern*.
- **Cubist (Cubism)** A form of abstraction that emphasizes planes and multiple perspectives.
- **Curvilinear** Rounded and curving forms that tend to imply flowing shapes and compositions.
- **Description** A verbal account of the attributes of an artwork or design.
- **Design** A planned arrangement of visual elements to construct an organized visual pattern.
- **Distortion** A departure from an accepted perception of a form or object. Distortion often manipulates established proportional standards.
- **Draftsmanship** The quality of drawing or rendering.

- **Earthworks** Artworks created by altering a large area of land using natural and organic materials. Earthworks are usually large-scale projects that take formal advantage of the local topography.
- **Emotional color** A subjective approach to color use to elicit an emotional response in the viewer.
- Enigmatic Puzzling or cryptic in appearance or meaning.
 Equilibrium Visual balance between opposing compositional elements.
- **Equivocal space** An ambiguous space in which it is hard to distinguish the foreground from the background. Your perception seems to alternate from one to the other.
- **Expressionism** An artistic style in which an emotion is more important than adherence to any perceptual realism. It is characterized by the exaggeration and distortion of objects in order to evoke an emotional response from the viewer.
- Eve level See Horizon line.
- **Facade** The face or frontal aspect of a form.
- **Fauve** A French term meaning "wild beast" and descriptive of an artistic style characterized by the use of bright and intense expressionistic color schemes.
- **Figure** Any positive shape or form noticeably separated from the background, or the negative space.
- **Focal point** A compositional device emphasizing a certain area or object to draw attention to the piece and to encourage closer scrutiny of the work.
- Folk art Art and craft objects made by people who have not been formally trained as artists.
- **Foreshortening** A distortion of a shape due to perspective wherein an object appears shorter than we know it to be.
- Form When referring to objects, it is the shape and structure of a thing. When referring to two-dimensional artworks, it is the visual aspect of composition, structure, and the work as a whole.
- Formal Traditional and generally accepted visual solutions.
- **Fresco** A mural painting technique in which pigments mixed in water are used to form the desired color. These pigments are then applied to wet lime plaster, thereby binding with and becoming an integral part of a wall.
- Gestalt A unified configuration or pattern of visual elements whose properties cannot be derived from a simple summation of its parts.
- **Gesture** A line that does not stay at the edges but moves freely within forms. These lines record movement of the eye as well as implying motion in the form.
- Golden mean A mathematical ratio in which width is to length as length is to length plus width. This ratio has been employed in design since the time of the ancient Greeks. It can also be found in natural forms.
- **Golden rectangle** The ancient Greek ideal of a perfectly proportioned rectangle using a mathematical ratio called the Golden mean.
- **Graphic** Forms drawn or painted onto a two-dimensional surface; any illustration or design.
- **Grid** A network of horizontal and vertical intersecting lines that divide spaces and create a framework of areas.
- **Ground** The surface of a two-dimensional design that acts as the background or surrounding space for the "figures" in the composition.
- Harmony The pleasing combination of parts that make up a whole composition.
- **Hieratic scaling** A composition in which the size of figures is determined by their thematic importance.
- Horizon line The farthest point we can see where the delineation between the sky and ground becomes distinct. The line on the picture plane that indicates the extent of illusionistic space and on which are located the vanishing points.

- **Hue** A property of color defined by distinctions within the visual spectrum or color wheel. "Red," "blue," "yellow," and "green" are examples of hue names.
- Icon A religious image meant to embody the actual qualities of the depicted saint. More generally, a symbol or sign, especially one with strong emotional power.
- **Idealism** An artistic theory in which the world is not reproduced as it is but as it should be. All flaws, accidents, and incongruities of the visual world are corrected.
- **Illustration** A picture created to clarify or accompany a text. **Imbalance** Occurs when opposing or interacting forms are out of equilibrium in a pictorial composition.
- Impasto A painting technique in which pigments are applied in thick layers or strokes to create a rough three-dimensional paint surface on the two-dimensional surface.
- **Implied line** An invisible line created by positioning a series of points so that the eye will connect them and thus create movement across the picture plane.
- Impressionism An artistic style that sought to re-create the artist's perception of the changing quality of light and color in nature.
- **Informal balance** Synonymous with **asymmetrical balance**. It gives a less-rigid, more casual impression.
- **Installation** A mixed-media artwork that generally takes into account the environment in which it is arranged.
- Intensity The saturation of hue perceived in a color.
- **Interpretation** A subjective conclusion regarding the meaning, implication, or effect of an artwork or design.
- Isometric projection A spatial illusion that occurs when lines receding on the diagonal remain parallel instead of converging toward a common vanishing point. Used commonly in Oriental and Far Eastern art.
- **Juxtaposition** When one image or shape is placed next to or in comparison to another image or shape.
- Kinesthetic empathy A mental process in which the viewer consciously or unconsciously re-creates or feels an action or motion he or she only observes.
- **Kinetic** Artworks that actually move or have moving parts. **Kitsch** Low or common art forms that appeal to sentimentality. **Legato** A connecting and flowing rhythm.
- **Line** A visual element of length. It can be created by setting a point in motion.
- Line quality Any one of a number of characteristics of line determined by its weight, direction, uniformity, or other features
- Linear perspective A spatial system used in two-dimensional artworks to create the illusion of space. It is based on the perception that if parallel lines are extended to the horizon line, they appear to converge and meet at a common point, called the vanishing point.
- **Lines of force** Lines that show the pathway of movement and add strong visual emphasis to a suggestion of motion.
- Local color The identifying color perceived in ordinary daylight.
 Logo A sign or image that is taken to be an easily recognized symbol representing a company or organization.
- **Lost-and-found contour** A description of a form in which an object is revealed by distinct contours in some areas whereas other edges simply vanish or dissolve into the ground.
- Mandala A radial concentric organization of geometric shapes and images commonly used in Hindu and Buddhist art.
- Medium The tools or materials used to create an artwork.
 Minimalism An artistic style that stresses purity of form above subject matter, emotion, or other extraneous elements.
- Mixed media The combination of two or more different media in a single work of art.
- Module A specific measured area or standard unit.

Monochromatic A color scheme using only one hue with varying degrees of value or intensity.

Monocular Pertaining to vision from one eye only.

Montage A recombination of images from different sources to form a new picture.

Multiple image A visual device used to suggest the movement that occurs when a figure is shown in a sequence of slightly overlapping poses in which each successive position suggests movement from the prior position.

Multiple perspective A depiction of an object that incorporates several points of view.

Multipoint perspective A system of spatial illusion with different vanishing points for different sets of parallel lines.

Narrative The story that is told in an artwork.

Naturalism The skillful representation of the visual image, forms, and proportions as seen in nature with an illusion of volume and three-dimensional space.

Negative shape A clearly defined shape within the ground that is defined by surrounding figures or boundaries.

Negative space Unoccupied area or empty space surrounding the objects or figures in a composition.

Nonobjective A type of artwork with absolutely no reference to, or representation of, the natural world. The artwork is the reality.

Objective Having to do with reality and fidelity to perception.

One-point perspective A system of spatial illusion in two-dimensional art based on the convergence of parallel lines to a common vanishing point usually on the horizon.

Op Art A style of art and design that emphasizes optical phenomena. **Opaque** A surface impenetrable by light.

Open form The placement of elements in a composition so that they are cut off by the boundary of the design. This implies that the picture is a partial view of a larger scene.

Optical mixture Color mixture created by the eye as small bits of color are perceived to blend and form a mixture.

Overlapping A device for creating an illusion of depth in which some shapes are in front of and partially hide or obscure others.

Pattern The repetition of a visual element or module in a regular and anticipated sequence.

Parallax The resolution of two images from binocular (two-eyed) vision.

Pentimenti (plural) The artist's changes or corrections sometimes evident as traces in the surface. From the Italian and implying "the artist repents."

Pictogram A simple pictorial sign or group of signs intended to communicate without words.

Picture plane The two-dimensional surface on which shapes are organized into a composition.

Plane The two-dimensional surface of a shape.

Pointillism A system of color mixing (used in painting and drawing) based on the juxtaposition of small bits of pure color. Also called *divisionism* (see **Optical mixture**).

Polyrhythmic A complex pattern employing more than one rhythm or beat.

Pop art An art movement originating in the 1960s that sought inspiration from everyday popular culture and the techniques of commercial art.

Positive shape Any shape or object distinguished from the background.

Primary colors The three colors from which all other colors theoretically can be mixed. The primaries of pigments are traditionally presented as red, yellow, and blue, whereas the primaries of light are red, blue, and green.

Progressive rhythm Repetition of a shape that changes in a regular pattern.

Proportion Size measured against other elements or against a mental norm or standard.

Proximity The degree of closeness in the placement of elements.

Psychic line A mental connection between two points or elements. This occurs when a figure is pointing or looking in a certain direction, which causes the eye to follow toward the intended focus.

Radial balance A composition in which all visual elements are balanced around and radiate from a central point.

Realism An approach to artwork based on the faithful reproduction of surface appearances with a fidelity to visual perception.

Rectilinear Composed of straight lines.

Repeated figure A compositional device in which a recognizable figure appears within the same composition in different positions and situations so as to relate a narrative to the viewer.

Repetition Using the same visual element over again within the same composition.

Representational An image suggestive of the appearance of an object that actually exists.

Retinal fatigue Fading perception due to overexposure and resulting in an afterimage effect.

Rhythm An element of design based on the repetition of recurrent motifs.

Saturation See Intensity.

Secondary color A mixture of any two primary colors.

Shade A hue mixed with black.

Shading Use of value in artwork.

Shape A visually perceived area created either by an enclosing line or by color and value changes defining the outer edges.

Silhouette The area between the contours of a shape.

Simultaneous contrast The effect created by two complementary colors seen in juxtaposition. Each color seems more intense in this context.

Site specific A work of art in which the content and aesthetic value is dependent on the artwork's location.

Spectrum The range of visible color created when white light is passed through a prism.

Staccato Abrupt changes and dynamic contrast within the visual rhythm.

Static Still, stable, or unchanging.

Subject The content of an artwork.

Subjective Reflecting a personal bias.

Subtractive system A color mixing system in which pigments (physical substances) are combined to create visual sensations of color. Wavelengths of light absorbed by the substance are subtracted, and the reflected wavelengths constitute the perceived color.

Suprematism A Russian art movement of the early twentieth century that emphasized nonobjective form.

Surrealism An artistic style that stresses fantastic and subconscious approaches to art making and often results in images that cannot be rationally explained.

Symbol An element of design that communicates an idea or meaning beyond that of its literal form.

Symmetry A quality of a composition or form wherein a precise correspondence of elements exists on either side of a center axis or point.

Tactile texture The use of materials to create a surface that can be felt or touched.

Tertiary color A mixture of a primary and an adjacent secondary color.

Texture The surface quality of objects that appeals to the tactile sense.

- Tint A hue mixed with white.
- **Tonality** A single color or hue that dominates the entire color structure despite the presence of other colors.
- **Transparency** A situation in which an object or form allows light to pass through it. In two-dimensional art, two forms overlap, but both are seen in their entirety.
- **Triadic** A color scheme involving three equally spaced colors on the color wheel.
- **Trompe l'oeil** A French term meaning "to fool the eye." The objects are in sharp focus and delineated with meticulous care to create an artwork that almost fools the viewer into believing that the images are the actual objects.
- **Two-point perspective** A scene that is viewed through an angle, with no objects parallel to the picture plane and with edges receding to two points on the horizon line.
- **Unity** The degree of agreement existing among the elements in a design.
- Value A measure of relative lightness or darkness.
- Value contrast The relationship between areas of dark and light.
- **Value emphasis** Use of a light-and-dark contrast to create a focal point within a composition.
- **Value pattern** The arrangement and amount of variation in light and dark values independent of any colors used.

- Vanishing point In linear perspective, the point at which parallel lines appear to converge on the horizon line. Depending on the view, there may be more than one vanishing point.
- **Verisimilitude** Accuracy or faithfulness in depiction or representation.
- **Vernacular** A prevailing or commonplace style in a specific geographical location, group of people, or time period.
- **Vertical location** A spatial device in which elevation on the page or format indicates a recession into depth. The higher an object, the farther back it is assumed to be.
- **Vibrating colors** Colors that create a flickering effect at their border. This effect usually depends on an equal value relationship and strong hue contrast.
- **Visual color mixing** Placing small units of color side by side so that the eye perceives the mixture rather than the individual component colors.
- **Visual texture** A two-dimensional illusion suggestive of a tactile quality.
- Volume The appearance of height, width, and depth in a form.
 Warm color A color closer to the yellow-to-red side of the color wheel.
- Wash drawing A technique of drawing in water-based media.

BIBLIOGRAPHY

General

- Berger, John. Ways of Seeing. London: British Broadcast Corporation, 1987.
- Buser, Thomas. *Experiencing Art around Us*. Belmont, CA: Wadsworth/Thomson, 2006.
- Canaday, John. What Is Art? New York: Alfred A. Knopf, 1980. Dondis, Donis A. A Primer of Visual Literacy. Cambridge, MA: MIT Press, 1973.
- Faulkner, Ray, Edwin Ziegfeld, and Howard Smagula. *Art Today: An Introduction to the Visual Arts*, 6th ed. Fort Worth, TX: Harcourt Brace College Publishers, 1987.
- Grosenick, Uta, and Burkhard Riemschneider. Art Now. London: Taschen. 2009.
- McCarter, R. William, and Rita Gilbert. *Living with Art*, 2nd ed. New York: McGraw-Hill, 1988.
- Preble, Duane, and Sarah Preble. *Artforms: An Introduction to the Visual Arts*, 5th ed. New York: HarperCollins, 1993.
- Roth, Richard, and Susan Roth. *Beauty Is Nowhere: Ethical Issues in Art and Design*. Amsterdam: Gordon and Breach, 1998.
- Tufte, Edward R. Visual Explanations: Images and Quantities, Evidence and Narrative. New Haven, CT: Graphics Press, 1996.

Art History

- Arnason, H. H. *History of Modern Art*, 3rd rev. ed. New York: Harry N. Abrams, 1986.
- Janson, H. W. *History of Art*, 4th rev. and enl. ed. New York: Harry N. Abrams, 1991.
- Kleiner, Fred S. *Gardner's Art through the Ages*, 13th ed. Boston, Cengage Learning, 2009.
- Smagula, Howard. *Currents*, 2nd ed. Englewood Cliffs, NJ: Prentice-Hall, 1989.

General Design

- Bacon, Edmund. *The Design of Cities*. New York: Viking Penguin, 1967.
- Bevlin, Marjorie Elliot. *Design through Discovery*, 6th ed. Fort Worth, TX: Harcourt Brace College Publishers, 1994.
- Bothwell, Dorr, and Marlys Frey. Notan: The Dark-Light Principle of Design. New York: Dover, 1991.
- Collier, Graham. Form, Space and Vision: An Introduction to Drawing and Design, 4th ed. Englewood Cliffs, NJ: Prentice-Hall, 1985.
- De Lucio-Meyer, J. Visual Aesthetics. New York: Harper & Row, 1974.
- De Sausmarez, Maurice. Basic Design: The Dynamics of Visual Form. Blue Ridge Summit, PA: TAB Books, 1990.
- Hoffman, Armin. *Graphic Design Manual*. New York: Van Nostrand Reinhold, 1977.
- Hurlburt, Allen. *The Design Concept*. New York: Watson-Guptill Publications, 1981.
- Hurlburt, Allen. *The Grid*. New York: Van Nostrand Reinhold, 1982.
- Hurlburt, Allen. *Layout: The Design of the Printed Page*. New York: Watson-Guptill Publications, 1989.
- Itten, Johannes. Design and Form: The Basic Course at the Bauhaus, 2nd rev. ed. New York: Van Nostrand Reinhold, 1975.
- Kepes, Gyorgy. *Language of Vision*. Chicago: Paul Theobald, 1969.
- Kerlow, Isaac Victor, and Judson Rosebush. *Computer Graphics*. New York: Van Nostrand Reinhold, 1986.
- Maier, Manfred. Basic Principles of Design. New York: Van Nostrand Reinhold, 1977.

- Mante, Harald. *Photo Design: Picture Composition for Black and White Photography*. New York: Van Nostrand Reinhold, 1971.
- Margolin, Victor. *Design Discourse*. Chicago: University of Chicago Press, 1989.
- Mau, Bruce. Life Style. New York: Phaidon Press, 2005.
- McKim, Robert H. *Thinking Visually*. New York: Van Nostrand Reinhold, 1980.
- Murphy, Pat. By Nature's Design. San Francisco: Chronicle Books, 1993.
- Myers, Jack Frederick. *The Language of Visual Art*. Orlando, FL: Holt, Rinehart and Winston, 1989.
- Stoops, Jack, and Jerry Samuelson. *Design Dialogue*. Worcester, MA: Davis Publications, 1983.
- Wilde, Richard. *Problems, Solutions: Visual Thinking for Graphic Communications*. New York: Van Nostrand Reinhold, 1989.
- Wong, Wucius. *Principles of Three-Dimensional Design*. New York: Van Nostrand Reinhold, 1977.
- Wong, Wucius. *Principles of Two-Dimensional Design*. New York: Van Nostrand Reinhold, 1972.

Visual Perception

- Arnheim, Rudolf. Art and Visual Perception: A Psychology of the Creative Eye, the New Version, 2nd rev. and enl. ed. Berkeley: University of California Press, 1974.
- Bloomer, Carolyn M. *Principles of Visual Perception*, 2nd ed. New York: Van Nostrand Reinhold, 1989.
- Ehrenzweig, Anton. *The Hidden Order of Art: A Study in the Psychology of Artistic Imagination*. Berkeley: University of California Press, 1976.
- Gombrich, E. H. Art and Illusion: A Study in the Psychology of Pictorial Representation. Princeton, NJ: Princeton University Press, 1961.

Space

- Carraher, Ronald G., and Jacqueline B. Thurston. *Optical Illusions and the Visual Arts*. New York: Van Nostrand Reinhold, 1966.
- Coulin, Claudius. Step-by-Step Perspective Drawing: For Architects, Draftsmen and Designers. New York: Van Nostrand Reinhold. 1971.
- D'Amelio, Joseph. *Perspective Drawing Handbook*. New York: Leon Amiel, Publisher, 1964.
- Doblin, Jay. Perspective: A New System for Designers, 11th ed. New York: Whitney Library of Design, 1976.
- Ivins, William M., Jr. On the Rationalization of Sight: With an Examination of Three Renaissance Texts on Perspective to Which Is Appended "De Artificiali Perspectiva" by Viator (Pelerin). New York: Da Capo Press, 1973.
- Luckiesh, M. Visual Illusions: Their Causes, Characteristics and Applications. New York: Dover Publications, 1965.
- Montague, John. *Basic Perspective Drawing*, 2nd ed. New York: Van Nostrand Reinhold, 1993.
- Mulvey, Frank. *Graphic Perception of Space*. New York: Van Nostrand Reinhold, 1969.
- White, J. *The Birth and Rebirth of Pictorial Space*, 3rd ed. Cambridge, MA: Harvard University Press, 1987.

Texture

- Battersby, Marton. *Trompe-l'Oeil: The Eye Deceived*. New York: St. Martin's Press, 1974.
- O'Connor, Charles A., Jr. Perspective Drawing and Applications. Englewood Cliffs, NJ: Prentice-Hall, 1985.

Proctor, Richard M. *The Principles of Pattern: For Craftsmen and Designers*. New York: Van Nostrand Reinhold, 1969. Wescher, Herta. *Collage*. New York: Harry N. Abrams, 1968.

Color

- Albers, Josef. *Interaction of Color*, rev. ed. New Haven, CT: Yale University Press, 1975.
- Birren, Faber. Creative Color: A Dynamic Approach for Artists and Designers. New York: Van Nostrand Reinhold, 1961.
- Birren, Faber. Ostwald: The Color Primer. New York: Van Nostrand Reinhold, 1969.
- Birren, Faber. *Principles of Color*, rev. ed. West Chester, PA: Schiffer Publishing, Limited, 1987.
- Birren, Faber, ed. *Itten: The Elements of Color*. New York: Van Nostrand Reinhold, 1970.
- Birren, Faber, ed. *Munsell: A Grammar of Color*. New York: Van Nostrand Reinhold, 1969.
- De Grandis, Luigina. *Theory and Use of Color*. New York: Harry N. Abrams, 1987.

- Fabri, Frank. Color: A Complete Guide for Artists. New York: Watson-Guptill, 1967.
- Gage, John. Color in Art. New York: Thames & Hudson, 2006. Gerritsen, Frank J. Theory and Practice of Color. New York: Van Nostrand Reinhold, 1974.
- Itten, Johannes. *The Art of Color*, rev. ed. New York: Van Nostrand Reinhold, 1984.
- Kippers, Harald. *Color: Origin, Systems, Uses*. New York: Van Nostrand Reinhold, 1973.
- Pentak, Stephen, and Richard Roth. Color Basics. Belmont, CA: Wadsworth/Thomson, 2003.
- Rhode, Ogden N. *Modern Chromatics: The Student's Textbook of Color with Application to Art and Industry*, new ed. New York: Van Nostrand Reinhold, 1973.
- Varley, Helen, ed. *Color*. Los Angeles: Knapp Press, 1980. Verity, Enid. *Color Observed*. New York: Van Nostrand Reinhold, 1980.
- Zelanski, Paul, and Mary Pat Fisher. *Color*. Englewood Cliffs, NJ: Prentice-Hall, 1989.

PHOTOGRAPHIC SOURCES

Frontmatter: v t Courtesy of the School of Visual Arts; b Image © Estate of Charles Harper. Photo courtesy of Charley Harper Art Studio; vi t Photograph by G.R. Christmas, courtesy The Pace Gallery © Thomas Nozkowski, courtesy The Pace Gallery; c Glen Holland and Michelle Herman; Erich Lessing/Art Resource, NY; vii t Niklaus Troxler; b © Ellsworth Kelly and Maeght Editeur, Paris; viii t Courtesy of Elliot Barnathan; c © Richard Meier, Licensed by SCALA/Art Resource, NY; b © Ellsworth Kelly. Collection of the artist; ix t t Lola Moreno and Ramon Rosanas; c Ardine Nelson; b Alan Cote; xii © Charles E. Burchfield, The Burchfield Penney Art Center. Munson-Williams-Proctor Arts Institute/Art Resource, NY

Chapter 1: 1 (from top to bottom) Courtesy of the School of Visual Arts; Image © Estate of Charles Harper. Photo courtesy of Charley Harper Art Studio; Photograph by G.R. Christmas, courtesy The Pace Gallery © Thomas Nozkowski, courtesy The Pace Gallery; Glen Holland and Michelle Herman; Erich Lessing/Art Resource, NY; Niklaus Troxler; 2 @ Bruce Eric Kaplan/The New Yorker Collection/www.cartoonbank.com; 4A © 1983 John Kuchera; 4B Steve Mehalo, http:// www.anotherposterforpeace.org; 5C Marty Neumeier, http://www.anotherposterforpeace.org; 6A Poster for Amnesty International. Stephan Bundi, Art Director and Designer; Atelier Bundi, Bern, Switzerland; 7B Andy Goldsworthy; 7C Paul Breitzmann; 8A Copyright Claes Oldenburg and Coosje van Bruggen, 1993; **8B** Courtesy of the School of Visual Arts; **9C** Collection of Daryl Gerber Stokols and Jeffery M. Stokols, Chicago; **10A-B** Raymond Loewy, Industrial Design (Woodstock, NY: Overlook Press). Copyright © 1988 Raymond Loewy; 11C Chris Rooney; 11D © Museum of Fine Arts, Boston. Gift of Governor Carlton Skinner and Solange Skinner, 2002 Accession number: 2002.789; 12A By permission of Aerospace Publishing Limited, London; 12B By permission of Dorling Kindersley Ltd., London; 13C Reproduced by permission of the American Museum in Britain, Bath; 13D Rune Hellestad/Corbis; 14A @ Copyright The Estate of Arthur Dove, courtesy of Terry Dinenfass, Inc. Image: Munson-Williams-Proctor Arts Institute/Art Resource, NY; 14B © 2010 Georgia O'Keeffe Museum/Artists Rights Society (ARS), New York. Photograph courtesy of The National Gallery of Art, Washington, DC Alfred Stieglitz Collection, Bequest of Georgia O'Keeffe; 15C-D Collection © 2010 Her Majesty Queen Elizabeth II; 16A Photography by Jeffery Nintzel 2008. Hood Museum of Art; 16C
Lauren Orr, Dartmouth College '08. Hood Museum of Art; 17C-D © Nancy Crow; 18A Réunion des
Musées Nationaux/Art Resource, NY; 18B © 2010 Estate of Pablo Picasso/Artists Rights Society
(ARS), New York. Digital Image © The Museum of Modern Art/Licensed by SCALA/Art Resource, NY; 19C
Robert Colescott. Image courtesy, Phyllis Kind Gallery, New York and Chicago; 19D Betty Crocker Through The Years, Courtesy of General Mills Archives; 20A © The Estate of Eva Hesse. Hauser & Wirth Zurich, London; 20B Sarah Weinstock, Untitled Drawing. 2006. Ink and soap bubbles on paper; 21C Art © Estate of David Smith. Licensed by VAGA, New York, NY. Courtesy Gagosian Gallery. Photography by Robert McKeever; 21D Art © Estate of David Smith//Licensed by VAGA New York, NY Image copyright © The Metropolitan Museum of Art/Art Resource, NY; 22A-B © 2010 Succession H. Matisse/Artists Rights Society (ARS), New York. Photograph: © The Baltimore Museum of Art; 23C Meredith Reuter; 24A Courtesy of the Author; 25B Courtesy of the Author; 25C Courtesy Gagosian Gallery, New York, with permission from the estate of Mark Tansey.

Chapter 2: 26 © 1959 Peter Arno. The New Yorker Collection/cartoonbank.com; 28A Art © Wayne Thiebaud/Licensed by VAGA, New York, NY; 29B Damon Winter, Communication Arts, May/June 2005; 29C Art @ Alex Katz/Licensed by VAGA, New York, NY; 30A @ 2010 Karl Blossfeldt Archiv/Ann u. Jürgen Wilde, Köln/Artists Rights Society (ARS), NY; 31B Photograph © 2008 Museum of Fine Arts, Boston, 19.124; 31C Hoefler & Frere-Jones; 32A-D Cengage Learning; 33E Courtesy Gagosian Gallery, New York. © Richard Prince; 33F Alex Bartel/SPL/ Photo Researchers, Inc; 34A-B Cengage Learning; 35C Amon Carter Museum, Ft Worth, Texas. Purchased by the Friends of Art, Fort Worth Art Association, 1925; acquired by the Amon Carter Museum, 1990, from the Modern Art Museum of Fort Worth through grants and donations from the Amon G. Carter Foundation, the Sid W. Richardson Foundation, the Anne Burnett and Charles Tandy Foundation, Capital Cities/ABC Foundation, Fort Worth Star-Telegram, The R.D. and Joan Dale Hubbard Foundation and the people of Fort Worth. 1990.19.1. 35D © 2010 Artists Rights Society (ARS), New York/VG Bild-Kunst, Bonn. Digital Image © The Museum of Modern Art/Licensed by SCALA/Art Resource, NY; 36A @ 2010 Artists Rights Society (ARS), New York/ProLitteris, Zurich. Photograph courtesy of Kunstmuseum Bern; 36B Joe Miller's Design Co; 37C Don Bachardy UNTITLED II, AUGUST 19 1985. Courtesy the artist and Cheim & Read, New York; 38A-B Cengage Learning; 38C © 2010 Artists Rights Society (ARS), New York/ADAGP, Paris. The John R. Van Derlip Fund and the William Hood Dunwoody Fund: The Minneapolis Institute of Arts; **39D** Janet Borden, Inc; **39E** 2004 BMW of North America, LLC, used with permission. The BMW and logo are registered trademarks; 40A-B Cengage Learning; 410 Wood/Phillips; 42A-C Cengage Learning; 430 © 2010 Artists Rights Society (ARS), New York/VG Bild-Kunst, Bonn. Photograph courtesy of the Solomon R. Guggenheim Museum, New York; 43E Art © Robert Rauschenberg/Licensed by VAGA, New York, New York. Digital image © The Metropolitan Museum of Art/Art Resource, NY; 43F Smithsonian American Art Museum, Washington, DC./Art Resource, NY. With permission from the family of Alfonso Roybal, aka Awa Tsireh, San Idelfonso Pueblo, New Mexico; 44A Image © Estate of Charles Harper. Photo courtesy of Charley Harper Art Studio; 45B Albright-Knox Art Gallery/Art Resource, NY; 45C Eva Zeisel Classic Century produced by Royal Stafford, England; **46A** Reza, National Geographic Services; **47B** Irises (folding screen), Korin, Ogata (1658-1716)/ Nezu Art Museum, Tokyo, Japan/The Bridgeman Art Library International; **47C** © 2010 Artists Rights Society (ARS), New York/VG Bild-Kunst, Bonn. Photograph Courtesy of the Artist and Yossi Milo Gallery, New York; 48A Erich Lessing/Art Resource, NY; 48B © Copyright Elizabeth Murray. Digital Image © The Museum of Modern Art/Licensed by SCALA/Art Resource, NY; 49C Norton Simon Museum, Pasadena (gift of Molly Barnes, 1969); 50A Michael Dwyer/Stock Boston; 51B Tom McHugh/ Photo Researchers, Inc; 51C Courtesy of Gehry Design, Santa Monica, CA; 52A Réunion des Musées Nationaux/Art Resource, NY; 53B @ 2010 Estate of Pablo Picasso/Artists Rights Society (ARS), New York. Digital Image © The Museum of Modern Art/Licensed by SCALA/Art Resource, NY.

Chapter 3: 54 © 1946 Whitney Darrow, Jr. The New Yorker Collection/cartoonbank.com; 56A Tibor de Nagy Gallery, New York; 57B © 2010 Succession H. Matisse/Artists Rights Society (ARS), New York. Photograph © St. Louis Art Museum, Missouri, USA/The Bridgeman Art Library; 57C Photo courtesy Chase Manhattan Bank Collection; 58A Yale Center for British Art, Paul Mellon Collection, USA/The Bridgeman Art Library; 58B © 2010 Artists Rights Society (ARS), New York/ SABAM, Brussels. Photo: A.K.G., Berlin/Superstock; 59C Columbus Dispatch, Columbus, Ohio; 59D Photograph by G.R. Christmas, courtesy The Pace Gallery © Thomas Nozkowski, courtesy The Pace Gallery © Thomas Nozkowski, courtesy The Pace Gallery 60A Luca Vignelli; 60B Courtesy of the University of Pennsylvania Art Collection, Philadelphia, Pennsylvania. (1889.0001); 61C Réunion des Musées Nationaux/Art Resource, NY; 62A Courtesy of Susan Moore; 62B © The Samuel Courtauld Trust, The Courtauld Gallery, London; 63C HIP/Art Resource, NY; 64A Lino/AGodoson.com; 64B © 2010 Estate of Pablo Picasso/Artists Rights Society (ARS), New York. Digital Image © The Museum of Modern Art/Licensed by SCALA/ Art Resource, NY; 65C Reactor Art and Design; 65D Christopher Sturman; 66A © 2010 The Pollock-

Krasner Foundation/Artists Rights Society (ARS), New York. Photo © 2004 The Museum of Modern Art/Art Resource, NY; 66B Mark Keffer/Esopous Magazine; 67C Chaz Maviyane-Davies.

Chapter 4: 68 © James Stevenson/The New Yorker Collection/www.cartoonbank.com; 70A © 1993 Richard Roth; 71B Glen Holland and Michelle Herman; 71C Photograph © 1992 The Metropolitan Museum of Art/Art Resource, NY; 72A Photograph © 1997 The Metropolitan Museum of Art/Art Resource, NY; 72A Photograph © 1997 The Metropolitan Museum of Art; 72B Réunion des Musées Nationala/Art Resource, NY; 73C © Board of Trustees, National Gallery of Art, Washington; 73D Photo Researchers; 74A © Howard Hodgkins, Christie's Images/CORBIS; 75B-C © 2010 Andreas Gursky/Artists Rights Society (ARS), New York/V6 Bild-Kunst, Bonn. Image courtesy of the Matthew Marks Gallery, New York; 76A Cengage Learning; 77B Nicolo Orsi Battaglini/Art Resource, NY; 77C Statens Museum for Kunst, Copenhagen, KMS 6202. photo © and by permission of Stiftung Seebull Ada & Emil Nolde, Neukirchen, Germany; 78A Mark Fennessey. Yale University Art Gallery (transfer from the Yale Art School); 78B Courtesy Gilbert Li; 79C From the series Landscapes of the Future Communist spared Station "Jupiter", erected in the year 2737, watercolour & black pen on paper, 17.5 x 25 cm, 2009. © Copyright Pavel Pepperstein; 79D JOHN MOORE Blue Stairway, 1998 0il on canvas, 28 x 24 in. Image courtesy of Hirschl & Adler Modern; 80A © 2010 C. Herscovici, London/Artists Rights Society (ARS), New York. Hotel & Casino LLC, Las Vegas; 81C Courtesy Regen Projects, Los Angeles, CA; 81D Fernando Botero, courtesy Marlborough Gallery, New York; 82A Cengage Learning; 82B Board of Trustees, National Gallery of Art, Washington; 83C Réunion des Musées Nationaux/Art Resource, NY; 83D © 2010 Estate of Pablo Picasso/Artists Rights Society (ARS), New York. Digital Image © The Museum of Modern Art/Licensed by SCALA/Art Resource, NY; 84A Cengage Learning; 84B Réunion des Musées Nationaux/Art Resource, NY; 85C Scala/Art Resource, NY; 84D Timothy Remus.

Chapter 5: 86 David Lauer; 88A Paris, Bibliothèque Nationale de France, Cabinet des Estampes; 888 © 2010 The Josef and Anni Albers Foundation/Artists Rights Society (ARS), New York; 89C Cengage Learning; 89D © 2010 Estate of Pablo Picasso/Artists Rights Society (ARS), New York. Digital Image © The Museum of Modern Art/Licensed by SCALA/Art Resource, NY; 90A Smithsonian American Art Museum, Washington, DC/Art Resource, NY; 90B Réunion des Musées Nationaux/Art Resource, NY; 91C Sheldon Museum of Art, University of Nebraska-Lincoln, UNL-Gift of Wallis, Jamie. Sheri and Kay in memory of their parents, Joan Farrar Swanson and James Hovland Swanson. Photo Sheldon Museum of Art; 91D Advertisement for Betty Cunningham Gallery. Art in America, April 2005; 92A-B THE KOBAL COLLECTION/Picture Desk; 93C Art O Alex Katz/Licensed by VAGA, New York, NY. Courtesy Timothy Taylor Gallery; 93D The Bridgeman Art Library/Getty Images; 94A © Ed Ruscha. Courtesy Gagosian Gallery, Photograph by Robert McKeever; 95B Photograph courtesy the artist and The Pace Gallery © Hiroshi Sugimoto, courtesy The Pace Gallery; 95C Courtesy of the artist and Jean Albano Gallery, Chicago; 96A © Nan Goldin 1994; 96B Courtesy Haim Steinbach; 97C Vision/Cordelli/Photodisc/Getty Images; 98A Cengage Learning; 98B © The Metropolitan Museum of Art/Art Resource, NY; 98C Illustration by Kristian Russell/Art Department. Published 2000 by Harry N. Abrams, Inc, NYC, 100 5th Ave , New York, NY 10011; 99D Offrant le Panal au Torero, 1873 (oil on canvas), Cassatt, Mary Stevenson (1844-1926)/Sterling & Francine Clark Art Institute, Williamstown, USA/The Bridgeman Art Library International; 100A-B Cengage Learning; 100C © 1991 The Metropolitan Museum of Art/Art Resource, NY; 101D The Art Institute of Chicago; 102A Cengage Learning; 102B The Granger Collection, New York; 103C The Annunciation, 1442 (fresco), Angelico, Fra (Guido di Pietro) (c.1387-1455)/Museo di San Marco dell'Angelico, Florence, Italy/The Bridgeman Art Library International; **104A** Digital Image © The Museum of Modern Art/ Licensed by SCALA/Art Resource, NY; 104B Erich Lessing/Art Resource, NY; 105C Courtesy of Estate of Garry Winogrand, Center for Creative Photography, University of Arizona; 106A Jerold & Linda Waldman/Bruce Coleman/Photoshot; 106B Courtesy Donald Yound Gallery, Chicago and Andrea Rosen Gallery, New York; 107C O Nancy Crow, published in Nancy Crow: Quilts and Influences (American Quilters Society); used by permission; 107D Public Domain; 108A © The Metropolitan Museum of Art/Art Resource, NY; 108B Art © Jasper Johns/Licensed by VAGA, New York, NY. Digital Image © The Museum of Modern Art/Licensed by SCALA/Art Resource, NY; 109C Timothy Hursley.

Chapter 6: 110 David Lauer; 112A © Charles E. Burchfield, The Burchfield Penney Art Center. Munson-Williams-Proctor Arts Institute/Art Resource, NY; 113B-C Photograph: Kunstmuseum Basel, Kupferstichkabinett/Martin Bühler; 114A © Bridget Riley. All rights reserved. Courtesy Karsten Schubert London; 115B © The Metropolitan Museum of Art/Art Resource, NY; 115C flogs Oschool of Art; 116A Courtesy the photographer, Bruce Barnbaum; 116B The J. Paul Getty Museum, Los Angeles (86.MV.527); 117C-D Niklaus Troxler; 117E Alan Crockett; 118A Courtesy of Locks Gallery, Philadelphia; 119B New York: Dover Publications, 1982), p. 6; 119C L & M Services B.V. Amsterdam 20040308. Digital Image © The Museum of Modern Art/Licensed by SCALA/Art Resource, NY; 120A © Ed Ruscha. Courtesy Gagosian Gallery. Photograph by Robert McKeever; 121B 1981. Center for Creative Photography, Arizona Board of Regents; 121C Art © Louise Bourgeois/Licensed by VAGA, New York, NY/Photo © Peter Moore; 122A Réunion des Musées Nationaux/Art Resource, NY; 123B © 2010 Estate of Pablo Picasso/Artists Rights Society (ARS), New York. Digital Image © The Museum of Modern Art/Licensed by SCALA/Art Resource, NY.

Chapter 7: 124 Scala/Art Resource, NY; 125 (from top to bottom) © Ellsworth Kelly and Maeght Editeur, Paris; © Ellsworth Kelly. Collection of the artist; Courtesy of Elliot Barnathan; © Richard Meier, Licensed by SCALA/Art Resource, NY; Lola Moreno and Ramon Rosanas; Ardine Nelson; Alan Cote; 126 Robert Gumpertz; 128A Photo by Gjon Mili/Time Life Pictures/Getty Images; 128B Richard Long. Image courtesy New Art Centre Sculpture Park & Gallery, Roche Court, UK; 129C © 2010 Artists Rights Society (ARS), New York/ADAGP, Paris. Digital Image © The Museum of Modern Art/Licensed by SCALA/Art Resource, NY; **129D** © 2010 The Saul Steinberg Foundation/Artists Rights Society (ARS), New York; 130A-B © 1998 Thomas Card; 131C Courtesy, USGS; 131D Cowtan & Tout Inc: 131E Mark Newman/Bruce Coleman/Photoshot; 132A Scott Stulberg/Photographer's Choice/Getty Images; 132B JOHN MACDOUGALL/AFP/Getty Images; 133C-D © 1982 The Metropolitan Museum of Art/Art Resource, NY; 134A-B Cengage Learning; 134C © The Cleveland Museum of Art (Hinman B. Hurlbut Collection 1133.1922); 135D Photo courtesy of Hirschl & Adler Modern, New York, NY; 136A © Ellsworth Kelly and Maeght Editeur, Paris; 136B Imaging Department © President and Fellows of Harvard College; 136C © 2010 Succession Giacometti/Artists Rights Society (ARS), New York/ADAGP, Paris; 137D Staatliche Museen zu Berlin; 138A Art © Deborah Butterfield/Licensed by VAGA, New York, NY. Courtesy, Edward Thorp Gallery, New York; 138B © 2010 Susan Rottenberg/Artists Rights Society (ARS), New York; 139C © Judy Pfaff. Printed by Lawrence Hamlin. Publisher: Crown Point Press; 139D The Art Institute of Chicago; 140A 2006 Uclick, L.L.C. Copyright © 2007 Universal Press Syndicate; 141B Courtesy of the Wetmore Print Collection, curated by the Art History Dept. Connecticut College, New London; 141C Anacostia Community Museum, Smithsonian Institution, Washington, D.C; 142A © The Estate of Alice Neel Courtesy of David Zwirner, New York; 143B

Chapter 8: 150 © 1968 Charles E. Martin. The New Yorker Collection/cartoonbank.com; 152A © Ellsworth Kelly. Collection of the artist; 153B © Ellsworth Kelly; 153C © FIRSTVIEW; 154A © Scott Noel: 154B © 1998 Kate Rothko Prizel & Christopher Rothko/Artists Rights Society (ARS), New York, Photograph © The Whitney Museum of American Art; 155C Estate of Roy Lichtenstein; 155D Courtesy of the artist; 156A © 2010 Bruce Nauman/Artists Rights Society (ARS), New York. Glenstone Courtesy Sperone Westwater, New York; 157B Robert Moskowitz, New York; 157C © 2006 Julian Opie Courtesy of the artist; 158A Kerry Waghorn Studios; 159B @ Noma Bar. Courtesy, Dutch Uncle; 159C Art Director: John C. Jay. Designer: Pao. Illustrator: Javier Michaelski. Creative Directors: Dan Wieden, Susan Hoffman. Source: Page 87, Print, March/April 1996; 160A 2007 Museum of Fine Arts, Boston; 160B Art Resource, NY; 161C The University of Westminster. All rights reserved; 162A Paul Resika, courtesy of Lori Bookstein Fine Art, New York; 162B Chugach Alaska Corporation; 163C Department of Art, Ohio State University; **163D** © 2010 The Arshile Gorky Foundation/The Artists Rights Society (ARS) New York, Photograph: © The Museum of Modern Art/Licensed by SCALA/Art Resource, NY; 164A © 2010 Artists Rights Society (ARS), New York/ADAGP, Paris. Photograph @ Albright-Knox Art Gallery/Art Resource, NY; 165B Courtesy of the Estate of the Artist and the Susan Teller Gallery, NY; 165C © 2010 Helen Frankenthaler/Artists Rights Society (ARS), New York. Blanton Museum of Art, The University of Texas at Austin, Gift of Mari and James A. Michener. 1991 photo credit: Rick Hall; 166A Transtock; 166B The Chap Book', magazine cover, Thanksgiving Number, USA, 1894 (litho) (see also 87429), Bradley, William H. (1868-1962)/Victoria & Albert Museum, London, UK/The Bridgeman Art Library International; 167C © Disney Enterprises, Inc; 167D © Markus Hofko, www.rainbowmonkey.com; 168A Courtesy Rocio Romero LLC, Perryville, MO; photo Richard Sprengler; 168B Elizabeth Dee Gallery, New York, New York; **169C** Tim Griffi th/Esto. All rights reserved; **170A** Cengage Learning; **170B** The Japan Ukiyo-e Museum, Matsumoto, Japan; 171C Copyright Aaron Siskind Foundation; 171D @ 2010 Richard Serra/ Artists Rights Society (ARS), New York. Photo © Kate Pentak; 172A-B Cengage Learning; 173C © 2010 Estate of Pablo Picasso/Artists Rights Society (ARS), New York. Digital Image © The Museum of Modern Art/Licensed by SCALA/Art Resource, NY; 174A Collection of McNay Art Museum, San Antonio, Texas bequest of Marion Koogler McNay); 174B Réunion des Musées Nationaux/Art Resource, NY; 175C The Metropolitan Museum of Art/Art Resource, NY; 175D Réunion des Musées Nationaux/Art Resource, NY; 175D Réunion des Musées Nationaux/Art Resource, NY; 175D Réunion des Musées Nationaux/Art Resource, NY; 176A Art © Al Held Foundation/Licensed by VAGA, New York, NY; 176B Print, March/April 1988, p. 105; 177C © 2010 Estate of Pablo Picasso/Artists Rights Society (ARS), New York. Photo © The Art Institute of Chicago; 177 D Design: Steff Geissbuhler, C&G Partners, New York.

Chapter 9: 178 © 1968 Lee Lorenz. The New Yorker Collection/cartoonbank.com; 180A Adrienne Salinger; 180B Margaret Courtney-Clarke/CORBIS; 181C @ 2010 Estate of Pablo Picasso/Artists Rights Society (ARS), New York. Digital Image © The Museum of Modern Art/Licensed by SCALA/Art Resource, NY; 181D Réunion des Musées Nationaux/Art Resource, NY; 182A Linda Whitwam/Dorling Kindersley/Getty Images; 182B Howard Davis/Artifi celmages; 183C-D © 2010 The M. C. Escher Company - Holland. All rights reserved. www.mcescher.com; 183E Die Hoffnung II (Hope II) 1907-08 (oil and gold paint on canvas), Klimt, Gustav (1862-1918)/Fischer Fine Art Ltd., London, UK/The Bridgeman Art Library International; 184A-B The Victorian Design Book: A Complete Guide to Victorian House Trim (Ottawa: Lee Valley Tools Ltd., 1984; **185C** Courtesy of Gretchen Bellinger Inc; **185D** *The* New One is the Most Beautiful of All, illustration for 'The Ugly Duckling' from Fairy Tales by Hans Christian Andersen (1805-75), c.1910 (engraving) (b/w photo), Clarke, Harry (1890-1931)/Bibliotheque des Arts Decoratifs, Paris, France/Archives Charmet/The Bridgeman Art Library; 186A Acquired 1978, Collection SFMOMA Purchase © Betye Saar 78.19"; 187B Courtesy of Elliot Barnathan; 188A Réunion des Musées Nationaux/Art Resource, NY; 189B Stephen Pitkin; 189C MINNEAPOLIS INSTITUTE OF ARTS, Estate of Roy Lichtenstein; 190A © Mary Bauermeister, Digital image © The Museum of Modern Art/Licensed by SCALA/Art Resource, NY; 190B Courtesy Joan T. Washburn Gallery, New York; 191C © 2010 The Josef and Anni Albers Foundation/Artists Rights Society (ARS), New York. Photo © Art Resource, NY; 1910 © 2010 The Josef and Anni Albers Foundation/Artists Rights Society (ARS), New York. Photo: Albers Foundation/Art Resource, NY; 192AThe Metropolitan Museum of Art, Anonymous Loan (L.2002.33.1) Image © The Metropolitan Museum of Art; 192B © 2010 Artists Rights Society (ARS), New York/ADAGP, Paris. Photograph: Wadsworth Atheneum Museum of Art/Art Resource, NY; 193C © Ed Ruscha. Courtesy Gagosian Gallery; 193D North Wall detail of "Broadway Gateway Mural" Albany, NY, designed by AlbanyMural principal artist Jan-Marie Spanard, 1999-2000

Chapter 10: 194 By permission of Sidney Harris, ScienceCartoonsPlus.com; 196A-B Michel Taupin: 1970 The Art Institute of Chicago; 1970 Steven Wynn Photography/istockphoto.com; 198A Tampa Museum of Art Collection, Museum Purchase (1984.15); 199B © 2010 Artists Rights Society (ARS), New York/VG Bild-Kunst, Bonn. Digital Image © The Museum of Modern Art/Licensed by SCALA/Art Resource, NY; 199C Suido Bridge and Surugadai (Suidobashi Surugadai) No.48 from 'Famous Views of Edo', Edo Period, Ansei Era, published May 1857 (colour woodblock print), Hiroshige, Ando or Utagawa (1797-1858)/Brooklyn Museum of Art, New York, USA/Gift of Anna Ferris/The Bridgeman Art Library International; 199D Lee Stalsworth/Hirshorn Museum and Sculpture Garden; 200A-B Cengage Learning; 200C © 2010 The Jacob and Gwendolyn Lawrence Foundation, Seattle/Artists Rights Society (ARS), New York. Photo: Lee Stalworth/Hirshhorn Museum and Sculpture Garden; 201D Bridgeman (AhS), New York, Front. Lee state of Tom Wesselmann. Licensed by VAGA, NY. Smithsonian American Art Museum, Washington, DC/Art Resource, NY; 204A Copyright © 1993 by the Trustees of the Ansel Adams Publishing Rights Trust. All rights reserved; 205B The State Hermitage Museum St Petersburg; 205C 2003 Board of Trustees, National Gallery of Art, Washington; 206A @ 2010 Frank Lloyd Wright Foundation, Scottsdale, AZ/Artists Rights Society (ARS), NY. Digital Image © The Museum of Modern Art/Licensed by SCALA/Art Resource, NY; 207B @ ARS, NY. Digital Image @ The Museum of Modern Art/Licensed by SCALAVArt Resource, NY, **208A** Scala/Art Resource, NY, **208B** Freer Gallery of Art, Smithsonian Institution, Washington, D.C.: Gift of Charles Lang Freer, F1903.54; **209C** © 2010 Andreas Gursky/Artists Rights Society (ARS), New York/VG Bild-Kunst, Bonn. Image courtesy of Sprüth Magers Berlin; **209D** Keny Galleries; **210A** Alinari/Art Resource, NY; **210B** Scala/Art Resource, NY; **211C** Thanks to Scandinavia, NY. Source: Page 122, Print, Jan/Feb. 1996; 211D Mairani/Grazia Neri; 212A-B Private Collection, New York; 213C Concept Art Gallery and Sukolsky Brunelle Inc., Pittsburgh PA; 213D Hood Museum of Art, Dartmouth College, Hanover, NH. P.976.281; 214A Museum of the City of New York, Berenice Abbott Collection; 214B-C Whitney Museum of American Art, NY, 50.23. By permission of the artist c/o DC Moore Gallery, NY; 215D Courtesy Friedrich Petzel Gallery, New York; 216A Agency: Inform Advertising Agency, Gothenburg. Art Director: Tommy Ostberg. Photo: Christian Coinberg; 217B Tony Mendoza; 217C Private Collection, Courtesy of DC Moore Gallery, New York; 216A Agency: BOSWELL, JR/National Geographic Stock; 218B © 2011 Estate of Amédée Ozenfant. ADAGP, Paris and DACS, London 2002. Licensed by ARS, Artist's Rights Society, NY. Image Courtesy, Tate Gallery, London; 219C Historical Society of Western Pennsylvania; 219D David Hockney; 220A The Cleveland Museum of Art, Gift from J. H. Wade; 220B © Richard Meier, Licensed by SCALA/Art Resource, NY; 221C David Hockney; 221D © 2007 The Josef and Anni Albers Foundation/Artists Rights Society (ARS), New York. Digital Image © The Museum of Modern Art/Licensed by SCALA/Art Resource, NY; 223C Agnes Gund Collection, New York. Photo: Jim Strong; 223D Art © Alex Katz/Licensed by VAGA, New York, NY; 224 A-C Cengage Learning; 225D Designer: Jennifer C. Bartlett. Design firm: Vickerman-Zachary-Miller (VZM Transystems), Oakland, California; 225E Art © Al Held Foundation/ Licensed by VAGA, New York, NY; Photo: Oeffentliche Kunstsaammlung Basel, Martin Buhler; 226A The Metropolitan Museum of Art/Art Resource, NY; 227B Réunion des Musées Nationaux/Art Resource, NY;

Chapter 11: 228 © 1995 Sam Gross. The New Yorker Collection/cartoonbank.com; 230A Erich Lessing/Art Resource, NY; 230B Réunion des Musées Nationaux/Art Resource, NY; 231C Harold & Esther Edgerton Foundation, 2003, courtesy of Palm Press, Inc; 231D Henri Cartier-Bresson/Magnum Photos; 232A © 2010 Artists Rights Society (ARS), New York/VG Bild-Kunst, Bonn. Digital Image © The Museum of Modern Art/Licensed by SCALA/Art Resource, NY; 232B © 2010 Artists Rights Society (ARS), New York/VG Bild-Kunst, Bonn. Digital Image © The Museum of Modern Art/Licensed by SCALA/Art Resource, NY; 233C Yellow Dog Productions/Getty Images; 234A V&A Images/ Victoria and Albert Museum; 234B Lola Moreno and Ramon Rosanas; 235C AP Photo; 235D Calvin and Hobbes. © 1985 Watterson. Reprinted with permission of Universal Press Syndicate. All rights reserve; 236A Courtesy of Elliot Barnathan; 236B © The Metropolitan Museum of Art/Art Resource, NY; 236C Siena College Athletics; 236D National Football League; 237E Gizmachine, Inc. 1989. All Rights Reserved; photo: Timothy Remus; 238A © The Metropolitan Museum of Art/Art Resource, NY; 239B Feng Li/Getty Images; 239C © 2010 Artists Rights Society (ARS), New York/ADAGP, Paris/Succession Marcel Duchamp. Photograph © The Philadelphia Museum of Art. The Louise and Walter Arensberg Collection, 1950/Art Resource, New York; 239D John Baldessari; 240A Photo by John Houston; 241B Niklaus Troxler; 241C From the collection of Faith and Stephen Brown; 241D © 2010 Estate of Pablo Picasso/Artists Rights Society (ARS), New York. Digital Image © The Museum of Modern Art/Licensed by SCALA/Art Resource, NY.

Chapter 12: 242 © 1967 William O'Brian. The New Yorker Collection/cartoonbank.com; 244A Cengage Learning; 244B Ardine Nelson; 245C Susan Moore; 245D Courtesy: jointadventures.org photo: Stephan Köhler; 246A Judith and Holofernes (panel), Gentileschi, Artemisia (1597-c.1651) Museo e Gallerie Nazionali di Capodimonte, Naples, Italy/The Bridgeman Art Library International; 246B Reunion des Musées Nationaux/Art Resource, NY; 247D € 2010 Estate of Pablo Picasso/Artists Rights Society (ARS), New York. Digital Image © The Museum of Modern Art/Licensed by SCALA/Art Resource, NY; 247D € © 2010 Succession H. Matisse, Paris/Artists Rights Society (ARS), New York. Digital Image © The Museum of Modern Art/Licensed by SCALA/Art Resource, NY; 248A Portland Museum of Art/Art Resource, NY; 249C-D Andy Goldsworthy; 250A Courtesy: ACA Galleries, NY; 250B Collection of North Carolina National Bank; 251C Edward Burtynsky/Toronto Image Works; 251D 1984 Suc Coe. Courtesy Galerie St. Etienne, New York; 252A Walter Hatke; 252B © 2010 Artists Rights Society (ARS), New York/SIAE, Rome. Photo: Luciano Calzolari, Bologna, Italy; 252C Arkansas Arts Center Foundation Collection: Purchased with a gift from Helen Porter and James T. Dyke, 1993 (93.035); 253D Yale University Art Gallery, New Haven (Everett V. Meeks Fund); 253E Art Director: Alan Aboud. Photographer: Sandro Sodano. Computer Manipulation: Nick Livesey, Alan Aboud, Sandro Sodano.

Chapter 13: 254 © 2004 Jack Ziegler/Cartoonbank.com; 257A-B Cengage Learning; 258A Tate London/Art Resource, NY; 258B The Philadelphia Museum of Art/Art Resource, NY; 259C Cengago Learning; 260A Cengage Learning; 261B Courtesy of Gretag Macbeth, New Windsor, NY; 262A Cengage Learning; 263B-C Cengage Learning; 264A-B Cengage Learning; 264C Domus Design Collection, New York; 265D Giraudon/The Bridgeman Art Library; 266A @ Adobe Systems; 267B-D Gamblin Artists Colors Co; 268A Photograph by Ellen Page Wilson, courtesy The Pace Gallery © Chuck Close, courtesy The Pace Gallery; 268B Photograph by Ellen Page Wilson, courtesy The Pace Gallery;

© Chuck Close, courtesy The Pace Gallery; 269C House of Tartan Ltd. Perthshire, Scotland; 270A

Photo by Michael Marca Courtesy 18, 1 Control 19, 10 Control 19, Photo by Michael Moran Courtesy P.S.1 Contemporary Art Center; 270B Cengage Learning; 271C Neil Welliver, Courtesy Alexandre Gallery; 272A Cengage Learning; 272B Glide Dental Floss Campaign Saatchi & Saatchi, New York. Creative Director: Tony Granger, Jan Jacobs, Leo Premutico. Art Director Menno Kluin. Copywriter: Icaro Doria. Photo: Jenny van Sommers; 273C Andy Goldsworthy; 274B-C © 2010 Successió Miró/Artists Rights Society (ARS), New York/ADAGP, Paris. Digital Image © The Museum of Modern Art/Licensed by SCALA/Art Resource, NY; 274A Art © Wayne Thiebaud/Licensed by VAGA, New York, NY; 275E Réunion des Musées Nationaux/Art Resource, NY; © 2010 Estate of Pablo Picasso/Artists Rights Society (ARS), New York. Digital Image © The Museum of Modern Art/Licensed by SCALA/Art Resource, NY; 276A Courtesy Crystal Bridges Museum of American Art, Bentonville, Arkansas; 277B Alan Cote; 277C 1980 David Hockney; photo © 2006 Museum Associates/LACMA; 278A Mark Tansey, Collection of Emily Fisher Landau, New York; 279B Natural History Museum of Los Angeles County (William Randolph Hearst Collection, A.5141.42-153); 279C © Elizabeth Peyton. Image courtesy of Gavin Brown's Enterprise; 280A Art @ Estate of Stuart Davis/Licensed by VAGA, New York, NY. Digital Image © The Museum of Modern Art/Licensed by SCALA/Art Resource, NY; 280B Van Gogh Museum, Amsterdam, The Netherlands/The Bridgeman Art Library; 281C Scala/Art Resource, NY; 282A-B Cengage Learning; 282C Art © Estate of Wolf Kahn/Licensed by VAGA, New York, NY; 283E
Deborah Pentak; 284A © 2010 Artists Rights Society (ARS), New York/SIAE, Rome Photo: Luciano Calzolari, Bologna, Italy; 285B The Ohio State University Department of Theatre; 285C © 2010 Milton Avery Trust/Artists Rights Society (ARS), New York. Image copyright © The Metropolitan Museum of Art/Art Resource, NY; 286A © 2010 Estate of Pablo Picasso/Artists Rights Society (ARS), New York. Photograph, courtesy Staatsgalerie Stuttgart; 286B Chicago Historical Society; 287C Art © Estate of Leon Golub/Licensed by VAGA, New York, NY. Photo, Courtesy Ronald Feldman Fine Arts; 287D © 2010 Estate of Hans Hofmann/Artists Rights Society (ARS), New York. Photo © The Art Institute of Chicago; 288A Goal AG; 289B Euro RSCG Zurich, Frank Bodin.

A	Ananymaya Angel (Densing Figure)	D. I
Abbott, Berenice, Wall Street, Showing	Anonymous, <i>Angel (Dancing Figure),</i> 236–237	Balance, 88–109
East River from Roof of Irving	Anonymous, "Whirligig," 107	asymmetrical, 96–105, 274–275
Trust Company, 214	Anticipated motion, 232–233	bilateral symmetry creating, 92–93 color and, 98–99, 246, 274–275, 280
Aboud, Alan, catalog spread, 253	Appelbaum, Ralph, Hallway in U.S.	crystallographic, 108–109, 182
Abstract art	Holocaust/Memorial Museum,	defined, 88
depth devices in, 198-199, 201	108–109	formal, 92–93
isometric projection in, 221	Apples, Ellsworth Kelly, 152	imbalance <i>vs.</i> , 89, 90–91, 275
multiple vanishing points in, 215	April, Chuck Close, 268–269	informal/casual, 96–97, 102
shapes in, 162-163, 198-199, 201	Arad, Ron, "Restless" Exhibition, 12, 13	patterns creating, 100–101, 108–109
unity in, 52-53	Arcade, Palazzo Spada, Rome,	pictorial, 89
Achromatic grays, 244, 256	Francesco Borromini, 211	position/eye direction creating,
Actual lines, 133	Arch Duo and Vented Star, Ronald	102–103
Actual texture, 188–189	Davis, 144	radial, 106-107, 182-183
Adam and Eve, Lucas Cranach the	Arch Oboler Guest House (Eleanor's	symmetrical, 92-95
Elder, 62	Retreat) plan, elevation, and	texture creating, 100-101
Adams, Ansel, Yosemite Valley from	perspective drawings, Frank	value creating, 98-99, 246, 275
Inspiration Point, 204	Lloyd Wright, 206–207	in various art forms, 94–95
Ada's Red Sandals, Alex Katz, 222–223	Architecture	The Baldacchino, St. Peter's basilica,
Adoration of the Magi, Leonardo da	balance in, 92-93, 97, 107	Giovanni Lorenzo Bernini, 92-93
Vinci, 210–211 Advertisements	linear perspective in, 211	Baldessari, John, Six Colorful Gags
"Betty Crocker" images, 19	plan, elevation and perspective	(Male), 238–239
Betty Cunningham Gallery, 91	drawings for, 206–207	Balthus (Balthasar Klossowski de Rola),
color in, 273, 280, 289	proportion in, 84	The Living Room, 38
Din Sko shoe store, 216	radial balance/designs in, 62, 107	Bar, Noma, Pulp Fiction, 158–159
idealism in, 161	rectilinear shapes in, 168, 169 rhythm in, 118–119	Barnathan, Elliot
"Music," P&G Glide Dental Floss	shape combinations in, 169	Brandywine, 187
campaign, 272-273	texture in, 188	Study in Motion, 236 Barnbaum, Bruce, Dune Ridges at
New York Times, 130	unity in, 33, 50–51	Sunrise, Death Valley, 116
Nike Sportswear, 159	Arno, Peter, cartoon, 26	The Bartered Bride (poster), Hans
one-element emphasis in, 64	Arrested action, 230–231	Hillman, 176
texture in, 101	Art nouveau, 166	Bartlett, Jennifer C., sweatshirt
Aerial perspective, 204–205,	Artichoke, Halved, Edward Weston,	design, 225
250–251, 276	120–121	Baseball photograph, 232–233
After the Bath, Woman Drying Herself,	Artifacts, as source, 16–17	Bathers on the Rocks, Abraham
Edgar Degas, 265	The Artist's Studio, Raoul Dufy, 128-129	Walkowitz, 198
Afterimage, 240–241, 265	Asgaard, Rockwell Kent, 204–205	Bathers with a Turtle, Henri Matisse,
The Agnew Clinic, Thomas Eakins, 60–61	Así en el cielo (As in Heaven), Felix de la	56–57
Alamillo Bridge/Cartuja Viaduct, Seville,	Concha, 213	Bauermeister, Mary, Progressions, 190
Spain, Santiago Calatrava, 97 Albers, Anni	Asymmetry	Beardsley, Aubrey, Garçons de Café, 102
Neck Piece, 191	analysis summary, 104–105	Becher, Bernd and Hilla, Industrial
wall covering material, 191	asymmetrical balance, 96–105, 274–275	Facades, 44–45
Albers, Josef	informal balance and, 96–97, 102	Beijing Celebrates the 60th Anniversary
Bookshelf, 88–89	planning of, 97	of New China, Feng Li, 238–239 Beirut, Michael, "Take Your Best
Structural Constellation II, 221	position/eye direction creating,	Shot," 60
study of color by, 258	102–103	Belinger, Gretchen, <i>Isadora</i> , 184–185
Alhambra, Granada, Spain, 182	texture/pattern creating, 100-101	Bellows, George, Stag at Sharkey's,
Allover patterns, 108–109	value/color creating, 98–99, 274–275	134–135
Altered Map, Esopus, Mark Keffer, 66-67	The Atheneum, New Harmony, Indiana,	Berg, Donna, New York Times
Alternating rhythm, 118–119	Richard Meier, 220-221	advertisement, 130
Alutiiq mask, 162–163	Atmospheric perspective, 204–205,	Bernini, Giovanni Lorenzo, The
Ambiguity, 176–177, 224–225	250–251, 276	Baldacchino, St. Peter's basilica,
Amplified perspective, 216–217	Attention, attracting, 56–57, 273. See	92–93
Analogous color scheme, 279	also Emphasis; Focal points	Bernstein, Leonard, Candide, 284-285
Andrade, Edna, Interchange, 118	The Attributes of Music, Jean-Baptiste-	"Betty Crocker" images, 19
Angel (Dancing Figure), Anonymous, 236–237	Siméon Chardin, 222	Betty Cunningham Gallery
Angelico, Fra, <i>The Annunciation</i> , 103	Audience, thinking about, 9	advertisement, 91
Angle of perception, 156, 209	Automobile design, 39, 85, 166, 237	Between My Eye and Heart No. 12, Karin
Animal Designs, Awa Tsireh, 42–43	Avery, Milton, White Rooster, 284–285	Davie, 144–145
Anna Mahlangu Painting Her Home for a	В	Bilateral symmetry, 92–93
Ceremonial Occasion, Margaret	Bachardy, Don, UNTITLED II, 37	Bill Clinton #3, The Kerry Waghorn Studios, 158
Courtney-Clarke, 180	Bahrain I, Andreas Gursky, 74–75	Biomorphic shapes, 163
Anna Wintour, Alex Katz, 92-93	Bahrain II, Andreas Gursky, 74–75	The Birth of the World, Joan Miró,
The Annunciation, Fra Angelico, 103	Bailey, William, TURNING (detail from), 91	274–275

Advertisements; Signage

The Birth of Venus. Sandro Botticelli. Caravaggio, Michelangelo Merisi da Clothing design, 153, 225, 256, 282 142-143 The Inspiration of Saint Matthew. Coca Cola storyboard. Lola Moreno and The Black Bow, Georges Seurat, 174 104-105 Ramon Rosanas, 234 Black Jacket, Alex Katz, 28, 29 Salome with the Head of John the Coe, Sue, Charlie Parker Watches His Black Venus, Ellsworth Kelly, 152-153 Baptist, 146 Hotel Room Burn, 250-251 Black Watch Plaid for Band Regimental Card. Thomas. New York Times Coinberg, Christian, Din Sko shoe store Tartan (#396), 269 advertisement, 130 advertisement, 216 Blossfeldt, Karl, Pumpkin Tendrils, 30 Caricatures, 158 Colescott, Robert, George Washington Blue Stairway, John Moore, 79 Cartier-Bresson, Henri, 1932, Paris. Carver Crossing the Delaware, 19 Blurred outlines, 236-237 France, Place de L'Europe, Gare Collages BMW Z4 Roadster, 39 Saint Lazare, 231 focal point absence in, 66-67 Bocskay, Georg, Dianthis and Cartoons nonobjective shapes in, 165 Almond, 116 Arno, 26 tactile texture in, 190-191 Bol, Ferdinand, Holy Family in an Interior. Calvin and Hobbes, Bill Watterson, 235 unity in, 30, 42, 43 248-249 cropped figures in, 235 Color, 256-289 Bookshelf, Josef Albers, 88-89 Darrow, Jr., 54 analogous color scheme, 279 Borromini, Francesco, Arcade, Palazzo Gross, 228 balance and, 98-99, 246, Gumpertz, 68 Spada, Rome, 211 274-275, 280 Botero, Fernando, Mona Lisa, 81 Harris, 194 color characteristics, 258-259 Botticelli, Sandro, The Birth of Venus, Kaplan, 2 color discord, 282-283 142-143 Lauer, 86, 110 color harmonies, 278 Bourgeois, Louise, Partial Recall. Lorenz, 178 color schemes, 278-281 120-121 color symbolism, 288-289 Martin, 150 Bowl with Candy and Shadow, Lowell New Yorker, 2, 26, 54, 68, 150, 178, color theory, 256-257 Tolstedt, 209 228, 242, 254 color wheel, 260-261 Bradley, Will H., poster for Thanksgiving O'Brian, 242 complementary colors, 264-265, Number of the Chap-Book, 166 Stevenson, 68 280-281 Brandywine, Elliot Barnathan, 187 Ziegler, 254 cool/warm colors, 270-271 The Bricoleur's Daughter, Mark emotions evoked by, 286-287 Casanova table/side chairs, 264-265 Tansey, 278 Cassatt, Mary Stevenson as emphasis, 272-273 Broadway Gateway Mural, Jan-Marie grays, 244, 253, 256, 262, 265 The Fitting, 205 Spanard, 193 Offering the Panale to the hue and color perception, 260-261 Brooklyn Bridge, November 28, 1982, Bullfighter, 99 intensity of, 264-265 David Hockney, 219 Cathedral #2, Roy Lichtenstein, 154-155 interaction between colors, 263 Centennial Certificate, Robert Brown, Taliek, 235 light, color as property of, 256-257, Bruegel, Pieter the Elder, The Rauschenberg, 42-43 258, 284 Harvesters, 226 Centre National d'Art et de Culture local color, 284 Brushstrokes, Roy Lichtenstein, 189 Georges Pompidou, 33 mixing colors, 256-257, 265, 266-Buchenwald in Herbst (Beech Forest Ceramic tiles (azuleios) from Portugal. 267, 268-269 in Autumn), Albert Renger-182 monochromatic color, 278 Patzsch, 115 Ceramics optical mixing of, 268 The Builders, Fernand Leger, 142-143 design integral to, 4 palettes, 266-267 Burchfield, Charles, The Insect perception of, 258-259, 260-261 radial balance/designs in, 62, 106 Chorus, 112 space occupied by, 196 primary colors, 256-257, 260 Burtynsky, Edward, Shipbreaking #10. texture in, 186 properties of color, 260-265 Chittagong, Bangladesh, 250-251 unity in, 44-45 rhythm created by color contrasts, 114 Ceramicware, Eva Zeisel, 44-45 Butterfield, Deborah, Tango, 138 secondary colors, 260 Chair, Charles Rennie Mackintosh, 115 spacial relation changes in, 204-205, Chaos, unity to avoid, 50-51 271, 276-277 Cabinet Makers, Jacob Lawrence, Chardin, Jean-Baptiste-Siméon, The surrounding changing colors, 200-201 Attributes of Music, 222 259, 263 CadZZilla, Larry Erickson and Billy F. Charlie Parker Watches His Hotel Room tertiary colors, 260 Gibbons, 237 Burn, Sue Coe, 250-251 tonality of color, 279 Caillebotte, Gustave, Rue de Paris: Che Cosa è Acqua, Judy Pfaff, 139 triadic color scheme, 280-281 Temps de Pluie (Paris Street, Chiaroscuro, 250 unity achieved through color, 52-53 Rainy Day), 196-197 Chicago 30, Aaron Siskind, 171 uses of color, 284-285 Calatrava, Santiago, Alamillo Bridge/ Chinese medallion, Ming Dynasty, 72 value relationship with color, 247, Cartuja Viaduct, Seville, Spain, 97 Christ Carrying the Cross, Rembrandt, 137 262-263, 264, 275 Calvin and Hobbes, Bill Watterson, 235 Christian Dior Boutique, Valentino, variety emphasized through, 48-49 Calvin Klein design, Francisco Costa, 153 Maurice Vellekoop, 65 vibrating colors, 114, 118, 283 Campo Santa Maria Zobenigo, Circus, Charles Henry Demuth, 198-199 visual color, 193, 268-269 Canaletto, 212-213 Claesz, Pieter, Still Life with Two Lemons, visual color mixing, 268-269 Canal, Giovanni Antonio (Canaletto), a Façon de Venise Glass, Roemer, Color/Tree Symphony, Wolf Kahn, Campo Santa Maria Zobenigo, 282-283 Knife and Olives on a Table, 192 212-213 Clarke, Harry, The Most Beautiful of All, Columbus Dispatch, Karl Kuntz, 59 Candide (scene from), Leonard Bernstein 184-185 Commercial design, 19, 101. See also

Close, Chuck, April, 268-269

and Richard Wilbur, 284-285

Communication, art as, 6	00.001//00.10.10	D'
Communication Arts, Lino, 64–65	as source, 18–19	Dianthis and Almond, Joris Hoefnagel
Complementary colors, 264–265,	symbol interpretation influenced by, 11	and Georg Bocskay, 116
280–281	Curvilinear shapes, 166–167, 169	Die Hoffnung II (Hope II), Gustav Klimt, 182–183
Completely Smash the Liu-Deng	odi viii lodi shapes, 100–107, 109	Din Sko shoe store advertisement, 216
Counter-Revolutionary Line, 161	D	The Disputing Physicians (or
Composition, 29	da Vinci, Leonardo	Philosophers), Miskina, 202
Composition with Circles Shaped by	Adoration of the Magi, 210–211	Distortion, 158–159. See also Abstract
Curves, Sophie Taeuber-Arp, 36	Studies of Flowers, 15	art; Exaggeration; Idealism
Concave shapes, 152-153	Study of Flowing Water, 15	Doing, 7, 20–23
Concha, Felix de la, Así en el cielo (As in	Virgin of the Rocks, 15	Doodle de Do, Alan Crockett, 116-117
Heaven), 213	Daniel-Henry Kahnweiler, Pablo Picasso,	Doria, Icaro, "Music" campaign, 272
Constructive criticism, 24-25	176–177	Doryphorus (Spear Bearer), Polyclitus,
Contaminated Drifting Blues, Thornton	Dark. See Light and dark; Shading;	160–161
Dial, 188–189	Shadows; Value	DoubleFrame Diana #2103, Ardine
Content	Darrow, Whitney, Jr., cartoon, 54	Nelson, 244
defined, 5	The Daughters of Edward Darley Boit,	Dove, Arthur, Tree Composition, 14-15
selecting, 10, 11	John Singer Sargent, 30, 31	Drawing
Continuation, 38–39, 48	Daumier, Honoré, Frightened	contour, 136-137
Continuity, 40–41, 52	Woman, 139	elevation, 206-207
Contour drawing 126 127	Davie, Karin, Between My Eye and Heart	gesture, 137
contour drawing, 136–137 cross contour, 130–131	No. 12, 144–145	perspective, 207
lost-and-found contour, 146–147	Davis, Ronald, Arch Duo and Vented	plan, 206–207
Contrast	Star, 144 Davis, Stuart, Visa, 280	wash, 253
asymmetrical balance created by,	De Kooning, Willem, 22	DS 1958, David Smith, 21
98–99	Decorative and Ornamental Brickwork,	Duchamp, Marcel, Nude Descending a
emphasis achieved by, 58-59	James Stokoe, 119	Staircase, 238–239 The Duel after the Masquerade, Jean-
rhythm created by color contrasts, 114	Degas, Edgar, After the Bath, Woman	Léon Gérôme
of scale, 78–79	Drying Herself, 265	arrested action in, 230
simultaneous, 265	Delaunay, Robert, Rhythme sans fin	balance in, 90, 275
value, 244-245, 248-249	(Rhythm without End), 118–119	complexity/subtlety in, 226–227
Converging patterns, 120–121	Demuth, Charles Henry, Circus,	emphasis in, 60–61
Convex shapes, 152-153	198–199	history/culture influencing, 18–19
Cooper, Douglas, Senator John Heinz	Deposition from the Cross, Jacopo	line in, 148
Regional History Center Mural	Pontormo, 48–49	pattern in, 181
(portion of), 219	Depth, illusion of	positive/negative integration in,
Costa, Francisco, Calvin Klein design, 153	aerial perspective creating, 204-205	174–175
Cote, Alan, <i>Untitled</i> , 276–277	color creating, 271	proportion in, 84
Courtney-Clarke, Margaret, Anna	devices creating, 198–215	rhythm in, 122
Mahlangu Painting Her Home for	linear perspective creating, 208–211	unity in, 52
a Ceremonial Occasion, 180 Crafts. See also Ceramics; Folk art;	multipoint perspective creating,	value pattern in, 246
Furniture; Jewelry; Quilts; Textiles	214–215	Dufy, Raoul, <i>The Artist's Studio</i> , 128–129
design integral to, 4	one-point perspective creating, 210–211	Dune Ridges at Sunrise, Death Valley,
radial balance/designs in, 62, 106	overlapping creating, 200–201	Bruce Barnbaum, 116
texture in, 186	plan, elevation, perspective creating,	Durand, Asher B., <i>Kindred Spirits</i> , 276 Durer, Albrecht, <i>Method of Perspective</i>
Cranach, Lucas the Elder, Adam and	206–207	Drawing, 196–197
Eve, 62	size creating, 198–199	Drawing, 130-131
Creative problem solving, 5	translating to two dimensions,	E
Creative process, 6–7	196–197	Eakins, Thomas
Critique, 24–25	two-point perspective creating,	The Agnew Clinic, 60-61
Crockett, Alan, Doodle de Do, 116-117	212–213	Pole Vaulter: Multiple Exposure of
Cropped figures, 235	vertical location creating, 202-203	George Reynolds, 238
Cross contour, 130–131	Der Himmel über der Schweiz ist gross	Swimming, 34–35
Cross-hatching, 140–141, 253	genug (poster), 289	Earthworks, 73
Crouching Woman, Pablo Picasso, 286	Design, defined, 4–5	Edgerton, Harold, Making Applesauce
Crow, Nancy	Design process, 4–25	at MIT (.30 Bullet Piercing an
Mexican Tiger Masks, 17 Mexican Wheels II, 17	critique in, 24–25	Apple), 231
Crying Girl, Roy Lichtenstein, 142–143	design, defined, 4–5	Egyptian art, 218
Crystallographic balance, 108–109, 182	doing in, 7, 20–23	Elevation drawings, 206–207
Cubism, 176–177	looking in, 7, 14–19 steps in, 6–7	Elm, Andy Goldsworthy, 273
Culture	thinking in, 7, 8–13, 20–21	EM Arena II, Andreas Gursky, 209 Embroidery: The Artist's Mother (Woman
color symbolism, cultural differences	Diagonal lines, 134–135	Sewing), Georges Seurat,
in, 288	Dial, Thornton, Contaminated Drifting	174–175
radial balance of cultural symbols, 107	Blues, 188–189	Emotions, 129, 138–139, 286–287

Emphasis, 56–67. See also Focal points absence of focal point and,	isolation creating, 60-61 multiple, 56	emphasis in, 60–61 history/culture influencing, 18–19
66–67, 108	one element as, 64–65	line in, 148
attracting attention and, 56–57	placement creating, 62–63, 202–203	pattern in, 181
color as, 272–273	scale and proportion creating, 70-71	positive/negative integration in,
contrast to achieve, 58-59	symmetry creating, 94-95	174–175
degree of, 64–65	unity maintained by, 65	proportion in, 84
on integration of positive/negative	value creating, 248–249	rhythm in, 122
shapes, 174–175	Folk art, 190–191. See also Collages; Crafts	unity in, 52 value pattern in, 246
isolation to achieve, 60–61 line quality creating, 138–139	Font, 30–31. See also Typeface/	Gestalt theory, 32–33
placement to achieve, 62–63,	typography	Gesture drawings, 137
202–203	Ford ("Deuce") Street Rod, 1932	Gettin' Religion, Archibald J.
scale and proportion for, 70-71	Modified, Thom Taylor, 85	Motley, Jr., 286
symmetry for, 94–95	Foreshortening, 196, 209	Ghirlandaio, Domenico, Last Supper,
on unity, 46–47	Form. See also Shapes	76–77
value as, 248–249	defined, 5	Giacometti, Alberto, Self-Portrait,
on variety, 48–49	function and, 12–13	136–137
vertical location for, 202–203 ways to achieve, 58–63	line defining, 130–131, 144–145 line suggesting, 146–147	Gibbons, Billy F., CadZZilla, 237 Girl with a Pearl Earring, Jan Vermeer,
on whole over parts, 66–67, 108	open/closed, 222–223	280–281
Enclosure, 222–223	pure, 164–165	Glasses and Bottles, Amédée
An End to Modernity, Josiah	selecting, 10–11	Ozenfant, 218
McElheny, 106	variety emphasized through, 48	Godoff, Heidi, New York Times
Ensor, James, Self-Portrait Surrounded	Formal balance, 92-93	advertisement, 130
by Masks, 58	The Fortune Teller, Georges de La Tour,	Golden rectangles, 82–83, 85
Equivocal space, 224–225	133	The Golden Wall, Hans Hofmann, 287
Erickson, Larry, CadZZilla, 237	Found materials, 191 Four Darks in Red, Mark Rothko, 154	Goldin, Nan, <i>Siobhan with a Cigarette,</i> 96–97
Escher, M. C., Pattern Drawing, 182–183 Europe After the Rain (Europa nach dem	Francesca, Piero della, View of an Ideal	Goldsworthy, Andy
Regen), Ernst Max, 192	City, 208	Balanced Rock, 6, 7
Evangeliste, John Moore, 135	Frankenthaler, Helen, Over the	Elm, 273
Evans, Frederic H., York Minister, Into the	Circle, 165	Snow gone by next day, bark stripped,
South Transept, 98	Fred H., Adrienne Salinger, 180	chewed and scraped off,
Exaggeration	Friedman, Tom, <i>Untitled</i> , 9	248–249
of scale, 78, 198–199	Frightened Woman, Honoré Daumier, 139	Sycamore stick placed on snow/
of shapes, 158–159	Frottage, 192	raining heavily, 248–249
Explicit lines, 144–145 Eye direction, 102–103	Function, form and, 12–13 Funeral under Umbrellas, Henri	Golub, Leon, <i>Mercenaries IV,</i> 287 Goodman, Sidney, <i>Maia with Raised</i>
Eye movement, 240–241	Rivière, 88	Arm, 250
Lye movement, 240 241	Furniture	Goodyear Tires, 6610 Laurel Canyon,
F	balance in, 88-89	North Hollywood,
Family Romance, Charles Ray, 81	color in, 264–265	Ed Ruscha, 120
Fantasy, 81	form and function in, 12, 13	Gorky, Arshile, Garden in Sochi, 163
Fantin-Latour, Henri, Still Life: Corner of	rhythm in, 115	Grand Mosque, Mecca, Saudi
a Table, 101	Shaker, 12, 13	Arabia, 46
Fashion. See Clothing design Fast shapes, 236–237	texture in, 186	Grand Teton Quadrangle map, 130–131 Granger, Tony, "Music" campaign, 272
Feelings, 129, 138–139, 286–287	G	Grapefruit with Black Ribbons, Susan
Feldstein, Mark, <i>Untitled</i> , 146–147	Garçons de Café, Aubrey Beardsley, 102	Jane Walp, 56
Fennessey, Mark, Insects IV, 78	Garden in Sochi, Arshile Gorky, 163	Grays
Fibonacci sequence, 83	Gehry, Frank	achromatic, 244, 256
The Fifer, Édouard Manet, 83	Guggenheim Museum, Bilbao, Spain	color intensity lowered mixing with,
Fifteen Pairs of Hands, Bruce	model, 50–51	265
Nauman, 156	Nationale-Nederlanden Building,	gray value scale, 244, 262
Fig Branch (Figue), Ellsworth Kelly, 136 Figurative art, 52	Prague, 169 Gentileschi, Artemisia, <i>Judith</i>	visual, 253 Greyhound Bus logo, Raymond Loewy,
The Fitting, Mary Stevenson Cassatt, 205	Decapitating Holofernes, 246	10
Five Paths, Richard Long, 128–129	Geometry, 82–85, 164–165	Grids, 40–41, 42–43
Flashlight Centaur, Pablo Picasso,	George Washington Bridge, kptyson, 132	Groover, Jan, <i>Untitled</i> , 38–39
128–129	George Washington Carver Crossing the	Gros Ventre #3, Michel Taupin, 196
Flatness, color emphasizing, 276-277	Delaware, Robert Colescott, 19	Gross, Sam, cartoon, 228
Focal points. See also Emphasis	Gérôme, Jean-Léon, The Duel after the	Ground, 152, 170–171, 176
absence of, 66–67, 108	Masquerade	Grumman HU-16 Albatross, 12
attracting attention with, 56–57 color as, 272–273	arrested action in, 230 balance in, 90, 275	Guggenheim Museum, Bilbao, Spain model, Frank Gehry, 50–51
contrast creating, 58–59	complexity/subtlety in, 226–227	Gumpertz, Robert, cartoon, 126

contrast creating, 58-59

Gursky, Andreas	Hofko, Markus, Mickey Mouse of the	Jacquette, Yvonne, Mixed Heights and
Bahrain I, 74–75	series Cartoon Particles,	Harbor from World Trade Center
Bahrain II, 74–75	166–167	II, 216–217
EM Arena II, 209	Hofmann, Hans, The Golden Wall, 287	Jay, John C., Nike Sportswear
Guston, Philip, <i>Transition</i> , 90, 91	Hokusai, Katsushika, South Wind, Clear	advertisement, 159
н	Dawn, 100–101	Jazz Festival Willisau (poster), Niklaus
Hallway in U.S. Holocaust/Memorial	Holland, Glen, Sweet & Sour, 70–71 Holy Family in an Interior, Ferdinand Bol,	Troxler, 116–117
Museum, Ralph Appelbaum,	248–249	Jewelry, 5, 106, 186, 191, 196 Joe, Richard Serra, 171
108–109	Homer, Winslow, Leaping Trout, 248	Johns, Jasper, <i>Map</i> , 108
Harlequin, Pablo Picasso	Hope II (Die Hoffnung II), Gustav Klimt,	Jour (Day), Auguste Herbin, 164
balance in, 89, 275	182–183	Judith Decapitating Holofernes,
emphasis in, 64-65	Horizon placement, 210-211	Artemisia Gentileschi, 246
history/culture influencing, 18–19	Horizontal lines, 134–135, 210–211	Julian, Elizabeth Peyton, 279
line in, 148	Hue, 260–261. See also Color	July, Paul Resika, 162
open/closed form in, 222–223	Human body	Juxtaposition, 216
optical movement when viewing,	human reference scale, 72–73	K
240–241 pattern in, 181	idealized, 82, 160–161	Kahn Wolf Color/Trae Symphony
positive/negative shapes in, 172–173	scale and proportion of, 81, 82–83, 160–161	Kahn, Wolf, <i>Color/Tree Symphony,</i> 282–283
proportion in, 83	symmetry of, 92	Kaplan, Bruce Eric, cartoon, 2
rhythm in, 122–123	Symmetry of, 32	Katz, Alex
unity in, 52–53	I	Ada's Red Sandals, 222-223
value pattern in, 246-247	Iceland photograph, Damon	Anna Wintour, 92–93
Harmony, 28–29, 278. See also Unity	Winter, 29	Black Jacket, 28, 29
Harper, Charley, Original painting	Icons, 10, 11	Keffer, Mark, Altered Map, Esopus, 66-67
for Titmouse Tidbit (Tufted	Idealism, 82, 160-161	Kelly, Ellsworth
Titmouse), 44	Imbalance, 89, 90–91, 275	Apples, 152
Harris, Sidney, cartoon, 194	Implied lines, 132–133	Black Venus, 152–153
The Harvesters, Pieter Bruegel the Elder, 226	Implied texture, 188–189 In the Platte River Valley, Keith	Fig Branch (Figue), 136
Harvey, Rebecca, Systema Naturae,	Jacobshagen, 91	Kent, Rockwell, <i>Asgaard</i> , 204–205 The Kerry Waghorn Studios, <i>Bill Clinton</i>
162–163	Industrial Facades, Bernd and Hilla	#3. 158
Hatke, Walter, Self-Portrait, 252–253	Becher, 44–45	Keyhole, Elizabeth Murray, 222-223
"Having a talent isn't worth much unless	Informal balance, 96-97, 102	Kindred Spirits, Asher B. Durand, 276
you know what to do with it."	Ingres, Jean-Auguste-Dominique,	Kinesthetic empathy, 112, 232-233
(poster), 8	Portrait of Mme. Hayard and Her	The Kitchen Maide, Jan Vermeer, 230
Hayllar, Edith, A Summer Shower, 201	Daughter Caroline, 136	Klee, Paul, New Harmony, 42-43
Held, Al	Inherent lines, 148–149	Klee Squares, II, Deborah Pentak, 283
Helena, 176	Inherent rhythm, 120–121	Klimt, Gustav, Die Hoffnung II (Hope II),
Yellow, 225 Helena, Al Held, 176	Inness, George, View of the Tiber near	182–183
Hepburn, Audrey, 92	Perugia, 82–83 The Insect Chorus, Charles	Kluin, Menno, "Music" campaign, 272
Herbin, Auguste, <i>Jour (Day)</i> , 164	Burchfield, 112	Korin, Ogata, <i>Irises</i> , 46–47 kptyson, <i>George Washington Bridge</i> , 132
Herms, George, <i>The Librarian</i> , 49	Insects IV, Mark Fennessey, 78	Krasner, Lee, <i>Untitled</i> , 66
Hesse, Eva, Studio, 20	The Inspiration of Saint Matthew,	Krishna Revealing His Nature as
Hettmansperger, Sue, Untitled	Caravaggio, 104-105	Vishnu, 234
Drawing, 250	Installation, Henry Moore, 157	Kuchera, John, It's Time to Get
Hieratic scaling, 70–71	Installation View, Sean Scully, 16	Organized, 4
Hillman, Hans, poster for The Bartered	Integration of positive/negative shapes,	Kuntz, Karl, Columbus Dispatch, 59
Bride, 176	172–173, 174–175	
Hiroshige, Ando, Suido Bridge and	Intensity, color, 264–265	L La Tour Coorgon de The Fortune
Surugadai (Suidobashi Surugadai) No. 48 from Famous Views of	Interchange, Edna Andrade, 118 Irises, Ogata Korin, 46–47	La Tour, Georges de, <i>The Fortune Teller</i> , 133
Edo, 198–199	Isadora, Gretchen Belinger, 184–185	A Lady at the Virginals with a
History, as source, 18–19	Isolation, 60–61, 172–173	Gentleman, Jan Vermeer,
Hockney, David	Isometric projection, 220–221	62–63
Brooklyn Bridge, November 28,	It's Time to Get Organized (poster), John	Landscapes of Future, Pavel
<i>1982,</i> 219	Kuchera, 4	Pepperstein, 78-79
Mulholland Drive: The Road to the	Itten, Johannes, color wheel, 260	Large Reclining Nude/The Pink Nude:
Studio, 276–277	IUCN Annual Report cover, Chaz	Two Stages in Process, Henri
Self-Portrait with Blue Guitar, 221	Maviyane-Davies, 67	Matisse, 22
Hodgkin, Howard, <i>Menswear</i> , 74		Large Reclining Nude/The Pink Nude
Hoefnagel, Joris, <i>Dianthis and Almond</i> , 116	J Jacobs, Jan, "Music" campaign, 272	Henri Matisse, 22
Hoffman, Susan, Nike Sportswear	Jacobshagen, Keith, <i>In the Platte River</i>	Larsen, Jack Lenor, Seascape, 130–131 Last Supper, Domenico Ghirlandaio,
advertisement, 159	Valley, 91	76–77
,		

238-239

rhythm and, 113, 114, 116-117

The Last Supper, Emil Nolde, 76-77 Lippi, Fra Filippo, Saint Lawrence Meier, Richard, The Atheneum, New Lauer, David, cartoons, 86, 110 Enthroned with Saints and Harmony, Indiana, 220-221 Mendoza, Tony, Yellow Flowers, 216-217 Donors, 70-71 Lawrence, Jacob, Cabinet Makers, Lissitzky, El, Of Two Squares: A Menswear, Howard Hodgkin, 74 200-201 Leaping Trout, Winslow Homer, 248 Suprematist Tale in Six Mercenaries IV, Leon Golub, 287 Constructions, 34-35, Method of Perspective Drawing, Albrecht Leger, Fernand, The Builders, 142-143 198-199, 232 Durer, 196-197 Length, line, 128 Leonard, Yeardley, Sita, 168 Livesey, Nick, catalog spread, 253 Mexican Tiger Masks, Nancy Crow, 17 The Living Room, Balthus, 38 Mexican Wheels II, Nancy Crow, 17 Lewitt, Sol, Wall Drawing 51, 149 Miata, Mazda, 166 Li, Feng, Beijing Celebrates the 60th Local color, 284 Michaelski, Javier, Nike Sportswear Anniversary of New China, Location. See Placement Loewy, Raymond, Greyhound Bus advertisement, 159 238-239 Mickey Mouse of the series Cartoon Li, Gilbert, Social Insecurity, 78 logo, 10 The Librarian, George Herms, 49 Particles, Markus Hofko, Logos Licht, Sydney, Still Life with Two Greyhound Bus logo, Raymond 166-167 Bunches, 155 Miller, Joe, space 47, 36 Loewy, 10 Milunic, Vladimir, Nationale-Nederlanden Lichtenstein, Roy Multicanal logo, 177 Building, Prague, 169 Brushstrokes, 189 Patriots logo, 236-237 Cathedral #2, 154-155 Siena logo, 236-237 Miró, Joan, The Birth of the World, Long, Richard, Five Paths, 128-129 274-275 Crying Girl, 142-143 Light and dark. See also Shading; Looking, 7, 14-19 Miskina, The Disputing Physicians (or Philosophers), 202 Shadows: Value artifacts as source, 16-17 Mixed Heights and Harbor from color as property of light, 256-257, history and culture as source, 18-19 World Trade Center II, Yvonne 258, 284 nature as source, 14-15 Lorenz, Lee, cartoon, 178 Jacquette, 216-217 lines creating, 140-141 photographic selected lighting, Lost-and-found contour, 146-147 Mixed media on paper, Susan 146-147 Lux, Loretta, Sasha and Ruby, 46-47 Moore, 245 Mocking Bird. Margaret Wharton, 94-95 relationship between, 244-245, М 248-249 Mona Lisa, Fernando Botero, 81 MacDougall, John, soccer photograph, Monet, Claude space suggested by, 204-205, 132-133 Poplars, 258 250-251 Mackintosh, Charles Rennie, Chair, 115 Poplars on the Epte, 258 techniques for creating, 252-253 theater lighting, 284-285 Magritte, René, Personal Values (Les Monochromatic colors, 278 variations in, 246-247 Valeurs Personnelles), 80 Moods. See Emotions Maia with Raised Arm, Sidney Goodman, Limbourg Brothers, Multiplication of the Moonlight Revelry at the Dozo Sagami, Loaves and Fishes, 72 250 Kitagawa Utamaro, 208-209 Make Jobs Not War (poster), Steve Moore, Henry, Installation, 157 Linear perspective, 208-211 Mehalo, 4-5 Lines, 128-149 Moore, John Making Applesauce at MIT (.30 Bullet Blue Stairway, 79 actual, 133 Piercing an Apple), Harold Evangeliste, 135 as artistic shorthand, 130 blurred, 236-237 Edgerton, 231 Moore, Susan Malevich, Kasimir mixed media on paper, 245 contour, 130-131, 136-137, 146-147 defined, 128 Suprematist Composition: Sensation Vanity (Portrait 1), 62 of Metallic Sounds, 113 Morandi, Giorgio diagonal, 134-135 Suprematist Composition: Sensation of Still Life, 284 direction of, 134-135 Movement and Resistance, 113 emotions conveyed by, 129, 138-139 Striped Vase with Flowers, 252-253 Manet, Édouard, The Fifer, 83 explicit, 144-145 Moreno, Lola, Coca Cola storyboard, 234 Map. Jasper Johns, 108 Morris, Sarah, Pools-Crystal House of force, 238-239 Martin, Charles E., cartoon, 150 (Miami), 215 form defined/suggested by, 130-131, Masaccio, The Tribute Money, 84-85 144-145, 146-147 Morrison, Caroline, New York Times Mass, 156-157. See also Volume grid of, 40-41, 42-43 advertisement, 130 horizontal, 134-135, 210-211 Mathematics. See Geometry; Ratios Moskowitz, Robert, Thinker, 156-157 Matisse, Henri The Most Beautiful of All, Harry Clarke, implied, 132-133 Bathers with a Turtle, 56-57 184-185 inherent, 148-149 interpreting, 133 Large Reclining Nude/The Pink Motion Nude, 22 anticipated, 232-233 linear perspective from, 208-211 The Piano Lesson, 247 motion suggested by, 134, 137, asymmetrical balance suggesting, 99 Maviyane-Davies, Chaz, IUCN Annual blurred outlines/fast shapes 139, 144 Report cover, 67 outlines, 128, 142-143, 236-237 suggesting, 236-237 Max, Ernst, Europe After the Rain cropped figures suggesting, 235 in painting, 135, 142-145 (Europa nach dem Regen), 192 lines suggesting, 134, 137, 139, 144 psychic, 133 Mazda Miata, 166 multiple images suggesting, 238-239 quality of, 138-139 McElheny, Josiah, An End to optical movement suggesting, shape and, 130-131, 144-145 Modernity, 106 240-241 types of, 132-133 McLaughlin, John, Y-1958, 226-227 as value, 140-141 repeated figures suggesting, 234, Meeting, James Turrell, 270

Mehalo, Steve, Make Jobs Not War, 4

vertical, 134-135

Lino, Communication Arts, 64-65

Motion, continued stillness and arrested action vs., 230–231	Nonobjective shapes, 164–165 Nozkowski, Thomas, <i>Untitled</i> , 59 <i>Nude Descending a Staircase</i> , Marcel	defined, 180, 184 order and variety of, 182–183 sequence and, 118–119
ways to suggest, 99, 234–239 Motley, Archibald J., Jr., <i>Gettin'</i>	Duchamp, 238–239	texture and, 184–185 value pattern, 246–247
Religion, 286	0	Pentak, Deborah, Klee Squares, II, 283
Movement. See Motion	O'Brian, William, cartoon, 242	Pentimenti, 23
Mulholland Drive: The Road to the Studio, David Hockney, 276–277	Of Two Squares: A Suprematist Tale in Six Constructions, El Lissitzky,	Pepperstein, Pavel, Landscapes of
Multicanal logo, 177	34–35, 198–199, 232	Future, 78–79 Per Arnoldi (Denmark) (poster), 211
Multiple images, 238–239	Offering the Panale to the Bullfighter,	Perception
Multiple perspective, 218–219	Mary Stevenson Cassatt, 99	angle of, 156, 209
Multiplication of the Loaves and Fishes,	O'Keeffe, Georgia, Shell No. 1, 14-15 Oldenburg, Claes	of color, 258–259, 260–261
Limbourg Brothers, 72 Multipoint perspective, 214–215	Proposal for a Colossal Monument	shaping, 152-153 unity and visual perception, 32-33
Munsell Color System, 261	in Downtown New York	Personal Values (Les Valeurs
Murphy, Catherine, Self-Portrait,	City: Sharpened Pencil Stub	Personnelles), René Magritte, 80
160–161	with Broken-off Tip of the	Perspective
Murray, Elizabeth Keyhole, 222–223	Woolworth Building, 8 Typewriter Eraser, Scale X, 73	aerial/atmospheric, 204–205, 250–251, 276
Painter's Progress, 48–49	Oliphant, Pat, 140	amplified, 216–217
"Music," P&G Glide Dental Floss	Olive Added to Red and Blue, Violet and	linear, 208–211
campaign, 272–273	Green, Single Reversed Diagonal,	multiple, 218–219
My Funny Valentine, Richard Prince, 33	Bridget Riley, 114 One-point perspective, 210–211	multipoint, 214–215 one-point, 210–211
N	Opalka, Roman, 245	perspective drawings, 207
Nationale-Nederlanden Building,	Open/closed form, 222-223	two-point, 212–213
Prague, Vladimir Milunic and	Opie, Julian, Shahnoza, 157	Peyton, Elizabeth, Julian, 279
Frank Gehry, 169 Naturalism, 158, 160–161, 198	Optical color mixing, 268 Optical movement, 240–241	Pfaff, Judy, Che Cosa è Acqua, 139
Nature	Organization, visual, 4–5. See also Unity	P&G Glide Dental Floss campaign, "Music," 272–273
biomorphic shapes alluding to, 163	Original painting for Titmouse Tidbit	Photographs
growth patterns in, 82–83, 120–121	(Tufted Titmouse), Charley	baseball, 232-233
progressive rhythm in, 120–121 proportion in, 82–83	Harper, 44 Orpheus and Eurydice, Scott Noel, 154	blurred images in, 236
radial balance in, 106	Orr, Lauren, photograph, 16	color, 269 cropped, 235
as source, 14–15	Ostberg, Tommy, Din Sko shoe store	Iceland, 29
symmetry in, 94	advertisement, 216	motion (illusion of) in, 231, 232-233
Nauman, Bruce, Fifteen Pairs of Hands, 156	Outlines, 128, 142–143, 236–237 Over the Circle, Helen Frankenthaler, 165	multiple images in, 238–239
Navajo blanket/rug, 279	Overlapping, 200–201, 224–225,	psychic line in, 132–133 selected lighting for, 146–147
Navigational Chart, Marshall Islands, 11	238–239	soccer, 132–133
Nazca earth drawing, Spider, 73	Ozenfant, Amédée, Glasses and	unity in, 29
Neck Piece, Anni Albers and Alex Reed, 191	Bottles, 218	value contrast in, 244, 248–249 Photoshop palette, 266–267
Neel, Alice, <i>The Pregnant Woman</i> , 142	P	The Piano Lesson, Henri Matisse, 247
Negative spaces	Paint Cans, Wayne Thiebaud, 28	Piazza del Popolo, Rome, Italy, 107
planning, 170–171	Painter's Progress, Elizabeth Murray,	Picasso, Pablo
positive/negative shapes creating, 170–177	48–49 Painting	Crouching Woman, 286 Daniel-Henry Kahnweiler, 176–177
three-dimensional design using, 171	line in, 135, 142–145	Flashlight Centaur, 128–129
unity and, 32	texture in, 188–189, 192–193	Harlequin, 18-19, 52-53, 64-65, 83,
Nelson, Ardine, DoubleFrame Diana	Palettes, color, 266–267	89, 122–123, 148, 172–173,
#2103, 244 Neumeier, Marty, War: What is it Good	Pao, Nike Sportswear advertisement, 159	181, 222–223, 241, 246–247, 275 (See Harleguin entry for
For?, 5	Parasols, Sophie Taeuber-Arp, 146–147	details)
New Harmony, Paul Klee, 42-43	Paris, France, 1932, Place de L'Europe,	Picnic Icons, Chris Rooney, 11
New York Times advertisement, 130	Gare Saint Lazare, Henri Cartier-	Pictograms, 10
New Yorker cartoons, 2, 26, 54, 68, 150, 178, 228, 242, 254	Bresson, 231 Partial Recall, Louise Bourgeois, 120–121	Pictorial balance, 89 Picture plane, 196
New York-New York Hotel & Casino, Las	Patriots logo, 236–237	The Pine on the Corner, Jeff Wall, 56–57
Vegas, 80-81	Pattern Drawing, M. C. Escher, 182–183	The Pink Nude, Henri Matisse, 22
Newbold, R., 253	Patterns. See also Rhythm; Unity	Placement
Nike Sportswear advertisement, 159 No. 74, Anne Ryan, 165	allover, 108–109 balance created by, 100–101, 108–109	balance and, 90–91, 102–103
Noel, Scott, <i>Orpheus and Eurydice</i> , 154	converging, 120–121	emphasis achieved by, 62–63, 202–203
Nolde, Emil, The Last Supper, 76-77	creating visual interest using, 180-181	of horizon, 210–211

overlapping, 200-201, 224-225,	Process Board: air PERSONA, Meredith	unity achieved through, 36-37, 44-45
238–239	Rueter, 23	46–47, 53
positive/negative areas based on,	Progressions, Mary Bauermeister, 190	varied, 44–45
170, 172–173	Progressive rhythm, 120–121	Resika, Paul, <i>July,</i> 162
proximity of, 34–35, 38	Projection, isometric, 220–221	"Restless Exhibition," Ron Arad, 12, 13
vertical location, 202–203 Plan drawings, 206–207	Propaganda, idealism in, 161 Proportion. <i>See also</i> Scale; Size	Rhythm, 112–123 alternating, 118–119
Point of view. See Perspective	distorted, 158–159	engaging the senses with, 112–113
Pointillism, 268–269	geometry as basis for, 82–85	grid variety and, 42, 43
Pole Vaulter: Multiple Exposure of	internal proportions, 76-77	inherent, 120-121
George Reynolds, Thomas	manipulating, 80-81	manipulating, 116-117
Eakins, 238	scale and, 70–71	motion and, 113, 114, 116–117
Polyclitus, <i>Doryphorus (Spear Bearer)</i> , 160–161	Proposal for a Colossal Monument in Downtown New York City:	polyrhythmic structures, 122–123
Polyrhythmic structures, 122–123	Sharpened Pencil Stub with	progressive, 120–121 visual, 114–115
Pontormo, Jacopo, <i>Deposition from the</i>	Broken-off Tip of the Woolworth	Rhythm Study, Michel Taupin, 196
Cross, 48–49	Building, Claes Oldenburg, 8	Rhythme sans fin (Rhythm without End),
Pools-Crystal House (Miami), Sarah	Proximity, 34–35, 38	Robert Delaunay, 118-119
Morris, 215	Psychic lines, 133	Riley, Bridget, Olive Added to Red and
Poplars, Claude Monet, 258	Pulp Fiction, Noma Bar, 158–159 Pumpkin Tendrils, Karl Blossfeldt, 30	Blue, Violet and Green, Single Reversed Diagonal, 114
Poplars on the Epte, Claude Monet, 258 Portrait of Dr. Gachet (Man with a Pipe),	Pure forms, 164–165	Ringgold, Faith, <i>Tar Beach</i> , 202–203
Vincent van Gogh, 104	Pygmy right whale, 12	Rivière, Henri, Funeral under
Portrait of Mme. Hayard and Her	, j., , , , , , , , , , , , , , , , , ,	Umbrellas, 88
Daughter Caroline, Jean-	Q	Romero, Rocio, Prefabricated
Auguste-Dominique Ingres, 136	Quilts	Home, 168
Portrait of the Artist, Vincent van Gogh, 188–189	allover patterns in, 108	Rooney, Chris, <i>Picnic Icons</i> , 11
Position, 102–103. See also Placement	artifacts as source for, 17 color conflict in, 283	Root rectangles, 84–85 Rosanas, Ramon, <i>Coca Cola</i>
Positive/negative shapes	Klee Squares, II, Deborah Pentak, 283	storyboard, 234
ambiguity of, 176–177	Mexican Wheels II, Nancy Crow, 17	Roth, Richard, Untitled, 70
blending of, 176	optical movement in, 241	Rothenberg, Susan, Untitled, 138
defined, 170	radial designs in, 62	Rothko, Mark, Four Darks in Red, 154
delineation of, 177	Signature Quilt, Adeline Harris	Route 66, Kingman, Arizona, 50
integration of, 172–173, 174–175 isolation of, 172–173	Sears, 108 spacial relationships on, 202	Rue de Paris: Temps de Pluie (Paris Street, Rainy Day), Gustave
planning negative spaces, 170–171	Triangles crib quilt, 241	Caillebotte, 196–197
Posters	9.00 0.00 4.00, - 0.0	Rueter, Meredith, Process Board: air
The Bartered Bride, Hans Hillman, 176	R	PERSONA, 23
Der Himmel über der Schweiz ist	Rabbit, Wayne Thiebaud, 274	Ruscha, Ed
gross genug., 289 "Having a talent isn't worth much	Radial balance, 106–107, 182–183 Radial design, 62–63	Goodyear Tires, 6610 Laurel Canyon,
unless you know what to do	Rancho, Ed Ruscha, 193	North Hollywood, 120 Rancho, 193
with it." 8	Ratios	Standard Station, Amarillo, Texas, 213
It's Time to Get Organized, John	proportion based on, 82-83, 85	Step on No Pets, 94
Kuchera, 4	ratio of golden mean, 83, 85	Russell, Kristian, 98
Jazz Festival Willisau, Niklaus Troxler,	Rauschenberg, Robert, Centennial	Ryan, Anne
116-117 Make Jobs Not War, Steve Mehalo,	Certificate, 42–43	No. 74, 165 Untitled No. 129, 190
4–5	Ray, Charles, <i>Family Romance</i> , 81 Rectangles	Ontinea 110. 129, 190
Per Arnoldi (Denmark), 211	golden, 82–83, 85	S
Stop Torture, 6	rectilinear shapes, 168-169	Saar, Betye, The Time Inbetween,
Stopp: Ja zur Minarett verbots-	root, 84–85	186–187
initiative, 288	structure of, 148–149	Saint Lawrence Enthroned with Saints
Thanksgiving Number of the Chap- Book, Will H. Bradley, 166	Recycled materials, 191 Reed, Alex, <i>Neck Piece,</i> 191	<i>and Donor</i> s, Fra Filippo Lippi, 70–71
Underkarl, Niklaus Troxler, 240	Rembrandt	St. Ambrose Addressing the Young St.
War: What is it Good For? Marty	Christ Carrying the Cross, 137	Augustine, Giovanni Domenico
Neumeier, 5	The Three Trees, 140-141	Tiepolo, 252-253
Prefabricated Home, Rocio	Renger-Patzsch, Albert, Buchenwald	Salinger, Adrienne, Fred H., 180
Romero, 168	in Herbst (Beech Forest in	Salome with the Head of John the
The Pregnant Woman, Alice Neel, 142	Autumn), 115	Baptist, Caravaggio, 146
Premutico, Leo, "Music" campaign, 272	Repetition. See also Patterns doing and redoing, 22–23	Salviati, Francesco, <i>Virgin and Child with</i> an Angel, 144–145
Primary colors, 256–257, 260	repeated figure suggesting motion,	Sandler, Irving, 22
Prince, Richard, <i>My Funny Valentine</i> , 33	234, 238–239	Sargent, John Singer, <i>The Daughters of</i>
Problem solving, 5, 9	rhythm based on, 42, 43, 112-123	Edward Darley Boit, 30, 31

naturalism and distortion of,

158-159

naturalism and idealism of, 160-161 space 47, Joe Miller, 36 Sasha and Ruby, Loretta Lux, 46-47 Scale. See also Proportion; Size nonobjective, 164-165 Spanard, Jan-Marie, Broadway Gateway Mural, 193 positive/negative, 170-177 of art. 72-73 predominance of, 154-155 Spider, Nazca earth drawing, 73 within art, 74-79 rectilinear, 168-169 (See also Stag at Sharkey's, George Bellows, contrast of, 78-79 134-135 Rectangles) exaggerated, 78, 198-199 Standard Station, Amarillo, Texas, Ed rhythm and, 116-117, 120 hieratic scaling, 70-71 shaping perception, 152-153 Ruscha, 213 human reference scale, 72-73 Steinbach, Ham, supremely black, internal proportions creating, 76-77 in two and three dimensions, 156-157 96-97 volume/mass and, 156-157 internal references to, 74-75 Shell No. 1, Georgia O'Keeffe, 14-15 Steinberg, Saul, Untitled, 129 large and small scale together, 79 Step on No Pets. Ed Ruscha, 94 Shipbreaking #10, Chittagong, manipulating, 80-81 Stevenson, James, cartoon, 68 proportion and, 70-71 Bangladesh, Edward Burtynsky, 250-251 Still Life: Corner of a Table, Henri unexpected, 78 Fantin-Latour, 101 A Short History of Modernism, Mark Scully, Sean, Installation View, 16 Still Life, Giorgio Morandi, 284 Sculpture, 187, 188, 196. See also Tansey, 25 Siena logo, 236-237 Still Life #12, Tom Wesselmann, 202-203 Three-dimensional design Signage, Route 66, Kingman, Arizona, 50 Still Life with Two Bunches, Sydney Sears, Adeline Harris, Signature Quilt, Signature Quilt, Adeline Harris Sears, 108 Licht, 155 Still Life with Two Lemons, a Façon Seascape, Jack Lenor Larsen, 130-131 Silhouette, 98 de Venise Glass, Roemer, Knife Silhouette of a Woman, Georges Seated Boy with Straw Hat (Study for the and Olives on a Table, Pieter Bathers), Georges Seurat, 253 Seurat, 174 Secondary colors, 260 Simultaneous contrast, 265 Claesz, 192 Stillness, 230-231 Siobhan with a Cigarette, Nan Goldin, Self-Portrait. Alberto Giacometti, 96-97 Stokoe, James, Decorative and 136-137 Siskind, Aaron, Chicago 30, 171 Ornamental Brickwork, 119 Self-Portrait, Walter Hatke, 252-253 Sita, Yeardley Leonard, 168 Stop Torture (poster), 6 Self-Portrait, Catherine Murphy, 160-161 Stopp: Ja zur Minarett verbots-initiative Six Colorful Gags (Male), John Self-Portrait Surrounded by Masks, (poster), 288 James Ensor, 58 Baldessari, 238-239 Size, 198-199, 201. See also Proportion; Striped Vase with Flowers, Giorgio Self-Portrait with Blue Guitar, David Morandi, 252-253 Hockney, 221 Scale Smith, David Structural Constellation II. Josef Senator John Heinz Regional History Albers, 221 Center Mural (portion of), Douglas DS 1958, 21 Stubbs, George, Zebra, 58 Cooper, 219 Untitled, 21 Snow gone by next day, bark stripped, Studies of Flowers, Leonardo da Senses Vinci, 15 chewed and scraped off, Andy color identification with, 270-271 Goldsworthy, 248-249 Studio, Eva Hesse, 20 rhythm engaging, 112-113 Snow White Models, Walt Disney Study in Motion, Elliot Barnathan, 236 texture/pattern evoking sense of Study of Flowing Water, Leonardo da Studios, 166-167 touch, 184-185, 186 Soccer photograph, John MacDougall, Vinci, 15 Sequence, patterns and, 118-119 Subject matter. See Content 132-133 Serial designs, 41 The Subway, George Tooker, 214-215 Social Insecurity, Gilbert Li, 78 Serra, Richard, Joe, 171 Sugimoto, Hiroshi, U.A. Play House, Sodano, Sandro, catalog spread, 253 Seurat, Georges Solutions, thinking about, 9 The Black Bow, 174 Suido Bridge and Surugadai (Suidobashi Embroidery: The Artist's Mother Source Surugadai) No. 48 from Famous (Woman Sewing), 174-175 artifacts as, 16-17 Views of Edo. Ando Hiroshige, Seated Boy with Straw Hat (Study for defined, 14 198-199 the Bathers), 253 history/culture as, 18-19 Sukenobu, Nishikawa, Woman and Child Silhouette of a Woman, 174 nature as, 14-15 South Wind, Clear Dawn, Katsushika beside a Mirror Stand, 220 visual color mixing by, 268 A Summer Shower, Edith Hayllar, 201 Hokusai, 100-101 Shading, 252. See also Value Suprematism, 113 Shadows, 271. See also Light and dark Space, illusion of, 196-227 Shahnoza, Julian Opie, 157 amplified perspective creating, Suprematist Composition: Sensation 216-217 of Metallic Sounds, Kasimir Shaker furniture, 12, 13 color and, 204-205, 271, 276-277 Malevich, 113 Shapes, 152-177. See also Form complexity and subtlety in, 226-227 Suprematist Composition: Sensation abstraction of, 162-163, 198-199, 201 depth devices, 198-215 (See Depth of Movement and Resistance. ambiguity of, 176-177 Kasimir Malevich, 113 for details) biomorphic, 163 supremely black, Ham Steinbach, 96-97 equivocal space, 224-225 combinations of, 169 Surface, depth and, 196-197 isometric projection creating, 220-221 convex vs. concave, 152-153 Surrealism, 80-81, 192 curvilinear, 166-167, 169 multiple perspective creating, Sweatshirt design, Jennifer C. Bartlett, 218-219 defined, 152 negative spaces, 32, 170-177 225 exaggerated, 158-159 Sweet & Sour, Glen Holland, 70-71 open/closed form creating, 222-223 fast, 236-237 line and, 130-131, 144-145 translating to two dimensions, Swimming, Thomas Eakins, 34-35 Sycamore stick placed on snow/raining 196-197 linear perspective altering, 209

transparency creating, 224-225

value creating, 204-205, 250-251

heavily, Andy Goldsworthy,

248-249

0 1 1	The There To be Developed 440, 441	
Symbols	The Three Trees, Rembrandt, 140-141	symmetry creating, 93
color symbolism, 288–289	Three-dimensional design. See also	with variety, 42–51
cultural, 11, 107, 288	specific types (e.g., architecture)	visual, 30-31
as visual solution, 9	combining two- and, 157, 188–189	visual perception and, 32-33
Symmetry	lines in, 138	ways to achieve, 34-41
asymmetry vs., 96-105, 274-275	negative space in, 171	Untitled, Alan Cote, 276–277
bilateral, 92-93	texture in, 187, 188	Untitled, Mark Feldstein, 146-147
emphasis created using, 94–95	unity in, 38–39	Untitled, Tom Friedman, 9
symmetrical balance, 92-95	volume/mass in, 156-157	Untitled, Jan Groover, 38–39
unity created by, 93	Tiepolo, Giovanni Domenico, St.	Untitled, Lee Krasner, 66
Systema Naturae, Rebecca Harvey,	Ambrose Addressing the Young	Untitled, Thomas Nozkowski, 59
162–163	St. Augustine, 252–253	Untitled, Richard Roth, 70
102 100	Tiles, 182	Untitled, Susan Rothenberg, 138
_		
Т	The Time Inbetween, Betye Saar,	Untitled, David Smith, 21
Tactile texture, 188–191	186–187	Untitled, Saul Steinberg, 129
Taeuber-Arp, Sophie	Titmouse Tidbit (Tufted Titmouse),	Untitled Drawing, Sue
Composition with Circles Shaped by	Original painting for, Charley	Hettmansperger, 250
Curves, 36	Harper, 44	Untitled Drawing, Sarah Weinstock, 20
Parasols, 146–147	Tolstedt, Lowell, Bowl with Candy and	UNTITLED II, Don Bachardy, 37
Untitled (Study for Parasols), 146–147	Shadow, 209	Untitled No. 129, Anne Ryan, 190
"Take Your Best Shot," Michael Beirut,	Tonality, 279	Untitled (Study for Parasols), Sophie
60		Taeuber-Arp, 146–147
	Tooker, George, <i>The Subway</i> , 214–215	
Tango, Deborah Butterfield, 138	Transiency, 231	UrbanLab, X House, 65
Tansey, Mark	Transition, Philip Guston, 90, 91	Utamaro, Kitagawa
The Bricoleur's Daughter, 278	Transparency, 224–225	Moonlight Revelry at the Dozo Sagami,
A Short History of Modernism, 25	Tree Composition, Arthur Dove, 14–15	208–209
Tar Beach, Faith Ringgold, 202-203	Triadic color scheme, 280–281	Ten looks for women's physiognomy/
Taupin, Michel	Triangles crib quilt, 241	enjoyable looks, 170
Gros Ventre #3, 196	The Tribute Money, Masaccio, 84-85	
Rhythm Study, 196	Trompe l'oeil, 193	V
the state of the s		Value, 244–253
Taylor, Thom, Modified 1932 Ford	Troxler, Niklaus	
("Deuce") Street Rod, 85	Poster: Jazz Festival Willisau, 116–117	balance created by, 98-99,
Ten looks for women's physiognomy/	<i>Underkarl</i> poster, 240	246, 275
enjoyable looks, Kitagawa	Tsireh, Awa, Animal Designs, 42-43	color relationship with, 247, 262-263,
Utamaro, 170	TURNING (detail from), William Bailey, 91	264, 275
Tension, imbalance creating, 90-91	Turrell, James, Meeting, 270	defined, 244
Tertiary colors, 260	Two-dimensional design	as emphasis, 248–249
Textiles. See also Clothing design; Quilts	combining three- and, 157, 188-189	line as, 140–141
colors in, 269, 279	shapes in two vs. three dimensions,	relationship between light and dark,
	156–157	244–245, 248–249
design integral to, 4		
line as value applied to, 140-141	translating space to, 196-197	space suggested by, 204–205,
patterns/texture in, 184-185, 186,	Two-point perspective, 212–213	250–251
190–191	Typeface/typography, 30-31, 101, 153,	techniques for creating, 252-253
recycled material in, 191	171	value contrast, 244-245, 248-249
Texture	Typewriter Eraser, Scale X, Claes	value pattern, 246–247
actual and implied, 188–189	Oldenburg and Coosje van	value scale, 244, 262
balance created by, 100-101	Bruggen, 73	variations in light and dark,
creating visual interest using, 186-187		246–247
defined, 184	U	van Bruggen, Coosje, Typewriter Eraser,
and the second s		
pattern and, 184-185	U.A. Play House, Hiroshi Sugimoto,	Scale X, 73
tactile, 188–191	94–95	van Gogh, Vincent
visual, 192-193	Underkarl (poster), Niklaus Troxler, 240	Portrait of Dr. Gachet (Man with a
Thanksgiving Number of the Chap-Book	Unity, 28–53	Pipe), 104
	chaos/control and, 50-51	Portrait of the Artist, 188–189
(poster), Will H. Bradley, 166		
Thawed Ledge, Neil Welliver, 271	of color (tonality), 279	visual color mixing by, 268
Theater lighting, 284–285	continuation to achieve, 38-39, 48	The Yellow House, 280
Thiebaud, Wayne	continuity/grid to achieve, 40-41,	van Sommers, Jenny, "Music"
Paint Cans, 28	42–43, 52	campaign, 272
Rabbit, 274	defined, 28	Vanishing points
Thinker, Robert Moskowitz, 156–157	emphasis on, 46-47	absence of, with isometric projection,
Thinking, 7, 8–13, 20–21	figurative and abstract art including,	220–221
about audience, 9	52–53	in linear perspective, 208-209, 211
		in multipoint perspective, 214–215
about problem, 9	focal point maintaining, 65	
about solution, 9	gestalt theory, 32-33	Vanity (Portrait 1), Susan Moore, 62
form and content, 10-11	harmony and, 28-29	Variety
form and function, 12-13	proximity to achieve, 34-35, 38	chaos/control and, 50-51
getting started, 8–9	repetition to achieve, 36–37, 44–45,	emphasis on, 48–49
with materials, 20-21	46–47, 53	grid variations, 42–43

Variety, continued light and dark variations, 246-247 line quality creating, 138-139 of patterns, 182-183 . of texture, 187 unity achieved with, 42-51 varied repetition, 44-45 Vellekoop, Maurice, Christian Dior Boutique, Valentino, 65 Verisimilitude, 192 Vermeer, Jan Girl with a Pearl Earring, 280-281 The Kitchen Maide, 230 A Lady at the Virginals with a Gentleman, 62-63 Vertical lines, 134-135 Vertical location, 202-203 Vibrating colors, 114, 118, 283 View of an Ideal City, Piero della Francesca, 208 View of the Tiber near Perugia, George Inness, 82-83 Virgin and Child with an Angel, Francesco Salviati, 144-145 Virgin of the Rocks. Leonardo da Vinci. 15 Visa, Stuart Davis, 280 Visual color, 193, 268-269 Visual grays, 253 Visual organization, 4-5. See also Unity Visual perception, 32-33 Visual rhythm, 114-115 Visual texture, 192-193 Visual training/retraining, 18-19 Visual unity, 30-31 Volume color creating illusion of, 271 line quality expressing, 138

shapes and, 156-157 value suggesting, 250-251

W Walkowitz, Abraham, Bathers on the Rocks, 198 Wall, Jeff, The Pine on the Corner, 56-57 Wall covering material, Anni Albers, 191 Wall Drawing 51, Sol Lewitt, 149 Wall painting in Tomb of Nakht. Thebes, 218 Wall Street, Showing East River from Roof of Irving Trust Company, Berenice Abbott, 214 Walp, Susan Jane, Grapefruit with Black Ribbons, 56 Walt Disney Studios, Snow White Models, 166-167 War: What is it Good For? (poster), Marty Neumeier, 5 Wash drawing, 253 Watterson, Bill, Calvin and Hobbes, 235 A Wave under the Moon, unknown Chinese artist, 240 Web design, 41 Weinstock, Sarah, Untitled Drawing, 20 Welliver, Neil, Thawed Ledge, 271 Wesselmann, Tom, Still Life #12, 202-203 West African Kente cloth, 140-141 Weston, Edward, Artichoke, Halved. 120-121 Wharton, Margaret, Mocking Bird, 94-95 "Whirligig," Anonymous, 107

White Rooster, Milton Avery, 284-285

White Sands National Monument, Garry Winogrand, 105 Width, line, 128 Wieden, Dan, Nike Sportswear advertisement, 159 Wilbur, Richard, Candide, 284-285 Winogrand, Garry, White Sands National Monument, 105 Winter, Damon, personal photograph from Iceland, 29 Woman and Child beside a Mirror Stand. Nishikawa Sukenobu, 220 Wood/Philips web page, 41 Wright, Frank Lloyd, Arch Oboler Guest House (Eleanor's Retreat) plan, elevation, and perspective drawings, 206-207

X House, UrbanLab, 65

Y-1958, John McLaughlin, 226-227 Yellow, Al Held, 225 Yellow Flowers, Tony Mendoza, 216-217 The Yellow House, Vincent van Gogh, 280 York Minister, Into the South Transept, Frederic H. Evans, 98 Yosemite Valley from Inspiration Point, Ansel Adams, 204

Z

Zebra, George Stubbs, 58 Zeisel, Eva, ceramicware, 44-45 Ziegler, Jack, cartoon, 254